THE PELICAN HISTORY OF ART

EDITED BY NIKOLAUS PEVSNER

Z18

ART AND ARCHITECTURE IN BELGIUM 1600–1800

H. GERSON · E. H. TER KUILE

H. GERSON · E. H. TER KUILE

ART AND ARCHITECTURE
IN BELGIUM

1600 TO 1800

PUBLISHED BY PENGUIN BOOKS

Penguin Books Ltd, Harmondsworth, Middlesex
Penguin Books Inc., Baltimore, Maryland, U.S.A.
Penguin Books Pty Ltd, Mitcham, Victoria, Australia

★

Written for the Pelican History of Art
Translated from the Dutch by Olive Renier

★

Text printed by Richard Clay & Company Ltd, Bungay, Suffolk
Plates printed by Percy Lund Humphries & Co Ltd, Bradford
Made and printed in Great Britain

★

CONTENTS

Part One

Architecture and Sculpture

BY E. H. TER KUILE

Part Two

Painting

BY H. GERSON

v

CONTENTS

CONTENTS

The Plates

LIST OF FIGURES

The drawings were made by Mr Donald Bell-Scott

LIST OF PLATES

If not otherwise indicated, the photographs of paintings and drawings were received from the owners of the original works. They are reproduced with their consent.

76 (A) Peter Paul Rubens: The Expulsion from Paradise. *Prague, Národní Galerie*

(B) Peter Paul Rubens: Elijah carried up to Heaven. *New York, Curtis O. Baer*

77 Peter Paul Rubens: The Reconciliation of Marie de' Medici with her Son. *Munich, Bayerische Staatsgemäldesammlungen*

78 Peter Paul Rubens: The Assumption of the Virgin, 1626. *Antwerp Cathedral* (Copyright A.C.L., Brussels)

79 Peter Paul Rubens: The Mystic Marriage of St Catherine, 1628. *Antwerp, Augustijnenkerk* (Copyright A.C.L., Brussels)

80 Peter Paul Rubens: Rubens and Isabella Brant. *Munich, Bayerische Staatsgemäldesammlungen*

81 Peter Paul Rubens: Self-portrait. *Vienna, Kunsthistorisches Museum*

82 Peter Paul Rubens: Caspar Gevartius. *Antwerp, Musée Royal des Beaux-Arts* (Copyright A.C.L., Brussels)

83 Peter Paul Rubens: The Duke of Buckingham. *Formerly Osterley Park, the Earl of Jersey (destroyed in the Second World War)* (Courtesy of Count Antoine Seilern)

84 Peter Paul Rubens: Helena Fourment. *Munich, Bayerische Staatsgemäldesammlungen*

85 Peter Paul Rubens: Helena Fourment with her Children Franciscus and Clara-Joanna. *Paris, Louvre*

86 (A) Peter Paul Rubens: Charles I called by James I to be King of Scotland, c. 1634. *Leningrad, Hermitage*

(B) Peter Paul Rubens: The Blessings of the Reign of James I. *Vienna, Gemäldegalerie der Akademie der bildenden Künste*

87 Peter Paul Rubens: 'Quos Ego' (Neptune stilling the Tempest), 1634/5. *Cambridge, Massachusetts, Fogg Art Museum* (Courtesy of the Fogg Art Museum, Harvard University)

88 (A) Peter Paul Rubens: The Apotheosis of Hercules. *Brussels, Musées Royaux des Beaux-Arts*

(B) Peter Paul Rubens: Mercury and Argus. *Brussels, Musées Royaux des Beaux-Arts* (Copyright A.C.L., Brussels)

89 Peter Paul Rubens: Triptych of St Ildefonso (central panel). *Vienna, Kunsthistorisches Museum*

90 Peter Paul Rubens: Madonna with Saints. *Antwerp, St Jacobskerk* (Copyright A.C.L., Brussels)

91 Peter Paul Rubens: The Martyrdom of St Thomas. *Prague, Národní Galerie*

92 Peter Paul Rubens: The Rape of the Sabines. *London, National Gallery* (Reproduced by permission of the Trustees, the National Gallery, London)

93 Peter Paul Rubens: The Feast of Venus. *Vienna, Kunsthistorisches Museum*

94 (A) Peter Paul Rubens: St Paul. *Madrid, Prado*

(B) Jacob Jordaens: Study of a Head. *Caen, Musée des Beaux-Arts* (Bulloz)

95 (A) Anthony van Dyck: St Peter. *Leningrad, Hermitage*

(B) Anthony van Dyck: St Matthew. *Althorp, Northants, the Earl Spencer* (A. C. Cooper)

96 Anthony van Dyck: The Carrying of the Cross. *Antwerp, St Pauluskerk* (Copyright A.C.L., Brussels)

97 (A) Anthony van Dyck: The Continence of Scipio. *Oxford, Christ Church Library* (Royal Academy of Arts)

(B) Anthony van Dyck: The four Ages of Man. *Vicenza, Museo Civico* (Alinari)

98 (A) Anthony van Dyck: Self-portrait. *Munich, Bayerische Staatsgemäldesammlungen*

(B) Anthony van Dyck: A forty-one-year-old Man, 1619. *Brussels, Musées Royaux des Beaux-Arts* (Copyright A.C.L., Brussels)

99 (A) Anthony van Dyck: A Gentleman. *Dresden, Gemäldegalerie* (Deutsche Fotothek, Dresden)

(B) Anthony van Dyck: A Lady. *Dresden, Gemäldegalerie* (Deutsche Fotothek, Dresden)

100 Anthony van Dyck: Frans Snyders. *New York, The Frick Collection*

101 Anthony van Dyck: Margaretha de Vos, wife of Frans Snyders. *New York, The Frick Collection*

102 Anthony van Dyck: Sir Robert Shirley, 1622. *Petworth, Petworth Collection* (Sydney W. Newbery)

103 Anthony van Dyck: Lady Shirley, 1622. *Petworth, Petworth Collection* (Sydney W. Newbery)

104 Anthony van Dyck: Marchesa Doria. *Paris, Louvre* (Archives Photographiques)

105 Anthony van Dyck: The Madonna del Rosario. *Palermo, Congregazione della Madonna del Rosario*

106 Anthony van Dyck: The Crucifixion. *Lille, Musée des Beaux-Arts* (Archives Photographiques)

107 Anthony van Dyck: The Vision of the Blessed Herman Joseph, 1630. *Vienna, Kunsthistorisches Museum*

EDITOR'S NOTE

THIS volume deals with the history of art and architecture in the Southern Netherlands from about 1600 to the end of the eighteenth century. Owing to the arrangement of material for the adjoining volumes, which seemed advisable for practical reasons, the volume also contains a survey of architecture and sculpture from the coming of Italian Renaissance influence to about 1600. This anomaly must be frankly admitted. It must also be admitted that the title of the volume is faulty in two ways. First, it does not acknowledge the anomaly just pointed out; and secondly, it introduces a geographical term which strictly speaking did not come into being until 1830. But that classic of historiography, Henri Pirenne's monumental history of the Southern Netherlands, is called Histoire de Belgique; and perhaps this may be accepted as a sufficient excuse for a title more manageable than correct.

INTRODUCTION

FROM the end of the fourteenth century the Dukes of Burgundy, by marriages and other means, gradually acquired more and more of the regions that are usually referred to as 'the Netherlands' or the Low Countries. By the marriage of Mary of Burgundy, heir to Charles the Bold, to Maximilian of Austria, these Burgundian lands became Hapsburg patrimony. Charles V, who was born in Ghent, was proud of his Low Countries heritage, and did all he could to extend it. His acquisition of the Duchy of Gelderland in 1543, after a long and strenuous fight, put him in complete control of all the duchies, counties, and principalities of the Low Countries, with the sole exception of the episcopal principality of Liège, which retained its singular autonomy until the French Revolution. The territories thus gained by the Dukes of Burgundy and their Hapsburg heirs kept their traditional administrative institutions, and their rights and privileges with regard to their Seigneurs, though the Burgundians did make a premature attempt to establish centralized administration. The representatives or States of the different territories were called more than once, and as early as the time of Philip the Good, to sit in joint session as the 'States General', while a supreme court of justice, the Grand Council, was established in Malines (Mechelen). At the same time other central boards and governmental councils came into existence. Moreover, Charles often appointed female members of his family as regents with authority over the stadholders (lieutenants) of the separate territories. These regents were assisted by the Council of State and other central administrative councils. Thus, towards the middle of the sixteenth century the Low Countries were well on the way towards becoming a formal Hapsburg monarchy. Charles V managed to break the feudal link between the French Crown and the south-western Netherlands, and to weaken that between the remaining Netherlands territories and the German Empire, by establishing Burgundy as an entity only nominally a member of the Empire.

Despite many kinds of political resistance, a unified Netherlands seemed an attainable goal provided the necessary precautions were taken. The fusion of more recently acquired territories with those that had become familiar with Burgundian and Hapsburg rule seemed to be mainly a matter of time and patience. Culturally there appeared to be no serious obstacles to the unification. With the exception of a relatively minor Walloon region in the south, and of the county of Friesland, closely related Germanic dialects were spoken everywhere, and the idiom of Brabant was on the way to becoming the universally accepted literary language of the Netherlands. Moreover, ecclesiastical connexions with bishops and archbishops whose sees were outside the Netherlands were broken when, in 1559, a reorganization of the hierarchy took place upon the insistent demand of the ruler. Three Netherlands archbishoprics were established, including all the patrimonial territories. It was too early yet for a true Netherlands

patriotism, but there was no question either of incompatibilities between groups of territories. Political frontiers were not yet, or not to any extent, clear cultural or economic lines of demarcation.[1]

As regards art, the acceptance of the Renaissance brought about more unity than had hitherto prevailed. Regional characteristics wilted away together with the Gothic style that had produced them, and the numerous pupils of the Antwerp painter, Frans Floris – according to van Mander there were over a hundred of them [2] – spread a uniform Mannerism throughout the whole of the Netherlands. Antwerp was the economic and artistic metropolis, just as Brussels was the administrative centre.

The central government expected that the ecclesiastical reorganization which it had introduced in 1559, in spite of violent opposition on the part of the clergy, would put an end to heresy. However, the religious groups that sprang from the Reformation brought about serious tensions, which came into the open after more than a score of years under Philip II, who succeeded Charles in 1555. Unlike his father, Philip was a stranger among his Low Countries subjects. After 1559, when he departed for his Spanish kingdom, he never again set foot in the Netherlands. His reign was marked by a religious and political intransigence which, if it did not actually give rise to the ensuing crisis, certainly hastened its development. The opposition of both nobility and people had a number of different causes: interests had been hurt, honour wounded, there was animosity against foreign administrators, the interference of the central government was resented, the financial results of the king's administration gave rise to objections, and there was, most of all, the religious sentiment of the Calvinists, the most militant among the Reformed, who were to be found principally in the towns of Flanders and of the neighbouring Walloon districts.

The year 1566 saw a series of dramatic events. First a written complaint was handed to the Regent in Brussels. Then there was a wave of wild iconoclasm that swept over Flanders, spreading as far as Friesland. The king dispatched his commander, the Duke of Alba, to the Netherlands, where he restored order by force of arms. Thousands fled abroad. Among the refugees was the richest member of the high nobility, William, Prince of Orange, Stadholder (i.e. Governor) of Holland, Zeeland, and Utrecht, and a member of the Council of State. He was by no means a fanatical Calvinist, but he belonged to the fiercest and most convinced opponents of the king's policy. He and his brother, with troops levied abroad, returned to invade the Netherlands at several points. Alba inflicted a decisive defeat upon them, however, after which the only way for the *émigrés* to damage the king's cause was by freebooting at sea. For the time being resistance on land throughout the Netherlands came to an end. Then, in 1572, the freebooters, the 'Waterbeggars', suddenly landed and occupied the port of Den Briel. This was the sign for a new revolt in a number of towns. William of Orange and his brother Louis carried out invasions in the south and east. Determined resistance to the central authorities broke out, particularly in the counties of Holland and Zeeland, although Amsterdam took no part in it. The Prince of Orange went to Holland to take the lead in this desperate stand. Now the central authority was thrown into confusion, and the Duke of Alba was recalled. The revolt grew, but by the Pacification of Ghent, William

of Orange eventually succeeded in persuading all the Netherlands to enter into a union. The States General, representing wellnigh the whole of the Netherlands, declared their solidarity in the task of expelling the king's troops from the country, though they recognized the king himself as their legitimate sovereign.

However, the dream of union in resistance against princely absolutism was not realized. Separatism, particularism, and the fear of the Roman Catholics and of the non-sectarians at the sight of the fanaticism of the Calvinists caused a split, especially in the towns of the south-west. Two leagues were formed in 1579, the Union of Arras (then still a town in the Netherlands) and the Union of Utrecht. At first the adherents of either union were few, but they soon increased in number. The Union of Arras, which included a large part of the Southern Netherlands, came to an agreement with the royal government. The members of the Union of Utrecht, i.e. mainly the territories and the towns of the northern half but including towns like Antwerp, Ghent, and Bruges, and large territories in Flanders, formed themselves into an indivisible league of states with their own States General and generality bodies, fully determined to continue their resistance against Philip II, and with freedom of conscience guaranteed in the statutes of the Union.

Now, under the leadership of William of Orange, the Union of Utrecht continued the struggle. In 1581 their States General, meeting in solemn session, declared that Philip II had forfeited his sovereign power. At that moment the Netherlands finally split in two, although the line of demarcation between the Republic of the United Netherlands and the King's Netherlands continued to fluctuate according to the development of military operations. The division of the Netherlands was a tragedy, because nobody in the Netherlands wanted it, because it was not based upon ethnical or linguistic differences, because the Reformation had at no time been a question of North versus South, because the division was neither economically nor culturally realistic, and because it was counter to all the intentions of William of Orange, who had to pay for his leadership with his life when at last, in 1584, he was murdered by one of the king's hired assassins.

During the last decades of the sixteenth century the condition of the Spanish Netherlands was desperate,[3] but about 1600 it looked as though a revival was coming about. Shortly before his death Philip II gave the Netherlands to his daughter Isabella as a dowry on the occasion of her marriage to her cousin Archduke Albert of Austria, since 1596 Stadholder of the King's Netherlands. The requisite conditions for a separate evolution, indeed for a reunion of the Netherlands, seemed implied in this concession, the more so since Philip III (1598–1621) agreed to the cession of the Netherlands. Nevertheless, the States General of the Northern Netherlands rejected what would have meant their subjection to an administration from Brussels, even though it looked like an administration belonging to the country itself. Moreover, there were ecclesiastical differences between the Reformed Church as the state church in the north and the revived Catholic Church in the south, and they made a common administration utterly unthinkable. It further became known that the act of cession by the Spanish Crown was burdened with a number of secret clauses and restrictions that turned the autonomy of

the Netherlands into an illusion. The main restriction was that the Spanish Crown would re-annex the Netherlands if the marriage of Albert and Isabella remained without issue – as in fact it did. Philip III, who despised Albert and appointed Ambrogio Spinola his 'mestre de camp general', took possession of the Netherlands once more in 1616. Spinola, however, was unable to achieve any lasting success in his war against the rebels. Archduke Albert died in 1621, leaving Isabella in deep mourning. She continued as regent till her death in 1633, even during the reign of Philip III, who succeeded to the Spanish throne in 1622.

During the rule of Albert and Isabella the complete restoration of the Spanish administration in the Southern Netherlands was accomplished. The twelve years' truce (1609–21) brought a short respite and made possible the reconstruction of the country's administration. Isabella's Spanish advisers, among them Cardinal La Cueva, a confidant of Philip II, were much hated, but there was no danger of a popular rising. Calvinism was dead. The efforts of a few noblemen to achieve independence were as a fruitless as the endeavours of the Archbishop of Malines to maintain ancient privileges.

Under the Archdukes, Belgium once more became one of the most Catholic countries in the world. The excellent Jesuit schools put the universities of Louvain and Douai in the shade. The archducal court was 'une des résidences les plus vivantes et les plus cosmopolites de l'époque', and an asylum for all Catholics who were persecuted for their faith.[4] The foremost artists of the Netherlands became their court painters; Rubens, moreover, was Isabella's confidential agent in a number of political missions. Yet, short of funds as it invariably was, the Brussels court was never able to equal Antwerp as a national art centre. It is characteristic of the situation that Rubens continued to live in Antwerp, as Jan Brueghel had done before him. Albert and Isabella's court exercised only a limited influence upon the country's culture, though the Catholic restoration put its stamp upon all the arts and sciences. Art, especially architecture, served the cause of the Counter-Reformation. But the same Church that had to defeat the heretical humanists found ways and means to fuse the spirit and the ideas of the Renaissance with the art and culture of a new age. Flemish art was characterized by a revival of classical forms. This revival followed a tradition of the sixteenth century, when men were already taking pride in the enrichment of ecclesiastical art by antique forms.

Even during the government of Isabella efforts were made to conclude a peace with the Northern Netherlands – Rubens undertook several diplomatic missions to this end. However, it was only under one of Isabella's successors, the Archduke Leopold Wilhelm (who ruled from 1647 to 1656), that the Peace of Munster was concluded. Concerning the Netherlands, the peace repeated the severe clauses of the truce of 1609: 'les bouches de l'Escaut et les canaux y aboutissant fussent tenus clos du costé des Seigneurs Estatz' (i.e. the Northern Netherlands). It was these Lords States General whose independence Philip III must now recognize and to whom he had to give up several frontier territories.

The second half of the seventeenth century is a chronicle of French threats and invasions. Spain was now powerless to defend her Netherlands territories, and the Spanish Netherlands actually had to accept the assistance of the Protestant Republic against French aggression. Devastated by French and Spanish troops and in the power of the

Dutch merchants, the country was reduced to provincial status.[5] Architectural activity stagnated after 1675. However, Leopold Wilhelm, a weak governor, was an outstanding art collector. The works of art which he bought in the Netherlands he bequeathed to his brother, the German Emperor, and they are today the pride of the Vienna Gallery. Other governors restored a number of privileges to provincial and local administrations, and respected the 'Joyeuse Entrée', which imposed upon them the recognition of local privileges. However, although many provincial administrations and administrative organizations recovered their autonomy, there was no national revival.[6] By the Peace of Utrecht (1713) and that of Rastatt (1714) the Southern Netherlands passed to Austria. Prince Eugène became Governor and Captain General, and after him the country was administered by Maria Elisabeth, Maria Theresa, and Charles of Lorraine. A revolt in Brabant against the arbitrary régime of Joseph II soon spread, but was suppressed after the death of the enlightened despot (1790). The conquests of the French Revolution put an end to Austrian rule, and after the fall of Napoleon the Congress of Vienna united the Austrian Netherlands and Holland into a Kingdom of the Netherlands under King William I (Union 1814, Kingdom 1815). The Union did not last beyond 1830.

Before the French conquests the eighteenth century brought a certain revival to the south, up to a point owing to the weakening of the northern United Provinces as a political power. Ostend acquired importance as a port, and industrial centres round Liège grew in importance too, though Liège, of course, was politically independent of the Austrians. Neither revival nor decline, however, was reflected in the visual arts, nor were they affected by the transition from Spanish to Austrian rule. Indeed, political, economic, or even religious troubles had few, if any, repercussions in the cultural field. The greatest creations of Flemish Baroque painting appeared during the years of war, when foreign domination was at its most severe. In the period after 1650, when traditional customs once more played a part in the administration of the country, not a single painting of more than provincial importance came into existence. It might be argued that the late style of Jordaens and of David Teniers is more Flemish than that of the young Rubens and Adriaen Brouwer; however, this later style can also be understood only as an Indian summer, no more than an echo of the great period of Flemish art between 1610 and 1640.

In the eighteenth century French influence steadily increased in architecture, painting, and sculpture, but a complete assimilation did not take place. French influence was strongest perhaps in architecture, as demonstrated by the Place Royale of Brussels. Side by side with the minor masters who practised French art in a provincial manner, there were others who decorated large surfaces with paintings of a diluted Rubenesque kind. Sculpture lost all national character.

Thus it cannot be denied that the great period of Flemish art was the time of economic decline under foreign rule. At that time, the first half of the seventeenth century, painting had a dynamism which affected the whole of Europe. Architecture, which was characteristically ecclesiastical throughout, managed in a striking way to graft the spirit of the Baroque upon the stem of national Gothic tradition. This great flowering can be

attributed in large part to the dynamic force of the Counter-Reformation, which renewed Catholic art and culture all over Europe. It was not directed by a monarch and his court, but was based upon the sense of style and the vitality of whole sections of the population. In this movement Flanders and Brabant were always in the lead, the other territories showing a minimum of artistic activity.

PART ONE

ARCHITECTURE AND SCULPTURE

BY

E. H. TER KUILE

ARCHITECTURE

THE SIXTEENTH CENTURY FROM THE APPEARANCE OF THE FIRST ELEMENTS OF THE RENAISSANCE

THE Low Countries were by no means slow in accepting Renaissance forms. No sooner had these penetrated into France than they also made their appearance in the Burgundian hereditary lands along the North Sea. This is not surprising if one considers the historical circumstances. One after the other, practically every territory in the Low Countries fell to the Burgundians or to their Hapsburg successors. As a result, they were drawn very strongly into international politics. Active trade relations existed with overseas countries. A large number of the inhabitants of the Southern Netherlands, and most certainly the circles that set the pace, either spoke French or were bilingual. The country was therefore open to innovations, and the high nobility was especially ready to follow fashionable examples in the matter of art and display.

Side by side, however, with this unmistakable readiness to accept novelty, which was very favourable for the triumph of Renaissance forms, forces of a conservative nature were present in the Netherlands, and more particularly in the Southern Netherlands. Late Gothic architecture was particularly rich and many-sided in Brabant, and precisely at the beginning of the sixteenth century this Brabant style of Gothic was going through a phase of expansion into the neighbouring regions. As a result, it acquired something of the character of a national style of the Low Countries. For generations men had become familiar with native versions of Gothic architecture. Having become so widely popular, the Gothic style was not lightly set aside.

As everywhere this side of the Apennines, the acceptance of the Renaissance in architecture was at first almost exclusively a matter of ornamental forms. Now and then these ornamental forms were impressively pure; sometimes, however, they betrayed a complete lack of understanding, and in these cases one can only speak of Gothic in fancy dress. In the first decade of the sixteenth century the new style was applied only by engravers and painters, but within a few years of 1510 Renaissance ornament spread from flat surfaces to three-dimensional forms. The oldest example of this is provided by some of the triumphal arches that were erected in 1515 at Bruges on the occasion of the solemn entry of the future Emperor Charles V. There the new style revealed itself in the form of grotesques and of medallions with relief heads.[1] A sample of rather unrestrained Renaissance ornamentation is provided by the rebuilt rood screen of the church of St Mary-in-Capitol in Cologne, ordered in 1517 from Malines artists who are not known by name. It may have been designed by the painter and decorator Jan van Roome.[2]

In these years, that is between 1515 and 1521, a purely architectural piece of Renaissance work came into being, the outer ward of the castle of Breda, which contains the

outer gate.[3] It still exists, though it has undergone considerable modifications. It is with this outer ward and its gate that Henry III of Nassau-Breda inaugurated the large-scale renovation of his ancestral castle, with which he was occupied till his death in 1538. As it appears at the present time, the framework of the gate is correctly classical. The pediment of the beginning of the sixteenth century, which was barbarously steep, was replaced in the course of the seventeenth century by one in better but less characteristic proportions. A highly unorthodox interpretation of the classical forms was shown by the steep, gable-like pediments of the vanished wooden gallery in the rear. Everything shows that knowledge of the Renaissance in the Netherlands was second-hand, and that round about 1520 people were still very uncertain in their attitude towards it.

After a few years, however, the craftsmen of the Southern Netherlands felt quite at home with Renaissance ornament and managed these Lombard forms, which had by then become international, with the greatest freedom and zest. How they relished the decorative possibilities is obvious from the bizarre architectural decoration in Lancelot Blondeel's paintings, and from the three-dimensional realization of his luxuriant dreams in the famous chimney-piece in the courtroom of the Franc at Bruges, which dates from the years 1528–30 and was entirely designed by Blondeel.[4] The festive façade of the Greffe on the Place du Bourg at Bruges dates from 1530, and the magnificent façade of De Zalm at Malines from the same year. The top of this house was unfortunately altered in the seventeenth century. In 1536 the palace of the Prince Bishops of Liège was provided with its galleries characterized by very odd, candelabra-like columns, and in the same year Henry III of Nassau replaced his castle at Breda by a new building whose proportions remind one of the Liège Palace but whose details were much more progressive than those used in Liège.

The Greffe at Bruges [5] and De Zalm at Malines are notable for an attempt to insert the classical orders of columns harmoniously into the façades. According to the Gothic tradition, the façades in both cases consisted almost entirely of large mullioned windows. The narrow spaces between the windows and the equally narrow horizontal courses at the level of the floors were entirely covered with pilasters and delicate entablatures. This was not particularly revolutionary: Gothic masons, such as the Keldermans of Malines, had more than once set demi-columns into the walls between windows (Hoogstraten Town Hall). But now the idea was no longer to put arches over the lintels, but the straight entablatures which went with the new style. Sometimes this was carried out to the letter, as in the Greffe at Bruges; at other times arches were introduced all the same in accordance with the traditional Gothic recipe, and this is how it was done at De Zalm at Malines. The difficulties were practically insuperable when it was necessary to decorate steep gables with the elements of the new style. Italy could supply no examples. The Greffe shows how it was done, and how the builders took refuge in a series of volutes.

The Liège Palace and the castle of Breda are by far the best-preserved of the considerable houses which the nobility of the Low Countries built in the second quarter of the sixteenth century. Both are remarkable as compositions with inner courtyards and arcades round all four sides. This method of construction has been compared with that of Italian *palazzi*. A comparison is, of course, justifiable, but the sixteenth-century

houses in the Netherlands certainly did not borrow their courtyards and arcades from the Tuscan Renaissance. Both motifs were already in use in the Netherlands while the Gothic style was still in fashion, as can be seen from the Hof van Busleyden at Malines and the Markiezenhof at Bergen-op-Zoom.

In the palace at Liège Renaissance motifs are limited to the crudely candelabra-like columns. This is not to be wondered at. The architect, Aart van der Mulcken, was a master of Late Gothic style, and during the same period built the churches of St Martin and St Jacques at Liège, both purely Gothic. The castle of Breda was quite another matter. Thomas Vincidor, born in Bologna and resident in the Netherlands since 1520, mostly in Antwerp, must have owed his appointment in 1536 as master builder for Henry of Nassau-Breda to the fact that he was supposed to be an expert in the new style. Had he not been sent by Pope Leo X to the Netherlands to keep an eye on the making of the tapestries for the Sistine Chapel? And must he not thus be familiar with the art of the Rome of Bramante and Raphael? Yet one rubs one's eyes when one looks at the sometimes childishly clumsy architecture of the castle of Breda and remembers that it was constructed to the plans of an Italian artist. It is hardly credible that an Italian could have designed this caricature of a triglyph frieze above the arcades, the jumble of gables in the courtyard, and the state staircase which disappeared during rebuilding operations in the nineteenth century. The high gables at the ends of the rear wing, which contains the enormous banqueting hall, are most un-Italian. Had some fifteen years' residence in the Netherlands so undermined Vincidor's grasp of classical principles, or were there native masters working alongside him and influencing what was done at Breda? The latter may well be true; for Vincidor was actually not an architect at all but a painter. The exact truth we shall probably never discover.

Military building brought new contacts with Italy in the middle of the sixteenth century. In 1540 the Emperor Charles V came to Antwerp with the fortification engineer Donato de' Buoni Pellizuoli from Bergamo, to arrange for the construction of a new ring of defences round the town. A beginning was quickly made with these. The new gates in the wall were designed in the modern Italian Mannerism of the day, and showed no signs of the uncertainty which marked the castle of Breda. The most impressive of these gates, the St Joris or Malines Gate, was dedicated in 1545 by Charles V himself. It can be assumed that Donato also looked after the decoration of the gates. Sebastian van Noye or van Oye (1493?–1557) seems also to have been concerned with the Antwerp gates, which were, alas, all demolished in 1865. Van Noye, born in Utrecht, was in Italy in 1523 as an officer of the Engineers with the armies of Charles V, where his fellow citizen Adrian van Utrecht had just been made pope. Because of his relations with Antoine Perrenot, Bishop of Arras, later better known as Cardinal Granvelle, Van Noye has been credited for more than a century with the palace which this prelate and statesman built for himself about 1550 at Brussels.

We know this palace, which disappeared long ago, from the engravings in Goetghebuer's *Choix des Momumens ... etc. du Royaume des Pays Bas*. It must have been a most remarkable piece of building, with the strict Italian style in contrast to the irregular layout and the disharmonious composition of the parts. The principal façade on the garden

side had below an arcade with a row of Tuscan pilasters, and above that a higher combination of an order with a blank arcade. Between there were windows with alternating triangular and segmental pediments. At the ends the pilasters were double. It was a piece of architecture wholly in the style then practised in Rome by Baldassare Peruzzi and the younger Antonio da Sangallo; one might call it a very reserved Mannerism. A man who could build like that must have been trained south of the Alps; for such ease in managing the Italian style had not yet reached the Netherlands. Could one expect this of Sebastian van Noye in view of what we know about him? Or is there truth in the undocumented suggestion of Schoy [6] that the real designer was an otherwise unknown Italian architect called Pastorana? The principal façade in the inner courtyard shows the influence of Italian Mannerism more strongly than that on the garden side. It immediately reminds us of Sansovino's Library of St Mark's (1548) and Palladio's Basilica at Vicenza (begun in 1549). If one compares these expertly composed façades with the rigid academism and the naïve clumsiness of the façade of the Utrecht Town Hall, of about the same period, by Willem van Noort (1546), it is quite clear that the 'House of Arras' at Brussels was Italian architecture on Flemish soil.

Another artist who had seen Italy was the painter-architect of Liège, Lambert Lombard (1506–66). To his credit stands the north portal of the church of St Jacques in Liège, dating from 1558, though there seems no positive evidence to support his authorship. One would not say that the designer of this portico must have been trained in Italy. Anyway, Lombard had lived in Italy for twenty years before the façade was constructed. The side pieces with their pairs of slender columns remind one strongly of Pierre Lescot's Louvre and the portico of the *corps de logis* of Anet designed by Philibert de l'Orme. The top storey suggests that the architect was at the end of his resources at this point. The detail is carried out with a meticulous care like goldsmiths' work.

Towards the middle of the sixteenth century native masters must have derived some help in adapting classical forms from the treatises on architecture which became available then. Sebastiano Serlio's *Regole sopra le cinque maniere degli edifici* (Book IV of his *Architecture*) appeared in 1537. As Schoy tells us, Pieter Coeck published in 1539 the first impression of a Flemish translation of this,[7] and translations of the other books of Serlio followed in later years. Pieter Coeck (1502–50), born in the little Flemish town of Aalst, had settled in Antwerp after living in Turkey. It was important for the spreading of Mannerism that he added to his translations of Serlio copies of the woodcuts of the original Italian editions. This undoubtedly helped to make it possible for a purer style to find a place alongside the excessive use of ornament. But it would be wrong to present Pieter Coeck as a determined pioneer of a correct Renaissance style or correct Mannerism. In 1550 he published together with the Antwerp Town Clerk, Graphaeus, a book of engravings showing the triumphal arches and other decorations which had been set up in Antwerp in 1549 on the occasion of the entry of Charles V and his son Philip into the city. Beside a few rather severe triumphal arches, we find illustrations of decorative pieces in which the ornament is almost entirely unrestrained. How far Pieter Coeck had a share in the planning of these architectural orgies it is difficult to discover, but he seems to have thought it worth while to perpetuate their memory.

Another important influence in the development of what is generally called Flemish Renaissance, but according to current terminology ought to be called Mannerism, was Cornelis Floris de Vriendt (1514?–75), son of a stonemason and, like Coeck, living in Antwerp.[8] According to his own testimony, he was in Rome about 1538. In 1556 he published a book of engravings with all sorts of adaptations of 'grotesque' ornament, and in 1557 his 'Inventions', comprising a series of funeral monuments. The extent to which he had mastered the range of forms is shown by his famous tabernacle in the handsome church of Zoutleeuw (between Louvain and Maastricht), which dates from 1550; and his masterly rood screen in the cathedral of Tournai (1572) shows to what a pitch of monumentality he could bring minor architectural work.

It is not possible to detect as early as the middle of the sixteenth century a settled policy in the architecture of the Southern Netherlands. The Guildhouse of the Weavers, built in 1541, in the Grote Markt at Antwerp, shows how laboriously the architects used the classical forms. Only with the new town hall of Antwerp (1561–6; Plate 1A) and the buildings influenced by it did a native style begin to develop, if not in all Belgium, certainly in the Flemish territories.

There is much doubt as to the way in which the design for the Antwerp Town Hall took shape. Different artists submitted plans, among them a certain Florentine Niccolo Scarini. It appears, however, that Floris had the last word, and that the work was executed according to his plans and under his active direction.[9]

The town hall is impressive not only for its substantial dimensions but also by reason of the reposeful composition, in spite of the great wealth of detail. The strongly vertically accentuated centre dominates the whole. This centre is not only entirely un-Italian but also un-French: in France a lofty centre would be unthinkable without corner pavilions to ensure balance. The Antwerp centre is a translation of the medieval belfry in a façade such as that of the cloth hall of Bruges or the town hall of Brussels. A tower would have been old-fashioned, and by way of substitute, the significance of which was purely aesthetic, a high gable was built which is quite independent of the rest and not very convincing.

The façade of the whole block shows a very free but at the same time happy adaptation of Doric and Ionic orders above a rusticated base with arcades. The effect of the façade is largely determined by the rhythm of cross-windows which pierce the walls in the traditional Gothic manner. They completely fill the spaces between the pilasters, and as the pilasters have a very shallow relief, it is the windows which dominate the whole. In addition, the pilasters are short, because the architect thought he was obliged to put them on pedestals in accordance with the books of orders current in the sixteenth century. The open gallery which surrounds the top storey is particularly graceful. The roof is carried above it with a vigorous overhang.

Although the centre does not lack authority, it seems by far the weakest part of the building. With its coupled columns and its broad and ever-repeated arches, it has a plasticity which disturbs the calm balance of the other façades. In contradistinction to the air of nobility which these show, this centre is undoubtedly trivial. In addition, the modern plate glass in the windows has a most disturbing effect.

Less impressive, but much more accomplished than the town hall owing to the absence of an over-emphasized centre, was the House of the German Hansa, built, according to some authorities, by Floris about the time that the town hall was being completed.[10]

The period of war which immediately followed the completion of the town hall had a limiting effect on its influence. The town hall was itself a victim of the war; in 1576 it was set on fire by the Spaniards. But certain consequences can be traced. In the first place there is the old town hall in The Hague, dating from 1563, which, on a much smaller scale and with entirely different relationships between height and width, represents a spirited variation. More clearly inspired by the Antwerp Town Hall are the town halls of Emden in East Friesland (Germany), begun in 1574 by the Antwerp architect Laurens van Steenwinckel, and that of nearby Flushing (1594, destroyed by the English bombardment of 1809).

The great propagandist of the style of Cornelis Floris was Hans Vredeman de Vries (1527–1606), born in Friesland, who wandered throughout the Netherlands and Germany. He did not practise as an artist as far as we know, but was responsible for series of engravings. The style of architecture and decoration in his engravings lacks all the grace and wit which mark the work of Cornelis Floris. His books of reproductions are popularizations in the worst sense of the word. He produced endless variations on the theme of the Antwerp Town Hall. Examples which could be carried out alternate with unrealistic fantasies like those of the *Variae Architecturae Formae* of 1601, with their colonnades, arcades, and fountains. The influence of Vredeman de Vries went on right into the seventeenth century, but the adaptation of his engravings can, again owing to the war, be found only on buildings of a fairly modest character. As good examples of the architectural style of the later sixteenth century in the Southern Netherlands, there is the east wing of the cloisters of Park Abbey near Louvain (1560) and various façades of guildhalls in the Gildekamerstraat and the Grote Markt at Antwerp; in the style of the Maas valley, the restfully balanced Butchers' Hall of Namur, built in 1588.

THE LAST FLOWERING OF THE SIXTEENTH-CENTURY STYLE AT THE BEGINNING OF THE SEVENTEENTH CENTURY

At the opening of the seventeenth century the political division between the Northern and the Southern Netherlands had become a fact, and this division was gradually beginning to appear in architecture as well.

In the first decades of the seventeenth century secular architecture in the South showed a tendency to cling to the style of the end of the previous century, and few traces of a new development can be detected. Regional schools had already been formed and consolidated and remained in being for a long time. This can clearly be seen in the Maas district in and around towns such as Namur, Liège, and Maastricht. The most typical example of this is undoubtedly the castle-like house which the industrialist Jean Curtius built for himself on the quayside at Liège. Other examples are the town hall of

Halle, south of Brussels, and the castle of Eisden, south of Maastricht. The exterior is dominated by the traditional alternation of deep red brick and a white or grey stone in bands, which is also used for the mullioned windows with their heavy cornerstones. Steep roofs with lead-covered eaves protrude far over the walls and form strong lines of shadow.

Practically no use was made of classical forms. In Flanders the tradition of Cornelis Floris was carried on. When at the beginning of the new century the town hall of Ghent was extended by a wing along the Hoogpoort, only their lifeless monotony distinguished these façades, with their stiff rows of windows set close together and their columns on pedestals, from those of the Antwerp Town Hall. The court house at Veurne (1612) also remained entirely faithful to the designs of Floris and his popularizer Vredeman de Vries. As late as 1638 the new wings of the cloisters of the Park Abbey at Louvain were designed in a style characteristic of the sixteenth century.

If anything new did develop in the South it was entirely in the field of ecclesiastical architecture, and it was the Jesuits who called the tune. At first they showed a strong preference for the Gothic style. Thus, Father Hoeimaker, born in 1559, designed the former Jesuit church of Tournai (built in 1601–5) as a completely Gothic structure, though he did not hesitate to decorate the entrance in the Renaissance style. When a few years later he built a Jesuit church in Ghent (since demolished), it was so Gothic that after a few decades it had to be modernized with plasterwork in the Baroque style by Father Hesius. But the same Father Hoeimaker also designed non-Gothic churches, such as the vanished Jesuit church of Brussels, begun in 1606.

It is generally stated that the Jesuits in the Southern Netherlands suddenly deserted Gothic for pure Baroque. This is quite untrue. Between the Jesuit Gothic and the Jesuit Baroque there was an intermediate style, a phase, which one could call pre-Baroque, and which was undoubtedly influenced by Italian Mannerism, even though one cannot go so far as to call it Belgian Mannerism. There is a certain danger in transferring labels of styles which are more or less easily applicable in Italy to styles of building which developed north of the Alps. One can even ask whether it is really possible to find genuine Baroque architecture in Belgium during the seventeenth century.[11]

The first great Jesuit church of the pre-Baroque period was that of Brussels, probably the work of Father Hoeimaker, and begun in 1606 (Figure 1). The church was removed in 1812, but we know it from old illustrations. It was a tri-apsidal basilica with rib-vaulting. The arches between the nave and the aisles rested on Doric columns. The arrangement of the spaces was really entirely Gothic, and only the forms Renaissance. There was no question of Baroque until Jacob Francart took over from Hoeimaker in 1616, and gave the church a façade and a tower behind the central apse (Plate 2A). This façade, the prototype of later church façades of Francart, showed a sort of transition from what one might call Mannerist architecture to Baroque. We shall return to it later.

It seems that the plan to which the Brussels Jesuit church was built was much admired. Wenceslas Cobergher adopted it in his designs for the church of the Carmelite Nuns in Brussels, a church which was begun in 1607 and which has disappeared too, and he repeated the formula in the church of the Augustinians in Antwerp, which dates from 1615.

Co(e)bergher is certainly one of the most important names connected with Belgian pre-Baroque. He brought to his country new ideas from Italy. Born about 1560 in Antwerp, he began his career as a painter and went to Italy in 1580 for a long stay, chiefly in Rome. Finally he settled in Brussels, where in 1605 he was appointed chief architect of the Archduke and Archduchess Albert and Isabella. His Roman training is clearly shown in the façade of the church of the Carmelites (demolished) in Brussels, which can only be regarded as a variant of the Gesù in Rome. It is incidentally noteworthy that this variant, to judge from a seventeenth-century print, was noticeably flatter than the prototype. It had no columns, only pilasters, and the volutes were fitted modestly into the composition. It was a modest piece of work altogether, extremely reserved as compared with Maderno's façade of S. Susanna of 1603, which Cobergher may have seen while

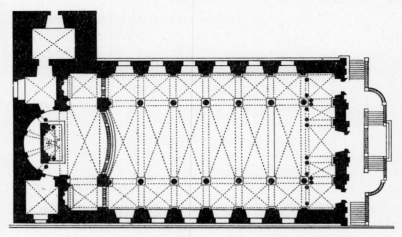

Figure 1. Father Hoeimaker (?): Brussels, Jesuit church (destroyed),
begun 1606. Plan

it was being built. Though we do not know what the church of the Carmelites looked like inside, the still extant church of the Augustinians at Antwerp, with its almost sixteenth-century-looking arcades, shows clearly that Cobergher was strongly dominated by tradition. He tried to get something personal and novel into the façade of the Antwerp church; remarkably broad bands of stone break up the brickwork into sections which are filled with Mannerist ornament, a not very successful method which found no imitators of importance. It is only with his pilgrimage church at Scherpenheuvel that he entered, however hesitatingly, the world of Baroque. This work also we shall have to discuss later.

A most remarkable monument of pre-Baroque or Mannerism is the well-known church of St Charles Borromeo at Antwerp (Figure 2). Here, too, Baroque decorative elements are to be found in the interior. Before a start was made on the final design in 1615, other plans were drawn up by Father François Aguillon, a professor of mathematics and physics.[12] When these plans were rejected in Rome, Father Huyssens was sent for. He had already built a church for the Jesuits at Maastricht with a nave without

aisles, and it is assumed that the designs finally carried out were Huyssens's, though it is still possible that Aguillon, who died only in 1617, helped with them. We shall discuss Huyssens later as an important Baroque artist, but the Antwerp church is, in its essentials, still a genuine piece of pre-Baroque architecture, except for the chapels and tower, which were added later.

In the ground plan the former Jesuit church of Antwerp followed the traditional plan of the Brussels church. The elevation, however, is different: there are galleries above the aisles, and the nave is not roofed with rib-vaulting but with a wooden tunnel-vault. One can, alas, no longer see the interior as it originally was, with its rich decoration designed by Rubens: the church was burned down in 1718, but though the original design was adhered to in the rebuilding, all the Baroque elements were left out. The most im-

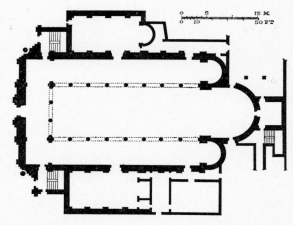

Figure 2. Pieter Huyssens, s.j.: Antwerp, St Charles Borromeo,
begun 1615. Plan (1 : 750)

portant part, from the point of view of the stylistic phase we are considering at present, is the façade, which ought to be compared with Buontalenti's model for the façade of the cathedral at Florence, kept in the Opera del Duomo – a first-rate example of Florentine Mannerism. The likeness is striking, though I would not go so far as to suggest a direct borrowing.[13] Buontalenti's model presents a firmer and purer style, which is what one would expect. Huyssens's façade is richer in so far as it is flanked by short towers with cupolas. In these towers are the stairs to the galleries. In a previous plan,[14] Venetian windows are shown in the towers. They belong to the stock-in-trade of Italian Mannerism. The tower behind the apse was originally pure pre-Baroque in design, but was finally changed into a vigorous Baroque. With this I have to deal later.

In the Walloon region there is little to mention for the period under review except the church of the Redemptionists in the Rue Hors-Château at Liège, begun in 1617, a typical pre-Baroque work, provincial in character. Secular architecture produced little original work except some by Cobergher, such as the town hall of Ath in Flanders, dated 1614.

Although it is impossible within the framework of this book to treat the expansion of the architecture of the Southern Netherlands in the north of Europe, it must be stated that the influence of the Mannerism of the Low Countries is most impressive in the buildings erected for the Danish kings Frederick II (1559–88) and Christian IV (1588–1648). The most glorious expression of this Netherlandish Mannerism is the castles of Kronborg and Frederiksborg, north of Copenhagen, fairy castles with fantastic spires and richly decorated façades. Kronborg is essentially the work of Antonis Van Opbergen, born in 1543 at Malines. He was in charge of the work from 1577 to 1585. Frederiksborg was begun in 1601, probably according to designs of Hans van Steenwinckel, who died in the same year. When he was still a boy, in 1567, he had emigrated from Antwerp to Emden with his father Laurens van Steenwinckel, who there designed the town hall which was built in 1576–8. In 1578 the son went to Denmark with Van Opbergen. One should, however, not forget that the style of the Danish castles is no longer purely Netherlandish. It has unmistakable German elements, which is not surprising, since the architects had left the Netherlands when they were young, and since especially Antonis van Opbergen, before his stay in Denmark, had, according to his own testimony, been in several places in Germany. In his later years he settled in Danzig, where he designed the picturesque Arsenal (1605).

BAROQUE ARCHITECTURE TO THE MIDDLE OF THE SEVENTEENTH CENTURY

Belgian Baroque of the seventeenth century is predominantly ecclesiastical architecture. Compared with ecclesiastical buildings in the towns and the monasteries in the country-side, secular architecture hardly mattered. Important town houses or châteaux were rarely built. The Archduke and Archduchess Albert and Isabella, sovereigns of the Southern Netherlands, and their successors, the Spanish and Austrian governors, lived till far into the eighteenth century in the medieval palace at Brussels or in the Late Gothic Palace of Nassau there. The aristocracy was not much keener to undertake building operations than the sovereign or the governor. The economic prosperity of the towns had been undermined by those wars which had given prosperity and independence to the North. The Northern Republic had closed the Scheldt to ships going to Antwerp. Only for building churches were resources available.

The new churches were not for the most part parish churches, of which there was little need, but rather churches for orders such as the Jesuits and the Augustinians, and churches for béguinages, those typical institutions of the Netherlands for single women who wanted to live in a nunnery without taking vows.

We have already looked at a few of the churches belonging to orders which we included among pre-Baroque buildings. The first church in which, in my view, Baroque appears, in a modest way, is that of Scherpenheuvel in the Brabant hill-country northwest of Louvain (Plate 2B). It is not, strictly speaking, the church of an order but a pilgrimage church, to which a Carmelite nunnery was attached. Cobergher was com-

missioned by the Archduke to design this church, and in 1609 the first stone was laid. Following Italian models, this sanctuary, in which a miraculous statue of the Virgin was worshipped, was designed on an almost entirely centralized plan. The principal space is a polygon of an extremely unusual type, that is to say a regular heptagon, certainly in order to symbolize the Seven Sorrows and the Seven Joys of Mary. This central space is surrounded by rectangular chapels on six of the sides, the remaining side being the entrance with its portico. This motif of a polygonal space, the sides of which open into chapels, is an old one. Brunelleschi had used it almost two centuries earlier for his unfinished S. Maria degli Angeli at Florence. As Plantenga has suggested, it is possible that Cobergher found the inspiration for his heavy central dome surrounded by enormous voluted buttress-walls in the plans the Florentine Mannerist Dosio made for S. Giovanni dei Fiorentini in Rome. The principal Baroque element is to be found in the flowing contours, especially the curves of the heavy volutes, which are taken up in the reverse outline of the dome, and in the windows, which are wide with segmental arches. The façade shows a very modest move in the direction of the Baroque. Unfortunately the spatial conceit is much disturbed by the tasteless decoration and furniture of the nineteenth century. It was no happy inspiration either to upset the soundness of the central plan by adding a massive tower, which rises above the two chapels at the rear in a completely disjointed way. The tower was never completed and remains a stunted giant. Most extraordinary are the volute-like ornaments on the topmost storey, the expression of an obstinate attempt at obtaining Baroque effects by an artist who was really not familiar with Baroque architecture.

From all this we see that Cobergher was not fully capable of carrying out his commission to build an impressive domed church. The external aspect of the chapels is poor, and does not balance the strong building-up of the centre. The entrance side looks flat in relation to the dome with its much coarser ornamentation, the rump of tower is unrestful, and its decoration lacks harmony. When we find that in his later years Cobergher (he died in 1634) did not attempt any more important works, and turned his attention to *monti di pietà*, or ecclesiastical pawnshops, and to the draining of marshes, we wonder whether he did not himself come to realize that his capacities as an architect were too limited for satisfactory results.

The type of church built on a central plan was not successful, very understandably, and the normal church plans remained basilican or aisleless. There was a whole series of churches on the basilican plan in the first half of the seventeenth century, mostly of impressive dimensions and richly ornamented. The principal architects were Pieter Huyssens and Jacob Francart.

Pieter Huyssens (1577–1637), a member of the Jesuit Order, has already been mentioned as an architect of the pre-Baroque in connexion with his share in the designing of the church of St Charles Borromeo in Antwerp (p. 16). He must have begun to specialize in architecture very early. He got into serious trouble because of the expensiveness of his designs, but the Archduchess Isabella protected him and in 1626 made it possible for him to go to Rome to study for at least a year.

Jacob Francart (1583–1651), the son of the painter of the same name, spent his youth

in Rome, and was himself originally trained as a painter. Perhaps because of his family connexions with Wenceslas Cobergher, who took as his second wife the sister of young Jacob Francart, he came in his maturity to the Netherlands. The first evidence of an interest in architecture came with his publication of a book of engravings with architectural details in 1616. Later he became principal architect and painter of the Archduchess. He was an invalid during his last years. His importance lies principally in his decorative gifts. He was the creator of a special sort of showy façade for churches, which was popular and which survived him.

There is nothing Baroque in the ground plans of his earlier churches. They are all aisled and have clerestories but no transept. Their main apses are flanked by side apses. The type of Hoeimaker's Jesuit church in Brussels (1606) can be found again in Cobergher's church of the Augustinians at Antwerp (1615), in the Jesuit churches at Bruges (1619) and Namur (1621), both by Pieter Huyssens,[15] and in the vanished

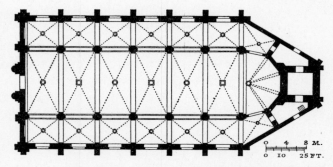

Figure 3. Jacob Francart: Malines, Béguinage church, begun 1629.
Plan (1 : 750)

Augustinian church at Brussels by Francart (1621). With the exception of the church of the Augustinians at Antwerp, which has a wooden roof, they all have rib-vaults which are completely Gothic in construction. The rhythm of the arcades is Gothic, and so is the sequence of a whole series of identical bays. Not a single new idea can be detected in the spatial development. If these buildings are indubitably Baroque, this is exclusively due to their decoration, in particular that of their façades.

Real Baroque façade-architecture began with the lost Jesuit church at Brussels, designed when Francart had replaced Hoeimaker in 1616 (Plate 2A). This had three storeys, twice stepped back, instead of the usual two storeys of the Italian and Italianate façades. The façade was thus very high, in conformity with the height of the nave. The third storey is a sort of compromise, with no order of pilasters of its own.

A more mature variant of this façade of 1616 was created by Francart in the façade of the Austin Friars at Brussels (1621). This has been removed to the new church of the Holy Trinity in the suburb of Elsene (Ixelles). The concentration of the relief is most skilful, and by subordinating the third storey entirely to the others the effect is much more monumental than that of the Jesuit façade can have been. The scheme, however,

remains alien, and one asks oneself whether Francart would not have achieved happier results if he had suppressed it altogether. In the façade of the Béguinage at Malines (begun in 1629) the third storey has once more the considerable size of the Jesuit church. The relief on the façade is particularly strong, and shows that Francart was developing more and more in the direction of the Baroque.

The church of the Béguinage at Malines and the church of the former Abbey of St Pieter at Ghent (Figures 3 and 4), both begun in 1629, are the first to diverge from previous internal systems by replacing the columns in the arcades by composite piers (Plate 1B). The effect is one of heavy monumentality. But, however much Francart in this respect showed his understanding of the Baroque, in the elongated ground plan without transept and without any central emphasis and also in his system of vaulting, he still conformed to the Gothic tradition. The fact that he retained rib-vaulting is perhaps

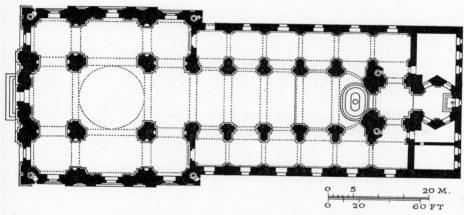

Figure 4. Ghent, St Pieter, begun 1629. Plan (1 : 750)

rather the result of technical than of aesthetic conservatism. Over comparatively small spaces, such as the chapels of the Holy Virgin and the Holy Sacrament on the left and right of the nave of St Charles Borromeo in Antwerp, added by Huyssens about 1625, and untouched by the fire of 1718, we find stone tunnel-vaulting of a highly monumental kind. So probably in dealing with large spaces builders felt safer with the traditional Gothic construction, in which they had more experience.

Only once in this period do we find tunnel-vaulting in use in a large basilica: in the former Jesuit church of St Lupus at Namur, begun in 1621 to designs by Huyssens. This is the more remarkable in that the ground plan and the elevation otherwise are of the most traditional Belgian kind, with columns, arches, a clerestory, and small penetrations into the vault. One would certainly not expect to find tunnel-vaulting here. In his somewhat earlier Jesuit church of Bruges (begun 1619) Huyssens had remained faithful to groin-vaulting. The aisles at Namur are also groin-vaulted.

The interior of St Lupus at Namur is a most remarkable example of South Netherlands Baroque (Plate 5). While the arcades of the Bruges Jesuit church are still slender

and light, the unpleasantly bulging shafts of the Ionic columns in Huyssens's church at Namur are furnished with block-shaped rings, Rubens-like in their heaviness. The archivolts are broken by radial blocks, and the impression of heavy splendour is greatly underlined by the massive, thickly moulded decoration of the vaults, by the costly enrichments, with red-veined marble, now dulled, and polished grey marble, and by the stately furnishings, dating from the time of the foundation. Aesthetically speaking, the difference between the Jesuit churches of Bruges and of Namur is greater than the difference between the dates of their commencement, 1619 and 1621, would lead one to expect. One seems justified in asking whether Huyssens did not make considerable alterations to his design for Namur after his study journey to Rome in 1626. There was time for it; the great tunnel-vault was constructed only after Huyssens's death in 1641. The façade, which was also completed only after his death, is a heavy Baroque variant of Francart's façade of the Jesuit church in Brussels. The decorative third storey is exceptionally large and vigorous. It is noteworthy that the columns and pilasters which enliven the façade are furnished with ring blocks in the shafts in the same way as the arcades of the interior.

By far the most important architectural creation of the first half of the seventeenth century, in my opinion, is the church of St Pieter at Ghent, the first stone of which was laid in 1629. The plan was so ambitious that the building could only be completed a century later (Plate 3A, Figure 4). The outside detail of the dome and of the topmost portion of the façade show that they were not carried out in accordance with the original plans, but elsewhere there was apparently no great departure from the original scheme.

The plan is most unusual. On entering the church one finds oneself in an impressive rectangular space divided by sturdy pillars into a central domed area, four arms, and four less lofty spaces in the corners (Plate 3B). On the east a nave with aisles is added to the rectangle. The nave ends in an apse, and the aisles run round it as an ambulatory. Over the middle of this ambulatory rises the slender bell tower, and behind the ambulatory is a chapel. The whole of this easternmost part gives the impression of being an appendix to the central space in front.

The impression of the whole interior, and in particular of the domed space, is overwhelming. There is nothing here to remind us of the timid Renaissance colonnades of the older churches. Instead, one receives an astonishing impact of light streaming through this exciting spatial composition. The vaulting over the four main arms is still ribbed in the Gothic way, and it is only over the low and narrow aisles and ambulatory that the cross-vaults are carried out without ribs. The rather broad coffered transverse arches dominate the fragile mouldings of the ribs, so that these do not interfere with the effect. The arcade arches have turned out somewhat thin, so that they provide a strong contrast with the heavy entablatures.

Anyone accustomed to Southern Baroque is immediately struck with the narrowness of the dome. In contrast to the custom in Italy, the architect made it no wider than the transept, and consequently the space under the dome is so lofty that it has the effect of a shaft. The same characteristic will be met with in later domes in Belgium. The

pendentives are treated quite unorganically, although they are constructional parts. They are hollowed out with *trompe-l'œil* sculpture.

In spite of a few shortcomings such as we have pointed out, St Pieter is the master-piece of the Belgian Baroque. It is not altogether clear who was its designer. In 1627, two years after the foundation stone was laid, Pieter Huyssens is recorded as 'engineer' of the building, and went on several journeys in that capacity. The actual building, how-ever, has little in common with what we know of his work. Leurs has put the question whether the Roman monumentality of the church is not the result of collaboration with other architects who influenced Huyssens in this direction.[16]

There is certainly reason to suppose collaboration. Generally speaking, the reader should remember that modern ideas concerning artistic copyright did not exist in those days, and certainly did not apply when the designers belonged to a religious order, as did Huyssens, and later van Hees, or Hesius. As far as Huyssens and the church at Ghent are concerned, we can only say that his architectural activity got him into trouble, and that a command from Rome in 1628 banished him to houses of his order where there was no building going on.

Before we move on to the ecclesiastical architecture of the second half of the seven-teenth century we must glance at the belfries. They are not so important a part of the town as a whole in the South as they are in Holland, but if we left them out certainly this survey would not be complete.

The oldest that concerns us here is the tower built by Francart after 1616 on to the choir of the Jesuit church at Brussels. From old prints of the vanished building it appears that, perhaps following the example of Scherpenheuvel, the corners were marked by fairly strongly moulded pilasters and attached columns. The lofty superstructure con-sisted of a series of three open eight-sided storeys reminiscent of Dutch towers. A more original design is the famous tower behind the choir of St Charles Borromeo at Ant-werp, which is usually ascribed to Huyssens. On the lofty shaft of the tower, which is articulated entirely with pilasters and columns, rises a circular lantern with a domed roof (Plate 4). What in Francart's tower had been meagre and thin is here vigorous and strongly three-dimensional. Unexecuted designs are known which are much flatter and more restrained, entirely in the spirit of Mannerism. Apparently the plans were finally altered in the Baroque way in agreement with the change of taste which can be seen in Francart's work too.

If the Antwerp tower was really entirely designed by Huyssens, it can be considered, with the church of St Lupus at Namur, as the expression of the final stage of his develop-ment. The Antwerp tower is undoubtedly an extraordinarily well-composed piece of architecture. We cannot give it unlimited admiration, however. The lantern with the steep domed roof reminds one of domed towers of the vulgar neo-Baroque of the end of the last century, and one must indeed admit that here the Baroque has passed its prime.

Two towers must be included here which belong to the second half of the seventeenth century, that of Saint-Jean of the Béguinage at Brussels and that of the château at Bergen in Hainault (Mons). The first of these, dating from approximately 1660 and never

completed, is striking for its unusual form and unusual decorative treatment. It is six-sided, changing higher up to an octagonal form. It seems that a better design, which consisted of a four-sided base and an eight-sided upper structure, was given up. But, even so, the design can never have been a masterpiece. The architect is not known. The campanile which stands detached on the site of the vanished château of Bergen was begun in 1662 to designs by Louis Ledoux, whom we otherwise know only as a sculptor of the school of François du Quesnoy. The importance of this tower lies not so much in its decorative motifs, which are in the usual Baroque of the period, as in the fact that it continues four-sided throughout. The pear-shaped motifs at the top show that as far as towers were concerned inspiration was not sought in Rome, even when, as here, the architect had studied there. The silhouette of the tower is almost as excellent as that of St Charles Borromeo.

The history of the Baroque in secular buildings begins with Rubens's own house in Antwerp, which he must have begun shortly after 1610 and probably completed in 1617. That Rubens was interested in architecture appears clearly from his book on the *Palazzi di Genova*, which he published in 1621. However, Rubens had not made the drawings of these palaces himself; he had collected drawings and then had them uniformly engraved. These engravings have nothing to do with the Baroque: what they represent is entirely Mannerism. It is remarkable, all the same, that nothing of the Genoese palace style can be found in Rubens's own house. The house, which had been made almost unrecognizable by later alterations, was restored not long ago in accordance with data which were certainly not sufficient to make a faithful reconstruction possible. It is uncertain how far the varied decorative work which appears in old prints was carried out in stone or was merely painted. What is original is only the arcade which divides the forecourt from the garden, and the pavilion in the garden, and here we have important samples of Rubens's architectural taste. One can hardly call them purely Baroque; there are everywhere reminiscences of Mannerism. Even less are they saturated with the Italian spirit. This is especially true of the garden pavilion, which has still a rather steep roof against which a small upper aedicula is set.

Rubens's own house and his engravings of the Genoese palaces are certainly not enough to justify the assumption that he gave the architecture of his time any kind of lead. One can postulate that he must have had some influence on St Charles Borromeo and on a few other buildings, but there is no definite proof. Among these latter buildings is the Water Gate at Antwerp, built as a kind of triumphal arch in honour of Philip IV in 1624. Here one can almost watch the Baroque spirit struggling to free itself from the bonds of Mannerism.

However, in the secular as in the ecclesiastical field Baroque feeling really expressed itself only in decoration. Houses retained their traditional forms. What changed is the ornamentation of the parts of the wall between the windows, of the sill-zone of the windows with their panelling, and above all the treatment of the gables. It is very enlightening to compare the Guild House of the Tanners of 1644 in the Grote Markt in Antwerp with the adjacent Guild House of the Weavers of 1541. An attempt to get away from the traditional style can be found in the house of the painter Jacob Jordaens

in the Hoogstraat at Antwerp, dating from 1641, and particularly in his studio, which was probably built somewhat later. One of the more representative country houses is the château of Beaulieu (1652) at Vilvoorde, north of Brussels, now in a ruined state. With its four square corner towers and gable in the middle, it lacks any Baroque feeling.

The Baroque appears in its purest form in independent pieces of decoration, such as the entrance gates of important houses, which have no connexion with the rest of the front and are known in Belgium by the popular name of 'Spanish Doors'. Here, as in ecclesiastical architecture, it is the Flemish regions which develop characteristic features: the eastern provinces have nothing to show.

THE SECOND HALF OF THE SEVENTEENTH CENTURY

When we review Belgian architecture as it developed after the death of Francart and Huyssens, we cannot avoid the conclusion that there was a lack of architects who could have given a lead. Most of the buildings with which we shall have to deal were still ecclesiastical. The principal figures are the Jesuit Willem van Hees, usually called Hesius,[17] and the sculptor Lucas Faydherbe,[18] who was also an architect – as a rule to the great financial disadvantage of those who employed him. Amateurism was in the ascendancy. When it was decided to build a new abbey church at Grimbergen near Brussels, the design was made by one of the monks considered capable of work of this kind. Somewhat later, for the abbey church of Averbode near Louvain, the famous but expensive Faydherbe was rejected in favour of an otherwise unknown Jan van den Eynden. In Liège the nun Aldegonde Desmoulins, daughter of the painter Jan Desmoulins of Mons, appeared in 1666 as the architect of the Benedictine church. We have to admit that the church in the Boulevard d'Avray which she designed is an excellent example of façade architecture under French influence. After 1670 architectural activity diminished a great deal because of the disastrous wars of Louis XIV, which were largely fought out in the Southern Netherlands.

The amateurism of the designers in clerical garb expresses itself in a scarcity of new ideas and a rigid adherence to the traditional composition of churches. This is clearly shown in St Michael, the former Jesuit church, at Louvain. The ground plan is entirely medieval: an aisled church with columns in the arcade, a clerestory, and transepts (Plate 6, A and B, Figure 5). These, like the choir and the aisles, have apsidal ends. This amounts to a remarkable regression, if one thinks of the Béguinage at Malines by Francart and St Pieter at Ghent.

The Jesuit church at Louvain was designed in 1650 by Hesius, who was then nearly fifty years old and could look back on a career as a lecturer in poetry, philosophy, and physics at Antwerp, and as a much admired and fashionable preacher at Brussels. The only unusual feature in Hesius's design was the high dome over the crossing, a feature which was unknown in Belgium apart from the dome on the centralized western part of St Pieter, Ghent. He designed his façade as a variation on the theme of the Jesuit church at Bruges. Fortunately the very arid design was not slavishly adhered to in execution,

though the general plan was followed. The nave was made longer, the clerestory higher, the dome lower, and the decoration was entrusted to an excellent artist.

On entering the church one is struck by several points of interest. The slender columns seem too light for the weight they have to carry. The thinness of the ribs in the traditional cross-vaulting is strange too. Before the church was finished certain structural faults were already apparent, so that Faydherbe's assistance had to be called in to save the building. And yet, in spite of all the changes in the original plan, the interior convinces because of the admirable decoration which binds the whole together and because of the splendid light that permeates it. The interior of the church at Louvain is, one might say, elegiac, where the Namur church is epic. In both buildings we are struck by the harmony between spatial form and decoration.

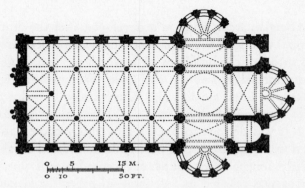

Figure 5. Willem Hesius and others: Louvain, St Michael,
designed 1650. Plan (1 : 750)

The same unknown hand as was responsible for modifying the original plan for the interior was obviously also concerned with the famous façade (Plate 6A). The design of Hesius was put on one side, and replaced by a brilliant variation on the theme which Francart, after 1616, had begun in the Jesuit church at Brussels, and which to date had found its richest interpretation at Namur. There is actually no new idea. Even the striking broken pediment in the middle over the entrance is to be found on the façade of the Augustinian church (now in front of the church of the Trinity) at Brussels. What is remarkable in the Louvain façade is the masterly way in which all the elements act together and are carried to their highest power of three-dimensional expression. That Belgium was capable of Baroque architectural creation is here emphatically proved. But this Baroque expresses itself entirely in the decorative treatment of surfaces. In the use of Baroque spaces, Belgium made only an extremely limited contribution.

Lucas Faydherbe (1617–97), whom I shall discuss later as a sculptor, is architecturally most significant as the designer of the very strange church of Onze Lieve Vrouwe van Hanswijk in Malines, his home town (Figure 6). The first stone was laid in 1663. The building process was one long story of difficulties, and the church was never finished. Faydherbe had previously been responsible for another piece of architecture, the interior

26

of the Turn and Taxis Chapel in the church of Notre-Dame-du-Sablon at Brussels, in 1651. His forms there are strongly reminiscent of Mannerism; the staccato quality of the smooth decoration shows nothing of Baroque feeling, which is certainly remarkable for an artist brought up in the circle of Rubens. He had not developed his architectural style much farther in the direction of Baroque when twelve years later he undertook the church of Malines. Even here Baroque really means no more than bizarre. The church has arcades on columns and fans out in the middle into a tremendous twelve-sided dome with gallery. The dome rises like a cylinder with high windows above the rest. The idea is fantastic. From the point of view of use it was not successful; from a constructional point of view it was decidedly reckless. The whole of the wide, high dome was to rest upon ten thin columns. The actual building raised the greatest difficulties. A number of

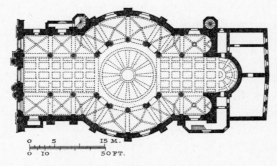

Figure 6. Lucas Faydherbe:
Malines, Onze Lieve Vrouwe van Hanswijk,
begun 1663. Plan (1 : 750)

the columns were made thicker and the dome had to be left without its superstructure. In the final simplified form, topped with a strange, bell-like roof, the dome is not unattractive, but the interior is feeble and lacks harmony. The façade can be regarded as a variation in very high relief on the ideas of Francart.

One of the most characteristic examples of the peculiarities of Belgian Baroque in the later part of the seventeenth century, and certainly one of the most charming, is the church of the vanished abbey of the Premonstratensians at Grimbergen, not far to the north of Brussels, begun about 1660. The columns in the unfinished nave, the short transept arms ending in apses, the dome over the crossing, and the tower behind the choir – all this adds up to nothing new. It resembles closely St Michael at Louvain. The soaring clerestory with its high windows and the traditional rib-vaulting also remind us of St Michael. The ambitious scale of the plan and the wars after 1672 probably account for the fact that the nave has only two bays and is shut off by a temporary wall. Here one can clearly see how intrinsically Gothic is the cross-section of the building. As a rule this cross-section is camouflaged by the Baroque front. At Grimbergen there is even a return to the Gothic mode not noticeable in his earlier churches, for example in the fact that the walls of the clerestory are sustained not by volutes but by straight buttresses,

and that so much loving care has been bestowed on the entire exterior. This impression is strengthened if we compare the tower, the top of which is unfortunately gone, with that of St Charles Borromeo in Antwerp: it is a travesty of a Gothic tower.

The interior shows again that the architect was best at the decorative aspects of his art. The decoration is finely carved in the sandstone of the building, and in spite of its profusion remains seemly. As in a Late Gothic church in Brabant, an excess of light floods in. The attraction of the interior is enhanced by the fact that the church has preserved its very fine original furnishings.

A few random pieces of evidence are held to justify the contention that this attractive but certainly not progressive church was designed by the Premonstratensian Canon Gilbert van Zinnik, who died shortly after the beginning of the work at the age of thirty-three. The name means little to us, for we do not know anything else by him, and the special style used at Grimbergen is not to be found elsewhere. We can only once more note that amateurism was in the ascendancy.

Two other churches from the third quarter of the seventeenth century show the same feeble architectural sense, in spite of having some interesting aspects, and the charm that comes from surprise. They are the church of Saint-Jean in the Béguinage at Brussels (1667–76), the tower of which has already been mentioned, and the church of the Premonstratensian Abbey of Averbode near Diest in the farthest north-east of Belgian Brabant.

The Brussels church is the more Gothic in spirit. It approaches a hall church in type and is entirely covered with net- and star-vaulting. The logical consequences of the plan with very broad aisles is straightforwardly carried out in the daringly rich façade with its three gables. This façade is by far the best thing in the church, original in form and composition, thoroughly Baroque in its modelling, convincing in style, and impressive in effect. I doubt very much, as does Plantenga, whether this façade was built to one design. One should compare the angularity of the central gable with the curves of the coarser side gables, the delicate ornamentation below with the more vigorously moulded motifs above the first cornice. Nevertheless, a remarkable and dignified unity is achieved.

The interior, on the other hand, is an example of disharmony and poor relationships. In St Michael at Louvain and in Grimbergen a community was achieved of Gothic spatial forms and Gothic construction with a Baroque finish. There is no such community in the Béguinage church at Brussels. The grouped columns of the crossing seem certainly to be left over from a medieval church. The columns have no properly developed bases and no entasis. The cherubim in the corbels above the columns are as tiresome as is the piling up of over-heavy ornamentation above the arches. Nowhere are the weaknesses of Belgian ecclesiastical Baroque so clear as here. We do not know which dilettante was responsible for such an immature performance.

The abbey of Averbode is one of the most picturesque groups of buildings in all Belgium. There is nothing left of the medieval abbey; what remains dates from different periods of the seventeenth and eighteenth centuries. Among these is the church with its tower, which was begun in 1664 from plans made by Jan van den Eynden, an architect

already mentioned. Undoubtedly van den Eynden was inspired by Huyssens's St Pieter at Ghent. Like this church, that of Averbode consists of a combination of a centralized space for the laity to the west, and a very deep choir for the convent. As at Ghent, the western part is a cross with arms of equal length, of which the inner corners are filled with less lofty spaces. However, this is as far as the similarity goes. The centre of the western part has no dome. The spaces in the corners between the arms of the cross are sectors of a circle and do not entirely fill the corners.[19] Moreover, the tower, exceptionally in the Southern Netherlands, is not behind the choir but in a rather arbitrary place on one side. Finally, the whole treatment of the church, both within and without, lacks the vigorous hand that one recognizes in the former abbey church at Ghent. The building is, on the other hand, astonishingly spacious, splendidly lit, and filled with luxurious furnishings which emphasize the character and atmosphere of the Belgian seventeenth-century Baroque. But the architect's power to create volumes and spaces appears, again and again, to be weak. This is particularly evident in the exterior. The lofty façade, which in its decoration harks back to Cobergher's much older Antwerp church of the Augustinians, cannot make us forget the bareness of the whole. The tower, completed later, is large enough to make a good show in the whole group of buildings, but it remains a tame piece of work all the same.

The descriptions on the preceding pages will have given a sufficient idea of the type of major church which characterizes the so-called Baroque of the Southern Netherlands. A building such as the abbey church of Ninove west of Brussels, which was under construction for nearly a century, is too heterogeneous to be discussed here. The traditional type of aisled church with clerestory, Gothic essentially, but Baroque in its decorative treatment, was so popular that it survived into the eighteenth century, as is proved by such a church as Notre Dame at Namur, which was begun as late as 1750.

Before the seventeenth century was over, however, a few churches had appeared of a more original design. Such a one is Notre Dame de Bon Secours at Brussels, begun in 1664, by a certain Jan Cortvriendt. He chose a six-sided domed space as his central theme, following the example of the church of Notre Dame des Consolations built shortly before, in nearby Vilvoorde. Three of the six sides open on to a very short aisled nave, the three others into the choir with flanking chapels. Neither the interior nor the exterior is very successful. The architect apparently lacked the experience and the technique to translate the theme of the dominating polygon with additional spaces into the unified and flowing idiom of Baroque. The true Baroque appears for the first time in the modest church of the Minimes in Brussels, dated 1700, where all traditions of arcades on columns and of Rubenesque ornamentation are thrown overboard. This building marks the end of the century of specifically Belgian church Baroque.

In secular architecture, too, the transition from the first half of the seventeenth century to the second half in no way implies a change of style. One of the most original designs, and one of the best in the Flemish Baroque style, is the Provost's House of St Donatianus in Bruges, built in 1665 by the architect Cornelis Verhoeve, in accordance with directions given by Frederik van Hillewerve, canon of the cathedral. In principle, the treatment of the long façade with windows set close together is the same as that used

when the town hall of Ghent was enlarged half a century earlier (p. 15). The decorative effects, however, are in a much higher relief, and the strongly unified composition combines richness with restraint so successfully that it is well above the average quality. Occasionally we find a long façade with giant pilasters, as was customary in the Northern Netherlands from the time of Jan van Campen onwards. A good example of this is the Priory of Leliendaal in Malines, dating from 1687, the work of Jan Lucas Faydherbe, son of the better known Lucas Faydherbe.

How extraordinarily enduring the native traditions were is shown most clearly in the famous series of guild houses on the Grande Place in Brussels (Plate 7). Nearly all the earlier houses of the guilds were destroyed in the cruel bombardment by Marshal de Villeroy in 1695. When with an unbelievable energy the people went to work to rebuild the market-place, the old sites were retained. The new houses are therefore as narrow and as high as before. One or two remain from before the bombardment, such as De Zak and De Kruiwagen. They have been previously referred to. In 1697 they were restored to their mid-century aspect. But when new façades were built, such as the Schippershuis of 1697 (by the joiner-architect Pastorana), the result is nothing but a paraphrase in a daring and full-blooded Baroque of the traditional type. In the case of a broad façade without a gable, an exception, such as that of the Guild house of the Bakers, the many windows, separated only by narrow spaces set out with pilasters, show that the builders could scarcely free themselves from medieval ideas. Only occasionally does the new manner of composition appear which insisted on a vertical unification of the whole front. That is the case with De Gulden Boom, belonging to the brewers, which was built in 1697 by Willem de Bruyn. This has attached giant columns and a thick-set gable. Much more civilized, and clearly the result of contacts with the international taste of the day, is De Zwaan of 1698, with its restful wall surfaces and the simple pediment above which a curved roof appears.

BAROQUE IN THE EIGHTEENTH CENTURY

Till after the middle of the eighteenth century, architecture in the Southern Netherlands remained Baroque in spirit. But eighteenth-century Baroque has little in common with that of the previous century. The Baroque of the seventeenth century was above all a style of church building. That of the eighteenth century manifested itself almost wholly in secular architecture. Few churches of any significance were constructed. There were indeed abbeys which rebuilt their monastic quarters and abbots' houses in a sumptuous manner, but the style used differed in no way from that of the châteaux and palatial town dwellings.

As regards style, it is less than ever possible to speak of any uniformity. In the Maas district there developed an influential building style of quiet distinction which sought a link with French architecture without abandoning all local characteristics, and which was generally so reserved in its expression that one can hardly speak of Baroque in connexion with it. An excellent example of this spirit is to be found in the town hall of

Liège, which was begun in 1714. Three architects were employed on the plans, but it seems impossible to tell who was responsible for the building as it was erected. The development of the principal private houses of Liège can be followed from the elegant but in some respects provincial house in the Rue Féronstrée (built about 1735) which now contains the Musée d'Ansembourg, to the much stiffer hôtel Rue Hors-Château 5 of 1765. The narrow dwelling-house of the ordinary citizen in Liège and Maastricht shows a certain regional development which uses in its own way the elements of French decoration. A much broader conception appears in the former palace of the Bishops of Namur, dated 1728, with its far-projecting wings on opposite sides of a courtyard and its typical mansard roofs. By far the most impressive work of the first half of the eighteenth century in the Maas district is the wing of the palace at Liège, built in 1735 and the following years by the Brussels architect J. A. Anneessens. The centre with its wide entrance, decorated with pairs of columns and pilasters, a meagre segmental pediment, and a domed roof dominates the very flat side parts (the end sections were added later). A late example of Baroque in the eastern region is the massive château of Roeulx, between Mons and Nivelles, with its concave and convex roof above the central pediment, and the curved connecting parts at the corners between the central block and the wings.

Architecture in Flanders is much more emphatically Baroque than that of the Meuse district. In Antwerp the chief influence was that of Jan Pieter van Baurscheit the younger (1699–1768).[20] His style shows a remarkable similarity to that which Daniel Marot had developed in Holland since 1715. Baurscheit was indeed in direct communication with Marot, for whose façade of the Royal Library in The Hague he carried out the sculptural decoration (1736). His first architectural works seem not to have been in what is now Belgium but in the Dutch province of Zeeland. He is reputed to have designed, round about 1735, the rich façades of the Beeldenhuis in Flushing and the Provincial Library of Middelburg (destroyed in 1940). However, he also found an important clientele in Antwerp. The Hôtel de Fraula there reminds us immediately of the Royal Library at The Hague. Soon after comes the town hall of Lier (1740) and the great houses for Antwerp patricians, in the first place the Hôtel van Susteren, now the Royal Palace (1743), and at the end of his career the Hôtel van Susteren-Dubois (Meir 45, also known as the Huis Osterrieth).

A motif which van Baurscheit repeatedly used is a deep arch above the entrance enclosing a big window and a small light above it, as in Marot's Royal Library in The Hague. It is not impossible that this motif originated with van Baurscheit. Originally the deep arch remained beneath the cornice, but in the case of the palace at Antwerp it pierces through the cornice, and in the Hôtel van Susteren-Dubois the concave central part splits the whole façade in two with a tremendous burst of Baroque energy.

The Baroque style entered Ghent with the work of the architects Bernard de Wilde (1691–1772) and David 't Kindt (1705–70). They were much less dependent on Marot's style than was van Baurscheit, and very soon the Rococo appeared in their façades. De Wilde is the more exuberant of the two, but there are few real differences between them. De Wilde's Exchange on the Kouter at Ghent is full of movement, with its

projecting and raised centre, topped by a segmental pediment. The upper windows rise above the capitals of the composite pilasters and break through the cornice. The Rococo can also be recognized in the stately and well-preserved Hôtel Faligan (1755) on the Kouter (Plate 8A). Here the cornice curves upwards above the dormer-windows of the side parts and outwards over the inorganically placed giant Corinthian columns which frame the centre. The play of curves is continued in the glazing bars of the windows. In the stately Hôtel d'Hane-Steenhuyse of 1768 the projecting centre with high curved pediment is a variation, and actually a rather forced one, on the same theme.

David 't Kindt had the same delight as de Wilde in the contrast between a tall centre and lower wings, and in high curved pediments and curved roofs, but he seems to have avoided pilasters and columns. The most imposing example of his talent is the house he built for himself at Ghent in 1746, now the Koninklijke Vlaamse Akademie.

Outside Antwerp and Ghent there is little to be seen of this new Baroque. It is remarkable that the motif of the deep concave niche over the entrance was twice used in the broad façades of the new abbey buildings at Averbode. It seems to be unknown who supplied the designs.

THE SECOND HALF OF THE EIGHTEENTH CENTURY

In 1751 a stately cathedral was built in Namur to the designs of the Milanese Gaetano Pizzano, who had been invited to the Southern Netherlands through the good offices of the Court at Vienna. This is the swan song of the Baroque, a truly Italian church on the Latin cross plan with the arms of the cross ending in apses, a high dome over the crossing, and a decorated façade, of which the central section projects in a dramatic manner (Figure 7). The design is still fundamentally Baroque, but, particularly in the interior,

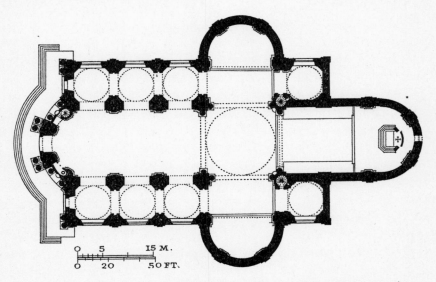

Figure 7. Gaetano Pizzano: Namur Cathedral, begun 1751. Plan (1 : 750)

a new, cooler classical spirit can be detected which tempers the old exuberance. Architecture here clearly is in a state of transition.

The uncertainty which characterizes such moments of transition is demonstrated in the new palace which the Governor Charles of Lorraine began in 1757 in Brussels to the plans of the court cabinet-maker and architect Jan Faulte of Bruges (Plate 9).[21] The familiar façade with the concave centre follows the composition of the garden side of the palace of Versailles. Faulte's work is not very successful: the detail is rather poor, and the relations between the parts far from elegant. The interior, in the richly decorated staircase and in the domed hall, shows already the Louis Seize style, but here too the architect did not really manage to achieve a harmonious unity. We do not know much of Faulte's work; he died in 1766, before the Brussels palace was completed.

The man who really introduced classicism is Laurent Benoit Dewez (1731–1812),[22] who was well grounded in international architecture. When he was twenty he went to Italy, with a scholarship, worked under Vanvitelli, then travelled in Greece, Syria, Egypt, and in many countries of western and central Europe. In 1760 he settled in Brussels. He obtained commissions from leading citizens and abbeys and became chief architect of Charles of Lorraine. Having met with difficulties in this job, he retired in 1782 to the château of Elewijt, which had formerly belonged to Rubens, and during the last thirty years of his life built little or nothing.

One of his best preserved works is the monumental abbey of Gembloux, between Namur and Brussels (1762–79), restrained and sober, well-proportioned, and with a very classical Ionic portico (Plate 8B). How dogmatically classical he was can be seen in the church of the abbey of Bonne Espérance in Hainault, with its unfluted Corinthian columns carrying a straight entablature. When he designed a lighthouse in Ostend in 1772, this was given the aspect of a Tuscan column. His work on the castle of Tervuren near Brussels was soon destroyed in a fire, and what he did to the palace at Brussels had to fit in with Faulte's work, but we still possess a brilliant example of his secular architecture in the princely country house at Seneffe, which he built about 1760 for Count Julien de Pestre, son of a knighted linen merchant and army contractor (Plate 10). The restrained *corps de logis*, of which the centre and end pavilions are marked with vigorous Corinthian pilasters, faces a forecourt with long Ionic colonnades on either side, curving in quarters of a circle towards the house and at the other end ending in domed pavilions. Its total effect reminds one somewhat of the great English country houses of the eighteenth century, but the elegant colonnades and in general the very delicate and harmonious detail are purely French.

Classicism quickly spread. Louis Montoyer, born in Hainault, still remained to some extent faithful to the Baroque when he built the façades of the Papal College at Louvain (1776), but when some years later he designed the palace at Laken near Brussels with Antoine Payen from Tournai (1782), the columnar portico, the central dome and long wings satisfied all the demands of the fashionable international style of the time. Montoyer's church of Saint-Jacques-sur-Koudenberg in Brussels is of an exceedingly cold classicism. The best architect after Montoyer, and probably a man of more talent, was Claude Fisco (1737–1825), born in Louvain, originally an engineer in the Army, and

later director of public works for the city of Brussels. A remarkable example of his talent is the Place des Martyrs in Brussels of 1775, a rather large rectangular open space surrounded by a series of uniform and monumental buildings (Plate 11A). It cannot be denied that the Louis Seize style of the Place des Martyrs is a little provincial, and that the octastyle Doric porticoes in the middle of the short sides are not particularly successful in their proportions, but the square has an atmosphere all its own and it has escaped the banality from which many squares carried out in a 'totalitarian' classicism suffer.

It is remarkable that architects with talents as high as Dewez's and Fisco's were overlooked when the most important commission for urban development which the Southern Netherlands at the end of the old régime had to offer was given out; that for the Place Royale in Brussels on the site of the old ducal palace which was burned down in 1731. After years of preparation, it seems that, as a starting-point, a plan drawn up in 1775 by the Paris architect N. Barré was chosen. The construction was put in the hands of Gilles Barnabé Guimard, a Frenchman by birth, who had worked as draughtsman under Faulte. It is not clear how far Guimard changed the plans of Barré.[23] The French character of the Place Royale in Brussels is obvious, particularly if one compares it with the Place Royale at Reims, which was designed by Legendre twenty years or so earlier (Plate 11B). The arcades with their banded rustication, the upper parts with their odd lesenes, the streets entering in the middle of the sides, the statue in the centre (Charles of Lorraine by Verschaffelt, destroyed in 1794) – everything looks like Reims. The street entrances in three of the four sides, however, are not happily conceived; they seem to draw out all the space from the square. But one ought to remember that there were originally gates to these street entrances to link up the great masses of the houses left and right. The construction of the Place Royale created endless difficulties, but undoubtedly the people of Brussels were proud of the result. When the Emperor Joseph II saw the square he expressed himself dissatisfied with its style, though Vienna had been kept informed by means of models. The style is indeed the current classicism, and this style was triumphant not only in the Place Royale but also in the Park north-east of it and in the surroundings of the Park. Guimard built the palace for the Council of Brabant at the end of the Park, now the Palais de la Nation, with a Corinthian portico. When we see how unsatisfactory this portico is, with its thin columns doubled at the end, we suspect that the undeniable merits of the Place Royale owe more to Barré than to Guimard. The quiet rows of houses behind uniform façades to the east of the Park, on the other hand, are attractive. They remind one of Bath, an improved Bath.

Fisco must have been very disappointed that he was passed over when the Place Royale was designed. He was able to take a modest revenge, and in so doing showed how his talent had matured, when he designed the Kollege van der Valk in his native town of Louvain, of which the gate shows the date 1782. The restrained and sombre monumentality of this building is extremely progressive for its period and breathes the spirit of that heroic style which typified the designs of Ledoux in France. At the end of the old régime Belgian architecture had joined the new international style.

SCULPTURE

FROM CIRCA 1600 TO CIRCA 1640

AT the beginning of the seventeenth century a strong sculptural tradition, formed in the sixteenth century, was already in being; so strong, indeed, that the Baroque could not encroach on it at first. Much was happening during these years. Under the new sovereigns Albert and Isabella, the Catholic Church was consolidating itself after the difficulties of the previous century. There were orders for new altars, for tabernacles, for rood screens, and for tombs. Whole series of statues of the apostles had also to be made for the churches.

The men who carried out the work were often the same who did the stone masonry for the buildings. The chief mason and the sculptor were not as yet sharply distinguished from one another.

Conservative ideas are clearly shown in works such as the tabernacle of the church of St Martin at Aalst (1604) by Hieronymus I du Quesnoy, the father of the more famous François and Hieronymus II. The composition reminds us particularly of work done by Cornelis Floris half a century earlier. Other examples were the pulpit and the tomb of Bishop Antoine de Hennin (1626) in the church of St Martin at Ypres, unfortunately destroyed in 1914.

The brothers Robert and Hans Colijns de Nole, who came from Utrecht and had settled in Antwerp by 1590,[1] are among those sculptors who, though they did not throw overboard the traditions of the sixteenth century, nevertheless reached towards a kind of pre-Baroque. The character of their figures points to the influence of Rubens, although their tomb of the Archduke Ernest of Austria in the cathedral at Brussels (1601) is decidedly lacking in spirit and still reminiscent of the work of Jean Mone. Much broader is the style of the alabaster statues (particularly the *St Augustine*) which belong to the church of St Gommarus at Lier, and were originally made for the cathedral at Ghent (1620). The pose is alive, the drapery falls amply, and we are immediately re- minded of the early style of Rubens. A somewhat further stage towards the Baroque is represented by the series of statues of the apostles in the cathedral at Malines (*St John, St James the Apostle* and *St James the Less, St Andrew, St Philip* (Plate 12), *St Matthew, St Thomas,* and *St Bartholomew*), most of which were produced by the workshop of the de Noles in 1630 and the following years. These are rather unequal; the hackneyed Rubens figures lack expression, and the style of drapery is almost like that of Late Gothic work.

Hans van Mildert is of the same generation. He was born in Koningsbergen, settled in 1610 in Antwerp, and had close contact with Rubens.[2] It is not easy to follow his de- velopment, because much of his work is lost. By far the best we have is his *St Simon* in

the series of apostles in the cathedral at Malines, made shortly before his death in 1638. One cannot speak here of real Baroque: the figure is as frontally designed as those of the de Noles, and the folds of drapery remind one of Hendrick de Keyser in Holland.

But, while in the Southern Netherlands sculpture during Rubens's lifetime was developing with some difficulty in the direction of the Baroque, a brilliant artist, François du Quesnoy (1594–1643), born in Brussels, was spending the years of his creative life in Rome. François du Quesnoy, nicknamed Il Fiammingo, was the son of Hieronymus du Quesnoy, who has been mentioned before, and who is best known as the creator of 'the oldest inhabitant of Brussels', Manneken-Pis.³ In 1618 François received a bursary from the Archduke Ferdinand to study sculpture in Rome. He soon felt at home there. He made friends with Poussin, who arrived in 1624, and became a member and later *principe* of the Accademia di S. Luca. He acquired patrons, such as his fellow-countryman Pieter Visscher, alias Pietro Pescatore, and the Marchese Vincenzo Giustiniani. He also worked for Pope Urban VIII. In 1643, after hesitating for many years, he started out for Paris in response to offers from the French Court. However, he fell ill on the journey and died at Leghorn.

The work of Il Fiammingo is not extensive, and an important part of it is lost. He made a number of reliefs on a small scale with figures of putti, a speciality of his. His masterpiece in this field, and one of his last works, is the relief of little angels making music in the church of SS. Apostoli at Naples. Only two monumental works by him are known, the huge *St Andrew* for one of the crossing piers in St Peter's, Rome, commissioned by Urban VIII (a small plaster model was ready in 1629, the marble statue was finished in 1633; Plate 13), and the marble *St Susanna* in the church of S. Maria di Loreto near the column of Trajan (1630–3).

The period of François's activity in Rome coincided with the astonishing rise to fame of Gianlorenzo Bernini (1594–1680) and of Bernini's rival Algardi. It says much for the personality of du Quesnoy that, though apparently on good terms with Bernini, he was able to keep independent as regards style, in contrast, for instance, to the Walloon sculptor Jean Delcour, who will be discussed later. A comparison of the *St Andrew* with Bernini's *Longinus* for one of the other crossing piers shows this clearly. Two artistic personalities of an exceptionally high ability have here expressed themselves, each in his own language. Both belong to the Baroque, but the *St Andrew* is entirely without the mannered qualities of the *Longinus*. Du Quesnoy's statue has a heroic quality that seems really inspired. The roots of this nobility must lie in du Quesnoy's profound study of Roman sculpture.

Of no less high quality, but much less Baroque, is the *St Susanna*, which also still commands admiration. The figure of the maiden with the gentle, thoughtful face who, in the original position, stood with her left hand pointing to the altar, has a classic charm about it. The marvellous treatment of the drapery obviously goes back to Roman models. If one compares it with the *St Bibiana* of Bernini, carved a few years before, one is once more struck by the fine simplicity of the one piece in contrast with the complicated virtuosity of the other.

Il Fiammingo did hardly any work for his native country. For the monument of

Bishop Triest in the cathedral of Ghent, which he had been commissioned to make, he completed only two putti: the rest is by his brother Hieronymus II. It is therefore reasonable to ask whether one ought to count François among sculptors of the Netherlands. If we do so it is first and foremost because his studio was the source of important influences which led to a change of style in the Southern Netherlands. Two talented sculptors were given their training in the workshop of François: his younger brother Hieronymus, and the extremely productive Artus Quellin. There are, indeed, other ties between sculpture in the Netherlands and Il Fiammingo: the apparently much admired putti undoubtedly inspired the passion for those figures among a score of Flemish sculptors.

From circa 1640 to circa 1700

The first piece of Baroque sculpture in the Netherlands – and even then only moderately Baroque – is the monument of Bishop Anton Triest in Ghent Cathedral (Plate 14A). How far the general plan was laid down by François du Quesnoy it is difficult to decide now. The execution, apart from the two putti already mentioned, is entirely the work of Hieronymus II du Quesnoy (1602–54). This certainly gifted but not very original eclectic had lived for many years in Spain and later in Florence and in Rome before he returned to the Netherlands after the death of his brother. That he was indeed an eclectic is very obvious from the Triest monument: the reclining figure of the dead man recalls that of Ammanati's tomb for Cardinal del Monte in S. Pietro in Montorio in Rome, the *Christ carrying the Cross* is practically a copy of Michelangelo's *Christ* in S. Maria sopra Minerva, and the *Caritas* on the left is a very coarse variant of the *Susanna* of François du Quesnoy.

Hieronymus's *St Ursula* in the chapel of Turn and Taxis in Notre Dame du Sablon in Brussels is a famous piece of sculpture, theatrical and only moderately Baroque. But the *Apostles* he made for the cathedral at Brussels, a *St Bartholomew*, a *St Thomas*, and a *St Matthew*, are Baroque of the Rubens order. There are indications that Hieronymus's work was much admired. However, this did not save him from being condemned to death by strangling, for having committed sodomy in a chapel where he worked.

A more important artist with a much more individual style was Artus I Quellin (1609–68), son of the sculptor Erasmus Quellin from Antwerp. In 1639 he went to live in Antwerp after a period of study in Rome, and from that year dates the first work we know of his: the plaque above the entrance of the Plantin Museum with the figures of Hercules and Constantia. Here already he shows all the individuality which was to remain characteristic in later works. The figures are carved with brio, the man, a nude figure, with bold naturalism, the woman in a richly draped garment, as he had seen them in the work of Algardi and his school. There is nothing Berninesque about it. His group of the *Madonna between St Joseph and St Anne* in St Paulus at Antwerp (1644) is Baroque in its merging of figures and ornamentation. The figure of the Virgin shows the artist inspired by Rubenesque visions. Shortly after the group at St Paulus, Quellin carved the *Madonna Araceli* in the choir of the cathedral of Brussels (Plate 14B). With its thoughtful

37

head, its delicately folded garments, and its stance as if floating in the air, this is the most spiritual of his works.

The growing fame of Artus brought him contacts in the Northern Netherlands, where he was commissioned to undertake the tremendous task of providing the sculptural decoration for the town hall of Amsterdam, the grandest building in the country, now the Royal Palace. In 1650 he went to live in Amsterdam, where he remained for fourteen years before returning to Antwerp.

The commission for the town hall was indeed a large one: all the sculpture for the Hall of Justice, the allegorical statues and reliefs in the Hall of the Citizens, the figures of gods and allegorical reliefs in the galleries, the limestone tympana on the front and rear façades, the bronze figures in the pediments, and a great deal of ornamental work. It is clear that he could not carry out all this personally. A number of artists worked under his direction, in the first place his cousin Artus II Quellin, Rombout Verhulst from Malines, and Willem de Keyser, son of the Amsterdam architect and sculptor Hendrick de Keyser. Differences in style and quality are clearly noticeable. An important factor was certainly also Jacob van Campen, the architect of the town hall. Van Campen drew the plans for the pediments, and there is every reason to believe that Artus I took grateful advantage of his withdrawal in 1654 to change the original plans for the western tympanum in all sorts of ways. That van Campen kept things in his hands very firmly is obvious when we see how much the ornamentation differs from what we would expect of Quellin.

Among the most famous pieces of sculpture are the four caryatids in the Hall of Justice: two upright figures and two hiding their faces in shame, all as far as is known the work of Artus I himself (Plate 15B). The nude is treated in a Rubenesque manner; the naturalistic representation of bodily beauty is almost perverse in the oppressive atmosphere of this hall, associated as it is with sentences of death. The reliefs between the caryatids lack style, are designed in a painterly way, and are trivial in plan and execution. There is also a certain triviality about the large and small figures in the galleries, with the exception of the *Venus*, which is signed by Rombout Verhulst. We see the skill of Artus I at its best in the terracotta sketches for the tympana of the façade and for the bronze statues, most of which are in the Rijksmuseum at Amsterdam. The sketch for the bronze statue of Justice is exceptionally fine, and reminds us of du Quesnoy's *Susanna*, and also of the statues of Justice and Prudence (Plate 15A) in the Hall of Justice. The somewhat vulgar touch of Artus's nudes disappears in his later works, the reliefs of the two tympana. The compositions suffer from rather too painterly a treatment, but there are splendid details, particularly in the front: the tritons, the sea-horses, and the naked women. Quellin could carve the most splendid bodies both of human beings and of animals, and he could make them turn and move in passionate scenes with an ease that is astonishing.

While Quellin was working on the town hall he carried out other commissions as well. He made a group of *Apollo with the Nine Muses* for Queen Catherine of Sweden, but this has been lost. For the church of St Mary in Berlin he carried out the monument of Field-Marshal Sparre (1658), which does not seem to have been a masterpiece. His

best tomb was probably the one at Bokhoven on the Meuse (in the province of North Brabant) with the reclining figures of Engelbrecht van Immerzeel and his wife Helena de Montmorency (1651), a very sensitive work. Broadly designed and full of dignity is the bust of Burgomaster Anton de Graeff (Amsterdam, Rijksmuseum); that of the Governor Louis de Benavides (Antwerp Museum) has uncommon vigour in attitude and expression. These are entirely Baroque pieces, and pieces in which observed reality is not smothered under manner. As Artus grew older his grasp of psychology became ever firmer, as is proved by the splendid marble figure of *St Peter* in the Andreaskerk at Antwerp (1658; Plate 16), shown at the moment of despair after the Denial.

We do not know exactly how much Artus influenced wood-carving among his younger contemporaries. The attribution to him of decorative work such as the famous confessionals against the north wall of St Paulus at Antwerp, with their figure-work, is uncertain. Perhaps they come from the studio, not from the master himself. If one looks at these and similar confessionals and choir stalls with figures, a speciality of the Southern Netherlands, one may well come to the conclusion that whole workshops of craftsmen must have carried them out. These craftsmen were certainly capable of exceptional achievements, but they were tied to a fixed manner of expressing devotion, emotion, and admonition.

Of the four principal sculptors in the second half of the seventeenth century two came from the group round Artus Quellin, that is Rombout Verhulst (1624–96) and Artus II Quellin (1625–1700). The two others were Lucas Faydherbe (1617–97) and the Walloon Jean Delcour (1631–1707).

Faydherbe was the only one of these four who came into direct contact with Rubens. He made various works in ivory after designs by the master, and in his studio. This is proved by a declaration made by Rubens in 1640. Faydherbe's sculpture is very uneven. Among his best works are without question the *St Simon* and the *St James the Apostle* which he made about 1650 for the series of apostles in the cathedral of Brussels. The Simon has a luxuriant beard and muscular arms and reminds one of Michelangelo's *Moses*. However, Faydherbe never went to Italy.

His monument of Canon Huen in the St Janskerk at Malines (1651) shows a painterly and theatrical style. About 1660 Faydherbe began his great monument of Bishop Andreas Cruesen in the cathedral at Malines (Plate 17). There are three marble statues, placed in remarkable isolation: in the middle is the bishop kneeling towards the naked Christ on his right, while a grim Father Time on the left seems to shrink back. The bishop is by far the most successful of the three figures; the Christ is very weak, though Father Time, whose head is again reminiscent of Michelangelo's *Moses*, shows a Rubenesque painterly and dramatic vigour.

Faydherbe's tendency to painterly representation in plastic forms is carried to the extreme in the two well-known reliefs under the dome of the church of Onze Lieve Vrouwe van Hanswijk at Malines: these scenes of the birth of Christ (Plate 18A) and the carrying of the Cross are full of furious movement and crowded with detail, technically skilful but empty, amazing but not convincing. At the end of his life Faydherbe made two funerary monuments, one at Modave, the other at Trazegnies. They have reclining

figures of a very old-fashioned kind, and there is nothing new or out of the ordinary about them.

Rombout Verhulst, a much more balanced artist, developed a special style of representing the human figure, characterized by a highly skilful interpretation of garments and of flesh. His *Venus* in the palace at Amsterdam is distinguished from the Quellin statues by an exceptionally delicate treatment. No other sculptor in the Netherlands made such sensitive portraits as Verhulst. His realism is never lacking in style, nor ever vulgar. He was without doubt the aristocrat of Flemish sculptors.

Verhulst was specially successful in the sculpture of mausolea, a remarkable number of which were erected in the second half of the seventeenth century in the republic of the United Netherlands. The series begins with the monuments of Jan van Galen in the Nieuwe Kerk at Amsterdam and of Admiral Tromp in the Oude Kerk at Delft (both of about 1654) and ends with the monument of Admiral de Ruyter in the Nieuwe Kerk at Amsterdam, completed in 1681 (Plate 19A). In the case of the first two the decorative enrichments were designed by others: by Artus I Quellin for the Van Galen, by Jacob van Campen for the Tromp.

The execution, as far as Verhulst is concerned, is almost everywhere on a very high level. The heads, particularly of the men, are modelled with the greatest devotion, the hands are wonderfully delicate and expressive, the putti are charming – still following, we can presume, the example of François du Quesnoy – and the suggestion of texture, particularly in the garments, is brilliant. Tombs by Verhulst appeared all over the republic: in Amsterdam, Delft, Leyden, Katwijk near Leyden (Plate 19B), Utrecht, and also in remote villages in the provinces of Groningen and Zeeland.

In the execution of a very elaborate monument such as that of de Ruyter, Verhulst made considerable use of collaborators. To them are due the cold relief figures to the left and right and the wholly unsuccessful figure of Fame. Verhulst was no pioneer. There is little variation in the compositions of his tombs, and one or two, such as that of Adriaan Clant at Stedum in the province of Groningen (1672), are remarkably archaic in design. The fine sea-horses which rise above the reclining figure of de Ruyter are undeniably akin to those on the eastern pediment of the Amsterdam Palace.

In contrast to Verhulst, Artus II Quellin was truly a man in search of new forms.[4] As a comparatively young man he showed his talent in the monument of Bishop Capello in the cathedral at Antwerp (1676), with the remarkable figure of the dead man who rises from his sleep to take part in the Mass (Plate 18B). Artus II soon developed a masterly facility in the creation of draped figures inspired by Roman sculpture and by that of François du Quesnoy (Tournai Cathedral), of heroic saints treated with a certain freedom from the traditional devotional style (also Tournai Cathedral), and of charming putti with a melancholy *sfumato* in the treatment of the heads. His marble *St Rose of Lima* (Antwerp, St Pauluskerk; Plate 22A) shows the most refined elegance. The putti round this figure are Rococo 'avant la lettre'. At the end of his life Artus II turned towards the illusionism of the Baroque. On the rood screen of the cathedral at Bruges is a God the Father above the clouds, a highly dramatic piece unequalled in the Netherlands for its boldness (Plate 20; it was placed in position in 1682). The strongest, almost im-

pressionistic accents are allied to an unusual tenderness in the treatment of surfaces. A few years later Artus II completed the high altar of St Jacobskerk in Antwerp, in which the patron saint is carried heavenward, robes flying. Generally speaking, it can be said that in his work the Netherlands was able to overcome that vulgar realism and that easy routine of traditional devotional style which might be called a national danger in sculpture.

The Walloon districts have produced only one sculptor of importance, Jean Delcour. We know remarkably little about him, particularly about his youth and a period when he was living in Italy. We know of no work of his before 1663, when he was already over thirty, having been born in 1631. Delcour is certainly a master of the Baroque, but he is so in his own, and distinctly reserved, way. His most impressive work is the monument of Bishop d'Allamont in the cathedral at Ghent, which was commissioned in 1667. We find that aristocratic spirit which is typical of much of Delcour's work in the courtly humility with which the kneeling prelate turns towards the Holy Virgin. The figure of Mary already has those characteristics which were to distinguish Delcour's statues of the Madonna throughout the years (Plate 21). She has an expression of tender grief as she looks down upon the bishop and at the astonishing bronze skeleton between them. An angel with fiery sword threatens the symbol of death.

Between 1675 and 1681 Delcour was executing for the church at Herkenrode the altar with its many figures which is now in Onze Lieve Vrouwekerk at Hasselt (province of Limburg). The masterpiece of this group of statuary at Hasselt is perhaps the marble *St Bernard*, with its dignified pose and beautifully draped garments, apparently inspired by a portrait figure from Roman antiquity. Delcour's technical accomplishment can be studied excellently from the marble *Dead Christ* in the cathedral at Liège (Plate 28B). The delicately chiselled body is that of a young athlete, the head is somewhat weakly modelled, and the garment has Delcour's characteristic touch, becoming by now a manner, in the arrangement of the folds.

Delcour made a whole series of wooden statues for the church of Saint-Jacques at Liège, now all removed from their original places and set up in the *Westbau*, and no longer painted in many colours. By far the most striking is the *St James the Less* (1682), which shows the saint in a state of mannered ecstasy also expressed in the dramatic draperies. In his most popular work, the charming fountain of the Rue Vinave d'Île at Liège, the master returned to a calmer style (1696). The charming bronze Madonna crowning the fountain, a serene figure despite the somewhat agitated folds of her cloak, is so happily conceived that it has frequently inspired copies and variants. The four bronze lions at the foot of the fountain are also exceptionally carefully modelled.

A number of sculptors imitated the style of Delcour, among them Panhay de Rendeux, but none became a master of any significance.

FROM CIRCA 1690 TO CIRCA 1800

At the end of the seventeenth century the big commissions for sculptors began to decline in number, and soon sculptors began to emigrate to England (Plumier, Scheemakers, Rijsbrack), to Scandinavia (Thomas Quellin, son of Artus II), to Germany (Gabriel Grupello, Pieter Verschaffelt), and to France (Sebastiaan Slodts).

It would appear that with the falling off in the number of great commissions, inspiration began to fail too. Technical ability was not lacking, but there were few important personalities among the artists left in the eighteenth century. National characteristics, and these solely in the sense of Flemish characteristics, express themselves only in the production of costly and lavish church furnishings equipped with hosts of statues, groups, and reliefs. Already in the seventeenth century this kind of production had been in full spate, but it has so far been mentioned only in passing because it must be counted as part of anonymous craftsmen's work. It is indeed perhaps not out of place to note that all attributions of Belgian choir stalls and confessionals are entirely unproven. This applies to the attribution of those at Grimbergen to Hendrik Frans Verbruggen, and of those at Wouw to Artus II Quellin, to name only two cases.

The traditional Antwerp stonemason's sculpture entered into a period of revival during the first half of the eighteenth century. This was not confined to Antwerp, but was more or less common to the whole of Flanders. Highly skilled wood-carving was concentrated upon pulpits. That of the cathedral at Brussels, made by Hendrik Frans Verbruggen of Antwerp in 1699, is epoch-making (Plates 22B and 23, A and B). Hitherto in the case of such furnishings, the contribution of sculpture had been limited to figures carrying the body of the pulpit. Now structure is entirely smothered by figures and all sorts of fantastically luxuriant plant growth. Under the body of the Brussels pulpit is the scene of the *Expulsion from Paradise*, treated with an unrestrained naturalism. In the pulpit of the cathedral at Malines (1721–3) Michel Vervoort (van der Voort) went even farther and surpassed Bernini's fountain on the Piazza Navona at Rome: he built a rock out of immense pieces of wood (Plate 24), within which is a cave where we see, most dramatically portrayed, the conversion of St Norbert; he is falling from his rearing horse, and above him is Christ crucified, surrounded by storm-swept trees which rise out of the clouds. The Malines sculptor Theodoor Verhaegen, pupil of the Antwerp artist Vervoort, used the same style in the pulpit of Onze Lieve Vrouwe van Hanswijk at Malines (1743; Plate 25). Jacques Bergé in St Michael at Louvain (1742), and even Laurent Delvaux, who in other works was much more inclined to classicism, adopted the riotous combination of illusionism and shallow naturalism for his pulpit in the cathedral at Ghent (1745), where the figures are of marble and the composition is somewhat less chaotic.

In other church furnishings, too, we find examples of this style, if one can call it a style. Theodoor Verhaegen produced a terrifying example in a confessional at Ninove in Flanders. One can ask whether all this has anything to do with art. This extreme naturalism lacks nobility; it is without spirit and entirely empty.

Happily extreme naturalism in sculpture was limited to wooden church furniture. There was side by side with it a healthy, though not particularly striking, art in stone and terracotta. There is firmness and strength of expression in the work of Gabriel Grupello (1664–1730), above all in his charming fountain for the House of the Fishmongers, now in the Museum at Brussels (Plate 29). That he had strong decorative inclinations is shown by his *Diana*, and particularly his *Narcissus*, in the same Museum. A *suavità* characterizes his group of *Faith* in the Turn and Taxis Chapel in the church of Notre-Dame-du-Sablon in Brussels, and reminds one that he was a pupil of Artus II Quellin. Grupello's unmistakable drawing-room manner belongs wholly to the eighteenth century. But before that century began Grupello had left the Netherlands.

Another transitional figure is Guillelmus Kerricx of Antwerp (1652–1719).[5] As far as we can see, his roots go back into the seventeenth-century tradition of Antwerp, but his extremely decorative bust of Maximilian Emmanuel of Bavaria (1694) in the Museum at Antwerp is surprisingly expressive. A related artist is J. P. van Baurscheit the elder.

A new tendency towards a cool academism is to be found in the work of Michel Vervoort (1667–1737) from Antwerp, the same, remarkably enough, who was responsible for the ultra-Baroque pulpit of Malines Cathedral. There is little or nothing of Baroque in his monument of Bishop de Precipiano in the cathedral at Malines (1709; Plates 26 and 27) and in the contemporary one of General de Precipiano placed immediately behind it. Vervoort's marble portrait bust of J. F. van Caverson (Brussels Museum), celebrated as perhaps the best of the eighteenth century in the Netherlands, is a tame piece of work compared with the sort of thing Artus I Quellin or Verhulst had done. Denis Plumier (1688–1721) produced convincing work in his monument of Spinola in Notre-Dame-de-la-Chapelle at Brussels (Plate 28A), but his grieving widow is a disappointingly cold piece of work. Plumier, shortly before his premature death of consumption, went to England, where he made the monument to the Duke of Buckingham in Westminster Abbey. This was completed by the slightly younger Pieter Scheemakers (1691–1781). Scheemakers also co-operated with Laurent Delvaux (1696–1778), a pupil of Plumier. Delvaux knew the world. In 1726 he went for six years to Rome where he zealously copied Roman sculpture. The Hercules in the Brussels Museum is evidence of these studies.

Even more of an international artist was Pieter Verschaffelt (1710–93),[6] who worked in Paris with Bouchardon, and after that went for some ten years to Rome. The bronze *Archangel Michael* on the Castle of S. Angelo was among his works there. Then he attached himself to the Elector Charles Theodore of the Pfalz at Mannheim. He did not, however, entirely sever his contacts with his native land. He made the monument for Bishop van der Noot in the cathedral at Ghent (1778), where the Holy Virgin is sitting upon a most remarkable cloud. A comparison with the monument by Delcour for Bishop d'Allamont in the choir of the same cathedral shows clearly how lifeless and how insignificant sculpture of the eighteenth century had become. Among the best things done is the fountain on the Grand-Sablon at Brussels, the work of Jacques Bergé. The light Rococo group on the massive pedestal is entirely in the French spirit. In

43

general, Belgian sculptors showed up best in their small works, as can be seen in the many *bozzetti* in the Museum at Brussels.

The triumph of the purest classicism and academism came with the extensive work of Gillis Lambert Godecharle (1750–1835), a pupil of Delvaux, who later studied in Paris. His reliefs on the palace at Laken near Brussels are charming, and the spirit of Rococo still lives in them. But in the long run his work became hackneyed. However, we must not overlook the fact that in a few busts, among them the portrait of his wife in the Brussels Museum, he rose above the emptiness of his ordinary productions and was able to express something of the spirit of the old times.

PART TWO

PAINTING

BY

H. GERSON

FOREWORD TO PART TWO

DURING *the years of preparing and writing my portion of this book, I had the good fortune of receiving generous help from many friends, colleagues, and collectors who share my admiration for Flemish painting. The names of many of them will be found in the bibliography. I am deeply indebted to all of them. The name of Dr Ludwig Burchard should occur more often than it does. The talks in his home were always stimulating. Many more names should occur, too, than I could record here. The hours spent with my colleagues in the galleries of London and Leningrad, Rome and Rotterdam, Paris and Prague, Madrid and Munich, Grasse and Groningen, in Flanders and outside Flanders, are as alive in my memory as are the paintings which we enjoyed together.*

The lectures given to students at Groningen, Leiden, and Utrecht, the excursions made with them, and the seminars at the institute which I have the privilege of directing helped to prepare the ground from which this book could grow. The institute to which I refer is the Rijksbureau voor Kunsthistorische Documentatie at The Hague. Its Flemish section has become in the past years my favourite from the scholar's as well as the administrator's point of view. My collaborators helped me to make the Flemish section a match for the longer-established Dutch section.

Finally, I have to thank my co-author and friend, Professor E. H. ter Kuile, for his forbearance with a colleague whose work was far behind schedule, Mrs Olive Renier for solving the difficult problem of translating a Dutch art historian's jargon into readable English, and the editor for devoting to my troubles and difficulties the same wisdom and energy which he had shown to the young student when he introduced him to the wonders of art history at Göttingen University almost thirty years ago.

H.G.

LATE SIXTEENTH-CENTURY TRADITIONS AND NEW TRENDS

MANNERISM AND CLASSICISM

The Traditions of Frans Floris and of Maerten de Vos

IT is not easy to determine the most appropriate point at which to begin an account of Flemish art in the seventeenth century. A moment of great significance is that of Rubens's return from Rome in November 1608, for the influence of his art soon became perceptible both inside and outside Antwerp, and even in the Northern Netherlands. However, the period preceding this is of sufficient importance for later painting to warrant an introductory survey, so that our starting-point will be in the later sixteenth century.

One characteristic of Flemish art from about 1580 to 1620 is its conservatism. If we compare post-Mannerist art in Holland and in Flanders it will be clear how much more intense in shape and spirit was the reaction towards Late Mannerism in the North. Moreover, in the South even this later Mannerism never attained the elegant grace and the expressive tension found in Haarlem.[1] Antwerp never finally shook off the sixteenth-century tradition. Italianizing forms were used but never really conquered. Which were in fact the principal currents that determined the style of the new century? Who were the most noteworthy representatives of what is called the period of transition, down to the unfolding of the art of Rubens?[2]

For many in the sixteenth century the art of Frans Floris was the ideal. It was an eclectic art, drawing upon Michelangelo's language of forms and Titian's or Tintoretto's rich colouring. Right to the end of the century most Flemish history painting offers variations on the style formed by Floris. Maerten de Vos (1532–1603), one of his pupils, continued in the pure Venetian strain of his predecessor. Nowhere in Flemish art are the spirit, the fantasy, and the pictorial richness of colour of Tintoretto so brilliantly recaptured as in his works. The *Jonah* formerly in Berlin (709) of 1589, the reverse side of an altar panel, is a model of Mannerist acrobatics in colour and shape (Plate 30). The tattered sails over the broken masts and spars of the richly ornamented ship accentuate the restlessness and lack of harmony of the composition. The warm iridescent colours of water and sky form an undulating frame for the sharply illuminated mass of figures on the deck, who are made to gesticulate wildly purely for the sake of chiaroscuro effect. Early works like the *St Paul at Ephesus* (1568, Brussels 862) and later ones like the gay, bustling *Marriage Feast at Cana* (painted for the Vintners in 1595/6; Antwerp Cathedral) are other instances of the lasting influence of the Venetian style on de Vos.

In Antwerp he is the 'Venetian' painter *par excellence*, even though other Italian influences are also discernible in his work.[3]

In most of the contemporaries of Maerten de Vos Mannerism consists of a mixture of various ingredients. The many representations of the Last Judgement, for instance, show clearly how sources of inspiration were combined with one another. The version of Chrispiaen van den Broeck (1560, Brussels 76) is still entirely derived from Floris. Maerten de Vos (1570, Seville 187) remains faithful to the Bruges tradition. A later van den Broeck (1571, Antwerp 380) is a more elegant Venetian–Mannerist interpretation. Jacob de Backer (1571, Antwerp 653) uses a more Classicist style of painting with sharp drawing, while the old Raffael Coxie (1588, Ghent s.54) goes back to the colour technique and sinuosities of Tintoretto. Finally, it was Venetian Mannerism that won the day against the Florentine–Roman interpretation, however, although Floris himself attempted, in his *Fall of the Angels* of 1554 (Antwerp 112), to give an example of the combination of the art of Michelangelo and Tintoretto.

One pupil of Maerten de Vos – Hendrick de Clerck (1560/70–1629) – remained faithful to decorative Mannerism till after 1625. Whether we look at an early work like the altar-piece with *The Family of the Virgin* (1590, Brussels 102; Plate 31), or at one of his last works, such as the *Descent from the Cross* (1628, Brussels 104), we find the same confusion of sharply broken folds and contours, drawn with the utmost delicacy. There is a certain charm in this abundance of detail which is further brought out by the contrast of the restless composition with the cold, Classicist architecture that supports and encloses it. The *Descent from the Cross*, though later, is more archaic in structure; the erect composition is of Late Gothic origin, and the muscular but ponderous bodies belong to the generation of Frans Floris and Maerten van Heemskerck. Only the detail, especially the multi-coloured drapery, is Venetian in its warmth and richness of painting. De Clerck was appointed court painter to the Archduke Ernest in 1594, and continued in the service of Archduke Albert. He must therefore have found it preferable to live in Brussels, and from churches in Brussels and its neighbourhood come most of his surviving altar-pieces. He also painted small mythological compositions in the spirit of Mannerist ornamental art. These were probably commissioned by the Court, and on many of them he collaborated with Jan Brueghel.[4]

Classicism had as long an ancestry in the sixteenth century as 'Venetianism' (quite apart from the frequent imitations of Michelangelo's powerful forms), and similarly the Classicist trend was equally as important as 'Venetian Mannerism' for the art of the seventeenth century, if not more so. The older generation of the Francken family, Ambrosius I, Frans I, and Hieronymus, can be taken as fair representatives of this cold Classicism. The *Lamentation* in Antwerp (573), nowadays attributed to Ambrosius Francken, provides an excellent example of what this Classicism is able to achieve (Plate 32A). The purity of the drawing, the magnificent poses, and the plasticity of the forms are in wonderful harmony with the classic, balanced, triangular composition. In the restless movements of the hands there is an attempt to counteract the somewhat chilly effect of this Bolognese design. Such a combination of Classicist construction and abundant detail also characterized the *Descent from the Cross* of Hendrick de Clerck. It is only

the proportion between these two elements that differs so markedly in the two artists. Both elements, the Classicist in the composition and the Mannerist in the detail, are characteristic of Flemish art at the turn of the century.

Ambrosius Francken (1544–1618), like Maerten de Vos, was a pupil of Frans Floris. In 1573 he was made a master at Antwerp, but it is only in the nineties that his style acquires its peculiar character (paintings in St Jacobskerk, Antwerp; Antwerp Museum 135 of 1598). An example of his occasional collaboration with de Vos is the side panels of de Vos's *Martyrdom of St James* (1594, Antwerp, St Jacobskerk), which Ambrosius painted in 1600(?).[5] Far from betraying any conscious or unconscious adaptation to the style of the older work, this altar-piece provides a good example of the way in which Venetian and Classicist traditions managed to exist side by side in Antwerp.

The importance acquired by Classicism in Antwerp about 1600 is evident in the works of Hieronymus I and Frans I Francken. When Hieronymus Francken (1540–1610) returned from France to Antwerp about 1590, his style suddenly changed. If *The Adoration of the Shepherds* (Paris, Notre-Dame) was still entirely in the style of Floris and Bassano, the altar-piece of St Eligius (1588, Antwerp 576–80) and the *Martyrdom of St Crispin and St Crispinian* (Antwerp 145; the side panels in St Charles Borromeo in the same town) are examples of harsh Classicism with the use of many colours. The Classicism of his younger brother Frans Francken (1542–1616) is less insistent and less intense, and perhaps somewhat tempered also by his predilection for picturesque bearded figures in the manner of Maerten de Vos (Altar-piece of the Schoolmasters, 1587, Antwerp Cathedral). On the other hand, a further example of pure Classicism is to be found in the frozen correctness of drawing and the chill pathos of Wenceslas Coebergher's *Entombment* of 1605 (Brussels 106).[6] The exaggerated foreshortening and the subtle criss-crossings are Late Mannerist tricks. At the end of the style the loose, painterly brush-work is everywhere replaced by cold and rigid drawing, and Tintoretto's colourful wealth of imagination gives way to somewhat heavy and massive forms. All this is characteristic of the late phase of Flemish Romanism.

The Late Mannerism of Haarlem, Utrecht, Prague, Munich, and Vienna practised by the generation born between 1540 and 1560 did not develop to the full in Antwerp. Was Classicism perhaps too powerful in that city? In any case, it was only Flemings abroad who followed the Late Mannerist trend. One of them, Bartholomeus Spranger (1546–1611), who was born in Antwerp, even acquired some importance in this field in Rome, Vienna, and Prague, where he worked at successive periods. His brief sojourn in Antwerp about 1602 produced no results. Karel van Mander (1548–1606), who was born at Meulenbeke near Courtrai, adopted the Mannerist style only in 1583, when he went to Haarlem, in co-operation with Goltzius and Cornelisz of Haarlem. His *Martyrdom of St Catherine* (1582, Courtrai, St Maartenskerk), the only surviving work from his Flemish period, is still pre-Mannerist.[7] Joost van Winghen from Brussels (1544–1603) revealed himself as a Mannerist only after 1585, in Frankfurt. His fellow-townsman Aert Mytens (1541–1602) painted his Mannerist-Bassanesque *Crowning with Thorns* about 1600 in Rome (Stockholm 755).[8]

Outside Antwerp the forces of tradition stultified all progress. Jan Snellinx (1549–

1638) and Jan Baptiste le Sayve (1540–1624), for example, continued a watered-down Romanism in Malines far into the new century; Josse van Baren, a painter from Louvain, as late as 1597 produced a *Martyrdom of St Sebastian* (Louvain Museum) in the style of Michael Coxie. The *Temptation of St Anthony* of Michael Coxie the younger (1607, Malines, St Rombouts) links up directly with the works of his father, and the *Execution* (Ghent, Castle) of 1607 attributed to Gerard Pietersz (d. 1612) remains tied to old-fashioned Romanism. The best-known instance of the revival of a dead tradition in Bruges is that of the pictures from the studio of the Claeissens family; in 1620 Pieter Claeissens was painting in the style of almost a hundred years earlier. Only the costumes, though not in the latest fashion, are of seventeenth-century cut (*Notre Dame de l'Arbre sec*, 1620, Bruges, St Walburgis). The Mannerism of 1600 was sometimes satisfied with the light-hearted copying of works of art from the early sixteenth century. Goltzius's free copies after Dürer and Lucas van Leyden belong to this *Kunstkammer* style, the style of the collector's cabinet. Other examples are Jan Brueghel's copy after Dürer in the Doria Gallery in Rome, which is crowded with detail, and the lesser known *Madonna with St Bernard* (Prague, private collection; Plate 32B) by the Antwerp painter Abel Grimmer (after 1570 – before 1619), which is a version of an unknown Bruges painting.[9] Even if Antwerp and Flanders did not take up Late Mannerism in its more extravagant forms, so full of inner tension and outward gracefulness, they did at any rate cultivate some variants of Mannerism, such as Classicism and Traditionalism.

Otto van Veen, Adam van Noort, and Abraham Janssens

Otto van Veen (1556–1629) was ten years younger than Bartholomeus Spranger, the same age as Hendrick Goltzius, and some ten years older than Abraham Bloemaert and Joachim Wtewael. He differed from his colleagues in Holland, however, by not being a representative of Netherlands Mannerism, though he had been trained by Federico Zuccaro in Rome (1575–80). Only the works he produced immediately after his return to the Low Countries in 1585 reflect his schooling at the hands of this arch-Mannerist. The charming *Mystic Marriage of St Catherine* (1589, Brussels 479; Plate 33A) is reminiscent of Parmigianino and, ultimately, of Correggio. Such a fascinating play of stylized forms, of graceful movements of hands, and of heads inclined towards one another had not been seen before in the Southern Netherlands. The composition almost gives way under a diagonal stress, and a diffused light plays across the iridescent colours. Our knowledge of van Veen's early style is further enriched by the painting of *Lot and his Daughters* (Potsdam, Sanssouci, 129; repeated in Berne, 511) and of *The Resurrection of Lazarus* (Ghent, St Michael).

Otto van Veen was born at Leiden in Holland, and was given his first training by Isaac Claesz van Swanenburg. In 1572 he was already in Antwerp and Liège, where he continued his studies. Italian schooling, therefore, came only after a training in the Flemish spirit, that is in the tradition of Frans Floris, and it is precisely these Romanist elements that are again most apparent after his return from Italy – particularly in his figures. Before entering the service of Alexander Farnese in Brussels in 1585 (as successor

to Joost van Winghen, who went to France), he also worked in Cologne, Leiden, and Liège, mostly, it would seem, as a portrait painter. About 1590 he settled at Antwerp. Here, in 1593, he was accepted a master. In 1602 he was elected Dean of the Guild, but in spite of this he preserved his connexion with the court in Brussels. This is proved by various commissions, including portraits of the Archduke Ernest and his successors Albert and Isabella. In Antwerp from 1596 to 1598 he had Rubens as a pupil, and Rubens continued to work with him until he left for Italy in 1600.

The *Adoration of the Shepherds* (Antwerp, Museum van Openbare Onderstand), probably painted before 1600, is a clear example of the disintegration of Mannerism. The floating composition is still Mannerist, and so are the restless contortions of the bodies and the unaccountable criss-crossings, but on the other hand the movements flow into one another. We look in vain for the play of sharply broken folds and for the precise drawing of ten years earlier. The surface is smooth, and the contrasts of light and shade are softened. In the principal work of this period, *The Martyrdom of St Andrew* (finished 1599, Antwerp, Andreaskerk), Mannerism is finally giving way to a gentle Classicism, and ten years later all trace of Mannerist playfulness is gone. The *Christ Carrying the Cross* from Ste Gudule (Brussels 480; Plate 33B) is powerful, heavy, and emphatically earnest. Every figure is restrained and purposeful in gesture and attitude. The three main characters are placed in a descending diagonal, an attractive piece of composition which is marred by the lack of support from the figures on the second plane.

Finally, in the period after 1610 a new vitality leavens this heavy formalism. The composition of the *Triumph of the Catholic Church* (formerly at Schleissheim; Plate 34) is more transparent. The figure of the *Verbum Dei*, threatening *Ratio Humana* with the sword, is full of elegance. Despite this partial lightening of the heavy composition of the past, there is no question yet of an artistic revival. No one would be prepared to argue that this painting is inspiring either to the sense of piety or the aesthetic sense; it is no more than a display of Christian symbols and dogmas, an illustrated procession. It is fascinating to see how ten years later Rubens puts new life into his *Triumph of Faith*, which has basically the same composition.

Otto van Veen's Classicism is a development of old age; his generation was that of the elegant Mannerists. The later stiffening grew from a desire for austerity, but the new forms did not express a true inner experience. Mannerism pales into a colourless Classicism; the *Christ* from the *Resurrection of Lazarus* at St Bavo in Ghent (c. 1608, another version in the Neues Palais, Potsdam) is a composition loaded with decorative devices, and full of resignation and restfulness. The gestures are relaxed, and all tension is gone.

Adam van Noort (1562–1641), canonized in nineteenth-century histories of art as the Flemish 'precursor of Rubens' (whose master he indeed was), has lost much of his importance since the discovery that many paintings formerly attributed to him are in fact masterly youthful works by Jordaens. In the ledgers of the Guild he is entered as a 'conterfeyter' or 'Pictor iconum', but none of his portraits have so far been discovered. From drawings and prints after his originals it appears, as might be expected, that his development went through the same phases as that of Otto van Veen. It is difficult,

however, to determine precisely when the turn towards Classicism took place in his case. His early compositions, such as the engraving of *The Five Senses*, represent a belated Classicism à la Floris, and are on the same level as the composition of *Lot and his Daughters* by van Veen. He enlivens Floris's forms by elegant movements. The *Pictura and Minerva* of 1598 (Rotterdam; Plate 38B) is restless, playfully elegant, and richly decorative. From the point of view of pure Mannerism it lacks the tension which should inform every motion and every line. The drawings for the *Thesaurum Precum* by P. Saillius (1609, Antwerp, Museum Plantin) are decorative compositions without Mannerist ambitions, while other drawings (Plate 38A) render effects of light and shade with particular sensitiveness. The intensity of Caravaggio is absent, but they have some of Bassano's playfulness. A painting that can confidently be attributed to van Noort is the *Baptism of Christ* in the Mary van Berg Collection in New York. It is a work of about 1600, with a Late Mannerist flavour.[10] Another *Baptism of Christ* (Antwerp, House of Rubens) is yet more narrative and less contemplative. The figures are spread evenly over the surface, without any inner tension but with some feeling for decorative beauty. The picture must therefore belong to a later phase of van Noort's activity. Late also are the various versions of *Suffer little Children to come unto me* (Brussels 976; Mainz Museum; B. Klosterman Collection), of which that at Brussels seems to be the earliest. A curious *Tailor's Shop* (legend of a saint?) in a private collection furnishes us with a date for this group of pale but pleasantly domestic biblical scenes. It carries the date 1608. Less than ten years later the effect of Jordaens's style began to make itself felt in van Noort's work, although Jordaens had been van Noort's pupil and became his son-in-law. The sign of the influence of the younger on the older man is more spirited brush-work. The spiritual and iconographic similarity between the two artists was strengthened (as Julius Held has suggested) by the fact that both were Calvinists.

In this phase of Flemish art, more instances can be quoted of masters of the older generation for whom the slow tempo of development was revolutionized by the emergence of the art of Jordaens and Rubens. Maerten Pepijn (1575–1643), who in 1626 was still carrying on the forms of Maerten de Vos and the elder Frans Francken (Antwerp 273 and 274, the latter a side panel of an altar-piece by de Vos), in the Altar of St Elizabeth (Antwerp 686) shows that he had absorbed the new plasticity, the clarity of form, and the soberness of colour of Rubens's art of the period 1615–20 as well as his concentrated composition. Ludwig Burchard has been able to attribute to Pepijn a number of compositions that are worthy of Rubens and that reveal the perfection of which he became capable when he followed the example of that great master. A late work like the *St Norbert* (of 1637) in the cathedral at Antwerp contrasts with the others because it is merely a feeble combination of elements from Rubens and van Dyck. The painter had degenerated into a tradesman, selling biblical pictures and prints that were shipped by the dozen to Spain.[11]

Hendrick de Clerck and Abraham Janssens (1573/4–1632), although almost exact contemporaries, are extremely different as artists, for the first is a belated Mannerist while the second is the principal representative of Antwerp Classicism. Abraham Janssens was a pupil of the rather insignificant Jan Snellinx. In 1598 he was in Rome. Soon afterwards

he must have settled in Antwerp, for in 1601 he became a master in that town, and in 1606 Dean of the Guild. He married in 1602. *Diana and Callisto*, his earliest known work (1601, Budapest; Plate 35), is a Mannerist painting that is hardly distinguishable from the work of his contemporaries in Haarlem and Utrecht; it may therefore be taken to derive from the same sources, namely Spranger and his imitators, such as Rotten-hammer. It may be that Janssens stood somewhat nearer to the Italian models than Spranger. His figure compositions did not have the extreme elegance and extravagance of those of the Haarlem painters, and his landscapes were entirely in the Flemish style of Jan Brueghel. Eight years later, however, there was a complete revolution: the *Scaldis and Antwerpia* (1609, Antwerp 212; Plate 36B), commissioned by the town of Antwerp for the States Chamber of the town hall, and placed there at the same time as Rubens's *Adoration of the Magi*, is a work of classical academic beauty with harmonious forms and unbroken colours. The bodies, gleaming in the cold light, are strikingly well modelled. Everything in the painting betrays his admiration for the art of Caravaggio, and one wonders whether perhaps Janssens paid another visit to Italy about 1604, when he could have seen Caravaggio's works in Rome. In any case, his Caravaggism precedes that of Utrecht and Ghent by more than ten years. In contrast with that of the Caravaggists of the years between 1620 and 1630, his art has a quietly decorative character and a wealth of entertaining detail. The decorative elements that dominate the surface, and the balance of light and shade throughout the painting, become more apparent still in another Allegory of the same year (Brussels 230) which, as has been shown by Julius Held, is iconographically dependent on Otto van Veen's (or Adam van Noort's) *Burden of Time*. However, the connexion between the two works is not merely iconographic but stylistic as well, for something of the Mannerist restlessness of the older artist has been preserved in Janssens's painting.[12]

The fascination exercised upon Janssens by Italian light effects was no more than sporadic. His main attention was riveted upon a noble Classicism. A fine instance of this style is the *Lamentation* in Malines (St Janskerk; Plate 36A). Never before in Flanders had large, solid bodies been modelled in so clear and powerful a manner. After his return from Italy Rubens must undoubtedly have admired the Classicism of his older fellow townsman. The *Crucifixion* at Valenciennes too is a work of considerable bravura and fine detail (Plate 37). However, it is characteristic of Janssens's temperament that true stylistic parallels must be looked for not in the work of Rubens, but in that of the young Jacob Jordaens. Both possess a feeling for decorative beauty, both soften the Caravagg-esque light effects by a display of full forms evenly lit. Janssens's fully-modelled Classi-cism has its prototype in Bologna, and there are even figures, for example the two kneeling women beneath the Cross, that are direct imitations of Domenichino.

The later work of Abraham Janssens is less exciting. Like all other Antwerp painters, he eventually fell under the spell of the loose style and the pictorial technique of Rubens. The *Flagellation* of 1626 in St Michael at Ghent already shows a weakening of colour, light, and forms in comparison with earlier works, and the Classicist architecture in the background makes the freedom of the figure composition even more striking. Never-theless, Janssens's work must still have been highly esteemed about 1620. In an inventory

of the merchant Immerzeel, drawn up in 1620, his *Four Elements* is valued highest in the collection, and in 1626 a *Crucifixion* (possibly that of Valenciennes) fetched one thousand guilders. In 1620 Immerzeel was offering 'twelve Sybils' for sale. Though no painter's name was mentioned, this may have been the series by Janssens now dispersed among a number of different collections. The fact that a few years later great numbers of his pictures were sold to Spain is, of course, a bad sign, for paintings exported in such quantities usually went cheap.

Portrait Painting

If we make a distinction between 'old' and 'new' types of subject, the portrait, in a biblical or mythological setting, must be assigned to the iconography of the fifteenth and sixteenth centuries, while the landscape, the rustic scene, and the scenes from high life belong to the new age. The portrait painting of the Netherlands of the sixteenth century was revived by Anthonis Mor. Whereas the Pourbus family at Bruges, for example, continued in the tradition of early sixteenth-century art, something new began with Mor: a portrayal of the human being as representing his station and profession, and his place in the civilized world, independent of local and provincial limitations. Titian was Mor's model, and Venetian art in general was the ideal of the majority of the late sixteenth-century portrait painters in the Netherlands. The best portraits of Frans Floris and Maerten de Vos are Venetian in their attitudes and painterly quality, though de Vos never attains the looseness of touch of Floris in his *Old Woman with a Dog* (Caen). Compared to the 'old-fashioned' Pieter Pourbus, Maerten de Vos is the painter of the pictorially telling detail. Other instances from the portraiture of the eighties, the *Family Scene* by Adriaan Thomas Key (1583, English private collection) and the portrait of Pierson la Hues by Gillis Congnet (1581, Antwerp 35), tell the same story. The painterly treatment of the texture of skin and fabric, following the Venetian example, continued to be the most important element in the painter's construction of the portrait in the form which had been fashionable since Antonio Moro.

The art of portrait painting was no more national at this moment than was fashion. All the important works reflected the new discoveries that were being made in European art under the leadership of Italy. The Venetianizing period in portraiture was followed by one in which the Late Mannerist portrait set the tone, with attitudes of a complicated elegance, restless movements, and especially with a great inner tension.

A family portrait by Otto van Veen (1584, Paris 2191; Plate 40) is one of the earliest expressions of this style. It is also one of the first dated works of this artist. While the portrait groups in the old style were nothing but the juxtaposition of beautifully painted heads, the Mannerist van Veen composed deliberately: the groups incline towards each other from the sides; a figure with its back turned appears twice; the vanishing-lines of the tiled floor suggest a depth which is immediately denied. In the same way the beholder's eye is guided along the white collars towards a centre that has no significance, since it is the hat of a child whose face is turned away from us. In spite of all the entertaining details, the restless tension that is the fundamental characteristic of the Mannerist style

is preserved. Frans Pourbus the Elder had already ventured into the new style with his *Wedding of Hoefnagel* (c. 1571, Brussels 944). Van Veen's work, however, is concentrated, in the movements as well as the lighting, into a narrowly enclosed space.

An unbending, sober, almost dry design also characterizes the official portraits that Pourbus painted for the Archduke Ernest (1553–95) and later for Albert and Isabella. We know these portraits best from the engravings made after his drawings (Plate 39, A and B). In them, accompanying allegorical figures provide a splendid pretext for Mannerist decoration and erudition. In a portrait of Alexander Farnese, the allegorical figures of War and Victory move with extraordinary vehemence along the frame of laurel branches. In the case of Otto van Veen this phase of deliberate stiffness and Mannerist restlessness is brief. Just as the large biblical compositions of about 1600 are simplified into pieces of decoration, so also the portrait of this period displays all the characteristics of a colourless and somewhat lax Classicism. The portrait of Bishop Jan Miraeus of 1611 (Antwerp 483; attributed to van Veen) is free from all compulsive tension and complication, a typical late work of a portrait painter whose acceptance of the new style was merely passive.

It is a matter for regret that Abraham Janssens painted so few portraits, for the imaginary portrait of the Emperor Nero (dated 1618, Schloss Grunewald; Plate 41B) proves that the Classicist portrait was an ideal medium of expression for Flemish art. This head by Janssens, one of a series commissioned by the Stadholder Frederik Hendrik of Orange from Dutch and Flemish artists, is most successful. Firm in structure, broadly painted, and brightly lit, it resembles a painted piece of sculpture rather than a study of a model.

As a rule, portrait painting was the preserve of specialists. A typical painter of Mannerist portraits is Frans Pourbus the Younger (1569–1622), typical both of his period and of his country at the time of international Mannerism by the fact that he did not work only in Antwerp, but was also a successful court painter in Italy and in France. To achieve a high standard painting had to transcend provincial limitations, and this applied particularly to the courtly type of portrait. As a result, Pourbus did not mean much in the art of Antwerp, but he was a leading representative of Flemish art abroad. In the year 1600 he left Antwerp and settled for some nine years as court painter in Mantua. He was then called to Paris to enter the service of Marie de' Medici and Louis XIII. Fate decreed that both in Mantua and in Paris he had to compete with Rubens, and it says much for him that he was able to maintain his position.

Among his pre-Italian works are the portraits of Albert and Isabella, of which numerous replicas exist. They can hardly be distinguished from contemporary Spanish portraits: this was due to the Spanish etiquette of the Brussels court, which the painter observed, or was made to observe. The formal, cold style of Mannerism was here entirely in place. His portraits of middle-class people of the same years are equally formal and equally graceful in design, as can be seen in that of his assistant Grapheus (London, P. D. Colnaghi & Co.) and of *A Man of Thirty-two* (now at Leeds). Both these portraits, as well as the artist's self-portrait in the Uffizi (Plate 41A), were painted in 1591, the year when Pourbus became a member of the Guild. This, in its rigidity of line,

penetrating observation of detail, and the immobility of an 'imposed' form, is Mannerist painting at its best.

It was in Italy, however, that the art of Pourbus reached its zenith. An impressive example of his skill is the portrait of Margherita of Savoy in S. Carlo al Corso in Rome (Plate 62), a majestic piece painted with the utmost refinement. The stiff lace collar, the coiffure, and all the accessories almost freeze life itself. This is in accordance with the style of the period, the geometrical style of Mannerism. But it was only at the courts that this lifeless, anti-naturalistic style survived into the first decade of the seventeenth century; outside it had long been given up. Yet it is a striking fact that in these years Rubens, at the courts of Mantua and in the palaces of Genoa, still remained true to it. Was it, one wonders, the compulsion of a stylized way of life that kept both patron and painter in its thrall? [13]

The new pictorial animation advanced, as it were, from the backgrounds – a curtain, for instance, is draped with a great sense of painterly requirements. Slowly the freer way of painting reached the figures themselves. The French portraits of Pourbus bear witness to this. They show powerful heads, broadly and firmly painted in a full light. Realism expresses itself in the careful observation and rendering of every unevenness of skin and of hair, in the direct glance, and the self-confident attitude.[14] Rubens and Velázquez were soon to liberate the official portrait entirely from the stylized grace which lingered on in the details of Pourbus's pictures, without depriving their portraits of any of their princely splendour.

CABINET PAINTERS

Pieter II and Jan Brueghel

Pieter Brueghel the Elder (c. 1525–69) had two sons, Pieter Brueghel the Younger, nicknamed Hell Brueghel (1564–1638), and Jan Brueghel I, nicknamed Velvet Brueghel (1568–1625). Both painters worked in the years of transition from the sixteenth to the seventeenth century, but they are so different as to offer yet another demonstration of the diverse trends that existed side by side in painting at the beginning of the seventeenth century.

The work of Pieter Brueghel the Elder contained an element of folk art, which must have been not without appeal for amateurs in the sixteenth century. Indeed, many collectors must have bought his paintings precisely because of their entertaining subjects. Pieter the Younger presents us with infinite variations on the genre scenes and landscapes of his father, though his work does not consist exclusively of copies. His compositions always appear in numerous variants; an example is the painting reproduced here (Plate 42B), of which two series of replicas are in existence. The one in which the stage is represented on the left (Amsterdam 425a) is attributed by some to Pieter Balten (1525–98).[15] The different versions are dated from 1624 to 1635. Entertaining though they may be, they lack not only the graceful technique of the elder Brueghel but also his concentrated composition. The younger Pieter Brueghel is engaging, amusing, but

lightweight. However, it would be unfair always to compare his works with those of his father. If one applied this standard, all art about 1600 would seem to mark the beginning of a period of decadence.

Among the compositions that probably go back to a lost work of the elder Brueghel is *The Crucifixion* (Plate 42A); copies are dated 1605, 1606, 1615, 1617, and 1618.[16] The differences between them seem to indicate that the rock formation on both sides is an invention of the younger Pieter, while the figures and the view of Jerusalem in the background, reminiscent as it is of van Eyck, belong to the art of his father. The return to sixteenth-century prototypes is typical of all Late Mannerist art. We have already noticed that prints by Dürer and after Raphael were hailed as a source of inspiration on both sides of the Alps.

Five years after the birth of the younger Pieter his father died, and by the time the young painter reached years of discretion the large-scale compositions of Pieter the Elder had long been sold. His knowledge of the work of his father came, therefore, from prints and from imitators, such as the above-mentioned Pieter Balten, Hendrick (d. 1589) and Maerten van Cleef (d. 1581), Gillis Mostaert (d. 1598), and Jacob Grimmer (d. 1590). He himself is one of the last representatives of this retrospective trend in Flemish painting. One can hardly speak of a development in his work. As is shown by the two examples quoted, throughout his life he varied themes, or even a single subject, taken from his father. The earliest paintings (of 1597; Graz and Vaduz, Liechtenstein A 1134) seem more delicate and careful in their execution than the later ones. The few small landscapes and peasant scenes, such as the *View of a Village* of 1634 (former Lassus Collection),[17] which appear to be based upon ideas of his own have an old-fashioned air, though they were painted at a time when the development of Rubens's Baroque had revitalized the whole of Flemish art.

It is possible that just before 1600 Jan and Pieter Brueghel occasionally collaborated; alternatively, both may have copied the same model from their father's work. A copy of *The Preaching of St John* dated 1598 (Munich 680) may have resulted from the collaboration of the brothers; if so, the landscape would be Jan's, the figures Pieter's.[18] Here Jan already displays his delicate technique, a technique which he may perhaps have taken over from the late works of his father (*The Dance round the Gallows*, 1568, Darmstadt; the small version of *The Tower of Babel*, c. 1565). Another even more remarkable case is that of the *Peasants' Brawl over a Game of Cards*, of which the original by Pieter Brueghel the Elder no longer exists.[19] Among the numerous replicas there is one in Dresden (819) which may have been painted by Jan. Later Rubens also copied the original, and here the landscape is once again by Jan Brueghel. It is possible that Jan owned the original and lent it to Rubens, for we know from other sources that he did own some of his father's works. Nevertheless, these few examples are insufficient evidence for calling Jan an imitator of his father, as Pieter II was. More typical of Jan's early work are the transpositions of his father's inventions into his own miniature style, and their adornment with a wealth of entertaining detail. Of this a good example is the *Adoration of the Magi* (Vienna inv. 617; another version at Leningrad, 3090) and a *Crucifixion* of the same year, 1598 (Munich 681). The latter is a variation of a composition

also used by Pieter Brueghel the Younger. The *Adoration of the Magi* is particularly significant as a Mannerist revival, for Jan Brueghel also worked into it the fantastic structure of the stable at Bethlehem by Hieronymus Bosch and some of Bosch's subsidiary figures. It is a last efflorescence of Late Gothic subtlety combined with Late Mannerist gracefulness in the play of lines and of light and shade. A coloured copy after Dürer's drawing of the Holy Family (Lippmann 460) cannot be called an intentional imitation either; it is rather a revival of a congenial art (Rome, Doria Gallery, 285).[20]

Like his brother Pieter, Jan frequently repeated his own pictures, and it is therefore difficult to determine how long Jan continued to embroider upon his father's themes. More exciting are the free adaptations of old motifs, such as *A Flemish Fair* at Windsor Castle (1600, cat. 1937, p. 93) or *The Harbour* of 1598 in Munich (187; a replica of 1606 in Stockholm, 2009). This *Harbour* is in reality a *Christ preaching*, but the biblical theme is completely lost in the crowd, which, with Mannerist playfulness, is divided in diagonal zones of light and shade. Jan's realism appears in the immediate foreground, in the group of fishmongers and their customers. This group is disposed in a triangle, and from it emanate the play of light and shade, the juggling with space, and the abstract decorative silhouetting. The style of the landscape is derived from the 'world landscapes' of Patinir, again enriched by gay decorative detail.

About 1589 Jan Brueghel went to Italy. In 1593–5 he stayed in Rome, where he met his great patron, Cardinal Federigo Borromeo. In 1595 Borromeo was made Archbishop of Milan. He was a man of great erudition and aesthetic sensibility, and he developed a warm affection for Brueghel. Some of their correspondence has survived, and provides a fascinating record of their friendship.[21] In October 1596, immediately after his return, Brueghel wrote to Federigo: 'Nothing in Holland and Flanders is as beautiful as the work of a certain German in Rome, and I beg you to hold his works in high, high esteem.' This is a reference to Hans Rottenhammer (1564–1625), who arrived in Rome a few years before Jan Brueghel. In the art collection of the cardinal was a small painting which is described as 'Il paradiso, l'ha fatto Rotenhamer, i fiori ce li aggiunse Brueghel'.[22] This collaboration was undoubtedly of significance for both artists. Rottenhammer's Venetian Mannerism à la Tintoretto must have pleased Brueghel very much. The paintings of hell with Christ in Limbo (1597, Mauritshuis 285), also resulting from the co-operation of the two artists, are proof of this. Other subjects from the underworld, such as *Juno* (1598, Dresden 877) and *Aeneas* (1600, Budapest 553), confirm this impression. Jan Brueghel surpasses himself in subtle Mannerist compositions, rich in unexpected vistas and strange constructions, brimming over with filigree detail. He remained devoted for a number of years to this Mannerism of *objets d'art*, in which Cardinal Federigo Borromeo took such delight. The *Four Elements*, created for him in the years following 1608 (Milan, Ambrosiana, 46 and 50; Paris, Louvre, 1919–20), mark the end of this style.

They follow immediately upon another series of the Elements (Rome, Doria Gallery, 322, 328, 332, 348) in which Brueghel's refined Mannerism reached its greatest height (Plate 43A). The foreground is sucked into the tunnel-like perspective. Everywhere the mass of detail is overwhelming. The completely unrealistic composition (there is a

chandelier hanging in the air) is encrusted with motifs copied from life – branches of trees, birds, and busy labourers. Light and shade play with the same sharpness over the metal and earthenware objects as over the masses of figures in the *Christ preaching* in Munich. The lack of balance, the conflict between decorative and constructive elements, contributes to the charm of Late Mannerism, a style that fascinated Brueghel as much as it did his Italian contemporaries. In Italy, too, people enjoyed the naturalistic detail in the midst, or more precisely in the foreground, of allegorical paintings of exceedingly complicated design. The *Coral Fishers* by Jacopo Zucchi (Rome, Borghese Gallery), painted a little less than ten years earlier than Jan Brueghel's Elements, and also his later allegories, are all painted to exactly the same pattern, which grows from the realistic little shells in the foreground towards the hard, statuesque, Mannerist nudes in the centre. Brueghel's *Allegory of the Fire* is not entirely a creation of his fancy. A study from nature is in existence (Leiden, Vosmaer Collection), carefully and delicately drawn, that provides the foundations for this 'grottesque'. For the figure composition, too, we have a preliminary drawing (Dresden). Its extravagant play of lines belongs to an entirely different style.

The particular facet of Brueghel's art which perpetuated his fame has not yet been mentioned: his landscapes, and with them his flower pieces. In the same way as he transposed the magnificent biblical scenes of his father into exquisite little miniatures, in his landscapes he mirrored on a reduced scale the wide woodland vistas of Gillis van Coninxloo. If the dates have been correctly read, the earliest instances go back to his Italian period: a woodland view of 1593 (sale, Brussels, 16 December 1932, no. 4) and a *Preaching of St John the Baptist* of 1594 are proof of this.[23] Gillis van Coninxloo had left Antwerp by 1586, so that Brueghel may either have received tuition from him before that date, or have seen Coninxloo's works at Antwerp or in Germany; it seems impossible that he should have rediscovered independently the play of delicately drawn foliage and of dark branches in front of pale leaves. We see this playful phase of Mannerist landscape again in works dating from 1597–8 (*St Jerome*, Munich 5171, of 1597; *Rest on the Flight into Egypt*, Amsterdam 647, *Latona*, Amsterdam 646, both undated) to as late as 1607 (*Wood*, Leningrad 424). It is probable that a meeting with Paulus Brill in Rome further strengthened this conception of composed landscape. Gradually Coninxloo's diagonal scheme changes into open woodland vistas, which suit Brueghel's vision better (Plate 46B), and which he repeatedly and successfully employed.[24]

A look at the drawings from Brueghel's early, Italian period broadens one's understanding of the genesis of his style. The woodland views (Rotterdam, London, Paris, and Brussels) connect with the work of Pieter Brueghel the Elder and with Venetian landscape painting.[25] Gillis van Coninxloo was in close contact with the Venetians, and he was probably one of those who transmitted the style. Jan Brueghel's Roman townscapes are nothing but copies of Matthijs or Paul Brill (London, cat. Hind, 12–13; Paris, Louvre, cat. Lugt, 470), but he is more graceful and more elegant and his conception is less schematic, especially when he works directly from nature. Numerous sketches of this kind have survived from his Antwerp period, from a journey to Prague in 1604, and from his time in Nuremberg in 1616.

The masterpiece of Brueghel's narrative art is his *Continence of Scipio* in Munich (827;

Plate 43B), dating from 1609. The story is set in the framework of a magnificent panorama. Notwithstanding the over-crowding, the composition betrays much thought: all diagonal movement converges upon the principal figure, and here a light-coloured tent and a dark group of trees give relief, while the opposite side is closed by a delicate silhouette. Between these two *repoussoirs* the eye runs over a world in miniature. The multi-coloured foreground is framed by a middle distance in brown tones, while the distances fade into light blue tints.

The love of detail, of a decorative filling of the picture surface, is characteristic of Brueghel's art. He often collaborated with others – Rubens, Hendrik van Balen, Hendrick de Clerck – in providing a suitable frame to another artist's figure composition. He carpets the woodland vistas with bushes and flowers, and fills the ponds with shells and fish and the skies with many-coloured birds (*Allegory of the Elements*, 1604, Vienna inv. 815). *Paradise* (The Hague 253), in which Rubens placed the enchanting little figures of Adam and Eve, was a subject which altogether suited his talents. Never has the desire to paint a paradise scene peopled with creatures both great and small, with all its trees and flowers, and to paint it with grace and care, received a lovelier expression than in this scene (Plate 44A).

In a certain sense these exquisite pictures of Jan Brueghel are old-fashioned. They belong to the *Kunstkammern* of the Mannerist collectors, who amassed with equal avidity objects curious, precious, and merely strange. Brueghel's composition was indeed old-fashioned, but the rendering of the detail was strikingly modern, that is realistic. It is observed, not invented. But Jan Brueghel's landscapes do not always consist of a carefully arranged assembly of items. There are also simple village views, at first still naïvely framed by a tree on the left and a mill on the right, with a dark track running straight across the foreground (Paris 1926 of 1600), but by about 1605 showing a more natural interplay of elements (*Village Street* (Plate 46A), with many repetitions).[26] Even in the Northern Netherlands painters were not more advanced at this moment. It is highly probable that prints or drawings of Pieter Brueghel the Elder (or prints such as the series *Praediorum Villarum*, Cock, 1561, that are based upon his work) prepared this fresh approach. From 1605 dates the *Shooting the Bittern* (Dresden 881), a surprisingly fresh, simple subject, soon to be followed by similar open landscapes such as the *Peasant Cart* of 1608 at Munich (830). Certainly there are still the separation of foreground, middle distance, and background, the somewhat schematic lighting, and the demonstrative diagonal lines; yet the composition is unified and self-contained, and there is a feeling for nature, not simply a realism of detail. Until the 1620s Brueghel painted both types: open, hilly country, and closed woodlands with 'old-fashioned' detail. Collaboration with Jodocus de Momper and Rubens did not really bring about any significant change in his work; he remains an entrancing painter precisely because of his constancy, and his slow progress along the road of loving observation of small things.

In 1621 Jan Brueghel sent a *Wreath of Flowers* to his patron, Cardinal Federigo Borromeo. This had not been commissioned; it was a very special piece of work, spontaneously conceived, and executed with the greatest care. It is 'il più bello e rara cosa che habbia fatta in vita mia. Ancho sig. Rubens la fatta ben monstrande sua virtù',

Brueghel wrote to the cardinal, and he waited impatiently for the news of its arrival. The composition was most subtle: a small painting of the Virgin was suspended by a blue ribbon from a colourful wreath of fruit and flowers (Plate 45). The Virgin was, of course, the work of his friend the young and erudite Rubens,[27] who rendered other services to Brueghel: it was he who looked after Brueghel's Italian correspondence with the cardinal, and how annoying it was for Brueghel when his secretary Rubens was not at hand, 'partita (sic) per Brussello' in 1616, or in France (1622).[28]

Flower paintings were an important business for Brueghel. In 1606 there is already mention of a flower wreath with a 'Madonna dentro' that is to be sent to Italy. Repeatedly and in great detail he reported to Federigo about the effort the work involved and about his difficulties. Brueghel studied from nature, and went in search of rare specimens for his bouquets even outside the place where he lived. He had to start on his collecting early every spring, in fact in February, for 'in August no more good flowering plants were to be had'. Then the season began for landscapes.[29] The numerous imitations by his son and his pupils and followers have damaged Brueghel's reputation in this field too; but careful study of every good specimen from his own hand is bound to arouse our admiration for his subtly stylized naturalism. In this genre, too, Brueghel stands on the border-line between a decorative sixteenth-century Mannerism and a 'modern' observation of nature. The sketches by him (Plate 44B) and a few younger contemporaries belong, by reason of their overwhelming naturalism and directness of vision, to the most advanced work in Europe at the time.[30] 'Even the most insignificant works of Jan Brueghel' – these are the words in which the cardinal praises him – 'show how much grace and spirit there is in his art. One can admire at the same time its greatness and its delicacy. They have been executed with extreme strength and care, and these are the special characteristics of an artist enjoying, as he does, a European reputation. So great will be the fame of this man one day, that my panegyric will prove to be less than he deserves.' In his own country Brueghel was equally admired. The Archduke Albert requested the municipality of Antwerp to exempt him from excise and other duties, because, although he was not attached to the court, he was nevertheless 'quelquefois occupé en ouvrages de nostre servise, mesmes en ceste ville et hors de son mesnage et résidence ordinaire'. Art collectors at home and abroad praised his works as enthusiastically as Cardinal Federigo. Thomas Sagittarius wrote a long and ponderous poem on his art; George Gage, the Antwerp representative of Sir Dudley Carleton, praised the 'neatnesse, force and morbidezza' of his works.[31]

Hendrik van Balen, Frans Francken, and Sebastiaen Vranx

Jan Brueghel painted for the cabinet of the discriminating collector, Pieter Brueghel for simpler clients and for the trade. The manufacture of large biblical scenes and of altarpieces for church and chapel was not part of their concern. Their older contemporaries, Maerten de Vos and Hendrick de Clerck, whose main output did consist of ecclesiastical art, also tried, however, to serve customers outside the Church. As we have seen, Hendrick de Clerck drew small mythological figures in the landscapes of Jan Brueghel.

Maerten de Vos, whose art had reached popularity through prints, in the last decade of his life painted biblical and mythological scenes in cabinet format (two biblical scenes, of 1602, London, E. Schapiro Collection; *Apollo and the Muses*, Brussels 758). Hendrik van Balen (1575–1632), a pupil of Adam van Noort, also liked to paint elegant mythological stories in the manner of Jan Brueghel, and sometimes in collaboration with him. These were destined for middle-class collectors. His few large triptychs (Antwerp Cathedral; St Jacobskerk; Museum) are sound but somewhat weak compositions. The *Preaching of St John* (Antwerp 365), from his early period, is a rustic variation upon the art of Adam van Noort, carried out with ponderous Classicism. The altar-piece of the Holy Family with angels singing and playing (Antwerp Cathedral and Museum 361–4) is brighter and more elegant. The work probably dates from his later period, when he was imitating Rubens in a heavy-handed yet rather agreeable manner. The majority of his mythological scenes painted after 1610 are fairly successful compositions in the spirit of Rubens with an inclination towards the pretty and the decorative. The somewhat earlier scenes have rather more spirit and life, with their sharp lines, their startling foreshortenings, twisted curves, and playful gestures (Plate 48A). It is the last phase of international Mannerism as professed in Antwerp by Hendrick de Clerck and Hendrik van Balen, and elsewhere, in Utrecht for example, by late arrivals such as Joachim Wtewael. Others at this moment had already given up this playful posing of graceful nudes.

The difference between sixteenth-century tradition and seventeenth-century renewal comes out clearly when we compare the works of Frans Francken the Younger (1581–1642) with those of his father, a specialist in great history paintings in the rigid Romanist style (see p. 48). The son is a genre painter of the time and in the manner of Jan and Pieter II Brueghel. He became a master in 1605. An early work, the *Witches' Sabbath* of 1607 in Vienna (Plate 48B), is still constructed entirely with the same Mannerist light effects as van Balen's *Marriage of Peleus and Thetis* or Jan Brueghel's infernal scenes of about 1600. The composition lacks balance and repose. In later years Francken constructs more systematically, with the help of triangular formations or long diagonals (Plate 49A). Like Jan Brueghel, Francken is fond of terse drawing and of sharp contrasts of light and shade in the small area of a face or a dress. Unlike Brueghel, however, Francken did not begin as a landscape painter, and this is why the landscapes of his mythological and religious scenes are mostly by other hands. As a painter of great altar-pieces (triptych of the Quattro Incoronati, 1624, Antwerp 158–62; *The Assumption*, 1628, Amiens Cathedral), he is certainly inferior to Hendrik van Balen. But among the enormous number of small scenes he produced throughout the fourth decade there are uncommonly witty inventions, characterized by a stylish chiaroscuro (*The Taking of Christ*, 1630, French Recuperation Service; Plate 49B; *Triumph of Neptune and Amphitrite*, 1631, Sarasota 230). The framing by *repoussoirs* right and left may be old-fashioned, yet this conservatism safeguards him from too facile an imitation of Rubens's Baroque art, which was just then claiming the allegiance of most of the younger painters. How popular and in how great demand the painters of this 'small genre' – Jan Brueghel, Hendrik van Balen, Frans Francken – were is proved by the numerous copies and repetitions that were in circulation, some being sent as early as the seventeenth century as cheap wares to

foreign fairs. The sons of Jan Brueghel and Frans Francken did not hesitate to make such copies.[32]

Among the *Kleinmeister* there was apparently only one who disliked increasing his output at the expense of quality by using assistants and pupils. He was Sebastiaen Vranx (1573–1647). His work was in great demand, primarily because of his attractive subjects – landscapes, battle-scenes with horses, and domestic scenes. In 1624 the painter and merchant Jan Brueghel II informed his partner in Seville: 'Vranx has plenty to do but refuses to employ studio assistants, which means that the work takes a long time. He does not allow copies to be put into circulation.'[33] He was not averse to collaboration with others, however. The *Ambush* at Aschaffenburg (6265) is marked with his monogram only, although it is evident that the lion's share of the picture was Jan Brueghel's, who painted the landscape.[34] As a figure painter Vranx continued the tradition of Pieter Brueghel. Vranx, who left for Italy about 1593, became master in Antwerp in 1600. Italian motifs occur in his work until the 1630s, but Italian Mannerism only in the works of his youth, like the series of prints *Romanorum Viri et Feminae Habitus*, which, remarkably enough, is more Venetian than Roman in character. Soon after 1610 Vranx emancipated himself from Venetian and Brueghelian examples. Only the way in which the vanishing-lines of a cart-track exert an engulfing pull into depth, the framing with trees on both sides, and a shaded area in the foreground are left to remind us of the old-fashioned scheme of composition (Plate 47B). The figures, in all their detail of colour, are realistic, that is modern, but the attention is still distracted by a surfeit of episodes which fill the lighted areas as in a medieval tapestry.

To sum up, the difference between Abraham Janssens (1573/4–1632) and Hendrik van Balen (1575–1632) – to compare two artists of the same generation – is not only one of format, or of problems inherent in the painting of great altar-pieces, with which the artists of small cabinet pieces do not concern themselves. The youth of both artists was linked with Late Mannerism, but – and this is no accident – Janssens's adherence to the elegant Mannerist forms (Plate 35) was more intense than that of Hendrik van Balen or of any of the other small genre painters (Plate 48, A and B). Janssens's second phase was characterized by a stiff Classicism not lacking in grandeur (Plate 36A). This Classicism was an undercurrent in the art of the sixteenth century. It provided one possibility of reaction against Late Mannerism, and as such it appeared throughout European art of the late sixteenth century. The *Kleinkunst* of Jan Brueghel, van Balen, and the young Franckens had no use for this Classicism. Their reaction against the Mannerist past was expressed in a use of naturalism of detail, partly based on direct observation but partly also nourished by the naturalist undercurrent in the sixteenth century which had, for instance, permeated the art of the elder Pieter Brueghel. The principles of composition themselves changed only gradually; their dry rigidity was broken open, as it were, by a multiplicity of entertaining detail. Flemish art, between Mannerism and Baroque, was never animated by a new vision, a new *élan*. Its strength was everywhere dulled by conservatism.

LANDSCAPE, VEDUTE, AND PERSPECTIVES

The development of landscape into a separate branch of painting is a fascinating story. We can give only an incomplete picture of it here, since its roots are in the art of the sixteenth century, and it reached its zenith outside the boundaries of this chapter. Many of the principal Flemish landscape painters settled abroad, and their work must be considered in relation to that of their adopted countries.

Modern landscape painting in the Netherlands may, with some justification, be said to stem from Pieter Brueghel. His art is more important for its development than that of Joachim Patinir and Herri met de Bles. Maerten and Lucas van Valkenborch, although they went to live in Germany about 1566 (and with them Maerten's sons, Frederik and Gillis van Valkenborch), were considerably influenced by Brueghel. Their style, even in Germany, remained Flemish, but their work contributed nothing to the formation of the younger generation of landscape painters in Antwerp. There Brueghel's style was continued by minor followers – Jacob Grimmer the Elder, Pieter Brueghel the Younger, Gillis and Frans Mostaert, and several others – who also imitated his genre scenes. Hendrick and Maerten van Cleef specialized in painting representations of the Tower of Babel. Pieter Balten remained satisfied with rustic drolleries à la Brueghel and with imitations of Brueghel's *Four Seasons*. Jacob Grimmer, too, adhered to the Brueghel formula. Hans Bol (1534–93), who was more gifted, moved in 1584 to Amsterdam.

Of an importance inferior only to Brueghel's work is that of Gillis van Coninxloo (1544–1606). Although he too left Antwerp for good in 1585, his influence upon Jan Brueghel (p. 59) proves that, through prints or other means, his art must have remained current in Flanders. From 1587 to 1594 Coninxloo worked in Frankenthal in the Palatinate, and afterwards in Amsterdam. He introduced what has been called 'the composed ideal landscape' in the form of intimate woodland vistas on Venetian models. Venetian influence was fairly strong, and it is fascinating to follow the reciprocal influence of Antwerp and Venice in artists such as Paolo Fiammingo and Lodovico Pozzoserrato (Lodewijk Toeput). Karel van Mander praises Gillis van Coninxloo and thinks highly of his influence on Dutch art. In Frankenthal he created a kind of colony of landscape painters, the best known of whom are Pieter Schoubroek (1570–1607) and Antoine Mirou (before 1586–1661?). Another side of this 'Italianism' comes out in the landscape art of Paul Brill (1554–1626). He and his elder brother Matthijs worked mainly in Rome. Their Flemish style enriches international Roman art, and need therefore not be discussed in a history of Flemish landscape painting. Their work was greatly admired by the German Adam Elsheimer and the Dutchman Cornelis Poelenburgh, and the development of their style, from the colourful fantastic towards the restrained intimate, corresponds to trends on this side of the Alps.

In the Low Countries the centre of landscape painting moved towards Holland. Almost all influential artists of the following generation emigrated to the North: Jacques and Roeland Savery (1576–1639) established themselves in Utrecht, David

Vinckeboons (1576–1633), Alexander Keirinx (1600–52), and Willem and Adriaen van Nieuland in Amsterdam, Claes and Gillis d'Hondecoeter in Delft and later in Utrecht. We have already mentioned Hans Bol. By 1600, therefore, there was something like a vacuum in Flanders. Only the Brueghel tradition continued in a few lesser masters who, as we saw, produced genre paintings and 'Seasons' as cheap wares for fairs. Jan Brueghel's delicate and graceful landscapes are the best paintings of this moment, and have therefore been dealt with separately.

One truly great landscape painter did remain in Flanders, however – Jodocus de Momper (1564–1635) – and his work reconciles us with the otherwise rather monotonous character of Flemish landscape of about 1600. His style shows no development. Moreover, in the absence of dated paintings the chronological arrangement of his *œuvre* is difficult.[35] Who was his master? Official documents are silent on the subject; all we have is an inventory of 1642 which mentions a landscape as painted by 'Momper's master Lodewijk of Trevi'.[36] This must refer to Lodewijk Toeput (or Pozzoserrato), who worked in Treviso. He came from Malines, which he left about 1580. Momper was received master in the Antwerp Guild in 1581, so that an apprenticeship before 1580 in Malines would fit perfectly. In 1611 Momper became Dean of the Guild. There is no documentary evidence of a journey to Italy, nor do we know of contacts with Flemish artists there. Italian motifs are rare in his painting. Yet the main theme of Momper's art, the representation of a world of mountains, could hardly have been achieved so powerfully without the experience of a journey across the Alps: some scholars therefore believe that Momper worked in Italy under Pozzoserrato. Meanwhile another source of inspiration for Momper's work was Pieter Brueghel the Elder, whose only worthy follower he was. Though he never actually allowed himself to be tempted into making mere copies of Brueghel, he tried to preserve Brueghel's special technique for the rendering of the spacious beauty and radiant warmth of a landscape. The rock formations are built up with blue glazes over a brown ground. Executed with bold, sometimes random brush-strokes, the masses of dark and lighter tones slant right across the panel. Winding paths meander with Mannerist elegance through the brown foreground, the green middle distance, and the blue background. Splashing water, thick branches, and tiny blades of grass are arranged in the foreground, and thick whites and yellows contrast with a blood-red underpainting of leafy branches and jutting rocks. In contrast again, the distant vista melts away in touches of blue and white. This rich technique, this personal style so full of fantasy, gives fresh beauty and characteristic charm to every painting of Momper. In his hands the terse Mannerist design acquires new vivacity and conviction, for in spite of all the artificiality of his compositions, fantasy and vision, free technique and sound colour remain the basic elements of his art. As the painter of fantastic Mannerism he is a worthy follower of Pieter Brueghel the Elder. Investigations of recent date have indeed revealed more contacts between the two artists than had hitherto been known.[37]

Momper's fantasy seems inexhaustible (Plate 50A). Even when his task was the mere surface decoration of rooms with series of landscapes (Copenhagen, Rosenborg Castle, Hillerød, Frederiksborg Castle), the power of his imagination and his personal touch

continued to triumph. Another motif upon which Momper liked to introduce variations is the mountain pass (Dresden 868; Oberlin 48 321, Chicago),[38] and there was a time when he enriched his repertory with 'open landscapes' and village vistas, in the style of Jan Brueghel and probably not without dependence on him. One of these, *The Flight into Egypt* at Oxford (Ashmolean 283; Plate 50B), appears to be very early (see the inexperienced way in which the path is foreshortened); others are so similar, in their graceful techinque and their construction, to small landscapes of Jan Brueghel of about 1605 that collaboration can be the only explanation. It is known, in any case, that both Jan Brueghel the Elder and his son Jan II frequently worked small figures into Momper's paintings.[39] Momper must have had a prosperous studio, for surviving works 'in the style of Momper' are legion. It is probable that the sons copied and varied the paintings of their father. Painters of the generation of Momper who worked outside his influence, such as Tobias Verhaeght (1561–1631) and Pieter Stevens (*c.* 1564–*c.* 1624), do not rise above a certain schematic decorativeness derived from the compositions of Lucas van Valkenborch and of Pieter Brueghel. There is, moreover, no real development between the works of Verhaeght in 1615 (Brussels 201; Berlin 2027) and in 1623 (Paris, F. Lugt Collection). Curious instances of 'picture-making' are quoted in inventories of the seventeenth century, for example a landscape by Gillis van Coninxloo and Tobias Verhaeght with figures by Jan Brueghel.[40] Pieter Stevens, whose work can be reconstructed from drawings with his monogram, adhered even more to the tradition of Valkenborch–Coninxloo.[41]

Side by side with those of Pieter Brueghel and of the Valkenborchs, the works of Gillis van Coninxloo have been an important source of inspiration for the later Flemish landscape painters. His woodland views composed in the Venetian manner were something new for the Netherlands. Kerstiaen de Keuninck (*c.* 1560–1632/5) developed the same motif with a dash and enthusiasm all his own. However, the tranquillity and intimacy of Coninxloo made way for a tempestuous play of masses in movement. The old-fashioned scheme of the three layers in space, brown, green, and blue, with their alternation of light and shade, was given a new unity by means of very rapid and broad brush-strokes (Plate 51A). The source of light is often masked by a powerful group of trees, so that slanting rays fan out across the landscape. If once in a while the principal motif is conceived a little less extravagantly, fanciful buildings provide a fairy-tale effect in the background (Plate 51B). Jan Brueghel and Kerstiaen de Keuninck represent two manners in Flemish art: the careful technique that goes with devoted observation on the one hand, and on the other an unbridled fantasy and an impulsive and vigorous touch. Both manners found followers. The art of Jan Brueghel was continued by a great many minor artists. Kerstiaen de Keuninck's lively trees and contours of hills appear almost unchanged in the early works of Lucas van Uden.

Gillis van Coninxloo and the brothers Jan and Pieter II Brueghel each attempted a definite type of painting, the romantic forest scene, the refined delicate landscape, and the village view with rollicking peasants. Their younger fellow-townsmen often drew on their accumulated stock, and made a mixture out of their, by then, old-fashioned ideals. Adriaen van Stalbemt (1580–1662), who came from Middelburg but worked in

Antwerp from 1609, was generally no more than an imitator of Jan Brueghel; nevertheless, his painting sometimes has a considerable amount of personal fantasy and daring (Plate 52B). The rocks are put on with a broad brush, like Jodocus de Momper's, and his dark ship is a clever variation upon the usual motif of the *repoussoir*. As was customary about 1620, the figures are grouped without sharp contours in the manner of Hendrik van Balen. On another occasion Stalbemt painted a woodland vista entirely in the style of Coninxloo–Vinckeboons (1620, Antwerp 469).[42] The manner in which he worked after 1630 is entirely unknown. Antoine Mirou (before 1586 – after 1661), in his small landscapes painted between 1599 and 1618, shows himself a faithful continuator of the style of Pieter Brueghel (1604, Berne), but with the addition of romantic woods in the taste of Coninxloo (1611, Prague 350; Plate 52A). Abraham Govaerts (1589–1626) was a pupil of Jan Brueghel before he entered the Antwerp Guild as a master. The Brueghel whom he paraphrased is the romantic Jan Brueghel of before 1600. The series of 'Woodland Views' in Budapest (377, 379, 9821; Plate 47A) is a good specimen of his ability and of his refined technique. It is worthy of Jan Brueghel, but has a fantasy and a love of movement that are his own. By 1612, however (The Hague 45), his woodland views had become more schematic and ornamental. To sum up, it can be said that during the whole seventeenth century a number of *Kleinmeister* busied themselves with the production of village views, river landscapes, and hillocks in the taste of Jan Brueghel.[43]

To create imaginary landscapes of decorative beauty was, as we have seen, the real aim of this art; interest in the faithful rendering of a real Flemish town or village was only of secondary importance. Nevertheless, a tradition did remain alive of landscape seen topographically. These renderings of things actually observed continue the Flemish sixteenth-century tradition of series of Months and Seasons, whose faithful reproduction of detail makes them look as if they were authentic illustrations of specific Flemish villages and landscapes. Apart from Pieter Brueghel, it was mainly Jacob Grimmer (*c.* 1526–90) and Hans Bol (1535–93) who practised this kind of landscape painting. In the work of Abel Grimmer (after 1570 before 1619), Jacobs son, the Brueghelian vistas continued right into the seventeenth century. Like Pieter Brueghel II, he was not satisfied with mere copies of his father's prints (e.g. Antwerp 831, of 1607; another series of 1600). He developed from the elder Brueghel and from his own father a dainty and intimate treatment of Flemish landscape in winter and summer, with merry-making peasants or with biblical scenes. Among his happiest landscapes are the vistas of Antwerp (Antwerp 672 and 817; Plate 53A), which bear witness to his imagination and powers of observation. Hendrik van Balen added the Holy Trinity to symbolize God's protection of the pious inhabitants of Antwerp. Grimmer also looked at the Flemish interior with the specialist's eye, and rendered it with as sure a hand as did the professionals of perspective such as the Steenwijcks and the Neefses, then and later (*Antwerp Cathedral*, 1595, sale Lord Chesham, 18 December 1946, no. 148; *Christ with Mary and Martha*, 1614, Brussels 194). Variations upon old-fashioned compositions such as the copies after Brueghel, biblical scenes in the style of the Bruges primitives (Plate 32B), or landscapes with small biblical figures *à la* Herri met de Bles (*Crucifixion*, 1599, Messrs Douwes, Amsterdam, 1925) consort strangely with these paintings.

Denis van Alsloot too (1570–1626) found a way to the new seventeenth-century style from his interest in, and his faithful rendering of, everyday life and festive occasions in and outside Antwerp and Brussels. In 1608 he was still painting woodland views in the tradition of Gillis van Coninxloo and Jan Brueghel, in co-operation with Hendrik de Clerck (*The Death of Procris*, Vienna 988), but about 1610 he broke away from the romantic conventions. The simple narrative of his *Procession to Notre Dame de la Sable* in Brussels (Brussels; London, Victoria and Albert Museum; Madrid; Turin) is innocent of any ambition towards a style of its own. We are impressed by the accuracy of the graceful town views that frame the procession, as the flower garlands of Jan Brueghel framed the biblical scenes painted by his colleagues. Winter landscapes are no exception in his *œuvre*; they allow a light background for the mass of small colourful figures in the foreground. The Abbey de la Cambre is another subject that repeatedly attracted him. *Festival at the Abbey de la Cambre* (1616, Madrid 2570) is perhaps the least conventional piece of topography by him and the least artificially designed (Plate 53B). At a later period painters of the generation of David Teniers were once more to represent these festivities in Antwerp, but then it was done in the free painterly style, and with the wit and gaiety of their time.

The combination of artificial composition with observation is characteristic of Flemish art at the beginning of the seventeenth century, and it became the problem *par excellence* of the specialists of architectural painting, whether they were inventing or observing interiors or streets and squares. Hans Vredeman de Vries (1527–*c*. 1606), born in Leeuwarden but working until 1585 mainly in Flanders, was a pure 'idealist', whose Mannerist fantasies were quite at home in the *Kunstkammern* of the eccentric courtly collectors who commissioned paintings from him. The perspective lines run from all sides to a vanishing-point, while the over-rich decoration casts a net over the painted surface – though a net which deliberately leaves holes (Plate 54A). Nowhere in the north of Europe did international Mannerism find a purer expression than in this fantastic architecture of Vredeman de Vries and his imitators.

In his later years he worked principally for the Emperor Rudolf II and other German princes. His sons Paul and Salomon, his pupil Hendrik van Steenwijck I, and the next generation with Hendrik van Steenwijck II (*c*. 1580–1649) helped to spread the style across Europe. If Vredeman was content to construct a perspective framework, Hendrik van Steenwijck the Elder was fascinated by pictorial problems (Plate 55A). His space seems genuinely experienced. His representations of Antwerp Cathedral (1583, Budapest 579) are the first church interiors that can be called observed, and his vision determined the treatment of this subject for the next fifty years. The tyranny of the vanishing-lines is broken by architectural motifs which cut them and by other small picturesque details. The Steenwijck family was Dutch (Frisian) in origin. Hendrik the Elder lived in Antwerp in the seventies and eighties, and his son, Hendrik II, was born there about 1580. The latter's early works (1603, London 443; 1605, Vienna 943) are much more subtle and detailed than his father's. The *Palace* of 1614 (The Hague 171), with its shining marble and its sharply drawn lines, marks the zenith of this new style of glittering detail and bright colours. Jan Brueghel's small and highly artificial panels stand at precisely the

same level of subtle Mannerism. After his death in London in 1649, Steenwijck's paint-
ings of this kind gradually ceased to be fashionable. From the 1620s we know a number
of works by him which have considerable decorative charm, a delicate colour sense, and
a highly inventive composition (Paris, Louvre, 2581, of 1620; London, Count Antoine
Seilern Collection, of 1624).

The purely Flemish interpretation of the church interior was taken up and carried on
by the Neefs family, and in particular by Peter Neefs I (c. 1578–1656/61) and Peter
Neefs II (1620–after 1675). Their work cannot be told apart. Now the exuberant fantasy
of architectural painting had withered into a dry study of linear perspective; the network
of vaulting-ribs, tracery, and shafts fills the space with a wealth of detail, but the light that
falls from the side breaks the severe perspective, a residue of cerebral Mannerism (Plate
54B). The Neefs family painted church interiors in this manner well into the seventeenth
century, and they were not alone in this; the landscape painter Abel Grimmer was
equally skilful, as his view of the interior of Antwerp Cathedral shows (p. 67). Grimmer's
church interiors, which are rather rare, are based upon the works of the Steenwijcks.[44]
Neefs may have been a pupil of Steenwijck the Younger, whose paintings he occasionally
copied.

Parallel with this development of the painted church interior was that of imaginary
streets and squares. Here also the example of Hans Vredeman de Vries and Hendrik van
Steenwijck was followed. A characteristic and still relatively unknown painter of this
genre was Louis de Caulery (from Cambrai?). His imaginary townscape (Hamburg
413; Plate 55B) is still entirely constructed upon the principle of lines in excessive fore-
shortening. Their incisiveness is further accentuated by sudden changes of light and
shade, but the same irruption produces an amusing decorative effect. The severity of
construction is softened by plenty of small figures in the taste of Frans Francken, and the
Mannerist composition is broken open by realistic detail – the typical Flemish reaction
to the old-fashioned style. Denis van Alsloot and Abel Grimmer produced village views
and festive scenes in town and country which also carried this genre closer to the realism
of the new times.

PETER PAUL RUBENS

YOUTH AND CHARACTER

PETER PAUL RUBENS was born at Siegen in Germany on 28 June 1577, the son of burgesses of some distinction in Antwerp. His father, Jan Rubens, was a lawyer and magistrate. Being a Calvinist, he left the town about 1568 and settled in Cologne. Rubens's mother, Maria Pypelinckx, must have been a woman of exceptional character and considerable refinement; this is clear from the letters she wrote to her husband from 1571 to 1573, while he was imprisoned at Dillenburgh for adultery with Anne of Saxony, wife of Prince William of Orange.[1] Rubens's balanced personality, the manner in which he reconciled his temperament and emotions with the will to inner peace and self-control, must to a considerable extent have been inherited from his mother. After his father's death in 1587 Maria and her children left Cologne, where the family had lived for nearly ten years, and returned to Antwerp. The memory of his childhood years in Cologne remained with Rubens throughout his life. When in 1637 he received a commission from a collector there for an altar-piece showing the crucifixion of St Peter he wrote: 'I have great affection for the city of Cologne, because it was there that I was brought up till the tenth year of my life.'[2]

Rubens's father was a man of learning and culture whose contemporaries looked upon him as a humanist, and Rubens's own education in Cologne and Antwerp must have been considerably above that of the ordinary run of painters. His knowledge of classical civilization, of Greek and Roman authors, and not least his familiarity with the Latin language, can have been obtained only through sound schooling. Later he acquired a fair number of modern languages, including French, German, and Spanish. He preferred to conduct his correspondence in Italian, which he must have spoken as fluently as his mother tongue; he even corresponded in Italian with the Dutch engraver Peter van Veen of Leiden. His letters are an extraordinarily valuable source of information: they reflect his interest in art, politics, and history; they show him as a connoisseur and collector of works of antique art and curiosities; and they tell us about transactions with patrons and with engravers who worked for him. We hear the humanist speak, and the business-man, and particularly the diplomat, who worked zealously for peace in the service of the Archduchess. His letters to Isabella Brant, Helena Fourment, and other members of the family have not been preserved; the Rubens of the letters is the painter in his studio, the lover of the arts, and the faithful servant of the Spanish Archdukes.[3]

His contemporaries praised the charm of his personality. Peiresc summed it up after he had read Rubens's letters with 'un singulier plaisir': 'Mr Rubens qui est né pour plairre et délecter en tout ce qu'il faict ou dict.'[4] This great scholar and zealous correspondent had met Rubens in Paris in 1621. When Rubens went to Antwerp Peiresc

could not praise his gifts sufficiently: 'Io non posso se non amirarlo sommamente et lasciarlo tornare da se con grando dispiacere di perdere la più dolce et più erudita conversatione ch'io habbia mai havuto; in materia dell'antiquita principalmente, egli ha una notitia la più universale et la più esquisita ch'io viddi mai.' [5] In 1607, when Rubens was still in Italy and his work had been seen by few Netherlanders, Scioppius praised him in the following words: 'Mon ami Rubens, un homme en qui je ne sais ce que j'aurais le plus à louer ou son habilité dans l'art de peindre, art dans lequel, aux yeux des connoisseurs, il semble avoir atteint la perfection, si quelqu'un en ce temps y soit parvenu – ou son savoir en tout ce qui appartient aux bonnes lettres, ou cette délication de jugement qu'il joint à un charme tout particulier de parole et de conversation.' [6]

The testimony to Rubens's many-sidedness is amazing: 'We also visited,' wrote the Danish doctor Otto Sperling in 1621, 'the very famous and gifted artist Rubens, whom we came upon at his work, when he was having Tacitus read to him and at the same time was dictating a letter. As we remained silent and did not wish to disturb him by speaking, he began himself to talk to us and went on painting meanwhile, the reading aloud going on also, and did not cease to dictate the letter, and answered our questions, whereby he wished to show his great cleverness.' [7] This display of mental acrobatics seems to us unworthy of a great personality. It would in fact be unbelievable, were it not that the very oldest biography of Rubens reports concerning his daily round: 'Rubens was always accustomed both winter and summer to attend the first mass ... After mass he applied himself to his work while a reader sat near him reading from Plutarch, Seneca, or some other book so that his attention was fixed both, upon his painting and the reading.' [8] It remains a marvel that one man could bring forth so vast and yet so fine a body of works, and at the same time accumulate a fortune and administer it, give up much time to lengthy diplomatic missions, and also prove himself an expert in classical culture, able to engage in extensive and thoroughgoing debates with the scholars of his day. This extraordinarily gifted man must have subjected himself to great spiritual discipline.

'In effetto io non son Principe sed qui manducat laborem manuum suarum,' wrote Rubens in 1618, in order to make quite clear to Sir Dudley Carleton that everything he was offering in exchange for Sir Dudley's antiquities was the work of his own hands. To which the English nobleman returned the following compliment: 'Io stimo Principe di pittori e galant huomini!' [9] In the midst of all the flowery compliments one senses everywhere real admiration for Rubens the artist and Rubens the man of the world. Soon after Scioppius's paean of praise there appeared a laudatory poem by Dominicus Baudius (1611), who gave him the title of 'Apelles nostri Aevi', homage which later contemporaries echoed.[10] Mingled with admiration for the artist was always respect for the wise and civilized man. The historian of Marie de' Medici expresses it thus: 'C'est un homme dont l'industrie, quoy que rare et merveilleuse, est la moindre de ses qualitez; son jugement d'estat, et son esprit et gouvernement l'eslevent si haut au dessus de la condition qu'il professe, que les œuvres de sa prudence sont aussi admirables que celles de son pinceau.' [11] In 1640 his passing was mourned as that of 'le plus scavant peintre du monde'.[12] For the generations that came after his works are 'pleins d'un beau feu

d'imagination, d'une érudition profonde et d'une intelligence dans la peinture' which no other painter has shown so clearly and so consistently.[13] Admiration for the unity of creation and creator demands, then, that we should deal with Rubens's life and his personality more fully than in the case of any other painter of his time.

EARLY WORKS: RUBENS IN ITALY

In 1598 Rubens was received as master in the Antwerp Guild. If we are to believe the oldest biographies, he had then been studying for eight years, and had spent an 'apprenticeship' as a page in the service of Marguerite de Ligne-Arenberg, Countess de Lalaing – an excellent training for a man who was later to move among the great of the earth. His teachers in painting were Tobias Verhaeght, Adam van Noort, and Otto van Veen.[14] Verhaeght's teaching has left no trace whatever in Rubens's youthful production, and van Noort's part in his formation is difficult to estimate. The art of Otto van Veen, or at any rate that Classicist Late Mannerism to which van Veen belongs, provides the background of Rubens's early style. It is probable that Rubens worked in van Veen's studio until he went to Italy. A *Parnassus*, now lost, a joint work of van Veen, Jan Brueghel, and Rubens, is thought to have been painted at this period.[15]

Otherwise he produced little before 1600, and what remains consists almost entirely of dubious attributions or paintings from which his personal style is absent. A little portrait of 1597 (New York, Jack Linsky Collection), two biblical scenes (London, L. Burchard Collection, and Polesden Lacy, Christopher Norris Collection), a copy after a painting by Otto van Veen, and a re-working of one of his drawings – that is about all we can attribute to Rubens with any degree of probability.[16] These works are characterized by a colourless Classicism such as might have been found anywhere in Antwerp studios about 1600. Rubens was apparently not one of those geniuses that mature young, and he did not, with the vigour of a new generation, shatter forms that had become out of date and empty; on the contrary, memories of Otto van Veen re-appear in works from his Italian period, and even in paintings from the period of the new Classicism which he reached about 1615 (pp. 73, 80). The young Rubens, at all events, not a revolutionary, but a man who surveyed the pictorial tradition of the past and re-created it, a man whose greatest virtue was respect for that classical and Christian civilization which his thirst for knowledge readily absorbed.

From his earliest youth Rubens copied, with a firm and swift touch, figures which interested him in the sixteenth-century compositions of Lucas van Leyden, Jost Amman, Tobias Stimmer, Hans Weiditz, Hendrick Goltzius, Konrad Meit, and many others. Certain poses or remarkable gestures impressed themselves so firmly upon his visual memory that they re-emerged years later in a different connexion in his own work. With almost scientific zeal he copied, too, the masterpieces of Italy: Roman statuary, classical coins, Michelangelo's frescoes and sculpture, Raphael's, Titian's, Correggio's works, and those of many other artists. Sometimes he reworked an old drawing or restored what had been torn off. More important to him than the composition was the

single figure or the single group. One of his peculiar gifts was that he could so think himself into the position in space of a piece of sculpture that he was able, for example, to draw Michelangelo's Medici tombs in Florence in an unusual perspective from an imaginary point at which in reality it was impossible to stand.[17] Later, too, comes evidence of Rubens's visual memory and facility; he makes a game of moving figures from right to left, turning compositions round, or using studies reversed as in a mirror.[18]

On 9 May 1600 Rubens set out for Italy, perhaps accompanied by a servant and pupil, Deodat del Monte. It is said that he met a nobleman in Venice who admired his paintings and introduced him to Vincenzo Gonzaga, Duke of Mantua. There is no reason to doubt the truth of this tradition. However, Vincenzo had been in Antwerp the year before, and the young painter, through the connexions which his teacher Otto van Veen had with the Court of the Archdukes, could already have met his future patron there. Rubens was in the service of this prince for eight years, though he sometimes spent months away from Mantua. Once the Archduke Albert tried to recall him, but Vincenzo refused with as much decision as courtesy to give up his court painter.[19] Among the people Rubens met in Mantua was his fellow-countryman Frans Pourbus. Both seem to have been in demand mainly to paint portraits, but Rubens soon rebelled, as we know from a letter of October(?) 1603, written in Valladolid, asking for a commission more agreeable to his talents.[20] Rubens was in Spain as head of a goodwill mission from the duke, bearing precious gifts – paintings and horses – for King Philip III and his powerful ministers. Various letters tell us of the vicissitudes of this journey, Rubens's first diplomatic mission (April to end of 1603).[21] One thing is certain: Rubens must have been deeply impressed by this first meeting with a king and with a royal collection. The pictures he painted here have a nobility and a freedom of brushwork which had not hitherto distinguished the ex-pupil of van Veen. Vincenzo Gonzaga also owned a considerable art collection.[22] His summer palace, the Palazzo del Tè, was built and decorated by Giulio Romano, whose Mannerist and dramatic art certainly found an echo in Rubens's early compositions, but contributed nothing either essentially new or out of step with the academic tradition.

In the short time before his Spanish journey Rubens had already produced a few remarkable paintings, the most important, surprisingly enough, not being for the Duke of Mantua. After what was probably a short stay in Florence,[23] Rubens spent the second half of 1601 in Rome, where he worked at three altar-pieces for S. Croce in Gerusalemme (now in the Hospital at Grasse; Rooses 444–6): a *St Helena*, an *Elevation of the Cross*, and a *Crowning with Thorns*. Rubens received the commission from Jean Richardot, the agent of the Archduke Albert. It is not clear whether Richardot had recommended the young painter, or whether Albert had already made his choice, when Rubens departed for Italy. The works were intended for the chapel of St Helena in S. Croce, which was the titular church of the Cardinal Archduke Albert. The *St Helena* is the most conventional of the three, with Classicist memories of Otto van Veen (and Raphael), and with playful angels that have all Parmigianino's elegance. The *Elevation of the Cross* is a somewhat insecure composition built up of elements which are uncoordinated and contradictory; powerful Michelangelesque movements peter out into

weakly Classicist, torpid figures. The *Crowning with Thorns*, on the other hand, is a really exciting piece of painting (Plate 56). It is true that some of the effects are borrowed from Bassano, but light and colour, types and composition are original and painted with great dramatic power. The Mannerist restlessness is permeated with personal feeling. The heads of the Roman soldiers are splendidly modelled. Light has a new function, that of making the colours gleam, and of helping to round the bodies. A preparatory drawing for this picture has survived (Brunswick), and it is thus among the earliest drawings which we have from Rubens's Italian period.[24] The *St Helena* was finished in January 1602. As early as 1614, however, the paintings were in a deplorable condition, and they required constant upkeep, restoration, and perhaps even re-painting.[25]

A few of the other works from Rubens's Italian stay have a Classicist Mannerism which connects them with this early commission, particularly the *Deposition* (Rome, Galleria Borghese, 411), and *Hercules and Omphale* (Paris) with the *Death of Adonis* (Amsterdam, P. de Boer) as its companion piece. These are closer to the *St Helena* than to the *Crowning with Thorns*, and one would be inclined, therefore, to put them in the first period of Rubens's stay in Italy. The cold Mannerism of Otto van Veen is stronger here than any Italian impressions.

Rubens left for Spain on 3 March 1603. About a year later he was back in Italy. The first news we have of him as a painter is that he had to restore and partly repaint the works which he had taken with him and which had suffered badly from rain and dampness. Instead of restoring two of those which were completely spoiled, he painted the *Heraclitus and Democritus* (Madrid 1680–1), a work which was much admired. He also copied portraits of Titian in the royal collections, and painted for the Duke of Lerma a series of twelve Apostles and the portrait of the duke on horseback. Heraclitus and Democritus are life-size, savage-looking in a bombastic way; the figures are squeezed into a long, narrow frame, and the brushwork is treated in a Venetian manner. The *Apostles* (Madrid 1646–57) are also life-size figures, thoroughly worked out and strikingly sculptural (Plate 94A). Some of the gestures are still rather mannered and cold, but the heads, with the hair thickly painted and reflecting the light and the deep-cut shadows, are realistic in a 'modern' way, like the portrait studies of his Roman period (e.g. Rome, Palazzo Corsini, 227), and already have the same power and assured touch as the Magi with their pages in the earliest Antwerp paintings (1609).[26] Baroque vivacity is now superseding the early academic, impersonal style.

The greatest surprise, however, is the equestrian portrait of the Duke of Lerma (Madrid, PP. Capuchinos de Castilla; Plate 57), particularly if we compare it with the court portraits painted by Frans Pourbus or Rubens himself shortly before (and perhaps even after) in Mantua. Oddly enough Spain, or rather the art of the Venetians Titian and Tintoretto, whose paintings he saw in the royal collection, freed Rubens from the strict international Spanish portrait style. He jettisoned the type of the traditional equestrian portrait in profile, though he later took it up again for official princely portraits. He places the viewpoint very deep and makes the rider pass us so that we see him almost from the front – a Mannerist trick, one might at first say. But by way of contrast to Mannerist rigidity and tautness we have here a presentation of 'iniquitante vitalità'.

Though the portrait itself is still circumscribed by Spanish etiquette, the head caught as it were in a stiff lace collar, the horse's movement breaks through the Mannerist barrier. The sensitive painting of the surface, the modelling with light and shade, and the openness of the background soften and expand the rational construction.

Italian sources tell us that Rubens was in Venice for a long period.[27] We do not know of any official commissions for or at Venice, but Rubens's interest in Venetian art was certainly stronger after his stay in Spain, and it was these impressions which caused memories of academic Late Mannerism to fade. Tintoretto, Bassano, and Paolo Veronese were more important for the development of Rubens's painterly and monumental style than the art of Titian, which he absorbed only much later. It is also notable that hitherto Rubens had only made pen sketches in preparation for his important commissions. From now on, apart from the sketch for the composition of the *Crowning with Thorns* already mentioned and studies of a few parts of bodies and heads intended for the *Raising of the Cross*,[28] like Tintoretto, he generally made coloured sketches for large altar-pieces. Sometimes they are *bozzetti*, first ideas, sometimes *modelli* for the approval of the people who had commissioned the picture. In the latter case they are the size of a cabinet painting. *The Adoration of the Magi* (formerly Polesden Lacy, Christopher Norris Collection) is such a *modello*, for which the relevant altar-piece has not been preserved or was never executed. It is a composition in the style of Veronese. The colour of this small painting is subtler in the gradations of shades than the occasionally somewhat faded palette of the Venetian decorator. Might the memory of some lost Ferrarese example have played a part in this? The heavy, dark colours against the fanning rays of light in the *Circumcision* painted for the high altar of S. Ambrogio, Genoa (Rooses 156; the oil sketch is in Vienna, Academy, 897; Plate 60) again remind us of Venice, but this time of Tintoretto, not Veronese.

Soon after Rubens got back from Spain, and so before the paintings in the Venetian style which we have just described, Vincenzo Gonzaga commissioned three large paintings from him. These were for the choir of SS. Trinità, which was dedicated on 5 June 1605. In the middle is *The Gonzaga Family in Adoration of the most Holy Trinity* (Mantua, Castello; Rooses 81), on the left *The Baptism of Christ* (Antwerp 707), and on the right *The Transfiguration* (Nancy; Plate 58). The main picture is badly damaged, for in the eighteenth century it was cut up, though the pieces have now been reassembled as far as possible. The ducal family – the men on the left, the women on the right – kneel on the terrace of their palace. Between a double line of columns a group of five angels (who look as if they had walked out of Tintoretto's *Miracle of St Mark*) hold on high a huge carpet upon which the Trinity is represented, an entirely new way of giving realistic expression to a spiritual concept. Everything Venice had to offer in the way of beauty of paint is here laid on with a firm brush in a mixture of colours. The princes in the first row are clad in golden yellow and white brocade and satin, painted with extraordinary verve. In the second row there are a few figures in dark colours. The muscular angels by contrast exhibit all the colours of the rainbow, but particularly red, yellow, and blue. Two fragments, a halberdier and a dog (Mantua, Palazzo Ducale, 140-1), give us another opportunity of studying the free brushwork of Rubens. Only the under-

painting, as it were, has been preserved of the *Baptism of Christ* (Antwerp). Because of this, borrowings from Michelangelo and Raphael are more obvious here (and in the *Transfiguration*) than must have been the case originally. But one can feel how the rays of light concentrate the restlessness of the painting into a great movement round the figure of Christ. Rubens made careful drawings for the portraits (Stockholm 1917-18). There is also a sketch of the composition of the *Baptism of Christ* (Paris, Louvre, cat. F. Lugt, 1009), and the other two scenes were probably prepared in the same way. The absence of oil sketches makes it likely that Rubens used this new technique only later, possibly after a stay in Venice.

For, or through the mediation of, Duke Vincenzo, Rubens was also occupied with other commissions. He made two copies after Correggio for the Emperor Rudolf II (1606), and several portraits for the ducal family. *A Martyrdom of St Ursula* (Mantua, Palazzo Ducale, 142) survives only in the form of a magnificent *bozzetto*, a work of intense vigour, powerful in its movement and its concentration by means of light.

As we saw, it is difficult to recognize the official portraits that Rubens painted during his first Italian period; the younger Frans Pourbus and he had an almost identical style, conforming to the international portrait type of the age. The first personal touches can be found in a group portrait of Rubens among his friends (Neustadt a.d.H., Abresch Collection), which was probably painted before the Spanish journey (and later re-touched by Rubens himself?). Spain brought liberation; the equestrian portrait of the Duke of Lerma marks the break with the past. The portrait group of the Gonzaga worshipping the Trinity, painted, as we saw, shortly after his return from Spain, shows that once he attained them, Rubens maintained his freedom of painterly form, his powerful touch, and the richness of his colours.

In Genoa a few years later (about 1606) Rubens again had a chance to paint a series of official portraits, chiefly of ladies of the Doria and Spinola families. They are among the most important of the early seventeenth century. The stiff Spanish costumes with their heavy embroidery could no longer stifle the imagination of the painter, and the mobility of the contours, the rustling magnificence of the draperies, and the new *mise-en-scène* of terrace or palace put an end to the international conformism of the Mannerist portrait type. The portrait of Catharina Grimaldi (Kingston Lacy, Ralph Bankes Collection; Plate 63) is the richest of the series. The servant pushes the curtain aside with a pugnacious gesture, and the sun's rays illuminate the rich background so that the sombrely clad princess emerges the more clearly from the painted surface. In Genoa too Rubens had another opportunity of painting the theme of the horseman, in a portrait of a member of the Doria family (Rome). This is still more moving, and in it the phlegm of the rider once again contrasts with the impetus of the horse.[29]

At the end of Rubens's stay in Italy he received two important commissions, which are connected; the *Adoration of the Shepherds* at Fermo and the high altar for S. Maria in Vallicella (the Chiesa Nuova) in Rome. The *Adoration of the Shepherds* at Fermo is another work in the Venetian style (Plate 59, A and B), but this time it was the art of Jacopo Bassano that inspired Rubens, who took over Bassano's colours and light and resolved them into a new unity.[30] Here is one more proof of Rubens's power to renew his art

by building upon tradition. He was never a revolutionary like Caravaggio, yet, though his painting in Italy was, as it were, carried along by certain tendencies, particularly Venetian ones, his style is extremely personal and modern – so modern indeed that there were difficulties, apparently, when the altar-piece for S. Maria in Vallicella came to be delivered.

From the end of November 1605 Rubens was once more in Rome. On 2 December 1606 he wrote to Mantua that he could not possibly come back at this moment when, in competition with Italian artists, he had secured the finest and most important job in all Rome, namely the painting of the principal altar of the Chiesa Nuova.[31] Six months later the altar-piece was ready (letter of 9 June 1607); only the image of the Virgin of Vallicella had still to be placed in the topmost section (Grenoble 557; Plate 61). The principal figure, St Gregory, stands in the middle under a Roman triumphal arch, with St Domitilla opposite him. The other saints, Maurus and Papianus, Nereus and Achilleus, are more in the background, the two last almost unrecognizable. Angels entwine a wreath of flowers round the image of the Madonna. Appearance and reality, static architecture and men under the stress of emotion are interwoven more closely than in the great canvas at Mantua. Rubens made a number of studies for this work – compositional drawings, detail studies, and oil sketches.[32] It is possible that the figure of the Virgin, a painting within the painting, was not intended from the first, for she covers the old, much-venerated image of the Virgin of Vallicella. The altar-piece is quite free from any direct borrowing from Italian art, and is the most personal work of Rubens that we possess from this period, a monument of early Baroque art characterized by lofty feeling, joyfulness, and decorative beauty. But it did not satisfy. Rubens himself blamed the lighting, which reflected the colours so unhappily that the whole was spoiled by it. The 'copy' which he had made on slate is an entirely different work – as he himself wrote. Were those who commissioned him not pleased with his first production?

The focus of the new work (Rome, S. Maria in Vallicella; Rooses 205, 442 bis, 443) is no longer St Gregory, but the adoration of the old image of the Virgin. Rubens was here recalling a composition by T. Zuccaro from the Gesù, in which angels and putti carry and adore the painting of the Madonna. The putti and angels in Rubens's picture, rosy and lively, have left Mannerism entirely behind; indeed, there was no other work in Rome (or in the Netherlands) at that moment which heralded so clearly and unmistakably the radiant glow of colour and the free movement of the Baroque. The three saints are painted in two separate scenes, fixed in the side walls of the choir. The figures at the right, now clearly recognizable as martyrs, look like Roman figures in togas – indeed one of them is exactly like a Roman statue which Rubens used in the same period to illustrate his brother Philips's *Electorum libri II.*[33] Though the new arrangement gained in iconographical purity, however, it lost the original unity of lively movement, Baroque feeling, and monumental architectural construction.

On 28 October 1608 Rubens wrote to the secretary of the Duke of Mantua: 'My work in Rome on the three great pictures for the Chiesa Nuova is finished, and, if I am not mistaken, it is the least unsuccessful work by my hand. However, I am leaving without unveiling it.' The reason for his hurried departure was the news of his mother's

illness, which obliged him to go to Antwerp – for a short time, as he declared – without the possibility of getting permission from the duke.[34] Rubens never saw Italy again.

RUBENS IN ANTWERP

In all probability Rubens was back in Antwerp before the end of 1608. He was still in Rome when, on 19 October, his mother died. It is likely that the thought of leaving the service of the Duke of Mantua and of returning home had been in his mind for some time, and that the news of his mother's illness was only a convenient excuse for putting an end to his engagement.[35] But, once returned, Rubens was again seized by the desire to settle permanently in Italy. Although he had received tempting offers to enter the service of the archduke, he felt little inclination to resume the life of a courtier.[36] However, a few months later, on 23 September 1609, the Archduke Albert and the Arch-duchess Isabella appointed him court painter with special permission to go on living in Antwerp and with full privileges as regards freedom from town taxes and exemption from all duties to the Guild. The same privileges had been previously accorded to Jan Brueghel, much to the annoyance of the Antwerp magistrates, who protested in vain against these exemptions. Three months earlier Rubens had been made a member of the Guild of Romanists, a society of artists and scholars who had lived in Italy. On 3 October 1609 he married Isabella Brant, and a year later bought a piece of land and a house on the Wapper. There, a little later, his studio and his dwelling were to be built. Rubens had indeed settled in Antwerp. The desire to return once more to Italy for a visit to friends in the South was never to be fulfilled.[37]

Rubens, then, was a court painter once more, but their Royal Highnesses did not waste their painter's time with commissions. In the course of the years he was asked to undertake many political tasks, which he apparently carried out to the full satisfaction of his patrons. He seems to have become increasingly Isabella's confidential adviser, par-ticularly after the death of her husband in 1621. He was also a favourite of Ambrogio Spinola, who had once more, from 1621, become the adviser of Isabella in the Nether-lands.

In 1602, commissioned by Albert, Rubens had painted the three altar-pieces of S. Croce in Gerusalemme (p. 73). Now, after his return to Antwerp, one of his first commissions was to paint the state portraits of their Highnesses.[38] But the important commissions came from the citizens of Antwerp and from the municipal and ecclesiastical authorities there. Rubens was much sought after as a painter even in those early years, so that it is not surprising that he got his pupils to work for him, and that his studio assumed industrial scale.[39] The city council of Antwerp ordered from him an *Adoration of the Magi* (Madrid 1638), a large picture which was hung in the same State Room of the town hall as Abraham Janssens's *Scaldis and Antwerpia* (Plate 36B). Rubens's composition is still entirely based upon his Venetian memories. The left part comes from the *Adoration* at Fermo, and a few details are familiar from early *modelli* (for example, those of the former Christopher Norris Collection). The triangular composition is

occupied by the procession of dignified Orientals accompanying the kings. The two slaves bend their muscular bodies under the load of gifts, and their movements correspond with the Virgin's gesture of presenting the Child. In 1612 the painting was presented by the municipality to the Spanish ambassador, Count Don Rodrigo Calderón, as being the gift 'the greatest and the most rare they had to offer'.[40] Fifteen years later, when it had come into the possession of Philip IV, Rubens considerably enlarged and added to the painting.[41] The changes do not spoil it at all, for Rubens carried out the later additions quite in his earlier Venetian spirit.[42] The marvellous sketch in Groningen gives us an idea of the dynamic light and colour of the original composition.[43]

The *Disputà* in the Pauluskerk in Antwerp (Rooses 376), nowadays unjustly neglected, is as rich in magnificent figures as the *Adoration*. Columns and pilasters frame the composition. The angels who carry the sacred books are just as graceful as the angels that venerated the effigy of the Virgin in S. Maria in Vallicella.[44]

The principal document for Rubens's early Antwerp style is the *Raising of the Cross* in Antwerp Cathedral (Rooses 225–85; Plate 65), which was originally placed on the high altar of St Walburgis, another church in Antwerp. We are well informed concerning the rapid completion of this great painting. The little known coloured sketch (Paris, Service de Récupération; Plate 64), entrancing in the apparently impulsive vehemence of the drawing, is an example of Rubens's pictorial powers equalled by few others of the same period. The first ideas appear to be set down with firm, mostly white touches. Yellow, red, and violet mark the main accents. Originally the sketch was meant for a picture without wings, but even with them the small triptych is still a unity. There are reminiscences of the Italian period, for example the old woman from the Fermo *Adoration* and the rider in striking foreshortening from the Lerma portrait. The actual altar-piece transposes the flying movement of the sketch into monumentality. The background scene of the stripping and crucifixion of the thieves was removed from the central panel, and all the attention is concentrated upon the Crucifixion of Christ. The strong modelling of the figures, the concentration of light, and the careful finishing off of the diagonal composition at each end are all characteristics of monumental Baroque art, which, consciously and carefully worked out, raise the altar-piece above the restless painting, the Venetian colours, and the impetuous movement of the sketch. On the outer wings are the four Saints Eligius and Walburga, Catherine and Amandus.[45]

Samson and Delilah (Cologne, G. Neuerburg Collection; Plate 66A), the *Massacre of the Innocents* (Brussels 682, as Sallaert),[46] *Juno and Argus* (Cologne 1040), *Prometheus* (Philadelphia), *Venus and Adonis* (Düsseldorf; Rooses 692), *Tarquinius and Lucretia* (Potsdam, Sanssouci, 89), and *Judith* (known to us only by the engraving of Cornelis Galle) are other equally important examples of Rubens's restless Baroque style in these years. Though the great figures are crowded together with almost frenzied power, the pictorial execution is more careful and thorough. Pale, almost polished flesh-tints emerge from luxuriant garments gleaming with warm red and violet. There is still a trace of the Venetian wealth of colour. The great panel pictures particularly, such as the *Samson*, are radiant and glowing; characteristic Rubens can be recognized in every detail.[47]

The transition from Rubens's 'Italian' phase to his Antwerp style is so gradual that it

is often difficult to draw a dividing line between paintings made in the North and those produced in Italy. Compositions which Rubens loved, such as the Fermo *Adoration*, he repeated in Antwerp (Pauluskerk; Rooses 154).[48] *The Brazen Serpent* (London, Count Antoine Seilern Collection, cat. no. 15), almost certainly painted in Antwerp, uses figure studies after Michelangelo; the great composition of the *Holy Family with a Dove* (Plate 66B) is built on a composition by Borgianni, but pathos, movement, brilliant colours, and vigour of brushwork have made both such personal creations of Rubens that only a careful analysis can detect the foreign models.

A sensitive contemporary must have found Rubens's painting almost unbearably daring and bewildering. Accustomed as he must have been to the limp Classicism of Otto van Veen or to that of Abraham Janssens, satisfying but cool, he could hardly have accepted Rubens without a certain hesitation. Nor was Jan Brueghel's graceful *Kunstkammer* style any preparation for the pathos of Rubens's Baroque. But there were other paintings of his which show him continuing the classical tradition, indeed fulfilling it. This 'calm style' was particularly suitable for book illustration. In the years 1612 to 1614 Rubens made new designs for the *Breviarium* and the *Missale Romanum* for Balthasar Moretus (Rooses 1250–62). Many of the compositions – the *Annunciation*, the *Adoration of the Shepherds*, the *Resurrection*, *All Saints* – are used again in his paintings, or in sketches for them. Balance and clarity in spite of movement and liveliness are the characteristics of the sharply drawn figures. In the large *Annunciation* in Vienna, probably of about 1609, the magnificent swirl of draperies is accompanied by a restrained harmony of beautiful forms in the figures of the Angel and the Virgin. The *Annunciation* in Dublin (Rooses 144), which was probably painted later than the engraving, is another example of noble clarity, of classic art. The *Raising of Christ* above the monument of Jan Moretus (Antwerp Cathedral), which is an exact replica of the same subject in the *Breviarium*, has a classical air, an impression that is strengthened by the two saints on opposite sides and the angels on the outer panels, which are reminiscent of antique statues.[49]

Today the visitor to Antwerp has the best chance of taking in the two phases, or better the two sides, of Rubens's art by going to the cathedral, where the *Descent from the Cross* of 1611–14 (Rooses 307–10) is the classical counterpart to the passionate Baroque of the *Elevation of the Cross*. The composition, in one plane and contained within a trapeze shape, maintains its balance by means of a gentle rise and fall.[50] Among the biblical scenes it is the *Tribute Money* (San Francisco, M. H. de Young Memorial Museum) with demi-figures which reflects the classical tradition most clearly (Plate 68A). Gesture and expression are well thought-out and welded together without weakening the narrative tension. The 'antique' wall in the background reveals the return to wisdom. *St Teresa's Vision of the Dove* (W. J. Roach Collection) is another example of the marvellous purity of Rubens's art. The dove, carefully placed in the opening of the classical portico, has the same powerful reality as the white kneeling figure in her long mantle of unbleached wool.[51]

Rubens seldom signed and dated his paintings, but just at this period, in 1613–14, he produced some six paintings all of which have his signature and a date.[52] Did he perhaps devote special attention to these paintings, characterized as they are by classic clarity and

purity? A copy after Parmigianino (Schleissheim; Rooses III, p. 69) was also recast in the
new spirit, and the *Flight into Egypt* (Kassel 87) is reminiscent of Elsheimer in its har-
mony and purity of form. The various compositions for the *Deposition* painted in these
years are eloquent witness to the preoccupation of the artist with the beauty of form in
movement. The big works in Antwerp and Leningrad (Rooses 312) are rather cool;
the *Deposition* after Caravaggio (Ottawa; Rooses 323) achieves harmony because of the
flowing movement and the warm light. Rubens did not take over the pathetic gesture of
the Magdalen, which in Caravaggio's original accentuated the Baroque effect. In the
Deposition at Lille (Rooses 311) the inner emotion is given expression by a great number
of falling movements in a canvas almost Gothic in its narrowness, and the static element
has entirely disappeared. The *modello* in the Seilern Collection (catalogue 23) shows a
deliberate departure from the cool balance of earlier representations; beneath the double
row of inclined heads Christ slips down into the lap of Nicodemus. There are sketched
figures here and in the picture at Lille which we recognize from the first Antwerp years;
some elements indeed go back to Rubens's Italian training. But undoubtedly these
productions of the second half of the second decade were created when a phase of
classic repose had superseded the earlier Baroque fury.

We can best study Rubens as a portrait painter during this period in the portraits of
Nicolaes Rockox and Adriana Perez on the wings of the triptych of *The Incredulity of
St Thomas* (Antwerp 307), commissioned by the sitters in 1613. The pale plasticity of
these portraits links them with Rubens's official portraits of the Archduke and Arch-
duchess, made some four years earlier. At that time a rigid Classicism with smooth
colours and few Mannerist ornaments was the height of fashion for portraits in the
Southern Netherlands, but we can see from the double portrait of Rubens himself and
his young wife, Isabella Brant (Munich 334; Plate 80), probably painted soon after their
marriage in 1610, what liveliness and feeling can be developed in a portrait group even
in this style. Remnants of Mannerist charm are still discernible beneath the ornamental
arrangement, but the portrait is full of a candour and a joy in living of which Mannerism
was incapable. A little later, and therefore rather cooler, though still lively, is the beauti-
ful head and shoulders of a boy at Kassel (89). The idealized portrait of the Emperor
Augustus (1619, Berlin, Castle Grunewald; Rooses 891) is the last in the series to remain
within the academic tradition and the first of the Roman portraits commissioned from
various artists by the Dutch Stadholder Frederik Hendrik. This princely collector had a
special predilection for Rubens's works in a classical or Classicist style.[53]

About 1620 Rubens's Classicism becomes less rigid, the flesh achieves a warm glow,
and light is allowed to play over the forms. The rigid lines lose their distinctness and
begin to intertwine. This delicate painting is first found mostly in the small cabinet
pictures, sometimes made in collaboration with Jan Brueghel. The almost transparent
group of *Adam and Eve in Paradise* by Jan Brueghel (The Hague 253; Plate 44A) is a mar-
vellously beautiful example of this new style. In spite of the careful symmetrical com-
position, the *Virgin with the Garland of Flowers* (Munich 331) remains delightfully play-
ful. The *Madonna with Angels* (Paris 2078) is still more informal, and still more loosely
composed. In the *Perseus and Andromeda* (Leningrad; Rooses 666; Plate 68B), Rubens

applied to a composition with large figures all the charm of gliding curves and delicate colours which he had so far reserved for small cabinet pieces.

The ten years from 1610 to 1620, though the most Classicist in Rubens's work, are also rich in creations distinguished by their *élan* and power. About 1615 a cycle of hunting scenes (New York, Rooses 82–3; Munich 4797; Marseilles; Rennes; Plate 146A) was begun, and many were sold immediately.⁵⁴ *The Hippopotamus Hunt* (Munich 4797) and *Wild Boar Hunt* (Marseilles 914), with their concentration of action and their massive forms, are exciting examples of Baroque composition. But here too each form, each colour, finds its proper place through just distribution and restraint of gesture. The diagonal of the composition is never broken by a true Baroque curve. The powers of arrangement that derive from Roman-Classicist training have won the day against the free play of imagination. In both *The Defeat of Sennacherib* (Munich 326) and its companion *The Conversion of St Paul* (London, Count Antoine Seilern Collection, cat. 21), the themes of blinding and of spiritual confusion are depicted. Dominant in the composition of the *Sennacherib* are two horses with their riders and a crowd of warriors. In the other composition the principal motif is an S-curve formed by rearing horses, repeated in the movements of the other figures. The elements of drama and restlessness are tempered by the warm colours, which recall the Venetians and Adam Elsheimer.

The Count Palatine Wolfgang Wilhelm, who had already ordered two hunting scenes from Rubens, in 1615 commissioned him to paint *The Last Judgement* (the so-called 'Great Last Judgement') for the high altar of the Jesuit church in Neuburg (Munich 890). No one who had lived in Rome could ignore Michelangelo's example; but the language of gesture which Rubens took over from the Italian he uses chiefly to make a purer and more transparent pattern of the groups of the blessed ascending to heaven and the falling damned. In the greenish-blue shadows on the bodies and the red reflection of the fires of hell there is a play of colour comparable to that of the early Antwerp altar-pieces.

Towards the end of the second decade gradations of colour became more delicate and the colours themselves lighter. The *Rape of the Daughters of Leucippus* (Munich 321; Plate 69) and the *Battle of the Amazons* (Munich 324) already have lighter transparent tints alongside the steady brown and green grounds. *Christ and the Four Penitents* (Munich 329) also has pure, light colours, and the forms are lovingly treated, while sensitively painted light plays round the group. We know that van Dyck was working in Rubens's studio during these years, when the execution of another composition of the same subject (Kassel 119) was entrusted to him. This gentle and sensitive group of scenes from the Passion must have made a deep impression upon van Dyck, and it was from this source that he assimilated Rubens's art (p. 113).

A work which seems to unite all the richness and warmth of emotion that belongs to this period is *The Last Communion of St Francis* (Antwerp 305), painted in 1619 for an altar of the Church of the Recollects at Antwerp and commissioned by Jasper Charles (Plate 75). Never before had Rubens so skilfully established a group of figures in relation to one another. The little acolyte takes up the diagonal movement of the arm of the dying man and of the brother who supports him and leads it back to the priest who is

administering the Viaticum. Other diagonal lines of light and movement cross the first inconspicuously. The links of community and devotion pass from one to another. Putti above the group break the strict articulation where the lifted altar curtain again takes up the diagonal of the bowed figure of the priest. Rubens had never before dared put into a picture this tempered golden-brown tone, with its rich gradations against the bluish grey colour of the body of the saint.

ENGRAVINGS, DRAWINGS, AND SKETCHES; THE RUBENS STUDIO

There are more than seven hundred seventeenth-century engravings based upon Rubens's compositions. He never himself etched or engraved,[55] but in the course of years he employed a number of engravers, who were obliged to carry out their work in the most careful accordance with his instructions. He was always trying to find or to train the ideal interpreter for his compositions, distrusting well-known and famous artists, who had their own style and personal views. In 1619 he wrote to Pieter van Veen, Pensionary of Leiden: 'I would rather have the work done in my presence by a well-intentioned young man, than by great artists according to their fancy'.[56] The young man he then engaged was Lucas Vorsterman, who carried out not less than fourteen engravings after Rubens's works in the years 1620 and 1621. Before his time it was mostly Cornelis Galle and a few Dutchmen, such as Willem Swanenburgh and Jan Muller, who worked for, or rather after, Rubens.

The engraving of the so-called 'Great Judith',[57] supposed to be among the first engravings after Rubens's compositions, is by Galle. It is undated, but has a long Latin inscription. This first engraving after a work of Rubens is dedicated to 'clarissimo et amicissimo viro Johannes Woverius' in compliance with a promise made in Verona, probably at the beginning of July 1602, when Rubens was staying there with his brother Philips and Jan Wouver. Was Rubens already thinking of drawing for engraving at that time? It would not be surprising; for a great deal of the work of his master van Veen consists of 'inventions' intended for engravings. There are also a few drawings from Rubens's Italian period, which may have been intended as preparatory studies for engravings.[58] We cannot be sure about this, but we do know that the illustrations for his brother's book *Electorum Libri II* were carried out after drawings by Peter Paul. These drawings must have been made at the very latest in about 1607. Philips took them to Antwerp, where the book came out the following year. Rubens kept a second set for himself; the saints on the right in the choir of S. Maria in Vallicella owe their dignity to the Roman statue which Rubens had drawn for his brother (p. 77).

There is thus some reason to suppose that even in Italy Rubens was thinking about having his work engraved, but it was only when he settled in Antwerp that he began regularly and systematically to compose and draw for this purpose. An element in this was his close lifelong friendship with the publisher Balthasar Moretus (1574–1641), who since 1610, together with his brother Jan II, had owned the Officina Plantiniana.[59] 'Vrayement,' wrote Moretus to the Chaplain of Marie de' Medici after the death of

Rubens, 'nostre ville a beaucoup perdu par la mort de Monsr Rubens, et moy au par-ticulier un de mes meileurs amis.'[60] The *Electorum Libri II* of Philips Rubens had appeared in the Officina Plantiniana in 1608, and Rubens drew for Balthasar Moretus the illus-trations for the *Missale* and *Breviarium Romanum*, which have already been mentioned (p. 80). Balthasar Moretus had known the painter as a schoolboy. The friendship was fostered by the admiration of both for antiquity, and the belief of both in 'Christian humanism'. Moretus composed a stylishly erudite epitaph for Rubens's brother Philips (d. 1611). Rubens worked for Moretus till 1637 or 1638, making vignettes and designs for title pages. After that Erasmus Quellinus took over this task, drawing the pages after Rubens's 'inventions'. The sums received by Rubens for his work were and remained modest; in 1613–14 it was not more than twenty florins for a folio page and eight for an octavo edition. The engraver got four times as much! Nevertheless, the account in-creased nicely, and was paid by Moretus in books from his publishing house. Letters have been preserved which tell us about this pleasant collaboration: in 1630 Moretus gives the following account of Rubens's method of work. 'The painter generally needs three months for a composition. It is the practice to warn the painter six months beforehand, "pour lui laisser le temps de réfléchir à la composition d'un titre et pour qu'il exécute avec tout le loisir voulu et cela les jours féris, car les jours ouvrables il ne s'occupe pas de pareils travaux ou bien pour un seul dessin il demanderait cent florins".' [61] In general, Rubens confined himself to drawings for the title pages of scientific, historical, and theological books. Placed side by side, the title pages give us an exciting picture of his talent for personifying abstract wisdom or for Christian symbolism. The dates of the editions, too, give us a welcome check upon the chronology of Rubens's work established on stylistic grounds.[62] Rubens worked as a book illustrator and designer of title pages exclusively for the Plantin Press. The illustrations of the *Pompa Introitus* (see p. 102), which was published by Jan van Meurs, were probably not made directly from drawings by Rubens; the sketches which have been preserved are the designs for the decorations themselves, which were then redrawn by another hand for the engravings. Jan van Meurs, for whom Rubens also designed a printer's trade-mark, was a partner from 1618 to 1629 in the Officina Plantiniana.

Rubens watched carefully over the execution of engravings after his designs, and him-self retouched many proofs (for which there was a special account in the books of the printing press).[63] The engravers who made prints of Rubens's painted compositions were also obliged, of course, to submit to his control. The preparatory drawing was generally made by the engraver himself. Rubens then improved it, or the proof.[64] In later years, for book-titles [65] as well as for other works, grisailles by Rubens himself sometimes took the place of the preparatory drawing. An excellent example, with the tone values carefully laid down, to the correct measurements, and intended specifically for this purpose, is the *Carrying of the Cross* in the M. Q. Morris Collection, engraved by Paulus Pontius in 1632. The composition is the same as that of the picture Rubens painted a few years later for the abbey of Afflighem (Brussels Museum).[66]

In Rubens's last years the wood-engraver Christoffel Jeghers worked for him. His most important production is *The Garden of Love*, engraved on two blocks. Jeghers's

preparatory drawing for this is so beautiful that ever since Crozat owned it in the eighteenth century it has been accepted as Rubens's own work. He did indeed retouch it, and also the first proof of the woodcut, with the result that the woodcut really expresses Rubens's intentions. The composition is known from the fine painting of 1631 at Madrid (1690).[67]

To Rubens the single painting, destined by the nature of the commission for a certain place, was not an independent work. Its composition was generally bound up with earlier and later creations relating to the same subject, or with works whose stylistic forms dealt with the same pictorial problems. Earlier studies gain a new significance and a new function with a new task: the figure of the naked man, which has an important place in the preparatory study for the *Baptism of Christ* (for Mantua), is not in the painting in its final form, but has its place as a St Sebastian in the sketch for *All Saints*.[68] Thus, in spite of all the accidents of commissions, Rubens's work achieved an extraordinary unity. This feeling for the unity of his work and for the importance of what he had already done is probably the principal reason why he chose to have paintings recorded in the form of engravings. The invention was always his, though his work on canvas and on panels was reproduced on paper by other hands.

The engravings needed another kind of protection, however. Without special privilege or patent anyone was free to reproduce his prints. Apart from the financial loss, he was also exposed to an irresponsible and unchecked plagiarism. Rubens went to a great deal of trouble to obtain protection. On 3 July 1619 he received sole rights from the French king for ten years, and less than a month later a similar authority for the dukedom of Brabant from Albert and Isabella. This was soon enlarged to include the whole territory of the Southern Netherlands. Even the States General of the Northern Netherlands protected his prints for seven years, starting on 24 February 1620, just when the truce was expiring; but the intervention of Sir Dudley Carleton, the English diplomatist and friend of Rubens (see p. 71) then at The Hague, was necessary to get the privilege, which had been refused at first. A letter of 23 January 1619 to Pieter van Veen is an important document, because it lists the works which Rubens had had engraved or was proposing to engrave.[69] Later on privileges were granted by Philip IV, who protected his creations until 1656, after Rubens's death. The renewal of the privileges was sometimes a hard task in which, as we saw, Rubens's friends abroad often had to help. There were difficulties later too: the break between France and Spain threatened in 1635 to annul the French privilege, but Rubens was able to point out, in a letter to Peiresc, that even 'gli stati delle Provincie Uniti mi fanno osservare gli lor Privileggi inviolabte in tempo di guerra aperta'.[70]

The engravers were not the only collaborators in Rubens's business; he also needed assistants who could paint under his direction. As Rubens, in his capacity as court painter, was free of any duties to the Guild, he did not have to declare his pupils. We therefore possess no list of them or his assistants, but from observation of his work there can be no doubt that early in the Antwerp period Rubens was already working with the help of an 'atelier', and indeed must have consciously organized this as a business. Dr Sperling, who visited Rubens in 1621, saw in a room of his house 'many young painters,

who all worked at different pieces, which had been drawn in with chalk by Rubens'.[71] Already on 11 May 1611 Rubens wrote to de Bie that he could take no more pupils, indeed, that he had already had to refuse some.[72] These stories are confirmed by two of his biographers, Joachim von Sandrart and Roger de Piles, but the most convincing testimony is that given by Rubens himself in his correspondence with Sir Dudley Carleton. 'The list of pictures which are in my house' which accompanied the letter of 28 April 1618 describes, apart from 'originals the whole by my hand' and others, sometimes with additions by a well-known specialist (for example Snyders for the eagle of Prometheus) or of an unnamed 'master skilful in that genre' (i.e. landscape painting), works by pupils after examples done by the master, which if necessary 'would be entirely retouched by my own hand, and by this means will pass as original'. Of the twenty-four works offered there were only five which were entirely painted by Rubens. The remainder were begun by pupils, or copied by them from originals. Carleton, however, did not want these studio products as part of his exchange transaction, even though they might be partly from 'the best of Rubens's pupils' and entirely retouched by the artist's own hand.[73] The year after there was a complaint about a hunting scene delivered by Rubens to the King of England, concerning which English advisers asserted that the work was 'scarce touched by his own hand'. Rubens took it back and replaced it with a new piece 'toute de ma main propre sans aucune meslange de l'ouvrage d'autruy'.[74] In Rubens's correspondence – the most authentic source we have – we continually come across references to pupils, and in contracts with church administrations and with princes there are demands for work by Rubens himself or requests for permission to carry out the job with the help of pupils.[75]

In his last years Rubens was often content with making sketches for the great decorative works (Torre de la Parada and the decorations for the Entry of the Cardinal Infante in 1634), while the actual execution was in the hands of a team of assistants (p. 103). There was work by pupils in Rubens's studio in all stages of completion. An Englishman remembered once having seen in Rubens's studio a view of the Escorial, which he sought to acquire. Rubens had to reply that the work in question was by 'un peintre des plus commun de ceste ville après un mien dessein'. However, he finally touched up the work and sent it.[76]

Rubens's style spread all over Europe, not only through the limited number of the master's own paintings, but also through the many engravings after his work and the mass production of the studio, which retained not only Rubens's ideas, but sometimes – after touching up – even a good deal of his personal power of expression.

Now a word must be said about Rubens's sketches and drawings. He often spoke of a 'dissegno colorito',[77] and in the contract with Father Jacques Tirinus the designs for the ceiling paintings for the Jesuit church were described as 'the drawing in small' or 'small drawings'.[78] In both cases we know that this meant small oil sketches. During his stay in Italy Rubens had ceased to make drawings in preparation for his big altar-pieces, and began to paint swift colour sketches instead. He possessed the rare gift of being able to visualize a subject, however big, straightaway in colour. These 'first thoughts' were either shown to patrons as they stood or given to pupils to be painted to their final size.

Such sketches have long been sought by collectors,[79] for they are the most intimate, the most personal, and the most immediate expressions of the artist. Roger de Piles writes enthusiastically about Rubens's sketches: 'On voit presqu'autant de petits tableaux de sa main qu'il en a fait de grands, dont ils sont les premières pensées, & les esquisses; & de ces esquisses, il y en a de fort légères & d'autres assez finies, selon qu'il possédoit plus ou moins ce qu'il avoit à faire, ou qu'il étoit en humeur de travailler. Il y en a même qui lui servoient comme d'original, & où il avoit étudié d'après nature les objects qu'il devoit représenter dans le grand ouvrage, où il changeoit seulement selon qu'il le trouvoit à propos.' [80]

There are, as de Piles had already noticed, two sorts of sketches: quickly painted small works, mostly in one colour only, with some white highlights, which interpreted the painter's first thoughts; and detailed colour sketches, which his assistants could follow. According to the commission, there were variations and stages. Designs for tapestries, for example, required a final sketch to the actual size, generally done by studio assistants with corrections by Rubens. The patrons would receive sometimes the first series of sketches to choose from, sometimes the second, and sometimes both.[81] It is not possible to draw a sharp distinction between *bozzetto* and *modello*.

Compositional drawings were rare with an artist who thought and worked in colour (Plate 72B). The exceptions we know of generally have a special reason. There are, for example, the drawings for the engravers; Rubens's designs for title pages; and the drawings made by the engravers and corrected by Rubens himself. But even this kind of work was in later years sometimes prepared by painted grisailles (see p. 84). Most of Rubens's drawings, however, are figure studies and portrait sketches, the latter sometimes as detailed and complete as a painting. The figure studies were generally produced while Rubens was busy turning an oil sketch into a full-scale work, the models posing in the attitudes demanded by the composition. There were, particularly in the early days, a few standard attitudes of kneeling and bent figures, and these were used in successive years on various occasions (Plate 72A).[82] There were also study sheets after Italian examples, to which Rubens was always turning for ideas.[83] The drawings, most of them in black and red chalk, have their own aesthetic value, particularly in their sensitive contours, their firm structure, and their magnificent design. The series of studies for the painting *The Garden of Love* are among the great works of seventeenth-century drawing (Amsterdam, Fodor Museum; Plate 73). Rubens's drawings have always been sought after. As sensitive a connoisseur as Mariette wrote in the foreword of the Crozat catalogue: 'Le beau génie de Rubens et sa parfaite intelligence se manifestent pour le moins autant dans ses desseins que dans ses tableaux. Dans ses plus légères esquisses, ce grand maître met une âme et un esprit, qui dénotent la rapidité avec laquelle il concevoit et exécutoit ses pensées. Mais lorsqu'il les met au net, alors, sans rien perdre de cet esprit, qui devient seulement plus réglé, il y ajoute tout ce qu'un homme, qui possédoit dans un éminent degré les différentes parties de la peinture, et singulièrement celle du clair obscur, étoit capable d'imaginer pour en faire des ouvrages accomplis.' [84]

The Great Commissions of the Twenties

The Decoration of the Jesuit Church and the Medici Cycle

Without the help of a well-organized studio Rubens would never have been able to accept the series of big commissions which arrived year in year out, and bring them to completion. Shortly after he settled in Antwerp he painted *The Elevation of the Cross*, *The Descent from the Cross*, and *The Adoration of the Magi* (all three for Antwerp), apart from many small pieces. For St Omer he painted a *Descent from the Cross*, an altarpiece with *Job* and an *Ascension* for Brussels, and a triptych with the *Adoration of the Shepherds* and another with the *Miraculous Draught of Fishes* for Malines, to mention only the most important works of the second decade. There were many more, as we have seen: the hunting pieces and the *Last Judgement* for the Count Palatine Wolfgang Wilhelm, the many mythological paintings, and the portraits. In April 1618 there were twenty-four paintings ready at the studio to be handed over to Sir Dudley Carleton. A document of 1619 lists eighteen compositions which Rubens wanted engraved (p. 85). The paintings for them had probably been finished only shortly before.

In a letter of 12 May 1618 Rubens speaks in passing of cartoons for tapestries ordered by Genoese noblemen; the tapestries, he says, are now being woven. This is the series of six scenes from the history of Decius Mus (Vaduz, Liechtenstein Gallery; Rooses 708–14). After the illustrations for the *Breviarium* and the *Missale Romanum*, it is the first big series commissioned from Rubens. The scene of the death of the Consul (Plate 67) is closely related to the *Defeat of Sennacherib* (Munich). The composition was inspired by the struggle round the flag in Leonardo's *Battle of Anghiari*, which Rubens had once copied.[85] Compared with the sketch for the *Sennacherib*, this shows greater concentration and clarity of arrangement. The principal group is brought to the front, and the bustle of the horsemen on both sides is indicated by the use of only a few figures. Other scenes from the series, partly because of their subject matter, are quieter and simpler in design. The cycle unites the classic clarity of Rubens's mythological scenes with the dramatic power of the hunting pieces. The execution of the Liechtenstein series is closely related to the art of van Dyck. In 1661 the paintings were being sold in Antwerp as van Dycks, and as van Dycks they must have been known in Italy, for Bellori describes them as such without even mentioning Rubens's name. There is no doubt that van Dyck helped to paint the panels, but it is difficult to accept that he originated the compositions.[86]

Among the works which were ready for the engravers in January 1619 were *The Miracles of St Ignatius* and *The Miracles of St Francis Xavier*. These were undoubtedly the paintings for the high altar of the Jesuit church in Antwerp [87] (Vienna inv. 517, 519, 528, 530). Rubens often worked for the Jesuits, both in Italy and in the Netherlands.[88] The church of St Charles Borromeo in Antwerp was built in the years 1615 to 1621. It has been suggested that Rubens had something to do with the design of the building. This is certainly untrue; but, on the other hand, the decoration inside and out on the west façade

looks as though it had come from a painter's brain; it is Rubens-like.[89] However, Rubens was busy in the same years with the preparation of the *Palazzi di Genova* (which appeared in 1622), a collection of ground plans and façades. The citizens of Antwerp could profit from these examples, for their buildings were mostly private houses. In the preface Rubens says 'the delightful churches of the Jesuits in Brussels and Antwerp, decorated with paintings, are examples of correct proportions in accordance with the rules of the old Greeks and Romans'.[90]

On 29 March 1620, after the big altar-pieces had been delivered, Rubens signed a contract with Father Tirinus, Prior of the Sodality, by which the painter was to make thirty-nine ceiling paintings for the aisles and galleries. Everything was to be finished by the end of the year. Van Dyck and other pupils could be used for the execution of the work, but the sketches must be made by Rubens himself; the painter did not need to hand these over to the church, provided he gave it yet another altar-piece.[91] The programme was carefully worked out by the Jesuits; following traditional usage, Old Testament stories were put alongside New Testament scenes, as their prefigurations. While the work was being done, however, certain subjects were changed. All these paintings were destroyed by fire in 1718, but we possess drawings of them made by Jacob de Wit and engravings by J. Punt, and in addition many of Rubens's own sketches. For some (originally for all?) subjects there are two or more designs, one brown in brown, being the painter's first idea, and one or two in colours as *modelli* for the pupil who was to do the work.

If we try to imagine what the total effect must have been, we may think of the festive decorations of Veronese and the more personal ones of Tintoretto; indeed, the compositions of both masters can be recognized even to the details (p. 101). The striking *di sotto in sù* is Venetian in origin. Titian's ceiling in S. Maria della Salute, copied by Rubens (Glück-Haberditzl no. 2), is another source of inspiration. But the impression of spontaneity is so strong that we can only assume that Rubens must have set down, rapidly and with absolute certainty, the compositions he had in his head, without any previous studies. Apart from the known iconographic schemes, there are new ideas dictated by Rubens's own imagination (Plate 76, A and B). The warm colours, the light brushwork, and the bluish shadows flow together into a delicious harmony of colour; it is difficult to imagine how this tender colouring and firm brushwork can have been transferred to great church decoration. Rubens no longer needed to prepare for his big paintings by drawings; he created them in colour straightaway. The two altar-pieces already mentioned were prepared by such colour sketches, and only a few figures were carefully drawn from the model in the pose which would be needed. The difference between sketch and painting (Plate 74) consists mostly in the greater clarity and movement of the latter as against the more flowing interaction of colour and form in the first oil sketch.

On 12 September 1621 the church was dedicated by Johannes Malderus, Bishop of Antwerp. Apart from the thirty-nine ceiling paintings, Rubens had designed the high altar and supplied two paintings, which could be exhibited front and back in turn. His *Return from Egypt* was placed at the east end of the south aisle under the gallery, and for

this painting Nicolaes Rockox appeared to be the donor.[92] It is not known where the two paintings of St Ignatius and of St Francis Xavier were placed. The Lady Chapel was not ready at the dedication, but it was entirely decorated after Rubens's designs, including the altar-piece, an *Assumption of the Virgin* (Vienna inv. 518). Rubens had never had a commission of such magnitude; but to him the size of a task was in itself a challenge to master it. The day after the dedication the artist wrote as follows to William Trumbull, an agent of Charles I: 'Quant à S. Majesté et son A. Monsr le Prince de Galles, je seray tousjours bien ayse de recevoir l'honneur de leurs commandemens, et touchant la sale au nouveau palays je confesse d'estre par un instinct naturel plus propre à faire des ouvrages bien grandes que des petites curiositez. Chacun a sa grâce; mon talent esttel que jamais entreprise encore quelle fust desmesurée en quantité et diversité de suggets a surmonté mon courage.' [93] The 'new palace' was the Banqueting House in Whitehall, which had been rebuilt by Inigo Jones after a fire in January 1619. The commission which Rubens desired materialized only much later.

Meanwhile in Paris plans had matured to entrust another enormous project to Rubens: the painting of two long galleries in the new Luxembourg Palace (Rooses 730–54). Claude Fabri de Pereisc already referred to this commission in a letter to Rubens of December 1621. At the beginning of the following year Rubens was in Paris to negotiate with the Queen Mother and her advisers. One of the two galleries was to be decorated with paintings glorifying Henri IV, her husband, who had died in 1610. The other was to be a tribute to her own rise and reign. On 9 May 1622 Rubens, who had meanwhile returned to Antwerp, sent a 'plan', and a year later he went to Paris with nine large pictures. The contract had stipulated that Rubens might carry out the work in Antwerp, but that when the first part of the paintings was done he was to bring them to Paris. From the beginning of February to June 1625 Rubens was again in Paris to deliver the rest and to finish them off on the spot. The Court had asked him to speed the work because everything had to be ready in time for the marriage of Marie de' Medici's daughter, Henrietta Maria, to Charles I of England. Rubens was present at the celebrations, and one of his letters contains a lively description of an accident during the service. Preparatory studies for this immense labour exist – two series of oil sketches (in Leningrad and Munich), a few drawings, and a few more sketches. The sketches in Leningrad are probably the *bozzetti* which were sent to Paris for approval in May 1622. The other *modelli* are direct prototypes for the big canvases at which Rubens worked with his pupils.

The glorification of the lives of a king and queen, within the framework of the world of ancient gods and adorned with Christian symbols, was a new challenge for the artist, and this perhaps explains the necessity he felt to put the first fleeting ideas for the compositions on paper in the form of drawings; thus they did not in this case come spontaneously from the artist's imagination. Nevertheless, the oil sketches are fine examples of Rubens's gift of using a few colours – whitish-yellow, pink, red, and grey – to turn commonplace stories and dry allegories into exciting paintings of mythological symbols: Mercury leading Marie to the temple of peace; Innocence placing her hand protectively on Marie's arm (one thinks of the Christian parallel of the Virgin on the steps of the temple); the stately figure of Peace putting out the torch of war, while the accoutre-

ments of battle lie abandoned at her feet, and Envy, Anger, and Suspicion fly at her in vain. The turmoil of war, with conflagrations and lowering clouds, forms a sinister contrast to the grace and stateliness of the Greek temple containing the statue of Peace (Plate 77). In each scene both ancient gods and Christian symbols accompany the queen: the three Graces and Apollo guard her education, while the group of Marie and Pallas Athene recalls the composition of an Education of the Virgin. In another scene, while Fame blows the clarion call, Marie leaves the ceremonial barge, which is being moored by three Naiads and two water gods; France, under a canopy worthy of a pope, invites Marie to enter the town of Marseilles. History and allegory alternate, or meet in one and the same scene. The marriage by proxy in Florence in the presence of the Grand Duke Ferdinand of Tuscany is almost entirely historical (though the allegorical figure of Hymen is present); the marriage itself, celebrated at Lyons, is an allegory, or a travesty: the Lady Lyons in a chariot drawn by lions gazes up towards the young pair like Jupiter and Juno on the clouds. The putti with burning torches look very much like their Christian brothers and sisters who might accompany a Triumph of the Church.

For centuries the Medici cycle maintained Rubens's fame in foreign lands.[94] For artists and theorists of the seventeenth and eighteenth centuries the gallery, and the paintings in the collection of the Duke of Richelieu, another ardent collector of Rubens's works, were the supreme monument to Rubens's style. Neither tardiness in payment nor criticism and envy in influential circles could temper Rubens's creative drive and joy. The queen, indeed, full of faith in the artist, had discounted every imputation preferred against him. It was as if with this commission the whole world was at his feet. He was now not only Court painter to their Highnesses the Archduke and Archduchess, and the leading painter of a leading city in the Netherlands, but commissions came to him from all parts of Europe. Collectors and amateurs visited his collection. Antiquaries and classical scholars asked his advice. 'Je suis,' wrote Rubens on 10 January 1625, before the ceremonial opening of the Medici Gallery, 'l'homme le plus occupé et oppressé.' [95]

The second Medici Gallery, which dealt with stories from the life of a great monarch, Henri IV, was to surpass the first. 'Al mio giudicio secondo la qualità del soggietto riuscirà più superba che la prima de maniera che spero chandaremo più tosto crescendo che calando,' wrote Rubens on 27 January 1628, when he was busy with the first sketches.[96] 'La qualità del soggietto' is naturally the absence of all allegorical ballast. A few big pieces, such as The Triumph of the King, were almost ready in October 1630. The two great scenes, The Triumph and The Battle of Ivry (Florence, Uffizi), bear witness to Rubens's immense powers. But things did not go smoothly after that. Rubens was held up by constant changes of plan and by lack of co-operation in Paris. When, in spite of frequent requests, he still did not receive certain measurements that he wanted, Rubens sighed that he was 'abattu de courage et dégoûté par ces nouveautez et changements'. 'Io me stuffa di questa corte' was his comment still earlier.[97] Perhaps he had heard rumours that there had been plans in Paris to give the commission to an Italian painter. However, in spite of obstructions, he went on working at the commission until 1631, though with interruptions. There still exist some fine sketches. A few large paintings,

incomplete at his death, were probably finished by pupils (Rooses III, p. 275).[98] The cause of all the difficulties was political squabbles and differences between Marie de' Medici and her son, Louis XIII, which resulted in Marie's flight from France in May 1631. Rubens was requested by the Spanish king to accompany the Marquis d'Aytona, who was to go and meet the proud queen. The task of waiting upon her fell on Rubens. He defended her interests with devotion; indeed, he went so far as to send a strong report to the Spanish king to suggest a war with France on her behalf, a bold plan for which there was little enthusiasm in Spain.[99]

Other Series of Paintings

The 1620s were rich years in Rubens's life, years of an unbelievable productivity, though, as we shall see, they were also years of busy political negotiations, of restless journeyings, and time-wasting discussions and reports. New series of paintings were produced at the same time as work was proceeding on the Medici cycle, and afterwards too when Rubens was thinking about the designs for the Henri IV Gallery. He was particularly occupied with designs for tapestries.

He must have received the commission for the *History of Constantine* from Louis XIII when he was staying in Paris at the beginning of 1622. There were to be twelve scenes in all, of which four cartoons were ready in the Paris studio of Marc de Coemans at the end of 1622. Many of the subjects lent themselves to allusions to the king's own life: *The double Marriage of Licinius and Constantia and Constantine and Fausta*, for example, was painted as a contemporary event to allude to the wedding of Louis XIII and Anne of Austria and of his sister Elizabeth and her brother Philip IV. The cartoons are lost, but a few of the tapestries from the 'Série Principe' have survived and are among the most beautiful that we possess. Compared with those for the Medici cycle, the sketches are somewhat colourless and dull (Rooses 718–27), for by being over-faithful to the Roman background Rubens restricted the free play of his imagination. Peiresc saw the cartoons in Paris along with several friends. He explains 'il particolare di ciascheduna historia', and everyone admired Rubens's erudition and skill 'in exprimere gli habiti antiqui, sino alle clavi delle calighe con grandissimo gusto sotto il piede d'un cavaliere siguitante Maxentio'. Others, however, questioned the correctness of certain details.[100]

The highest point of Rubens's Christian allegory is reached with the series of the Eucharist (Rooses 53–78), which depicts the triumphs and victories of the Church over her adversaries the heretics, the heathens, philosophy, and ignorance. Here the whole apparatus of Christian knowledge was brought into play – the prototypes of the Old Testament, the defenders, the Fathers, the Princes of the Church, and the temporal powers who reverence the Holy Sacrament. The triumph of the restored Church could not be more effectively portrayed than by this glorification of the Eucharist, the supreme sacrament. The Archduchess Isabella Clara Eugenia had commissioned the tapestries of the Eucharist about 1627; they were intended for the Convento de las Carmelitas Descalzas in Madrid, an institution in which she was especially interested. Rubens must have been working on them during the years of his greatest activity. We do not know

of any preparatory drawings, and in view of Rubens's ability to think in colour they are not to be expected. But there are various series of designs, first small oil sketches with rapid touches of colour,[101] then bigger sketches on panels and composed mirror-wise. These were copied on canvas in the studio to the correct dimensions, but additional work was done on them by Rubens. They were then used by the weavers as direct models for the tapestries, but turned once more so that the original left and right became left and right again. The bigger series of sketches on panels, that is the second series, was copied again by the engravers.

Never before had so much preparatory work been done. The purpose was the production of the maximum number of copies of this *propaganda fidei*, so that they could be sent forth into all the world. The commission must have satisfied some inner desire of Rubens. Was he spurred on by the conviction, as he himself wrote on 11 May 1628, that religion takes hold of men's hearts more than any other emotion? Was it from a sense of gratitude to the princess who had put her confidence in him? What the small sketches only suggest is given full expression in the wooden panels, where the surge of Baroque feeling gives abundant life to the dry bones of dogma. The heretics fly in fear and trembling before the Church, a magnificent figure sailing through the clouds, preceded by Time. The followers of the false gods fall down before the shining Sacrament, and the men of science submissively follow the Virgin triumphant on her chariot borne by angels and putti. The scenes are treated in an illusionistic manner, as if they were painted on tapestries hung between two antique columns or held by angels. The picture seemingly on a piece of tapestry had already appeared over the heads of the Gonzaga (p. 75), and, used here as a design for real tapestries, the illusion had a further justification. The tapestry border is full of symbolic allusions: the power of Faith overcoming the cunning of the heretic, for example, is symbolized by the lion seizing the fox in his claws. And are we to regard the classical framework of column and achitrave merely as a decoration recommended by tradition, or is it not rather the vision inspired by a Christian humanist's faith, that classical civilization is the progenitor of all civilization?

We know little about the last cycle, the life of Achilles; we are in ignorance as to who commissioned it, and we can only guess when it was produced. There is much to suggest that the paintings were made after the Spanish–English journey. What remains is sketches: the fairly large panels with the figures gesturing with their left hands at the Boymans Museum and at Detroit, and a second, even bigger series on panels, more detailed than the first. The first series is very unequal – some pieces are lightly coloured, others carefully worked out with deeper colours. The surrounding decoration, also designed by Rubens, paraphrases the theme with symbolic representations, as in the cycle of the Eucharist. (The designs for the *History of Constantine* were without a painted border.) In spite of the dramatic events (for example, the combat of Hector and Achilles), the style is more sedate and the colours warmer and more painterly than in the more formal Eucharist. There are thus good reasons to put this last series after 1630, when Rubens, who had renewed his contact with the works of Titian, was seeking fresh ideals of beauty.

Baroque Art

It is useful for a study of the change in style in Rubens's painting in the years between his settling in Antwerp and his departure for Madrid (1628) to consider also those of his creations which did not form part of any of the great series. No subject is more illuminating for this purpose than his various interpretations of the Adoration of the Magi. By following this one theme, one could reconstruct the evolution of his style throughout his whole life. Here, however, it must be sufficient to compare the altar-piece in St Janskerk at Malines of 1617–19 (Rooses 162–7; Plate 70) with the great panel for the abbey of St Michael at Antwerp of 1624 (now in the Museum at Antwerp, 298; Rooses 174; Plate 71). The graceful style of the Malines painting has its origin in the Classicism of Rubens's early years. The five heads of the kings, the Virgin, and the Child incline towards one another in perfect harmony, and a softly flowing light plays round them. The spectators recede gradually in a diagonal line, two by two, into the background. An arch shuts off the composition on both sides; in the dim light a few people with torches from the procession are wandering down the staircase.[102] The hushed expectancy and the subdued light of this painting are not to be found in the Antwerp Magi: here bright colours in full daylight accentuate the sculptural roundness of every figure and the sweeping movement of the luxuriant robes. The descending diagonals on the left and the rising ones on the right surround the Moorish king, above whose head the camels stretch their necks. The props of the stable roof and the column and pilaster on the left in the background provide a strong framework, an important function of which is to support the Virgin's delicate figure in the midst of so much masculinity. The execution by long, powerful brush-strokes generously full of pigment is entirely in agreement with Baroque ideas of heroic composition.[103]

Whichever paintings we choose as examples, we find that those of the twenties surpass the earlier pieces in Baroque pathos and controlled power. *The Martyrdom of St Stephen* (c. 1615, Valenciennes, Museum; Rooses 410–13), it is true, already has all the elements of a Baroque martyrdom – the excited movement, the diagonal composition, and the effects of strong light. But it is only in such an altar-piece as *The Conversion of St Bavo* of 1623 (Ghent, St Bavo; Rooses 396) that we get the whole composition emphatically built up and held in motion by a controlled and concentrated impulse that drives through the fully modelled bodies. The flowing clarity of the early work is here sacrificed for the sake of a strong, dark tone.[104] The *Assumption* in Antwerp Cathedral (1626; Rooses 359; Plate 78) and the *Mystic Marriage of St Catherine* in the Augustijnenkerk at Antwerp (1628; Rooses 214; Plate 79) are the key works of this period; both grew out of a long series of preparatory studies or are based on older compositions, and they are related to one another by the same problem of composition – that of linking the Virgin with the crowd of her followers. The *Assumption* was ready in 1626, but the contract had been agreed in 1619, and Rubens had submitted two designs a year earlier. He must have started upon the final execution immediately after his return from Paris in June 1625. Thus everything points to a lengthy period of incubation.[105] The elements

of the composition are partly the same as those of the altar-piece of 1617 for Notre Dame de la Chapelle in Brussels (now at Düsseldorf; Rooses 358).[106] The shroud is here, and there are apostles bending over the empty tomb and others pointing excitedly upward. We recognize, too, from earlier work the floating pose of the Virgin and her gesture. Nevertheless, what was once accentuated by means of a multitude of gestures, and by contrasts of light and shade, is here bound together into one harmonious pattern of movement, colour, and graceful attitudes. The Virgin is closer to mortals and yet upon a higher level. Not only playful putti, but four dignified angels advance to meet her. The composition demands that the apostles and the women bow their heads; they are in shadow, which frames the upward movement. Only one apostle follows the Virgin with his eyes and with a gesture of his arm as she floats upwards. At the same time he shuts off the composition on the left. The regions of heaven and earth are separate and yet closely linked. The pink and light blue of the Virgin, in the midst of angels and ringed by white clouds, are picked up and strongly accentuated in the figures below. Baroque art is not only synonymous with powerful movement, effects of bright light, and massive gesture; it also implies painterly refinement and harmoniously flowing movement. Rubens was one of the first to fulfil these implications.

The Mystic Marriage of St Catherine (Plate 79) in the Augustijnenkerk in Antwerp is the largest altar-piece Rubens ever painted, and, since his creative powers expanded in response to the magnitude of the commission, it is also one of the most beautiful.[107] The painting developed into a Sacra Conversazione such as Christian art had never before known. The earlier unilateral diagonal movement is enriched by a counter-movement. The whole makes an oval frame for the throne of the Virgin, and is in itself multiform and contrapuntal, forming separate groups. Among the patron saints of the Augustinians St Augustine himself has a prominent place; opposite him stand St Sebastian and St George. To the charming group of the marriage of St Catherine is added the wild figure of St John the Baptist, who stands opposite the marble pillars in whose shadow St Peter and St Paul are on guard. The colours here are so light and shining that this altar-piece appears indeed to be a joyful witness of the restored Church.

Rubens's portrait painting similarly reflected the progress of his art; from Classicist, accurate, strict formalism he moved powerfully towards the Baroque supremacy of the principles of painting. If at first glance the differences here are less evident, this is due to the obvious tendency of official portraits to be impersonal and conservative in their compositions. On the other hand, Rubens's portraits of his friends and family show an astonishingly direct vision, which seems to by-pass fashion and stylization. He painted many portraits of both kinds.[108] Portraits of donors occupy a position between these two groups. Nicolaes Rockox and his wife on the wing of the *Incredulity of St Thomas* (Antwerp 308, 310) were early examples, in the period of cold, exact realism (p. 81). The triptych was a form not much used after 1620, however, and naturally the portraits of donors on the side panels disappeared with it. The donor of the *Adoration of the Magi* of 1624, Mattheus Yrsselius, was painted as a separate portrait (Copenhagen 613; Rooses 1081), probably done at the same time as the large picture. The powerfully rounded forms, the strong ornamentation, and the generous flesh colours are typical of the healthy

Baroque sentiment which inspires Rubens's work. The portrait of Caspar Gevartius in Antwerp (706; Plate 82) is more delicate in execution and composition. The black of the costume shines in a variety of nuances; the head is so subtly but so firmly painted that all our attention is concentrated on the dark eyes, and we forget the skilful composition of the gestures of the hands, the allusions to erudition in the background, and the Baroque chair back.

While working on the Medici cycle, Rubens painted a self-portrait for the Prince of Wales, later Charles I (Windsor Castle; Rooses 1043). Despite the Baroque pose, the elegant hat, and the fashionable moustache, this gives the impression of a man at peace with himself and examining the world with sharp, observant eyes.[109] The most grandiose official portrait of the same period, that of the Duke of Buckingham on horseback (Rooses 907; formerly Osterley Park, near London, destroyed in the Second World War; Plate 83), is more conventional than the Lerma portrait and less 'aggressive' than the equestrian portraits of the Italian years. But the individual portrait has developed into a representation of a hero, a warrior, expressed with Baroque pathos and the full apparatus of allegory. Neptune and Amphitrite lie at his feet, protecting goddesses with laurel wreaths point the way, and angels blow away the black clouds which threaten the fleet. It is not difficult to detect the style of the Medici cycle in this portrait.[110] Even more striking is the *Apotheosis of the Duke of Buckingham* (Rooses 819; also formerly Osterley Park, and destroyed in the Second World War), which repeats even to details the pattern of the *Ascension of Henri IV* of the second Medici cycle, though it avoids the bombast of the latter by the concentration on one motif, by the clarity of the colours, and by the inspired composition *di sotto in sù*.[111]

Buckingham's whole personality, his knowledge of art, his status as a collector, must have made a deep impression on Rubens when he met the statesman for the first time in Paris in 1625. They were negotiating a peace between England and Spain, but they probably also discussed the purchase of works of art, for Rubens's collection of classical statues, taken in exchange from Sir Dudley Carleton less than ten years ago, was handed over to Buckingham, together with thirteen paintings by Rubens himself and many other precious things. Buckingham, who died in 1628, had by then collected thirty paintings by Rubens. It was said that in these years he paid Rubens 100,000 florins for works of art, while the agent, Michael le Blon, got a big commission. These princely transactions appealed to the imagination of the seventeenth century as much as Rubens's artistic achievements. His air of magnificence, his statesmanship, his erudition were carefully studied and joyfully reported by the oldest biographers.

POLITICS AND PAINTING

On 30 September 1623, in the Citadel of Antwerp, Rubens received ten écus for special services. These services can only have been political. Was Rubens concerned in the repeatedly re-opened peace negotiations with the Northern Netherlands? His brother-in-law Brant at any rate appears in the secret reports, as '*el catolico*'. Rubens himself was

in Holland several times. During his journey in July 1627 he met Joachim von Sandrart in Utrecht, and the latter accompanied him through Holland. What Sandrart did not realize, however, was obvious to the professional diplomats: Rubens once again had orders to discuss with other agents the possibility of a peace treaty between England and Spain, a prerequisite to peace with the Northern Netherlands. The Governess Isabella gave him his orders, but official Spanish policy never fully supported the mission, and it was again Isabella who ordered Rubens to carry on peace negotiations in Paris with Buckingham.

After the death of Albert in 1621 Spaniards filled all the high administrative posts. The resistance of the Flemish nobility sometimes took questionable forms: they sought liberation through France and by contact with the Dutch. Rubens, as Isabella's confidential agent, had more than once the painful task of shadowing them. At the beginning of 1633 he was sent to Holland with this aim, for a third or fourth time.[112] Then came disaster: the official negotiator, the Duke of Aerschot, wrote Rubens an insulting letter and took care that the letter was published,[113] so that yet again the chance of an approach to Holland was lost, at least on a basis that Rubens could accept on Isabella's behalf. It must have been this disappointment which led Rubens to relinquish all political ambitions. He announced this in an excited letter to his friend Peiresc: 'Posso dire senza ambitione', he wrote, 'che gli miei impieghi e viaggi di Spagna et Ingleterra mi riuscirono felicissimè.' Yet, he continued, on the first opportunity of a small secret journey 'mi gettai alli piedi di S.A. pregandola per mercede di tante fatiche la sola essentione di tali impieghi e permissione di servirla in casa mia', which favour was granted very reluctantly.[114]

But it would be wrong to regard Rubens's political activities solely as service to the ruling house, and as unsuccessful service at that; for he had the satisfaction of having helped to prepare the peace between England and Spain. In spite of many intrigues and much opposition, and after years of negotiation, this peace was signed on 15 November 1630. Concerning it, Rubens wrote on 24 August 1629 to Olivarez: 'mi pare il nodo della catena de tutte le confederacioni d'Europa, la cui apprehensione sola causa hormai de grandi effeti.' [115] His motive for these weeks of negotiation, these continual journeyings, this talking with diplomats and holding his peace with his friends, appears in a moving document in which he rejects the Spanish maxim 'pereant amici dum inimici intercidant', and paints the dire necessities of his city in these words: 'questa città va languendo come un corpo ethico che si consume poco a poco. Ogni di vediamo mancar il numero degli habitanti, non havendo questo misero populo alcun mezzo da sostentarsi colla industria degli suoi arteficii o traffichi.' [116]

From September 1628 to March 1630 Rubens was hardly at home for more than a few days. The negotiations with the English agents were so far advanced that the Infanta thought it necessary to send Rubens to Spain to deliver his letters personally. Philip was not particularly enthusiastic about the idea of receiving a painter, a man 'de tan pocas obligaciones', as ambassador in a political affair, but Isabella continued to press for it, and her desire (which must have been that of Rubens too) was eventually complied with. At the end of August 1628 Rubens left for Spain, appeared before the Junta, and

won the king's confidence. After the deliberations, which lasted seven months, Rubens was commanded by the king to carry on the negotiations in England and to do his best to bring them to a successful conclusion – which, as we saw, he managed to achieve. The satisfactory trend of affairs was already apparent at the end of 1629, and Philip IV wrote approvingly to his aunt: 'The merit of Rubens, his zeal and devotion during his services, justify every thing one can do for him.' [117]

Meanwhile Rubens found the opportunity to carry out another command of the Infanta, to paint the portraits of the Spanish royal family in Madrid. He made five portraits of the king, one of them on horseback. This remained in Madrid; it was destroyed by fire in 1734, and is known to us only by a copy in Florence. Rubens also painted Queen Isabella de Bourbon and the brothers and sisters of Philip IV, and probably made portraits of Philip's ancestors (after Titian and Coello).[118] These portraits are much graver and more reticent in colour than anything Rubens had painted hitherto. The Baroque exuberance and grace, and the ceremonial dress, have gone. The change was due to Rubens's discovery, or rather rediscovery, of one of the greatest portrait painters of the past – Titian. Pacheco, who, through his son-in-law Velázquez, was well informed of all that roused Rubens's enthusiasm, remarked that Rubens copied everything by Titian that the king possessed.[119] This included not only portraits, but also many of Titian's later compositions in the royal collections, as well as in many others in Madrid. Rubens kept the copies, and the inventory of his collection lists more than thirty-two of them (see p. 108). The royal portraits, too, or at any rate the first versions, remained in Rubens's studio, so that he or his pupils could make replicas to order.

King Philip bought eight paintings from Rubens which the artist, as a good business-man, had brought with him from Antwerp. 'His Majesty,' writes Rubens on 2 December 1628, to Peiresc, 'takes an extreme delight in painting.' He also commented: 'Questo Principe e dotato di bellisime parti.' The king came nearly every day to talk to Rubens in his rooms at the palace, and it was probably during the course of one of these visits that Rubens received the commission for the decoration of the hunting lodge 'Torre de la Parada', on which he did not begin work until much later. The equestrian portrait of Philip IV ('con molto suo gusto e sodisfattione') and the other portraits of the royal family were by then finished.[120] The king was fascinated by his painting: again and again during the thirties he caused works by Rubens to be bought for him in Antwerp (see p. 103), and at one time more than a hundred and twenty paintings by Rubens must have decorated the walls of the royal palaces.

Once the king had decided on the mission to England, Rubens had to undertake it straightaway. He was able to stay for only four days in Brussels. Some knowledge of his activities had filtered through to Paris, and Dupuy sums up the impression: 'Je voi qu'il commence à estre fort connu et n'a que faire de chercher des protecteurs car ses ouvrages le recommandent assez'.[121] In England Charles I was happy 'de connaître un personne de tel mérite'. The 'Gentilhomme de la maison de Son Altesse Sérénissime' and later 'Secretaris di Sua Maijesta catolica et di suo consiglio secreto' was ennobled, and the University of Cambridge conferred a doctorate on him.

Rubens stayed in London with Sir Balthasar Gerbier, whom he had met in Paris in

1625 in the retinue of Buckingham. Since then Gerbier had been concerned in all Rubens's political negotiations, and was at the same time the agent in a number of art deals between Antwerp and London. It is sad that Rubens did not have a more cultured opponent; but this political adventurer does not seem to have cut across any of his plans. Rubens delighted in the treasures of the royal collection and those of the Duke of Buckingham, and in the antiques of the Earl of Arundel. 'La quantità incredibile di pitture, eccellente statue, et inscrittioni antiche' made a great impression on him.[122]

Rubens was in England for more than nine months, but did not do very much painting; political discussions apparently took up most of his time. He did, however, paint a family portrait of his host and hostess with their four children, a work which was later enlarged to twice its original size (Windsor Castle).[123] As messenger of peace, too, Rubens gave Charles I an allegorical representation of 'War and Peace' in which Minerva protects Peace and routs Mars. Gerbier's children served as models for happy youth, plucking the fruits of concord (London 46; Rooses 825). Finally, Rubens painted what Vertue called 'in honour of our nation the history of St George wherein (if it is possible) he has excelled himself; but the picture he hath sent home into Flanders to remain as an monument of his abode and employment here' (Buckingham Palace).[124] In this picture mythology and history meet. The armour of the saint disguises the historical portrait, for St George has the features of the king, who is rescuing his princess Henrietta Maria. The survivors thank the king as their saviour. Spectators on a hill look on at the liberation like the unbelievers who would not accept the miracle of Moses. A few little buildings by a river must be intended to convey that the dreamy river landscape represents London and the Thames. Reality and fantasy mingle. These works of the English period, titanic but controlled, usher in the last phase of Rubens's work, which will be discussed in its wider implications later.

Rubens's years of political cares, of secret messages and discussions, of detailed reports and long-drawn-out negotiations were thus years of unbroken creative power and of zealous correspondence with learned friends and trusted advisers. The correspondence with Peiresc had temporarily ceased, probably in order to avoid political suspicion, but was resumed with renewed zest with the famous letter in which Rubens announced to him the end of his political career.[125] After Peiresc's departure from Paris in 1624 his brother, the Seigneur de Valvales, became Rubens's confidential adviser in the difficult affair of the second Medici gallery. After 1627 it was with Pierre Dupuy in Paris that Rubens exchanged political and artistic news every week. From this correspondence we learn that in August 1627 he painted the portrait of the Marchese Spinola, but that the engraving was not yet ready.[126] We hear, too, about the difficulties experienced in digging the 'fossa Eugeniana', a defensive ditch against the Dutch, and of other troubles and outrages of the long war.

On 20 June 1626 his wife Isabella Brant had died. With an almost stoical restraint Rubens told Dupuy of his sorrow and misery. He added: 'Io crederei un viaggio esser proprio per levarmi dinansi molti oggietti che necessariamente mi raffrescono il dolore, ut illa sola domo maeret vacua stratisque relictis incubat; et le novità che s'offeriscono al occhio nel mutar paesi occupanno la Fantasia, di maniera che non danno luoco alla

recidiva del cordoglio.' [127] Much of the restlessness of Rubens's life in the second half of the twenties may be due to this event. But his desire to travel and to play an important part in the world of politics implies an urge to externalize his powers. We have already seen that the paintings of the years 1620 to 1628 were immense and grandiose, and more Baroque in feeling than his earlier works. The Medici cycle indicates the beginning of this new phase, and the gallery devoted to the deeds of Henri IV would have marked its zenith had Rubens been able to carry out what his imagination dictated.

In March 1630 he had returned from England. On 6 December 1630, at the age of fifty-three, he married Helena Fourment, a girl of sixteen. Another mission to England loomed ahead, but although Rubens managed to avoid this unpleasant task, there followed the unsatisfactory negotiations with the Dutch and the painful exchange of open letters with Aerschot of January 1633. However, despite illness, a few years of domestic happiness and undisturbed work were still to be vouchsafed to him.

THE LATE COMPOSITIONS

Towards the end of the twenties, when Baroque sentiment and power gave way to a style in which warm colours are combined with rhythm and balance, Titian's art became a source of fresh inspiration for Rubens. Two of the most perfect transcriptions were made even before the journey to Madrid: *The Feast of Venus* and *The Bacchanal*, now in Stockholm (590, 600).[128] There are few examples in the history of art of such an artistic kinship, spanning the centuries. The colouristic vision of man and nature in these versions, however, is peculiar to Rubens; we recognize his hand in every brushstroke.

The Feast of Venus in Vienna (830; Plate 93) is a unique evocation of the spirit of Titian, without being inspired by any specific picture.[129] The statue of Venus is the centre of a whirling rhythm of dancing putti and angels weaving garlands. The putti embracing one another repeat an old motif of the Infant Christ and the Infant St John kissing, and the girls rushing in resemble the victims in an antique sacrifice. Dancing fauns and nymphs unite in a graceful, harmonious dance. The rhythms of colour and movement are repeated in the various groups and connected in rising and falling waves. Where in previous phases of Rubens's art the powerful diagonal movements had determined the dynamics of the painting, it is now the considered distribution of groups, the rhythmic interchange of light and colour in an open space which preserve the unity of the composition. Finally, there is a new unity in the brushwork, in the movement of the living hand which guides the brush over the rough surface. Rubens's late works are much more personal than his earlier ones, where the style, whether for reasons of classic patterns or of Baroque orchestration, tended to adhere to more general ideals.

In the horrifying *Massacre of the Innocents* (Munich 572; Rooses 181) and in the *Rape of the Sabines* (London 38; Rooses 803; Plate 92), the rhythm of whirling masses is the same, but restless movement and dramatic action are controlled by a harmonious grouping of figures, and by imperious gesture and balanced contours. The light background,

which intercepts the range of colours of the large figures, irradiates the scenes of cruelty and glorifies the martyrdoms. These, the suffering of Christ, and the deaths of ancient heroes are dominant themes in Rubens's late work: *The Beheading of St Paul*, *The Crucifixion of St Andrew*, *The Crucifixion of St Peter*, *The Martyrdom of St Thomas* (Plate 91), *The Martyrdom of St Livinus*, *The Crucifixion*, *Christ Carrying the Cross*, *The Death of Dido*, and *The Lamentation of Andromeda* are all pictures of a glittering magnificence which transforms cruelty and suffering into an overwhelming dazzle of colour and a wonderful harmony of movement. The compositions are less rigidly constructed than before: they are open on all sides, and the great streams of colour, line, and light flow together and over everything as if they had been released from all restraint.[130]

The ceiling paintings of the Banqueting Hall in Whitehall (Rooses 763–71) are the chief monumental work of Rubens's late period; they are also the only monumental paintings by Rubens which are still in their original position. The paintings were done in Antwerp, and had been ready for some time before the end of 1634, when the canvases stood rolled up in Rubens's studio. A year later they were sent to London, after Rubens had worked on them again. It had even been suggested that Rubens should touch them up *in situ*, as he had done with the Medici paintings. As regards theme, the Whitehall cycle has much in common with the Medici cycle, for in both the life of a monarch had to be glorified. In composition and design, on the other hand, it can be compared with the ceiling paintings of the Jesuit church in Antwerp, for both cycles depend on Veronese. This applies not only to their decorative gaiety and to the arrangement of framed panels on the pattern of Veronese's ceiling in S. Sebastiano in Venice, but also to certain specific passages, for example the representation of James I on his throne, which is a secular adaptation of the *Coronation of Esther* in S. Sebastiano or of Veronese's *Venezia enthroned* in the Sala del Collegio in the Doges' Palace.

The three canvases in the middle glorify the wise and benevolent rule of James I. In the first panel Charles I, represented as a putto between the allegorical figures of England and Scotland, is called to be king of Scotland by his father James I, who appears seated on the throne like another King Ahasuerus. In the middle panel is *The Apotheosis of James I*, a kind of Ascension in classical guise. Rubens's *Henri IV* and *Duke of Buckingham* are its forerunners. The third panel represents the prosperous reign of James I. This also is full of restless movement and the richest decorative effects. The allegorical figures of Peace and Plenty embrace passionately, Wisdom (Minerva) prevents Rebellion (Mars) from rising against the king, Trade (Mercury) with his caduceus chases Envy down to hell. James sits enthroned above with drawn sword and commanding gesture, while three putti hold a laurel wreath above his head. These three main scenes are accompanied by four allegories of Wisdom and Courage triumphant in the corners, and on the long sides by two friezes which also symbolize the good government and liberality of the king.

The ceiling of the Banqueting House is the climax of the art of 'live allegory'. Action replaces abstract ideas, and men and gods symbolize royal qualities. Again it is the colours and the inspired brushwork that bind floating compositions into a perfect unity. The bravura of the brush-strokes can be admired more easily today in the sketches (Plate

86, A and B). Bellori's description of Rubens's '*furia di penello*' applies even more here than to the paintings in the Jesuit church. Rubens did much preparatory work for the English commission: apart from the *modelli* for the individual panels there are many detail studies of single groups or parts of the composition. Both the sketches and the canvases are among the supreme examples of his creative power. Excitement at yet another opportunity to paint on a large scale, admiration for Charles I, the patron of the arts, and the inspiring renewal of contact with the work of the Venetians in the royal and other collections may all have contributed to make the paintings what they are. The delay in their acceptance by the Crown and the still slower payment did not at all diminish Rubens's enthusiasm.

Two other great commissions kept Rubens occupied for some time during his last years. One was connected with the decorations for the triumphal entry into Antwerp of the new governor, the Cardinal Infante Ferdinand (Rooses 772–90). Tremendous sums of money were spent to ensure that this should be the most magnificent entry that Antwerp had ever seen – an extra tax on beer was not sufficient to cover the costs. There were triumphal arches, walls for special displays, grandstands, and triumphal chariots with actors, and Rubens had to design them all. Many of his sketches have been preserved. The big scenes were painted by many different artists to his designs, though a few of them he finished himself. Ferdinand, who entered the town on 17 April 1635, was capable of assessing Rubens's work at its true value: instead of the 9,000 florins offered him by the town, he chose the best of the paintings executed by Rubens himself from one of the gates, after the artist had touched them up.

The programme was extremely complicated. Compliments to the new governor were mingled with allusions to war and the languishing trade of the town. Once more Rubens was able to unite allegorical and historical themes in a visually exciting picture, with illusionistic effects befitting an open-air display of this kind. The welcome to the cardinal, for example, is shown on a painted tapestry attached to the triumphal arch by three putti. In vain the benevolent forces of Church, Trade, and the Sciences attempt to keep closed the door of the Temple of Janus, through which the annihilating War God rushes forward. Old motifs of *trionfi* are revived: the Cardinal Infante on the Roman chariot of victory appears as a second Henri IV at the beginning of his glorious progress. The two Ferdinands – the Cardinal Infante and the King of Hungary, the victorious commanders in the battle of Nördlingen – greet each other in a composition which had earlier been used for the reconciliation of Abraham and Melchisedek. Here and elsewhere there are heroes protected by gods: Neptune routs the angry winds to smooth the passage of the Infante (Plate 87). Mars, Courage, and Victory accompany the prince to the allegorical figure representing Belgium, who is supported by Fortune. Above them is the image of Hope, and beneath them merry putti symbolize the happiness in store. Allegorical and mythological characters are inextricably mingled with contemporary heroes, broadcasting their fame and proclaiming their nobility. Those who can no longer understand the scenes will find a learned explanation in Gevartius's *Pompa Introitus Ferdinandi*, with illustrations by Theodoor van Thulden.

But the greatest, and the most impatient, of his patrons was not the city of Antwerp,

nor Charles I of England, but Philip IV of Spain. The precise details for the decoration of the Torre de la Parada (p. 98; Rooses 501–56) with illustrations of the Metamorphoses of Ovid were arranged in 1636, although there may already have been discussions about them during Rubens's stay in Spain. Philip IV was continually asking the Infante Ferdinand how Rubens was getting on with the work. In March 1638 112 paintings were sent, mostly by assistants and fellow painters to Rubens's designs, but the king appears to have been insatiable; a year later Rubens and Snyders were commissioned to produce another eighteen. Many of the paintings were destroyed in a fire in 1710, but we have a great number of sketches. Most of them are small studies on wood, the tone of which is gold-brown, with a few light touches and bluish-grey shadows. Rubens as a draughtsman in paint is here seen at his best. Almost without any support from architectural framework, without the weight of allegorical and historical trappings, the stories flow direct from the imagination of the artist. It is just this freedom from finery and flourishes that makes these less spectacular works so attractive. Execution and conception have, as it were, become one. The designs seem less dated than almost any other paintings of the Baroque. They are, moreover, precious to us as revelations of Rubens's late, most personal style (Plate 88, A and B).

Among the mythological scenes which Philip IV bought from Rubens through the good offices of his brother the Cardinal Infante is *The Judgement of Paris* (Madrid 1669; Rooses 662). This delightful painting was ready at the beginning of 1639, but it was apparently too big to be sent with the others. 'In everyone's opinion it is the most beautiful painting Rubens ever made,' wrote the Cardinal Infante to his brother, 'and', he went on, 'the artist does not want to cover the nudity of the figures, because this is regarded as "la valentia de la pintura",' the value of painting.[131] Indeed, the nudes are marvellously painted, as they are also in the other late mythological scenes. The composition is on the same lines as his earliest representation of the same theme (Madrid 1731):[132] Paris and Hermes on the left, the three beautiful goddesses in a group on the right, and Venus in the middle. Yet the tortuous grace of Late Mannerism is here replaced by the glowing colours of mature Baroque. The late work of Rubens has the beauty of a classical relief, and the warmth and sensitivity of a dream landscape; for the landscape is more than mere background. The figure composition is, as it were, received by the peaceful forms of the second plane, which is bathed in golden yellow light. Another *Judgement of Paris* (London 194), painted a few years before the Madrid piece, is still more fiery in colour and freer in composition, and the movement is more spread out in space. A classic calm and simplicity are, however, the hallmarks of Rubens's last works.[133]

Since Rubens's first political allegories in honour of heroes of the past and princes of the present, he had not ceased to extol the blessings of peace, and the wise rulership that can overcome the powers of darkness and war that threaten happiness and well-being and trample knowledge and the arts underfoot. Even in the years of his greatest political activity, Rubens continued to paint such scenes; we have seen how Marie de' Medici and Charles I were glorified as defenders of peace, prosperity, and happiness, and how the triumphal entry of the Cardinal Infante was introduced by representations of Janus, who

is stronger than the powers of Reason, Knowledge, Trade, and the Arts. We have also seen that in England Rubens painted an allegory of peace which he presented to Charles I (p. 99), a fine and apt gesture to the prince who was prepared to sign peace with Spain. In this picture Minerva drives out Mars so that Venus can harvest the rich blessings of peace. Yet the war in Europe goes on, and Mars is more powerful than ever. He pays no heed to Venus, who tries to hold him back, but brandishes his bloody sword, urged on by Alecto, one of the Furies, accompanied by Hunger and Pestilence. Harmony, Fruitfulness, and Knowledge are trampled underfoot. Behind Venus stands the figure of a woman desperately stretching her arms to heaven: doubtless 'quella matrona lugubre, vestita di negro e col velo stracciato, e spogliata delle sue gioie e d'ogni sorte d'ornamenti, è l'infelice Europa, la quale già per tanti anni soffre le rapine, gli oltraggi e le miserie, che sono tanto nocive ad ognuno, che non occorre specificarle. La sua marca è quel globo, sostenuto da un angeletto o genio, con la croce in cima, che denota l'orbe cristiano.' These are the words with which Rubens concludes the description of a painting which was sent to an unknown patron in Florence in 1638 (Florence, Uffizi),[134] the only surviving detailed description by Rubens himself of one of his works. It is remarkable that although Venus is caught between desperate Europe and savage Mars, her light colours and tender flesh dominate the darker masses. It is the same here as in *The Massacre of the Innocents* and the scenes of martyrdom: the beauty of the subdued colour, the sensitivity of the brushwork, and the rhythm of movements flowing into each other exalt suffering and joy, cruelty and ecstasy alike, to a wonderful harmony.

The great religious themes, such as the Assumption of the Virgin, the Adoration of the Magi, the Holy Family, or the Madonna with Saints, recur again in the later years. The *Assumption* of the Liechtenstein Collection (*c.* 1635)[135] is quieter in its colours than the blazing *Assumption* in the cathedral of Antwerp (1626; see p. 94; Plate 78), and the *Adoration of the Magi* formerly in the collection of the Duke of Westminster (1634)[136] less restless than the spectacular one of 1624 (Antwerp Museum; Plate 71), but both late works have the feeling and the bright warm colours which are typical of the paintings of Rubens's last style.

Before he went to Spain and to England Rubens painted the *Mystic Marriage of St Catherine* for the Augustijnenkerk (Plate 79; p. 95). As soon as he returned, he started on a commission for the Infanta, the triptych of S. Ildefonso, which in February 1632 was placed in position on the altar of the Ildefonso Fraternity of St Jacques-sur-Coudenberg in Brussels (Vienna inv. 678; Plate 89). The magnificence of former paintings is here crystallized into silver to express devout homage. St Ildefonso kisses the garment offered him by the Virgin. St Barbara, St Catherine, St Agnes, and St Rosalie bend their heads attentively. The semicircle formed by the five heads is extended upward by a richly decorated altar niche. Originally Rubens had included the donors with their guardian angels in the central panel – the sketch in Leningrad shows this first idea. On the outside of the wings is the Holy Family under the apple tree, an unusual composition, developed later in other representations of the Holy Family (Vienna inv. 698).[137] The motif of the niche on the inside was also used again later. The *Mystic Marriage of St Catherine* at Toledo, Ohio (Rooses 400), has essentially the same structure. The big figures are most

skilfully bound together, and their carefully contrived movements provide the main lines of the composition, which is focused on the Virgin and Child with a web of light and shadow. The ample garments of the women make a flowing carpet of soft colours.

Rubens had laid it down that if his heirs were minded to honour him with a burial chapel in St Jacobskerk, it should be adorned 'with nothing else but a painting of Our Lady with the child Jesus in her arms, accompanied by various saints, etc., and also a statue of Our Lady in marble'.[138] The statue of the Madonna, by Faydherbe, is still there, as is the beautiful Sacra Conversazione with six saints worshipping the Madonna (Rooses 207; Plate 90). The Child lays his hands on the shoulder of a cardinal. Behind him are three women, the foremost of them probably the Magdalen. St George closes the line on the left with an elegant movement. Opposite, at the feet of the Madonna, kneels St Jerome, the curve of his arms binding together the group of Madonna and saints. Without the lion, he might well be taken to represent Time, included in order to link the spectator with the Madonna and Child. St George has the conquering pose of a Mars; both he and the other saints look as if they were portraits. The warm colours flow back and forth over the forms, the lights are reflected in the white metal, and the warm yellowy-white of the bodies tempers the emotion in the movements of the main figures. It is indeed a happy chance that has preserved Rubens's most harmonious creation in a sacred place.

LATE PORTRAITS, SCENES FROM DAILY LIFE, AND LANDSCAPES

The rediscovery of Titian was very important also for Rubens's portraits. Those he painted of the royal family in Madrid are already more serious, more reserved, and warmer in colour than the Baroque portraits of the third decade. The portrait of Caspar Gevartius (c. 1622, Antwerp 706; Plate 82) glows with light, firm colour, and is as full of detailed drawing as many of the figures in the altar of the Augustijnenkerk at Antwerp (1628; Plate 79). The self-portrait at Vienna (859), painted at the end of his life, has the stateliness, the inner tranquillity, and the sensitively tempered, deep colour of Titian's mature portraits (Plate 81).[139] By this time the official portrait had ceased to be exuberant and had become intimate. Examples are Rubens's portraits of the Archduke Ferdinand painted after his state entry into Antwerp.[140] The equestrian portrait (Madrid 1687), the culmination of that long series which began with the Italian–Spanish portraits (see p. 74), is excitingly, challengingly powerful, and full of spontaneous observation. The type of the portrait of the Duke of Buckingham (formerly in the collection of the Earl of Jersey, destroyed by fire; p. 96, Plate 83), which was representative of the impressive rhetoric of Baroque portraiture and shared the grandeur of the Medici cycle, was now replaced by this almost tender official portrait of the Archduke, which takes up once more the Classical-Venetian tradition of controlled luxuriance, of broken colours, and of soft, diffused light. Both monumentality and human dignity triumph over Baroque pathos and allegorical trappings. There is no real difference now between the state portrait and the intimate family portrait.[141]

On 6 December 1630 Rubens had married the sixteen-year-old Helena Fourment. She was frequently his model in his last years, but he never painted her more glowingly and spontaneously than in the bridal portrait at Munich (340; Plate 84). The hundreds of glittering dots and broken folds are but an orchestral accompaniment to the brilliant eyes, which turn their dazzling glance towards us. The dark violet of a beautifully draped curtain – a colour that Rubens used more and more during these years – adds a new broken accent in colour to the pink and golden tones. The sparkling richness and decorative beauty of this portrait seem once more to echo the Venetian tradition; it is certainly reminiscent of Veronese.[142] Helena Fourment was also the model for *Hagar*, and for Veronica in a *Crucifixion*; she appears among the women in the *Assumption of the Virgin*, she is Paris's chosen beauty, and the Virgin herself. In the most perfect of the portraits she appears as a young mother with two children (Paris 2113; Plate 85). The colouring is masterly, built up from almost pure white, light yellow, and pink shades. The structure is completely hidden beneath the vibrant, painterly surface, and it is as if the brush-strokes themselves decided the true inner unity of the painting, while the artist's own handwriting replaces ordinary composition and construction. The painting is really a large sketch in colours, with the same radiant and spiritualized technique as the wonderful small sketches for the Torre de la Parada.[143]

Although the painting of the intimate portrait as such was not confined to Rubens's later years, the earlier works are more exuberant and more challenging; in fact, more Baroque. The *Chapeau de Paille* (London 852) is probably the most beautiful example of the sparkling eyes and the intense concentration of colour and line of the twenties, when Rubens's immense powers were at their height.[144]

His fellow men were never just ordinary people in everyday dress to Rubens; he saw the individual as the representative of his station in life and his profession – the ruler, conqueror, scholar, or artist. Fame and Victory attend him on his way, antique heroes and gods are at his side and hover over him. Rubens's women, too, are not only models for the great women of the past, they are often themselves great. The allegorical and classical portrait becomes one with the contemporary portrait. Did Rubens paint *Hagar* (Dulwich College) with Helena Fourment as model, or was he really painting a portrait of his wife with Hagar's attributes?[145] In the same way, the natural surroundings of his figures are given a heroic scale appropriate to the fatherland of Odysseus and Nausicaa, yet they are still the meadowland round his own country house, Steen, and the soil which the peasants plough and where the huntsmen pursue the chase. *The Garden of Love* (Madrid 1690) is the portrait of an enchanted world far in time and place from our daily life,[146] but though putti play everywhere, the figures are of Rubens's own time, and even the classical statues look like flesh and blood. A similar interaction links the figures with one another. There is an ideal unity between the joyful life of man and the stylized background with Greek temples. With the same sensitiveness, the vibrant brush touches man and nature, putto and statue. This uniting of art and nature by means of the tenderness and feeling of colour and brushwork is typical of Rubens's late style – it is not usually present in the earlier genre scenes, such as *The Prodigal Son* (Antwerp 781). The latter are genre scenes and nothing more, though spontaneously felt and painted.[147]

It is not altogether certain whether Rubens was already painting landscapes in Italy. The *Landscape with the Ruins of the Palatine* (Paris 2119; Rooses 1175) could have been painted there, since the traces of Mannerism, the pallid conformity of colour, and the surging movement make an early date probable. In addition, the landscape is closely related to the background of the *St Gregory* at Sanssouci, which in its turn is, if not a preparatory study, at least a work from the same period as the altar-piece for the Chiesa Nuova (see p. 77 and Note 32). The Classicist tendency in Rubens's work of 1610–20 comes strongly to the fore in his landscapes, too. On the other hand, the hunting scenes of the same period have a Baroque air. The three landscapes which best show Rubens's style at this time are those at Vaduz (Liechtenstein Collection 412), at Buckingham Palace (Plate 138), and at Munich (322).[148] The rustic element and the tradition of the Carracci combine most convincingly in the Liechtenstein landscape. The framework provided by *repoussoirs* in the foreground, and the division of the space by hills, groups of trees, and bunches of reeds show an ordered and classically trained mind. The other two landscapes are less formal and less confined. The crossing lines, particularly at the sides, suggest a fidelity to nature which refuses to be fettered by any schemes of composition whatever. The groups of milkmaids and peasant women have a heroic grace and a Baroque elegance which we have already met in the shepherds and maidens bearing gifts in the *Adoration of the Shepherds*. This intense feeling in colour and movement also transfuses the sky and the trees. The natural landscape acquires grandeur through the daring of the brushwork and the richness of the colours.

In the twenties Rubens apparently painted few landscapes. The great commissions for church and palace decoration and his life as a diplomat were not conducive to contemplation outdoors, away from the studio or the palace. His sojourn in Spain too was a period of restless political activity, though it was also one of careful study of the treasures of Venetian art. In addition, Rubens was free of his pupils, his studio, and his household cares. Titian's and Tintoretto's landscapes impressed him deeply. We have seen that the *St George* (Buckingham Palace) is a re-creation of a landscape in the Venetian style (p. 99). The mythological landscapes in *Odysseus and Nausicaa* (Florence, Pitti) and the *Shipwreck of Aeneas* (Berlin 776E) are probably also recollections of Spanish themes and Venetian colours.[149] The colours themselves become darker and warmer, and the paint is laid on less thickly, preferably on a canvas with a reddish ground, as was the practice in Venice. We know that Rubens visited with Velázquez the wild, bare, and stony plateau on which the Escorial is built, and made a sketch which a pupil later turned into a painting.[150] Nature itself and the Venetian art of landscape combined to make the picture a dionysian tumult of elemental forces, a rare interruption in the serene, clear, and well-organized world of Rubens.

After he returned from England Rubens bought a country house, Steen, near Elleweert. Political and diplomatic missions were behind him, and now he often stayed in the country, leaving a trusted pupil to look after his town house and studio. Steen and its surroundings were frequently the themes of his landscapes. These are magnificent paintings, magnificent in extent as well as in emotional content. *The Château de Steen* (London 66; Plate 139) and *The Rainbow* (Wallace Collection 63), originally meant to

be a pair, are perhaps the most beautiful renderings ever achieved of the splendour and dazzling lustre that can be given to nature and man. As in all the late works, it is the force of the brushwork that binds earth, bushes, trees, and sky together. These landscapes have such immediacy that one sees exactly what Rubens saw, and does not at once take in the profound conception of construction on a grand scale which they represent.[151]

Just as the great mythological and biblical scenes of the last years were accompanied or prepared for by oil sketches, so the landscape paintings had additional or preparatory sketches. Among them are some which are fully worked out, such as the *Landscape by Moonlight* (London, Count Antoine Seilern Collection; Plate 140), full of poetry and peace, or *Sunset* (London 157; Rooses 1193) and the *Landscape with Birdcatchers* (Paris 2117; Rooses 1176; Plate 142A), both glowing with a warm evening light.[152] The small figures merge into the play of light and colour, the harmonious rhythm of gently swelling hills, clouds that float by, and patches of sunlight. Owing to their direct vision and uncomplicated, or seemingly uncomplicated, compositions, the sketches do not seem to be tied to style or period. It is certainly no accident that Rubens's landscapes have always aroused the immediate admiration of every true painter. The *Landscape by Moonlight* is more than a mere sketch; it is a perfect painting combining the immediate vision of the sketch with a conception of which only a man of genius was capable.

In the last letter of Rubens that we possess we can hear something of the final perfection of happiness which he achieved. Playfully, with none of the formulas which clung round the Baroque style, the old master in this letter wishes his trusted colleague Lucas Faydherbe on the occasion of his marriage 'every happiness and complete, long-lasting contentment'.[153] These are the feelings that speak to us in Rubens's later works, and nowhere more strongly than in his landscapes. Happiness and contentment did not come to him unsought. More than once his life was darkened by *Storm Clouds over the Lake*,[154] and the wealth of divine gifts with which he was endowed might have been fatal to a less disciplined and less cultured man. The greatest achievement of his life was that he 'conquered the boundless riches of creative power which the gods had given him, so that every one of his works stands before us as completely mastered in contour and form'.[155]

He died in Antwerp on 30 May 1640. In the last years he suffered almost constantly from gout. In spite of this paintings continued to leave his hands, and every one enriched not only princely collections but the treasure-house of humanity. Rubens's own collection was princely, too: there were 319 paintings, of which ninety-three were by him, ten by Titian, and twenty-six by Veronese and Tintoretto, besides many statues, medals, and ivories. There were paintings by Dutchmen and very many copies by Rubens 'tant après Titiaan qu'autres renommez maistres'. After his death Philip IV of Spain, Charles I of England, and Cardinal Richelieu were for the last time given the opportunity to buy from Rubens, and they availed themselves of it gratefully.[156]

CHAPTER 6

ANTHONY VAN DYCK

IT is difficult to do justice to van Dyck as an artist because of the historically unjustifiable temptation to compare his work with that of Rubens. For a number of years he was Rubens's most highly esteemed collaborator, so that his paintings tend to be measured against those by Rubens of the same period, though the latter was twenty-two years older. Van Dyck was in no sense Rubens's pupil, for before sharing a studio with him he had for some time painted independently. Van Dyck's gift matured early. While the youthful Rubens developed his powers only gradually, so that his early, pre-Italian paintings are hardly distinguishable among the current Antwerp production, van Dyck was astonishing everyone from his earliest days by his daring and personal vision.

His years in Italy were also very successful, but here too Rubens had preceded him. Rubens had created the portrait of the Genoese type and the Early Baroque altar-piece, and the next generation, to which van Dyck belonged, could only build upon the work done by the founders of the new style. However, both in Italy and after his return to Flanders, van Dyck painted some works of exceptional beauty and grace. As a portrait painter he was outstanding in the field of European painting. Years of intensive labour in London among an art-loving aristocracy gave his work an international, even a supra-national character. Throughout Northern Europe his style became the accepted vehicle for the elegant Baroque court portrait. This sort of fame was never vouchsafed to Rubens. Yet art critics, particularly continental ones, have not been willing even here to recognize the significance of van Dyck, and have been inclined to despise the mass production of his studio, disregarding the fact that an artist with such an extensive clientele could not have fulfilled his commissions without a team of helpers. Yet any one work painted by van Dyck himself during his years in England is enough to convince us that his art – at once sensitive and tasteful – surpasses everything else created in Europe in the same field. Rubens's portraits are more powerful, and glow with more life, but what van Dyck's reflect is court society in the seventeenth century. His fame is justified. Comparison with the genius of his predecessor must not tempt us to underestimate his particular gifts and his special place in European art.

THE EARLY YEARS

Anthony van Dyck was born in Antwerp on 22 March 1599. In 1609/10 he was already among the five pupils of the dean of the artists' guild, Hendrik van Balen. At the beginning of 1618 van Dyck was received as master in the guild.[1] We know from a curious lawsuit of 1660–1, however, that he already had his own studio 'in the Dom van Ceulen' near the Greyfriars, and the documents of this case are among the few

I

papers that throw light on van Dyck's activities in these years.[2] The lawsuit concerned the genuineness of a series of paintings of the Apostles, including the figure of Christ, which van Dyck is supposed to have executed in the years 1615–16. The testimony of the artists, who all knew van Dyck and partly worked with him, is conflicting, but this at least is clear: van Dyck must have painted such a series at this time. A few pupils then made copies under the supervision of the sixteen- or seventeen-year-old painter, who was still not a master of the guild. These copies may or may not have been retouched by van Dyck. One series – according to Jacob Jordaens, the original one – was sold in 1622 to the Dutch art dealer Henricus van Uylenburch. That the different witnesses were not mistaken – one said that one half of the series was copied by him and the other half retouched by van Dyck, and many others referred to a few copies or retouched copies – is clear from the many heads of apostles which survive and show differing degrees of authenticity. It seems unlikely, however, that they were all painted in 1615–16.

It was most odd, and certainly against all guild rules, that an artist should have a studio and make independent paintings and sell them before he had become a master. However, regulations were often infringed, and that van Dyck was able to act independently is shown by the fact that in December 1616, with his father's consent, he took action against the guardians who administered the estate of his grandmother. In 1618, in addition, he was declared of age, a few days after he had become a master.

About 1617/18 van Dyck must have been working in Rubens's studio as an assistant (not a pupil). In the contract which the Principal of the Jesuits drew up with Rubens for the decoration of the Jesuit church, paragraph two explicitly permitted Rubens to allow van Dyck 'with some others of his disciples to work up and finish' the big paintings. In addition, the Principal was 'to commission from Sr van Dyck at a suitable time a painting for the aforementioned four side altars'.[3] In the correspondence between Rubens and Sir Dudley Carleton in connexion with the negotiations about their exchange of works of art, Rubens praised a 'quadro di un Achille' as being 'fatto del meglior mi discepolo' (and entirely touched up by himself) [4] – who else can he have meant than van Dyck? No one will deny that there are quantities of van Dyck paintings based on Rubens's work of this period. The dividing-line between the designer of the composition and the executant is sometimes difficult to draw. There are also great works from the Rubens studio in which van Dyck only painted a few heads: *Christ with Simeon* at Leningrad (Rooses 254) is an instructive example of his co-operation with one or more lesser painters from the Rubens studio.

Van Dyck must also have carried out for Rubens work of an entirely different nature. G. B. Bellori, who was in an exceptional position to know about van Dyck through the latter's protector Sir Kenelm Digby, tells us that Rubens was fortunate enough to have found a collaborator 'che sapesse tradurre in disegno le sue inventioni, per farle intagliare al bulino'.[5] And we know from many of his letters to engravers and intermediaries how deeply Rubens felt about the faithful rendering and distribution of his creations in the form of engravings.

Collaboration in these years must have been of a most intensive character. If we are to believe Baglione, it was van Dyck 'che fece il cartoni e quadri dipinti per le tapezzerie

dell'historie di Decio'. The question whether the series in the Liechtenstein Collection was independently painted by van Dyck after sketches by Rubens, or whether the collaboration was even closer, is still unresolved. Rubens in a letter of 26 May 1618 to Sir Dudley Carleton speaks of *his* cartoons for the history of Decius Mus. Is he making an unwarrantable claim here? In an inventory of 1661 the series is merely entered as 'painted by Antonie van Dyck', but in 1682 and 1692 respectively as 'painted by van Dyck after sketches by Rubens' and as 'composed by Mr Rubens and painted by Mr van Dyck'.[6]

The later biographers, such as Arnold Houbraken, have much to recount concerning the joint studio of Rubens and van Dyck. They also speak of the jealousy of the older artist, hinting that he would have liked to get rid of the young man from Antwerp. In reality, the relationship was not strained. In July 1620 an agent of the Earl of Arundel writes to England 'Van Deick sta tuttavia con il Sigr Rubens'. His works are highly thought of, 'poccho meno di quelle del suo maestro'. There is little hope of getting him to come to live in England. A few months later, in a letter of 25 November 1620, Sir Dudley Carleton is told that van Dyck, Rubens's 'famous Allievo is gone into England'. In Antwerp it was already known that King James I had allowed him a salary of £100 a year.[7]

This first stay in England was brief. At the end of February 1621 the artist, 'one of his Mayesties servants', received a 'passe to travail for 8 months', while a few days before he had been given the sum of £100 'for special services'.[8] It is probable that the Earl of Arundel had managed to get this special leave for van Dyck. It was to be spent, it is believed, in Italy, where van Dyck would be able to accompany the Countess of Arundel. However, whatever the intention may have been, van Dyck spent the next eight months in Antwerp. There is a tradition, which cannot be verified, that during those months he painted the *St Martin* and a *Holy Family* (later destroyed) for the church of Saventhem. On 3 October 1621 he set off from Antwerp for Italy, being then the same age as Rubens when he undertook the journey in 1600.

Apart from a few dated portraits, not one of van Dyck's works before the Italian journey can be ascribed to a precise year. The series of apostles whose genuineness was called in question in the lawsuit of 1660–1 (see p. 109) has apparently not survived. We know today two complete series of apostles, one only in the form of the engravings of Cornelis van Caukercken (*c.* 1660), the other the so-called Böhler series, which is now scattered in different collections. Various small groups of apostles, such as the four in the collection of Earl Spencer, the six in Dresden, and many single heads (apart from many replicas), show that van Dyck must have been concerned with this subject for some considerable time. Probably he also knew the series which Rubens had painted and some years later (about 1610) copied in his studio (see p. 74). In addition, there are a number of studies of heads of apostles. It is not a simple matter to assess the material, or to arrange it chronologically. The studies (for example Munich 1248/862; 4809/1563; Bamberg 177/9; Paris 1979) have thick, brown, dry paint roughly brushed on, and the brush-strokes and the composition of the faces are sometimes very like the earliest studies of Jacob Jordaens. It is precisely this connexion with Jordaens that points to an

early date, before van Dyck accepted, with a certain reserve, the clear cool manner of Rubens's classical style. Jordaens was already a member of the guild in 1615, and his painterly bravura must have made a greater impression on the young van Dyck than the playful Classicism of his master van Balen (see p. 127).

The various more or less complete series of apostles are more colourful. The paint itself is carefully prepared and carefully applied, sometimes with an enamel-like sheen comparable to Rubens's paintings of the years 1614–15. The beautiful pink and brownish-red colours and purple shadows are characteristic, and these too are in accordance with Rubens's taste. The series which belongs to Earl Spencer represents this phase of van Dyck's style very well (Plate 95B). The so-called Böhler series may, as Glück suggests, be the last, prepared for by such excellent pieces as the *St Peter* at Leningrad (Plate 95A). The modelling with yellow-white lights and the colour range of broken bluish-yellow display a refinement in advance of the early, almost barbarous studies.[9]

Glück and Rosenbaum, who have worked in great detail on the early paintings of van Dyck, call his pre-Rubens manner the 'confused' or the 'robust style'. The *Drunken Silenus* and the *Crucifixion of St Peter* (Brussels 163–4) belong to this period,[10] as does the *St Sebastian* in the Louvre (1964), with its heavy brushwork which corresponds entirely to the technique of the first study heads. The youthful self portrait (Vienna, Academy) belongs technically to this phase too, although there is nothing coarse or robust about the model or the careful attention with which the artist observes himself. In reconstructing van Dyck's early work one must bear in mind that this young and precocious talent developed in spasms, and also that there were repetitions, and often slight variations, of one or more cherished motifs. Just as van Dyck would feel the need to work out some discovery of Rubens – we shall look at this more closely later – so too he played with his own inventions, which he sometimes worked out with nervous haste from one basic motif. The *Lamentation* and the *Betrayal* are examples of compositions which exist in several versions with variations and alterations, and, moreover, accompanied by numerous studies of composition and detail.[11] Chronological arrangement is sometimes very difficult, and special caution is necessary in dating the studies, which, though often unequal in merit, must have been produced within quite a short period of time.

Before we look more closely at van Dyck's early portraits, we must examine a few other important compositions. The *Carrying of the Cross* in the Pauluskerk at Antwerp must have been painted between 1617 and 1620 (Plate 96). It belongs, together with Rubens's *Scourging*, a *Crucifixion* by Jacob Jordaens (p. 129), and many other pictures by older Antwerp artists, to a series of the Mysteries of the Rosary. It is remarkable, incidentally, that van Balen's work in this series was remunerated more generously than the paintings of van Dyck and Rubens.[12] The proximity to Rubens's *Scourging* invites comparison. The muscular executioners on the right are Rubens-like, but the flowing lines, the restless arrangement of light and shade, the nervous haste, and the confusion of the parallel movements are alien to Rubens. The crumbly brushwork, too, particularly in the faces, is entirely unlike the enamel-like paint and the full modelling of Rubens's works of this period and the years immediately before. Only Rubens's oil sketches provide a link with van Dyck's art; here we find something of the hasty brush-

work, of the rough, open surface – in short of the sketchiness which van Dyck managed to keep in his large paintings.[13] His style of drawing in the various preparatory studies for this work [14] is fairly close to that of Rubens. Another example of this painterly bravura is the *Continence of Scipio* (Oxford, Christ Church; Plate 97A). Here the four hands flow into one another with a playful grace such as had never before been seen in Flanders, and instead of impressive strength we have a display of subtle elegance. A few of the subsidiary figures, such as the naked men on the right, are free copies from Rubens, but Rubens's restrained power and majestic pose are replaced by a decorative pattern of light and shade on a granular surface. Scipio sits in a far from majestic attitude in the middle of the antique ruins. Draped curtains close the composition on the left. Rubens's collaborator has here freed himself from the strict orderliness of his master; colour and brushwork are in harmony with new ideals, ideals which to a certain extent are those of Venetian art.[15]

Van Dyck's hand can be detected in many of Rubens's works from the years 1616–20. The principal examples are the *Virgin with the Repentant Sinners* at Kassel (119), the *Coup de Lance* at Antwerp (297), the *Crucifixion* in the Louvre (2082), and the *Bacchanal* at Berlin (776B).[16] In addition, there are also small versions of large pictures by Rubens, not to be confused with the sketches (drawings and grisailles) referred to, which were intended as patterns for the engravings. It is difficult to guess the purpose of these 'reductions'. They have much to tell us, however, about van Dyck's interpretation of Rubens's painting.

St Ambrose and the Emperor Theodosius (London 50; Rubens's work in Vienna, inv. 524) demonstrates well the different attitudes of the two artists. Van Dyck's sketch is a translation of Rubens's broad composition in terms of the limited space of a stage packed with figures, linked together by their consciousness of each other and by their movements. There is something almost neurotically sensitive about the hands that reach out and the light which brushes past the heads. The whitish-yellow brush-strokes which model the heads, the reflections on the armour, and the sheen of the robes combine with the texture of the canvas (which, in the Venetian manner, appears through the paint) to make a decorative web, binding together principal and subsidiary figures on equal terms. The emphasis of Rubens's careful and logical build-up, culminating in the figure of St Ambrose emerging from a classical temple gate, is shifted, and the flow of the gestures broken; moreover, the concealment (by a dog) of the corner of the flight of steps where the meeting takes place shows that construction in space has been ignored from the beginning. And yet these are not simply the shortcomings and misjudgements of a young artist – on the contrary, van Dyck has deliberately exchanged monumentality for richness of movement and emotional expression. The look in the eyes of the rejected emperor is imploring, and the whole figure is suffused with emotion.

Van Dyck's works in these years were often paraphrases of Rubens. He certainly did not have Rubens's marvellous power of visualization, which enabled him to reach perfection in the first sketch or drawing. An example of free paraphrase of an older work by Rubens is *Samson and Delilah* (Dulwich). Here again we find the restlessness and impassioned movement, and also the lack of concentration. Van Dyck is not economical

with gesture. There are wonderful painterly effects; for instance the sleeping giant with his rusty-brown, taut skin snuggling into the white satin drapery which falls in restless folds about him. The falling movement is reflected in a remarkably suggestive manner by a repetition of the declining diagonals. In colour and technique (for example the blue-grey shadows) this painting is closer to Rubens's ideas than those we have discussed so far. Perhaps it is one of van Dyck's first variations on Rubens.

Van Dyck painted *St Martin* twice.[17] There is a story attached to the painting at Saventhem that van Dyck did it while he was staying in the village before his departure for Italy, but in fact it must date from a few years earlier. It is close to Rubens in technique and spirit; the enamel-like colour is put on according to Rubens's usual procedure, and the two beggars (and the preparatory drawings for them) are both of the same character as Rubens's figures of the sick and the possessed in the *Miracles of St Francis Xavier* (Vienna; Plate 74). The other version (at Windsor; possibly from Rubens's collection) is not only an improvement (for example, the more eloquent pose of the arm holding the sword), but it is also expressed in the van Dyck idiom of a few years later. As in the *Taking of Christ* (Madrid), van Dyck's style has here freed itself from that of Rubens by taking on Venetian elements. The thin, dry colours (on a canvas!) give more warmth and depth than the glossy colours of before. However, the painting at Saventhem still has the savour of Rubens's uncomplicated compositions, in which the principal figure dominates, and architecture rounds off the whole. The Windsor version is more restless and more lively. The cloth which the saint is cutting in two with a sharp sword swells more turbulently (like the mantle of St Ambrose in van Dyck's reduction of Rubens's painting; see p. 113). The architectural theme is replaced by a more richly varied group of five figures, who burst the frame of their triangle with gesture and glance to come nearer to the saint.

We have already referred to the youthful *Self Portrait* (Vienna, Academy; see p. 112), which fits in so well with the early study heads as far as technique is concerned but announces an entirely new approach to portraiture. As a portrait painter van Dyck appears in quite a different light from that of the painter of apostles and saints in biblical scenes. Although his early portraits have a very personal style, many of them were ascribed to Rubens in later centuries, and even today there are difficulties in distinguishing between the work of the two artists at this period.[18] There are no reliable signatures, though a number of dates exist of the years between 1616 and 1620.[19] Between official commissions van Dyck painted a few portrait studies and 'genre' portraits, such as the *Portrait of a Lady* and the *Man Putting on Gloves* (both Dresden, 1023 c and d; Plate 99, A and B). These have exactly the same free brushwork as the study heads of the apostles in the 'robust style'. The strength and inner life are reminiscent of Frans Hals, who was himself born in Antwerp.

The portrait of Jan Vermeulen of 1616 (Vaduz, Liechtenstein Collection), one of the earliest we have, is already astonishingly elegant and assured. Van Dyck managed to maintain his own style of portraiture alongside that of Rubens, and he did not adopt the robust plasticity of Rubens's portraits, nor the enamelled gloss of his rendering of flesh colours. He also destroys the roundness of Rubens's forms by thick, white brush-

strokes. The effect of dark eyes against a fair complexion is most striking. Van Dyck's new style broke up the smooth, rounded colour areas demanded by the art of the Baroque–Classicist portrait, and it became livelier, more tense, more intimate. There are numerous examples from the years 1617–19 (especially at Dresden and in the Liechtenstein Collection). *Jean Charles de Cordes and his Wife Jacqueline van Caestre* (Brussels 386–7) belong to this phase and must have been even more characteristic of van Dyck's portraits before they were cut down.[20] About 1619–20 (portrait in Brussels (659) of 1619; Plate 98B) his emancipation from Rubens was complete.[21] Sometimes the delicate moulding in whitish-yellow shades goes so far that the portraits look like early works of Cornelis de Vos (Dresden 1023B, the so-called portrait of Marie de Clarisse).[22]

The years 1620–1 mark the climax of van Dyck's portraiture in the pre-Italian period. His handling is so perfect that the portraits appear to be spontaneously painted. This achievement seems all the more remarkable when we think how few works there are by Rubens at the same age that bear his personal stamp. The new style produced a new gracefulness, first in the *Self Portrait* (Plate 98A) perhaps, and after that in portraits of friends and fellow artists. The slightly inclined head, the play of hands, the multiple reflections of the light on rich garments give just that hint of controlled movement, of rhythm, of purpose, which the artist aimed to attain after he had lost faith in the robust forms of Baroque Classicism. The background is integrated into the composition. Columns, balustrades, and other fragments of Italian architecture support the structure and add a deeper note to the mood of the picture. Van Dyck now preferred to represent married couples in one double portrait or in portraits complementary to one another. The most exciting example of the period is the double portrait of Frans Snyders and Margaretha de Vos (New York, Frick Collection; Plates 100 and 101). No gesture is repeated, and each movement is seen afresh in both portraits. The first indications of Venetian elegance emerge without causing any disturbance in Flemish painting. Portraits so spontaneously perceived and painted were supported by a grand display in the background. Van Dyck painted respected citizens such as Pieter van Hecke and his wife Clara Fourment (Paris, Edm. Rothschild Collection), Nicolaes Rockox and his niece Balthasarine van Linick with her son,[23] Isabella Brant,[24] and the art collector Cornelis van der Geest (London 52), Lord Arundel, and many others whose names we do not know (for example the so-called brother of Bishop Anton Triest, Gulbenkian Collection). The formal portrait of Isabella Brant is not less impulsive than the light-hearted one of Rockox's niece with the two-year-old Adriaen van den Heetvelde. Lord Arundel's portrait (New York, D. Guggenheim Collection) was probably painted during van Dyck's short stay in London (1620–1). It is more conservative and traditional than the others, but technically precisely the same as the preceding Antwerp portraits. English characteristics cannot be detected. The lost portrait of James I, which the artist certainly painted during his first short stay at the English court, must have been in the same style. Seen by the side of the traditional work of Paul van Somer and Daniel Mytens, van Dyck's portraits must, by their gracefulness, spontaneity, and naturalness, have made an immediate impression.

VAN DYCK IN ITALY

We have not a great deal of information about van Dyck's stay in Italy, and the sources contradict each other on many points. Unlike Rubens, van Dyck did not serve any one patron. Though it is thought that he lingered in Genoa with his friend Cornelis de Wael, he must have travelled around a good deal – Rome, Venice, Florence, Milan, Mantua, Turin, and Palermo are named as stages – looking for patrons and making rapid sketches after ancient statues and works of the Renaissance. He was driven from Palermo by the plague while he was in the middle of painting a great votive picture. Rome seems to have been spoiled for him because he quarrelled with the artists' club of the 'Bentveugels'. In Venice he must have met the Countess of Arundel, who quickly took him on to other places in northern Italy, and would have liked to have got him to England. There is something insecure and aimless about van Dyck's wanderings in Italy, and the six years in the south were not productive either. His earlier years in Antwerp were richer in creative ideas and great works. While Rubens was able to report proudly to the Duke of Mantua that he had received the most desirable commission in the whole of Rome, van Dyck was never a leading figure in any of the artistic centres of Italy; only as a portrait painter in Genoa did he produce any exceptional and outstanding work, continuing the style created by Rubens.

It is an open question whether van Dyck went first to Venice. Bellori begins his biography with a description of van Dyck's activities there, but Dumont, who emphasizes the importance of Venetian art for van Dyck,[25] maintains that he arrived in Genoa on 20 November 1621, thus taking one and a half months to reach Genoa from Antwerp. The following year he was for a short time in Rome, Florence, Bologna, and Venice, and then for eight months in Rome again, whence he returned to Genoa. During the spring and summer of 1624 he was in Palermo. Dumont considers that the year after, that is in 1625, after a final stay in Genoa, he returned to Antwerp via Marseilles, but we have reason to believe that he returned home only in 1627.[26]

One precious document of van Dyck's Italian journey has not been mentioned yet: the Chatsworth sketchbook. This is a book containing notes on numerous Italian drawings and paintings, the latter copies in a few lithe strokes after compositions by Titian and also by Raphael, Leonardo, the Bolognese artists, and others. He filled in the shadows with the brush, producing extremely picturesque effects. The sketchbook does not give any decisive clue to his journey. Only one date is noted, 12 July 1624, when the artist did a portrait of 'Sigra. Sofonisma' (Sophonisba Anguisciola) in Sicily. Portrait studies from life are otherwise rare. It does not necessarily follow from the great number of Venetian compositions that van Dyck worked chiefly in Venice, but only that his attention was everywhere specially drawn to the paintings and drawings of Titian. He was fascinated by Titian's use of colour, by the softness of his drawing, and by his open, unfettered composition. Apart from Titian, van Dyck was thrilled by Veronese's decorative style – more than by Tintoretto's expressionist and ecstatic Mannerism.

Among the painted copies after Titian the most beautiful example is the *Madonna*

with St Dorothy (London, Count Antoine Seilern Collection).[27] Without abandoning his personal style, van Dyck has succeeded here in creating a work in the Venetian vein with all the pictorial beauty of Venetian art. Another painting entirely in the spirit of Titian is the allegory of *The Four Ages of Man* (Vicenza; Plate 97B). The gestures, flowing into one another, provide a beautiful rhythmic accompaniment for the subdued movements of the principal figures. The light, too, has the calm radiance of a Giorgione painting. On the left, where the man with a grey beard is placed above the baby, the colours are harsher and the contrasts clearer. The *Tribute Money* (Genoa, Palazzo Bianco) is also a painting in the Venetian spirit, but more restless than the *Four Ages*. Among the compositions of the Virgin and saints are a number of pieces which interpret ideas by Titian and Veronese (Turin, New York, formerly Henry Goldman).

It is difficult to date the Italian paintings exactly. We can assume that the paintings executed in the Antwerp technique – with thickly laid-on colour and with sharp white lights on the folds of the garments and on the beards of old men – are earlier than those paintings whose characteristics include thinly laid-on paint on rough Venetian canvas, with delicate nuances. Thus the *Incredulity of St Thomas* (Leningrad) and the *Susanna* (Munich) are earlier than the *Holy Family* at Turin or the *Adoration of the Child* in Rome, and earlier, too, than the serious *Ecce Homo* (Birmingham, Barber Institute). Yet Titian's art, and indeed sometimes that of Tintoretto, had meant a great deal to van Dyck already in Antwerp. The last version of the *Taking of Christ* (Cambridge, on loan) is more Venetian than the earlier. We have noticed the same trend in the second version of the *St Martin*, and in his portraiture (p. 115). In some cases it is difficult to decide whether a painting was produced while van Dyck was still in Antwerp or after his arrival in Italy (*Magdalen*, Amsterdam; *Incredulity of St Thomas*, Leningrad; *Stoning of St Stephen*, Lord Egerton).

Titian's sense of *peinture* fascinated van Dyck. Light and shade play over the whole surface, crossed hands merge into the folds of a garment. The magnificent gestures of the High Renaissance and the Baroque force of the diagonal are subtly transformed by a loose composition and an informal, painterly treatment. Van Dyck's penchant for softening effects, for the refinement and enrichment of forms created by an older generation, is not only a question of personal vision; it embodies the tendency of his generation, building on the achievements of the first generation of Baroque artists, who had themselves in their early days protested against what they felt to be the outdated Mannerism of their teachers. On the other hand, one should not overestimate the Venetian heritage in van Dyck's work. His Bolognese experience, especially that of the classical art of the Carracci and of Guido Reni, made a deeper and more lasting impression on him.[28]

Side by side with Bologna and Venice the work of Rubens, particularly his Italian paintings, continued to excite van Dyck. The various versions of *St Rosalie* were derived from compositions related to Rubens's *Assumption of the Virgin*.[29] The mood of heroic ecstasy is replaced by something elegiac, or fierily dramatic. Every movement is drawn out to twice its value without any counterpoise or support. The principal work of van Dyck's last years in Italy is *The Virgin of the Rosary* at Palermo (Plate 105).[30] When in

the autumn of 1624 he left Palermo because of the plague, it was not finished. He there-
fore had it sent to Genoa, where he worked on it till his final departure. The first plan
follows the scheme of Rubens's *Virgin and Saints* for the Chiesa Nuova in Rome (Plate
61), in its original version which Rubens had taken with him to Antwerp, with the
Virgin high in the air, and the two stately female saints on the right with supporting
figures behind. Otherwise van Dyck followed his own course. Nothing remains now of
architectural framework but one arch which seems to float in the air. It is typical of his
new conception that he avoids all the rigidity of horizontals and verticals, and an open
play of gesticulation between the figures replaces the tectonic structure of the older com-
position. Eyes and gestures follow an open ellipse from the Virgin to the saints and
back. This rising and falling movement gives the monumental painting a sort of in-
terior vibration which verges on sentimentality. The broken colours and the light spread
irregularly over the whole painting correspond with the restless luxuriance of the ample
draperies, and with the flying angels and the delicately drawn faces. The *Virgin of the
Rosary* is certainly van Dyck's most important work during his Italian period. Because it
was painted for a church far from the great centres of art, it made less impression on con-
temporaries and successors than it would otherwise have done. Indeed, van Dyck was
never really accepted outside Genoa, and even there it was not the altar-pieces that
established his name and brought him financial rewards, but the portraits of members
of important families. These formal portraits were mostly painted in the second part of
his Italian period.

As it happens, we also have a few outstanding and exceptionally well-documented
portraits from the first years of van Dyck's stay in Italy. Among the rare studies after
nature (or rather after a model) in his sketchbook are two pages with fashionably dressed
ladies and gentlemen, which, apart from a few notes on colour, are described as 'Am-
basciatore di Persia in Roma'. These drawings are preparatory studies for the portraits
of Sir Robert and Lady Shirley (Petworth Collection, Petworth; Plates 102 and 103),
which must have been painted by van Dyck in the summer of 1622 in Rome. Sir Robert
Shirley was at that time ambassador of the Shah of Persia in Rome. His picturesque
appearance and his beautiful Persian wife must have made an impression all round, and
not least on van Dyck himself. 'Antonio ritrasse questo Signore, e la moglie nell'habito
persiano, accrescendo con la vaghezza di gli habiti peregrini la bellezza de' ritratti', says
Bellori of these portraits.[31] Indeed, the broadly brushed-in garments are fine examples of
van Dyck's decorative art. The thick, firm use of paint is still entirely in the later style of
the Antwerp painters, when Flemish colourfulness was tempered by Venetian influences
which impart to the whole a deep warm glow, as if everything were filtered through
the coarse canvas. The paintings most like this are the portrait of Rubens's wife (Wash-
ington, Gulbenkian Loan; p. 115), and the so-called *Portrait of an Artist* (London 49),
which last was perhaps painted in Italy.[32] The delicate, creamy-white faces, from which
the dark eyes seem to leap out, are reminiscent of Cornelis de Vos, like the portraits of
Arundel and Cornelis van der Geest (p. 115). No break with the Antwerp past can be
discovered in van Dyck's portrait style. In this period he must have painted another
Englishman, George Gage, also ambassador to the Papal Court. This portrait of one of

van Dyck's personal friends is unfortunately lost. It was to Gage that van Dyck dedicated the etching of the *Descent from the Cross* after his return to Antwerp.

If Dumont is to be believed, van Dyck left Rome quickly for Venice and returned by a devious route the following year (1623) for about eight months. It is likely that during his second period in Rome he painted the portraits of Georg Petel (Munich 406), Frans Duquesnoy (Brussels 777), and Jean Leclerc (private collection).[33] They are more Italian than those of the Shirleys, and the colours are quieter, greyish, and less firmly modelled. Renewed contact not only with Titian but also with living Venetian artists may have stimulated this change. The formal portraits, too, were more freely painted now, and the artist placed himself at a greater distance from his model, both actually and metaphorically, as is evident in the portrait of Cardinal Bentivoglio (Florence, Uffizi).[34] The elegant Baroque pathos and the refined texture are entirely consonant with the Roman tradition. The *Bentivoglio* is perhaps van Dyck's most Italian portrait, although it does not seem to be based on any particular prototype.

The Genoese portraits are quite different. 'È à Genova che Rubens esercitò la massima influenza su Van Dyck' – the point has been put somewhat over-forcibly regarding this period.[35] Little is known as to the exact date of these portraits, though a few are dated 1625.[36] Van Dyck was often in Genoa, and it is probably necessary to postulate a longer period of time during which they could have been painted. It was in Genoa that van Dyck's portraiture flowered. Refinement and dignity, subtlety in colours, and great elegance of composition are here happily combined. The portraits of women are in no way soft or weak; on the contrary, their stateliness and the nobility of the pose accord with the palatial architecture of the background. To the famous works, such as *Paolina Adorno* and *Marchesa Brignole Sale with her Son* and the *Marchesa Elena Grimaldi Cattaneo* (both in Washington), we must add some lesser-known ones, such as the *Marchesa Doria* from the Rothschild Collection (now in the Louvre; Plate 104), the portrait of *Catherina Durazzo Adorno* (Genoa, Galleria Durazzo-Giustiniani), and the lady in the Galleria Balbi di Piovera at Genoa. All these astonish us by their tender colouring and majestic composition. At that time there was no one in Italy to equal van Dyck as a portrait painter. Though the type and the manner stem from Rubens's Genoese portraits (which applies as well to van Dyck's equestrian portraits), van Dyck painted with such personal conviction that he was able to produce something new and modern. These portraits are his most important contribution to Baroque art in Italy.

VAN DYCK IN ANTWERP, 1628–32

On 27 May 1628 James Hay, Earl of Carlisle, wrote from Antwerp to the Duke of Buckingham that he had shortly before been 'at Monsr Van-Digs to see some curiosities'. There he met Rubens, fresh from Brussels.[37] (The renewed personal contact of Rubens and van Dyck, incidentally, belies the old gossip about ill-will and envy between the two artists.) We have plenty of information about van Dyck's 'curiosities'. A few years later (1631) Marie de' Medici had the notion 'd'aller chez luy, où elle

vid dans la sale le cabinet de Titian; ce veux dire tous les chefs d'œuvres de ce grand Maistre'.[38] A catalogue has also been found, from which it appears that van Dyck owned nineteen paintings by Titian, besides some four of his own copies after Titian and other Venetian paintings.[39] Knowing what we do about van Dyck, we are not surprised at this continued passion for Titian.

It is uncertain how long van Dyck had been in Antwerp when the Earl of Carlisle visited him. We have seen that on the occasion of a settlement concerning the Virgin of Palermo on 8 April 1628 the painting was referred to as 'nuovamente fatto'; in any case the artist was already in Antwerp on 8 March 1628, when he made his will.[40] In that year he became a member of the Brotherhood of Bachelors. Two years later the Archduchess Isabella Clara Eugenia made him her court painter.

The Antwerp years were extremely active. Van Dyck painted many portraits, of princes and commoners, of collectors and fellow artists; he also sent paintings to England and was at work on great commissions for churches in Antwerp and other towns. Again in 1628 he painted the altar-piece which is still in the north aisle of the Augustijnenkerk, *The Vision of St Augustine*.[41] Rubens painted the high altar in this church, and Jordaens did the *Martyrdom of St Apollonia* in the other aisle (see pp. 95 and 131). The patrons who knew van Dyck's ecclesiastical work from the *Carrying of the Cross* in the Pauluskerk (Plate 96) or from the *St Martin* at Saventhem must have noticed that the former colleague of Rubens was now painting and composing in an entirely different style. Indeed, anyone who looked carefully at his last paintings before he left the Netherlands would have realized that the young painter had left behind Rubens's Baroque Classicism. The *St Augustine* of 1628 is not only more 'Venetian' than the older works, but it is also more painterly. The move from plasticity to painterliness is typical of the development in Flanders between the second and the third and fourth decades. Rubens's work shows it, and we shall note it also in the work of Jordaens and the lesser masters. Van Dyck's painterliness was, of course, expressed in a different idiom from that of Rubens, and even on different materials. Van Dyck is the artist of the canvas, the canvas which gives colours a warm ground in Venetian manner, and in which greys, blues, and browns are predominant. The light is tempered with grey. Compositions remain in one plane, and their charm lies in a refined movement of contours and in the pathos of the gestures. Heavenly and earthly beings are caught up in the sweep of elegiac sentiment or intense emotion. The *St Augustine* is also an example of the well-thought-out groups and disposition of light and shadow within the closely organized half-circle out of which the saint rises. It is not impossible that the tremendous agitation of the *St Augustine* is the result of an effort to emulate the brio of Rubens's painting in the same church.

As a rule, scenes from the contemplative life of saints or the Passion of Christ suit van Dyck's temperament better. He painted such a subject the following year, *St Dominic and St Catherine of Siena at the foot of the Cross*, for the convent of the Dominican Sisters. An inscription painted as though carved in stone explains what occasioned this work (Antwerp 401).[42] Van Dyck had painted *Christ on the Cross* earlier in Antwerp and again in Italy, with a pathos and strength derived from Rubens. The *Crucifixion* in Lille (Plate 106), which was probably painted soon after his return to Antwerp, is a large

work whose composition is unusual: the two Marys and St John point towards the figure of Christ at the left of the picture. The diagonal movement is taken up by the trotting horsemen. Van Dyck had already tried something of the same kind in Italy (S. Michele di Pagana), but the earlier painting lacks the concentrated diagonal movement of the later. A few years afterwards he returned to the idea of a central composition (Malines, St Rombout; Dendermonde, Notre Dame). About 1630 he attained in the *Crucifixion* in St Michael at Ghent (now badly damaged) a complete dematerialization of the body through its flat presentation and the *sfumato* of the grey tones. The old Baroque diagonal movement is replaced by internal vibration and tension, with controlled gesture and restrained grace in the lines of the composition. Like the *Crucifixion*, the themes of the *Lamentation* and the *Deposition* gave rise to a series of variations. It is remarkable that one of the earliest versions (at Antwerp, 403, painted for the Begijnhofkerk) in the pathos of its simple gestures resembles one of the later versions (of *c.* 1634, Antwerp 404). Between are some whose Venetian qualities dominate in so many details as to diminish the monumental effect.

The Sacra Conversazione, the Virgin and saints, the Rest on the Flight into Egypt are the subjects in which van Dyck's new style finds its most complete expression. Among the three themes it is perhaps the Munich *Holy Family* (555) which is the most perfect Flemish painting after the Venetian pattern: the folds ripple over the figures, the light is absorbed into the tender tones which fade into the background in washes of rosy-blue, the heads are quietly bowed, and the hands point down in descending lines.

Van Dyck was a hypersensitive artist with means of expression more subtle than those common to his age. There can be few paintings in the whole of Baroque art which express surrender and devotion so strikingly as the *Vision of the Blessed Herman Joseph* (Vienna inv. 488; Plate 107), one of the two altar-pieces which van Dyck painted in 1630 for the Brotherhood of Bachelors. The three hands of the Virgin, the Angel, and the Blessed Herman Joseph are joined. Venetian composition and the dynamics of Flemish painting, shown in the warm surface of the draperies, have combined here to produce a painting of magical charm and grace. The new style of the thirties now finally displaces the early 'robust' or plastic style. At exactly the same time Rubens was accomplishing a decisive enrichment of his pictorial expression, and here too the change was brought about by renewed contact with Venetian painting.

Van Dyck's portraiture also underwent a noticeable change, though he did not bring the Genoese type to the Netherlands – the pair of portraits in the Louvre (1973–4) in its Italian composition is an exception. What distinguishes all the portraits of the years round 1630 from their predecessors is their greater pictorial freedom, their easy placing in space, and the soft modelling, which subordinates the details to a general impression of great sensitivity. We look in vain for the piercing eyes, the thick paint, and the rigid lines of earlier days.

A touch of the Venetian spirit in painting has ennobled the nervous early style. If we compare *Prince Rupert* (Vienna inv. 484) with an early self-portrait (at Leningrad or New York) or the *Lady with her Daughter* (Munich 599) with the same theme in Leningrad, *Balthasarine van Linick* (see p. 115), the difference leaps to the eye. One must see the

Munich portrait together with its companion piece the *Portrait of a Gentleman* (portrait of Colÿn de Nole, Munich 603) to realize to the full on how large a scale and yet with what freedom this group of two paintings is built up. The flowing brush-strokes have a masterly looseness and the attitudes are easy. The freedom and delicacy of expression are equally admirable in portraits that are more simply constructed. The couple in Dresden (1027–8) is another excellent example. Van Dyck's most successful portraits are often groups or pairs. The figures are not bound together by actual movements towards, or away from, each other, but the relationships are more subtle: a gesture which is repeated in the complementary picture with a slight variation, the bowing or turning of a head which is answered almost imperceptibly. Among the portraits of bourgeois families are two groups whose sensitivity and pictorial delicacy place them among the most beautiful painted by van Dyck in this period. They are the so-called *Daniel Mytens and his Wife* (Duke of Bedford Collection) [43] and the *Sebastian Leerse with his Wife and Son* (Kassel 123). There is a rare balance between observation and elegance of effect, between human dignity and outward display.

About 1627 van Dyck painted Isabella Clara Eugenia, Governess of the Netherlands, probably not from life but after a Rubens picture of 1625. The year after he painted the Stadholder of the Northern Netherlands, Frederik Hendrik, and his wife Amalia van Solms, and in 1631 Marie de' Medici, a portentous representation of a portly person.[44] Marie's courier, Jean Puget de la Serre, could not sufficiently praise van Dyck's achievement.[45] The series of portraits of artists and of Antwerp citizens are, however, more dignified, pleasanter, and more exciting than the court portraits for which van Dyck had as yet found no new style of his own. The portraits of Philipp Le Roy and his wife Marie de Raet (London, Wallace Collection),[46] for example, have more grace than the portraits of the Dutch Stadholder and his wife; yet van Dyck's contemporaries admired the official portraits just as much – as is shown by de la Serre's praise.

There was certainly no lack of commissions in Antwerp, whether for portraits or for ecclesiastical paintings. Why, then, did van Dyck not stay on? Was it the ambition to be as highly honoured abroad as Rubens, and to work at a real court, or was it the same restlessness that drove him from place to place in Italy? For a time it looked as though he might settle in Holland; in the end, however, it was his stay in England that culminated his career as a portrait painter.

THE LAST YEARS

Van Dyck's English portraits dating from his first stay were no longer representative of his style, and he therefore tried to re-introduce himself in England as a painter of historical subjects. In 1629 Charles I, whose intermediary was Endymion Porter, bought van Dyck's *Rinaldo and Armida* (Baltimore).[47]

In 1632, just as van Dyck was preparing to go to England, Sir Balthasar Gerbier had the good fortune (or so he thought) to sell his *St Catherine* to Charles I. In the event, there were all sorts of difficulties, for van Dyck suddenly had the idea that another

version of the same composition (which had been sold to Holland) was the real one; but according to Gerbier van Dyck 'estoit mis un soudaine caprice en teste de ne vouloir faire le dit Voiage', and moreover he was 'si malicieux que d'aveoir voulou faire passer pour bastard sa propre créature'. Gerbier's annoyed letters from Brussels date from 12 and 13 March 1632. Van Dyck, he says, is now in Brussels again 'et fait dire qu'il résolu d'aller en Angleterre'.[48]

Before he actually crossed to England van Dyck must have been in Holland. In January 1632 he painted the portrait of Constantijn Huygens, and perhaps another portrait of the Stadholder and his wife. In any case there were a number of his paintings in the possession of the House of Orange.[49] He seems to have painted a big *Rest on the Flight* for Frederik Hendrik – it turned up in the sale of paintings at Het Loo – and another version, according to Bellori, for Henrietta Maria.[50] From this period, too, may date his *Amaryllis and Mirtillo* (Göteborg and Turin), 'una favola del Pastor Fido' (Bellori), which does honour to van Dyck's skill as a composer of mythologcial scenes, but which is disappointing as a Baroque resurrection of Titian's example, particularly if one compares it with Rubens's *Bacchanal* (Stockholm).[51]

Biblical and mythological subjects proved not to be in demand in England. *The Cupid and Psyche* (Hampton Court) is rightly regarded as the most personal and least traditional of the small series, for in it refined feeling is accompanied by great simplicity of composition and directness of gesture. It is a fragile painting, Baroque–Classicist in character.[52]

Van Dyck was at first engaged by the king as his portrait painter, with prerogatives hitherto unheard-of in the way of payment, status, and accommodation. As 'the principal painter in ordinary to their Majesties' he was knighted in 1632. In the following year he was granted a pension of £200. He was repeatedly visited in his studio by the king, who lavished commissions on him: portraits of himself, of his royal entourage, and of his children and children-in-law.[53] The aristocracy and the courtiers completed his clientele. With all his own copies and with later ones, copies of copies after copies, van Dyck's style threatens to be submerged in a uniform gallery of costume pieces, but the hundreds of portraits, innovations in the way they were seen and formulated, are yet works of outstanding quality, and show that van Dyck was an ideal portrait painter, who could convey the social position of his sitters and their secret longing for elegance. His colours, which betray a predilection for light blue, yellow, and green on a background of grey satin or of dark blue, are overwhelmingly rich, and show a pictorial refinement which was unique at that moment in European art.

Concerning van Dyck's technique we have a certain amount of contradictory information. Lanier told Sir Peter Lely that he sat for him for seven days, from morning to evening, without being allowed 'to look at the picture till he was content with it himself'.[54] Others tell us that he worked quickly, and never spent longer than an hour on the same model: the servant came in at the appointed hour to lead away one visitor and bring in the next. In this way the artist could easily finish two portraits in one day, with the help of assistants for the background and detail.[55] Possibly one story is as true as the other. Van Dyck worked in an irregular manner, for he was too highly strung to

be systematic. There are two points of view about his likenesses too. Sophia of Hanover was disappointed when she saw Queen Henrietta Maria in the flesh – van Dyck had made her far too beautiful; other English ladies thought he had done them less than justice, and asked to have their portraits touched up.[56] But the very fact that van Dyck painted so many portraits in so short a time, and that Mytens and Janssens went instantly out of fashion, shows that he was famed and sought after as a portrait painter.

Apart from those in English and American collections, the portraits in the Hermitage show his skill particularly well:[57] the *Eberhard Jabach* (Plate 109B), for example, from the first years of his stay in England, delicate and graceful with marvellous reflections of light on the glittering black,[58] and the two sisters *Philadelphia and Elizabeth Cary* (Plate 108B), one of his last works, with fine, broad brush-strokes of white and blue paint in the draperies, and a green curtain forming a pillar of colour to support the younger sister. It appears, however, that in his last portraits, painted between 1638 and 1640 – for example *Sir John Borlase* and *Lady Borlase* (Bankes Collection; Plate 109A) – van Dyck used a very generous, broad, open manner of painting, while the first English portraits were highly delicate, with broken colours and grey *sfumato*. However, the latest portraits were simpler and less aristocratic than the demonstratively courtly ones from the beginning of the thirties. Might renewed contact with the bourgeois art of the Netherlands have brought about this remarkable change in style?

For in 1634 van Dyck was again in the Netherlands. Why did he go? The fact that he did not become naturalized shows that he hesitated to settle for good in England. Was he perhaps thinking of becoming court painter to the new governor (Isabella Clara Eugenia had died on 30 November 1633)? In any case, he painted the portrait of the new regent, Archduke Ferdinand, in Brussels. A copy of it, made for the town authorities at Antwerp, was used for the decorations when the archduke arrived in Antwerp the following year. Commissions came from all sides, evidence of the admiration in which he was held. In Brussels he painted a large group portrait of the town council, which was unfortunately destroyed in the bombardment of 1694. The Antwerp artists made him honorary Dean of St Luke, a title until then granted only to Rubens. He bought a country house.

Was he then intending to stay in the Netherlands? Once more he set furiously to work, painting portraits of noblemen of the Brussels court, such as Francisco de Moncada and Prince Thomas of Savoy, both on horseback, and both without originality as types of portrait; the Duke of Orléans; Count Jan van Nassau Siegen; two Duchesses of Orléans; and Beatrice de Cusance, in spirit and form the most English of them all.[59] The *Abbé Scaglia* is the most successful of these great portraits. It has a calm nobility and distinction about it which inspire reverence.[60] The Abbé commissioned the melodramatic *Lamentation* (Antwerp 404) referred to above, a painting much stiffer and cooler than the Titianesque, more sentimental picture of the same subject at Munich (606), which must have been painted in the same year, 1634. The wealth of blue in the Munich version, however, is exceptionally beautiful.

But again it is the simple, unaristocratic portraits which are most exciting: for example *Justus van Meerstraten and his Wife Isabella van Assche* (Kassel 126–7) and

Quinten Simons (The Hague 242; Plate 108A). The latter particularly is a lovely example of how real vision and grand display can go together, and how a little landscape can mean more in the background than decorative architecture. The delicate shading of dark brown and green tones heightens the feeling of spatial freedom. A balance is attained between the sometimes rather forced gesticulation of the earlier Antwerp portraits and the frigid grace of those of the English nobility. The dreamy atmosphere is needed as a safeguard against a liveliness now considered out of date. The best portraits are sensitive and refined abstractions of what would otherwise be too personal or too realistic. Rubens's vitality was as alien to van Dyck as was his use of colour in all its rich beauty.

In his etchings and drawings van Dyck could sometimes produce completely painterly effects. He put this gift to good use in the great series of portraits which is known as the *Iconography*. It consisted at first of eighty etched or engraved portraits of princes, scholars, and artists. Eleven of them were etched by van Dyck himself, a few were begun by him and finished by others, and the remainder were made independently by engravers after his drawings. We do not know exactly when the plan was conceived. Naturally van Dyck used portraits from an earlier period as his models, but it does not follow that we can date the beginning of the series as early as the models. The scheme probably matured slowly after his return from Italy. His journey to Antwerp in 1634 may also have been undertaken with the purpose of finding a publisher for this venture.[61] On 14 August 1636 he wrote from England to the learned librarian of Lord Arundel, Francis Junius: 'I have caused the portrait of the Chevalier Digby to be engraved, with a view to publication, I humbly request you to favour me with a little motto by way of inscription at the bottom of the plate.' The motto was sent: *Impavidum ferient*. This is the only document which we can connect with the *Iconography*. The early prints are very sensitive, elegant, and lively. Sensibility finds adequate expression in extremely fine lines, in the faces generally more than in the costumes (which van Dyck often only sketched, leaving the execution to others). The *Iconography* was the first series of painted portraits which had *grandezza*.

At the beginning of 1635 van Dyck must have been back in England. Apart from the portrait commissions which we have already referred to, he was busy for some time with a large-scale plan, the decoration of the Banqueting Hall in the Palace of Whitehall (where Rubens had just painted the ceiling) with scenes from the history of the Order of the Garter. Three scenes were to be carried out in tapestries of which the designs were supplied by van Dyck. Sir Kenelm Digby, whom Bellori calls his friend and protector, had got the king to agree to the plan, but nothing came of it because the cost – 300,000 scudi – was shockingly high. All that remains is the oil sketch of one scene (Duke of Rutland Collection), a thin composition of grey shapes which gives our imagination insufficient material on which to build.[62] We do not know whether it was this setback which drove van Dyck once more from London, or whether it was the clearly foreseeable breakdown of court life. The king was behindhand with his payments and – equally as tiresome – had substantially reduced those already agreed.[63] In any case van Dyck was back in Antwerp and Brussels after Rubens's death in 1640. It was proposed to

ask him to finish a painting commissioned from Rubens by Philip IV, but the Cardinal Infante Ferdinand feared that the artist, 'siendo tan gran pintor', would refuse to complete another man's work, though he was ready to paint according to his own ideas.[64] The following year he was in Paris for a short time. He was not able to secure the commission for the decoration of the Louvre, and he was too ill to paint Richelieu's portrait. Shortly afterwards he died in London (9 December 1641).

The years in England enriched van Dyck's vision as a portrait painter. Compared with his portraits, his 'histories' are flat and dry, while his decorative schemes got no farther than a first draft, or – as in the case of the Louvre – not even as far as the first sketch. But as a portrait painter he rose high above the level of provincial Flemish art. Not only was he copied and imitated; in spite of his irritability, oversensitiveness, and instability, he was able to create a type of portrait which gave a new direction to European art.[65]

From this survey the royal portraits have been excluded, as they have already been dealt with in another volume of the *Pelican History of Art*.[53] There remain, however, van Dyck's drawings, in which the artist reveals himself as a man of creative power and of unusual visual awareness. Like Rubens, he made quick sketches in pen and ink for biblical compositions, but unlike him he repeated and varied the same theme very often till he found the perfect solution. His vision grew and took shape as he worked. He followed Rubens's example in making detailed sketches in chalk from life. He also used oil sketches, mostly grisailles, as preparatory studies for compositions and as models for the engravers when the painting was finished. When he began to work systematically on the *Iconography* he produced a series of excellent brush drawings from nature (Plate 111), a type of sketch very rare in Rubens's work. All of them are original works of art with their own characteristic beauty.

Van Dyck's landscape studies are a great surprise. The pen and ink drawings are rather in the style of Jan Brueghel (Plate 110A), but they are more graceful and delicate and less laboured. The water-colours and drawings with body colour which were done in England are so free from the usual conventions and technique that their traditional attribution to van Dyck has been doubted (Plate 110B); yet there is much that supports it, not least the fact that the landscape backgrounds of the portraits are often brushed in with the same freedom and fire. It was not the first time in art history that watercolour had provided a medium for free and inspired expression.

JACOB JORDAENS

ALTHOUGH Jacob Jordaens (1593–1678) was some six years older than van Dyck, a discussion of his work has been delayed until now because his most productive period tends to coincide with a later phase of Flemish painting than that of van Dyck. This does not imply that the later work of Jordaens is artistically more important than that of his younger years; on the contrary. But it cannot be denied that an artist who was mentioned after the death of Rubens as 'prime painter here' [1] must have been one of those who determined the aspect of the art of painting in Flanders for another thirty years. Whatever one may think of Jordaens's art, broad rather than profound as it is, by comparison with other history and genre painters of the post-Rubens period (Caspar de Crayer, Theodor Rombouts, Gerhard Seghers) he shows greater originality as well as richer fantasy.

EARLY WORKS

At the time when Rubens was staying in Italy, Jordaens, then fourteen years old, became an apprentice under Adam van Noort; however, as with Rubens, one cannot detect a direct influence of teacher upon pupil in Jordaens's work. Such an influence did not even make itself felt in later years, when van Noort had become Jordaens's father-in-law. In the years before 1620 his style rather indicates co-operation with van Dyck (although there is no documentary evidence), for we meet the same wild studies of heads of apostles in the early work of both (Plates 94B and 95A). Everything points to cross-influences between the painters of these studies. One-sided influence of van Dyck on Jordaens is less likely. Jordaens's heads are brushed a little more broadly even than those by van Dyck. They are, on the other hand, less sensitive and less refined, and one is tempted to say that their bravura is more superficial. Sometimes there is also a tendency towards a colourful and decorative arrangement of forms on the picture plane which is absent in van Dyck's work. This almost coarse, broad touch is a pre-eminent characteristic of Jordaens's sketches.[2] However, even in the great compositions of the early period we come across heads and hands painted in a very free manner. The portrait in Leningrad of Jordaens with his parents, brothers, and sisters is painted entirely with the broad and firm touch of the early sketches.[3] For certain recurrent types, such as aged apostles, the satyr, or the Negro, the artist clung for several years to this formula. Other heads and portraits are painted more carefully in 'opaque' colours, and are finished as carefully as Rubens's portraits of the same period, though perhaps not with quite his frozen perfection. The couple in Boston (173232; Plate 114) and a few apostles in American collections belong to this series,[4] while the family portrait in Kassel (107) unites characteristics of the free and the polished style. Finally, in the family portrait in Madrid

(1549) the artist has abandoned all youthful bravura and restlessness and has aimed at stateliness and dignity.

In the great historical and mythological compositions of Jordaens's early period, however, other influences prevail, both new and old, which give them their peculiar character. These are – apart from the continuation of Mannerist scrolls – a vigorous modelling of the human body and a realistic treatment of the surface which came to the Low Countries as part of Caravaggism, and the well-composed, cold Classicism of the art of Rubens in the years between 1614 and 1618. It is precisely in the alternate application of these different elements and in their remarkable interweaving that the great charm of Jordaens's work at this period resides. In the large nudes, such as the *Daughters of Cecrops* (1617, Antwerp 842), the allegories of the *Fertility of the Earth* (Munich 10411),[5] and *Aeneas crowned by Venus* (also called 'Venus saving Leander'; Copenhagen 344 as Isaacsz) the survival of the Mannerist play of undulating lines can be clearly observed. But even more evident is the vitality of the bodies with their white and pink and the bluish-grey shadows of the kind that Rubens painted about 1614–16. The realism in demonstratively displaying the soles of the feet, on the other hand, is Caravaggesque. Because the spectator is looking from below, the eye is drawn emphatically upward towards the plane on which the action takes place. This makes it possible to obtain the desired exaggeration of perspective for the foreground. This, together with the many feet, human and animal, and the many ornaments, produces an amazingly lifelike *trompe l'œil* effect.

There is a second *Allegory of Fertility* (Brussels 235; Plate 113), which must have been painted in the twenties and in which all these elements have been combined with more deliberation and economy.[6] Instead of serried repetitive movements, we are now shown one tall figure flanked by a squatting and a seated one precariously placed on the edge of the foremost plane. The background is closed by a luxuriant display of the fruits of the earth, supported on one side by a satyr and on the other by a Bacchante with grapes. The suppleness of movement is as striking as the glow of the pale flesh. During those years Jordaens worked on other allegories and mythological scenes in a similar manner. The *Offering to Ceres* (Madrid 1547) surpasses in clarity of arrangement the *Allegory of Wisdom* (formerly Berlin art trade).[7] This is probably an older work, as it exhibits a remarkable mixture of the rotund Classicism of, say, Abraham Janssens and the sensitive lighting of Rubens. The female figure on the left has been modelled entirely in the spirit and in the flesh of Rubens. Its contour is lively and the surface sensitive, and the light plays around it as on the female nudes in Rubens's work about 1620 (e.g., *Perseus and Andromeda*, Leningrad (Plate 68B) and Berlin). We may doubt, however, whether the greater or lesser degree to which Jordaens appears in command of the composition, and the greater or lesser crowding and concentration of masses, are always a criterion of early or late work. In the *Offering to Ceres* (Madrid 1547), for instance, several rough sketches exist which may, perhaps, be assigned to a much earlier period, whereas many details of the massive allegory show a relationship with Rubens's work of about 1620. *Meleager and Atalanta* (Antwerp 844), a composition of five half-length figures, has been tentatively placed at the end of the early period, about 1620: the *contrapposto* of the attitudes has

completely solved the problem of Mannerist lack of balance. Light and intermittent shade provide both spatial clarity and contrasts, and these are accentuated by a few accents of warm red and green.

Apart from the *Daughters of Cecrops* of 1617, there are only two paintings which bear a date before 1620. These are two *Adorations of the Shepherds*, one of 1616 in New York,[8] the other of 1618 in Stockholm (488). The candle-light effect makes the earlier work appear more Italian than the later, and it still has the doughy, unarticulated spread of the forms which was a feature of the *Daughters of Cecrops*. The greater economy and the more skilful apportioning of light and shade place the Stockholm version by the side of the Brussels *Allegory of Fertility* (Plate 113). The colours, too, have the sonority of the following years of Jordaens's activity. Again there is a passion for three-dimensionality in everything in the lower part of the painting: the copper jug is a masterpiece of illusionist painting, and the artist's signature is carved into the handle. Paintings with demi-figures cut off on both sides to achieve unexpected effects were one of Jordaens's predilections in those years. This mode of composition emphasizes the *trompe l'œil* idea of the painting as a piece of reality looked at through a window. Jordaens produced several variations on these compositions (San Francisco, M. H. de Young Memorial Museum; London, National Gallery, 164 and 3215; Stockholm 1678; Haarlem, Rhodius Collection; Antwerp, Mayer van den Bergh). Scenes of the Holy Family, sometimes with St Anne and St John, others of the Virgin and the Child alone, are equally numerous in this period (L. Burchard Collection; Reval, private collection; Warsaw Museum). The version at Bristol is broader and more spacious and therefore probably a little later. The apotheosis of all the early Adorations is, however, the painting at Grenoble (608), which is particularly striking because of its majestic fullness (Plate 115). The figures crowd in upon one another, and one should not seek here the clear mind of Rubens; but it is precisely this elemental and insouciant grouping of the figures, the busy movement, and the rough brush-strokes that give the painting its great charm.

It may be surmised that biblical scenes existed of a date earlier than the *Adoration of the Shepherds* of 1618, and that these showed in a special sense the influence of Rubens. Such an early work must be the *Holy Family* in Brussels (965). The Classicism here is reminiscent of Adam van Noort and of paintings by Rubens of about 1615, but Jordaens's execution is more robust. R. d'Hulst has added to this group a *Nicodemus and Christ* (Brussels 715, now at Tournai) which had hitherto been ascribed to Rubens.[9] The most important example, however, of an early adaptation of Rubens-like strength to the rough, sketchy painting technique which we associate with Jordaens's early studies is the *Crucifixion* in the Pauluskerk at Antwerp, which belongs to the Cycle of the Rosary (see p. 112). Jordaens repeated the subject a few years later (Teirninck Foundation).

In spite of such other influences as have been mentioned, the work of Rubens was decisive for Jordaens's early years. Rubens's Classicism often neutralized the Italian inspiration from Caravaggio. *Christ Blessing the Children* (St Louis, City Art Museum), with its half-length figures and classical tendencies, is closely akin to similar compositions by Rubens, such as the *Christ and the Woman taken in Adultery* (Brussels 381), where a few intruders disturb the dignity of the design.[10] More successful is the *Christ*

by the Sea of Tiberias (Antwerp, St Jacobskerk), in which the placing of the figures has real grandeur, where pathos and *contrapposto* go together, and where the classically beautiful profile of Christ is framed by the faces of dignified bearded men (Plate 112).[11] Also worthy of Rubens and reminiscent of him is the painting of the flesh, bluish-green in the shadows and reddish-white in the light. Yet Jordaens retains his own very personal style, particularly telling, for instance, in undulating contours of robes and body and in contrasts between dark clothes and white skin over-emphasized by strong light falling in from the side (*The Good Samaritan*, formerly in the Polish Collection; *Moses striking Water from the Rock*, Karlsruhe).[12]

In 1615 Jordaens was already a Master of the Antwerp Guild; remarkably enough he was put down as a '*water scilder*', that is as an artist who preferred to paint in tempera. Such painters at the time concerned themselves with painting on canvas or paper as a cheap (though less durable) substitute for tapestries.[13]

WORKS BETWEEN 1620 AND 1640

It is one of Jordaens's most characteristic traits that he often repeated a composition with slight variations or resurrected a theme a few years later. He must often have carried out these re-creations himself, particularly in the early part of his career; the later ones, however, must be assessed with caution, for Jordaens did not mind making use of his pupils. From 1623 onwards their names appear in the guild books, though none of them achieved fame.[14] From other documents it appears that Jordaens undertook large commissions with the proviso that he should be allowed to finish them with the help of pupils. In 1648 he declared that a certain number of paintings, sold under his name, were only copies by his pupils, which he 'painted with his own hand, over-painted, and re-painted' so that they could pass as originals![15]

Jordaens was chosen as dean of the guild for the years 1620–1, a nomination which he seems not to have accepted straight away. But we can say that by about 1620 his early period was over and a homogeneous new style began to appear. He never went to Italy, nor did he ever work abroad, and for this reason his art, unlike that of van Dyck and Rubens, does not show any breaks between the different stylistic phases. The influence of Rubens declined as time went on. Although a few of his motifs continued to appeal to Jordaens, there was never any return to a specific Rubens style. Classicism was watered down, or rather it remained as the scaffolding, as background articulation, or sometimes as a mere architectural *coulisse*.

For the period 1620–30 we have only a few precise dates. Of 1628 is the *St Apollonia* (Antwerp, Augustijnenkerk), of 1630 the *Miracle of St Martin* (Brussels 234). In 1635 he collaborated on the decorations for the state entry of the Cardinal Infante Ferdinand, and there are a few more dated pieces from the end of the third decade.[16]

The plasticity which gave Jordaens's youthful paintings their special strength now lost some of its force. The foreground figures, which had formerly been pushed out towards the spectator, as it were, were now given more space, and with the space more

freedom of movement. *Mary and Martha* in Tournai (replica in Lille) is a good example of the gain in clarity of form and beauty of line. The great compositions of the *Lamentation* (Antwerp, Maagdenhuis) and the *Crucifixion* (Antwerp, Teirninck Foundation; Tournai, Museum) have more grandeur and pathos than the earlier creations, though in the compositions proper there is not much that is new. The *Martyrdom of St Apollonia* (Antwerp, Augustijnenkerk; Plate 117) of 1628 is a far from inferior complement to van Dyck's *St Augustine* in the north aisle of the same church. There is, indeed, a curious antinomy in Jordaens's picture: on the right is dramatic movement in the principal figures, echoed in the daring foreshortening of the eastern knights, while on the left there is such a *horror vacui* that every space is crammed with gesticulating subsidiary figures and with decoration. This muddle nullifies the dramatic movement on the other side of the picture.[17] Another example of dramatic effect choked by decoration is the *St Martin* of 1630 at Brussels, where the group of the possessed and their keepers forms a compact mass below a stone portico decorated with a tapestry, and populated by one dignified spectator. On the left, the saint who performs the miracle remains a small and modest figure.

There are some subjects where, precisely by means of this crowding and animation, a sense of richness and balance is achieved. Joachim von Sandrart could call Jordaens's representation of *St Peter Finding the Stater* simply *The Ferry at Antwerp* (Copenhagen 149; Plate 116A). In fact, the departure of the overloaded boat is the real subject, and the interest in the catch shown by the naked men on the bank is no more than incidental. The boat itself makes a lovely silhouette with the naked sunburnt sailors, and the people and the cattle bathed in sunlight. The colours are rich, the patches of shadow most engaging, and the outlines against the blue sky make a fascinating pattern. Jordaens had real feeling for people in action, though sometimes his bourgeois realism became prosaic and pedestrian. In the *St Peter Finding the Stater*, however, the liveliness of the figures is counterbalanced by the idealized muscular nakedness of the biblical figures close to the frame, and by the shape of the boat.

The theme of the single figure of a sage, or of God, a saint, or a pagan god surrounded by a number of figures greatly appealed to Jordaens. His many representations of the Satyr and the Peasant with his family, of Diogenes looking for a man among the crowd, of Christ in the Temple (full of robust Pharisees), are concerned with the solution of the same artistic problem. Biblical and mythological subjects are treated with plenty of realistic detail. His predilection for a burlesque interpretation of lofty subjects, such as the martyrdom of a saint or an offering to Venus, separates Jordaens's world from that of Rubens, where Christian and Human *virtù* are equally sublime and treated in the same grand manner. Jordaens's taste for the trivial as well as for the great saved him from the danger of becoming an epigone of Rubens. With it goes his delight in feasts, in the Flemish theme of 'The King drinks', in sayings and proverbs, all represented with cheerful exuberance. 'As the old sang, so the young pipe' is one of these themes. He painted it in many variations and on many levels of boisterous good humour. Here the crowding itself becomes an important means of suggesting unbounded content and happiness.

An artist with such a distinct feeling for the filling of a surface and the disposition of figures on the picture plane was bound to have a talent for designing tapestries. Some of his pictures give the immediate impression of being painted tapestries; indeed, as we have seen, Jordaens began as a painter of decorative substitute-tapestries in water-colour. One of his earliest series of tapestries is that of a 'Riding Academy'. Jordaens must have made such designs at least twice. In a contract of 1652 a set of 'Grands Chevaux' is described which seem from a stylistic point of view later than those of the 'Riding Academy'. Of some of the series we possess a few cartoons in tempera, of others we have water-colour sketches.[18] Between these two types of preparatory sketches fall small oil-paintings which served as *modelli*. The *Young Horseman* in the Spencer Churchill Col-lection (Plate 116B) is such a painting. It is connected with the early 'Riding Academy', and may thus be dated around 1635.[19] Mercury and Mars appear in it, and there are other more obscure allusions.[20] Reality and allegory are represented on equal terms, as are spatial illusion and decorative flatness. It is a game between constant indications of depth and the decorative spreading-out of forms on the surface with the delightful blues, reds, and yellows in the foreground. Jordaens's 'naïve' composition here shows itself at its best, and the absence for once of shouting, jostling people is a gain, especially in such a piece of ornamental art.

When, between 1635 and 1640, Rubens was obliged by gout to work more slowly, Jordaens was appealed to for help by various official bodies who had commissioned paintings. The collaboration began in 1635 when, together with Cornelis de Vos, Jordaens painted the triumphal arch of Philip IV, after Rubens's designs. For this occasion Jordaens also had to retouch the work of other artists, but none of the pieces left us from this festive decoration is important for our knowledge of his art. He also painted an *Apollo and Marsyas* in 1637 for the Torre de la Parada (now Prado 1551), after a sketch by Rubens, of which Philip was demanding completion. Jordaens's work is nothing more than an enlargement, and shows little personal ambition to equal Rubens's exciting design. But it is understandable that the Archduke Ferdinand was glad to find Jordaens so willing to finish the two large Bacchanalia which stood uncompleted in Rubens's studio at his death in 1640, for van Dyck, who was approached first, had refused to undertake such work.[21]

Just before this Jordaens had succeeded to another commission originally given to Rubens: the decoration of the Cabinet of Queen Henrietta Maria in the Queen's House at Greenwich. He was to provide at least twenty-two scenes from the story of Cupid and Psyche. The commission was given in a very mysterious manner, and Jordaens was not allowed to know the name of the person for whom the work was to be done.[22] The paintings which were delivered were sold under the Commonwealth and have since disappeared. The remainder may be identical with the paintings of Cupid and Psyche which are known to have existed in a house Jordaens bought in the same year.[23]

This renewed contact with the art of Rubens put a brake on Jordaens's powers of self-expression. All his paintings of these and later years, in which he followed either Rubens or van Dyck, tend to be dull. The *Betrayal* (Gaunø; after van Dyck, Madrid) and the *Prometheus* (Cologne), painted after a much older work of Rubens, are rather flat,

spread-out repetitions: they lack concentration and spontaneity. However, this falling-off in quality at the close of the thirties was soon followed by a recovery.

WORKS BETWEEN 1640 AND THE END OF HIS LIFE

The ten years between 1640 and 1650 were among the most prolific in Jordaens's life. Commissions poured in from Scandinavia, Holland, England, and France. The assistants had a busy time, which certainly did not conduce to high quality in the work. But apart from these large-scale commissions, there were enough paintings carried out by Jordaens alone to give us an insight into his true powers. The first works, such as the *Visitation* of Rupelmonde (Lyons, Museum) of 1642, are still a little pale in colour, and derive their composition from older pictures by Rubens. Even a masterpiece such as the *Adoration of the Magi* at Dixmuiden (1644; destroyed in the First World War) still depends upon a composition by Rubens; but Jordaens's own verve appears in the arrangement of masses and the filling of the surface. The surge of movement has a painterly freedom and boisterousness which belong to the High Baroque. The forms are rounder and plumper than those of Rubens, and of Jordaens's own earlier days. Another allegory, the *Fertility of the Earth* (1649, Copenhagen 151), has a similar piling up of ample bodies, which surround the arrangement of fruit and flowers in the middle like the points of a star. Yet in the composition of the figures there is much more freedom than in earlier works. Hercules leaning on his club, for instance, is a solitary figure outside the central group. This free management of painterly accents marks the next phase of Flemish Baroque, indeed its final phase. The climax from the point of view of the arrangement of masses in movement is the *Triumph of Frederik Hendrik* in the Huis ten Bosch (near The Hague; 1652; Plate 118). The architect, Jacob van Campen, who divided up the subjects for the various walls among the different painters chosen to carry out the decoration, provided fairly detailed instructions as to how the allegories and triumphal processions were to be worked out. Jordaens objected, asking for 'the freedom which is particularly necessary for such an occasion'. He said he would quickly send four or five sketches for Her Highness (Amalia van Solms, widow of Frederik Hendrik, whose plan it was to decorate the house in honour of the memory of the Stadholder). When he had finished the big canvas Jordaens sent to The Hague an 'annotation' consisting of fifteen points. In this he said that Mercury and Minerva are driving the four white horses which draw the chariot of victory. In the chariot the Stadholder, crowned by a bronze Victory, is seated. A second laurel wreath in front on the right is for Prince Willem, who had died young. In the air Death and Fame are locked in combat, while Peace is descending with putti bearing wreaths and garlands.[24]

At first sight the whole appears no more than an overwhelming, superabundant collection of men and statues, gods and beasts, through which four horses thrust their way exactly and rather comically in step. The allegory of Peace and Victory is so larded with dramatic and realistic details that it becomes a teeming historical procession. The classical architecture, a principal means for securing clarity of composition, is over-

whelmed by this procession, cutting across it, and filling every inch of space. Baroque movement has shaken off the last remnants of Renaissance balance and *contrapposto*. Or are we to take it that the statues of dead members of the family, the group of four daughters, and the youthful horseman, Prince Willem II, at opposite corners of the composition, are intended to round it off?

However, this may be, it was Jordaens's fate, after this climax of the Baroque, to have to go on working for another twenty-five years in a period of Classicist reaction. Tapestry design always invited the exercise of the decorative sense in the filling of surfaces. In the forties we have the *Proverbs* (the contract is of 1644), a series of eighteen tapestries bought by Archduke Leopold Wilhelm, Stadholder of the Southern Netherlands since 1647 (now in the collection of Prince Schwarzenberg, Frauenberg). Two cartoons and a number of preparatory drawings have been preserved.[25] We also know of one painting which repeats or varies the composition of one of the tapestries (*St Ivo* of 1645, Brussels 243). In comparison with the older series of the 'Riding School' there are remarkable differences to be noted. The elegant and playful architecture of the earlier work with its restless changes of light and shadow is replaced by heavier forms and more sober gestures. The new Baroque Classicism of the forties strikes a deeper note; there are still reminiscences of the stormy pathos of Rubens.

As the years went on the Classicist elements which had always been present in Jordaens's work became more dominant, and his vision soberer. He continued to paint boisterous peasant jollifications and family life, but when it came to ecclesiastical festivals and religious ecstasy, always the stock-in-trade of the Baroque, he had little inspiration to draw upon. Here indeed he was more restrained than his Flemish contemporaries. This new artistic sobriety is also connected with Jordaens's deepening religious views. He must have had contacts with the Calvinists for some time, and in later years he became a member of a Calvinist community, 'De Olijftak' (The Olive Branch), whose existence in Antwerp was tacitly allowed. He even became one of the leading members of this community and services took place in his house. He was fined by the sheriff of Antwerp for having 'written some scandalous writings'.[26] His predilection for painting moralizing subjects, sermons, and admonitions (sometimes with rather outspoken criticism of the Roman faith) is thus partly to be ascribed to his Calvinism. A moderate and restrained Classicism provides the right formula for this intellectualizing art. In Jordaens's case basic proverbial wisdom is embroidered upon and enlivened by his love of ordinary pleasures and the jollifications of burghers and their families.[27] However, his Calvinism never prevented him from carrying out commissions given him by Catholics.

In his biblical and allegorical scenes the rational element increases at the expense of the glowing quality of the painting. Classicism is a pleasant stage property to give the necessary cold splendour to the narrative. *Christ among the Doctors* (1663, Mainz) and *Christ blessing the Children* (Copenhagen 153) are examples. It cannot be denied that the unusually large *Christ among the Doctors* (originally in the St Walburg Kerk at Furnes; Plate 119) is a stately piece. The heads of the Pharisees and the scribes encircle the young Christ like the wreath of flowers round the statue of the Virgin in a Daniel Seghers. The

three-tiered composition of the figures creates solemnity. The scene is divided into horizontal zones by a balustrade, and columns and pilasters supply vertical accents. The stepped design with accompanying fragments of classical architecture is even more emphasized in *Christ blessing the Children*. In this case the figures are merely supers on a large stage. Groups of men, women, and children are spread over the wide staircase in a somewhat haphazard fashion. Movements lead nowhere. No gesture is emphatic, none calls for a counter-gesture. Christ himself is an insignificant figure among the apostles, and he is lent no support by the architecture, for the rhythm of arch and pilasters cuts right through his body.

The later works of Jordaens are for the most part pale in colour, greyish-brown with a few white accents. Equally typical of his late style are indeterminate compositions and loosening contours. A Classicist, somewhat theatrical architecture sometimes becomes the framework or the backcloth within which, or against which, the figures are placed. This Classicism of Jordaens's last years is in keeping with the universal style in Belgium and Holland, when under French influence Baroque Classicism was the strongest tendency there. But in the case of Jordaens this style, apart from the Rubenesque phase of his youth, had always been his personal idiom. His designs for tapestries are always worked out to Classicist formulas, in complete contrast to Rubens's Baroque pathos. In general, Jordaens's late historical scenes are poor in colour and weak in spirit, though once in a while he still succeeded in painting something that impresses by reason of movement and action. Thus the *Miracle of Moses* at Kassel (110a) is an attractive work, brimming with life. The contrast between the procession of thirsty humanity, divided into three zones, moving towards the spring, and the dignified semicircle of Moses and a few other figures results in one of the happiest compositions which Baroque Classicism has produced. The seemingly accidental interweaving of men and animals and of movement forward and backward gives much needed vitality to a composition rigidly divided into three horizontal zones.[28]

OTHER PAINTERS OF THE SEVENTEENTH CENTURY

BAROQUE AND CLASSICISM IN HISTORY PAINTING AND PORTRAITS AFTER THE DEATH OF RUBENS

APART from Jordaens there were few painters whose strong personality or fresh vision rendered them capable of exciting work in the field of the large altar-piece or of secular decoration in the grand manner. There is a tendency among scholars to measure everything that appeared in Flanders after Rubens's death by standards derived from his work, and to regard his successors as more or less weak imitators of his manner. In reality, however, most of the later history painters preferred to follow in the footsteps of van Dyck, and to imitate his painterly refinement and his attractive compositions. Important as Rubens's art was for the anti-classical trend in the twenties and thirties, he exercised little influence on the artists who belonged to the next generation. Many of them, including Caspar de Crayer, Erasmus Quellinus, Jan Cossiers, Cornelis de Vos, and Theodoor van Thulden, had a share in the work of painting the great canvases for the triumphal entry of the Cardinal Infante Ferdinand and for the hunting lodge of Torre de la Parada in Spain. For both the sketches were late works of Rubens, but in the stiffly painted enlargements there is not a spark of the charm of the originals.

Classicism with a feeling for the firm modelling of bodies, characteristic of Abraham Janssens and of Rubens himself in the years 1614 to 1618, was completely dominant in the second decade. Lodovicus Finsonius (c. 1580–1618), who mostly lived outside Flanders, never departed from this style; Anthonis Sallaert (c. 1590–1657) and the Dutchman Pieter Soutman (who was Rubens's pupil about 1618–20) tried to compete with Rubens himself in their early, strongly coloured and rigidly composed works, such as Sallaert's *Martyrdom of St Bartholomew* (Brussels, C. Vliegen Collection; Brussels Exhibition, 1935, no. 213) and Soutman's *Christ Appearing to the Disciples* (Oxford 413).[1]

In the work of Cornelis de Vos (1584–1651) we can follow the waning of Rubens's influence in portraiture. Before 1620 Rubens's style of about 1615 was decisive,[2] but about 1620 de Vos was already beginning to paint faces in thick, whitish colours like those of the young van Dyck. He never really got beyond this somewhat matter-of-fact but not unattractive style. All those changes in the direction of more refined colour and play of line which van Dyck made in Antwerp after 1627 left him unmoved. As a painter of altar-pieces he does not lack merit, a fact which goes largely unrecognized. His *Adoration of the Shepherds* in the St Pauluskerk in Antwerp (Plate 120A) is a sensitive interpretation of Rubens's altar-piece in Malines of 1617–19 (Plate 70). The *Finding of Moses* (Dufour Collection), the *Allegory of Vanity* in Brunswick (109), and the *Anointing of King Solomon* in Vienna (877) are probably rather earlier, and link up with Rubens's works of 1615–16. They are heavy in line and in construction, rather like Abraham

Janssens's work in the same years. The *Diana and Actaeon* in Graz of 1623 shows that the transition to an elegantly soft play of forms had by then been made. It is difficult to detect whether Cornelis de Vos had modelled himself on Rubens's mythological pictures of about 1620 with their delicate figures (*Perseus and Andromeda*, Berlin and Leningrad; Plate 68B) or the amusing scenes of Hendrik van Balen. A strange historical painting is the *St Norbert* of 1630 (Antwerp 107; Plate 125A), which depicts a nobleman returning to the saint the church vessels hidden in the time of the heretic Tanchelius, whose chagrined face can be seen between the protagonists of the story. Although the powerful composition and great forms are drawn from the Baroque art of Rubens, de Vos had by now developed a style of his own as a painter of group portraits, with occasional borrowings from van Dyck (cf. the man in the background on the left). The use of a biblical or religious story as a framework for a family portrait is relatively uncommon in Flemish art, though it had long been familiar to the Calvinist Dutch. In Flanders, portraits were usually found on the wings of an altar-piece. A comparison with the work of Abraham Janssens and Hieronymus van Kessel (1578–after 1636), both only a few years older, makes it clear that Cornelis de Vos deserves a place of honour as a history and portrait painter in his own generation.[3] Van Kessel's portraits of the years 1618 to 1620 are entirely in the tradition of Frans Pourbus, and as solid and dry as those of the Dutch Cornelis van der Voort and the Louvain painter Gortzius Geldorp, who later worked in Cologne. In de Vos nothing is left of this 'fossilized Mannerism'.[4]

An example of pure native Flemish painting is the work of Caspar de Crayer (1584–1669). Unlike his contemporary Jordaens, he did not descend into the burlesque or the popular genre. He had a feeling for the decorative possibilities of great altar-pieces, and was prolific without becoming banal. He too, naturally, was under the influence of Rubens and van Dyck, but he followed their changes of vision and style with a certain reserve, so that the development of his own personality was not obscured. De Crayer became a pupil of the Late Mannerist Raphael de Coxie in Brussels, and was made a master there in 1607. Apparently he at first concentrated on art dealing, for his earliest dated works appear only at the end of the second decade. Good examples of his early style are the *Job* at Toulouse (438, of 1619), *The Judgement of Solomon* in Ghent (1622), and the *St Catherine* in Grenoble (600), where we still find the powerful palette and extreme plasticity of Rubens's works of the years 1612 to 1615. If we date de Crayer's paintings according to the extent of their independence of Rubens, we shall have to assume that the *Adoration of the Magi* with the self portrait of the artist at St Maarten in Courtrai must be earlier. It is based on the Rubens composition of 1609–10 in Madrid which hung for a short time in the town hall of Antwerp (see p. 78). In its disposition of light it is even richer in contrasts than the model; there is clearly a Caravaggesque touch in the play of shadows which reminds us of the works of Theodoor van Loon, another Brussels painter. Something of these violent effects of lighting is still retained in the *St Julianus* of 1623 (Brussels 133), but gradually the contrasts between light and shadow fade into the 'moderate Classicism' of 1620–30, with which we are already acquainted. The figures often remind us of van Dyck at the beginning of the twenties, but the colour is lighter

and softer. Moreover, de Crayer has his own repertoire of sentimental figures, more blond and robust than those of the rather highly-strung van Dyck.

To the fifth decade belong de Crayer's most important works, mostly paintings of saints (*The Four Martyrs*, 1642, Lille 208) or of the Virgin with saints (e.g. Munich 809; Plate 121B). The iconographic and stylistic ancestor of most of the Virgins is Rubens's *Betrothal of St Catherine* in the Augustijnenkerk at Antwerp (1628; Plate 79), but the *sfumato* is that of van Dyck. De Crayer probably lived for a while at Ghent; he certainly painted much for the churches of that city, and delivered no less than eight large canvases for the decorations in honour of the state entry of the Cardinal Infante Ferdinand. Most of his altar-pieces are or were to be found in and around Ghent and Brussels. After 1664 he settled in Ghent. In later years, and even in works that must date from about 1650, we find a remarkable and very sensitive revival of a Venetian range of colours and Venetian schemes of composition (*Sacra Conversazione*, Brussels 124; *St Barbara, Circumcision, Adoration of the Shepherds*, St Michael, Ghent). Venetian influences had shown themselves already in earlier works of de Crayer; his *St Teresa* at Vienna (771) is a perfect re-creation of a Venetian van Dyck.

As a portrait-painter too, de Crayer is a reflection of van Dyck and Cornelis de Vos. It must not be forgotten, however, that the attribution of many attractive portraits of 1620–30 is not well founded (for example the *Portrait of a Woman*, Vienna, Academy, 514). The later, partly signed portraits of the Cardinal Infante Ferdinand (Madrid 1472) show no marked personal characteristics.

Dependence on Rubens was no longer the starting-point for the generation born in 1600–10. As younger contemporaries of van Dyck, they felt themselves drawn to his refined, less robust style. Jan Cossiers (1600–71), a pupil of Cornelis de Vos, proves this in an early work, the *Trinity* (Culemborch), painted in 1628, shortly after his return from Italy. The *Adoration of the Shepherds* of 1643 at Louvain (painted in collaboration with S. A. Delmonte) is much more in a bourgeois genre style, such as was popular in Holland. This mixture of Dutch and Flemish elements is also to be found in the series which he painted for the Béguinage in Malines. Though about 1635–40 he worked on large-scale paintings after Rubens sketches for the Torre de la Parada, he did not take over anything of Rubens's late style. His genre pictures – a scene with a soothsayer (Leningrad) was often repeated (Karlsruhe, Stockholm, Valenciennes) – are probably among his earliest works. Memories of his Italian journey, of Caraveggesque 'bamboccianti', are still alive in them, and in such subjects he is close to Simon de Vos (1603–76), also a pupil of Cornelis de Vos. But Simon de Vos's origins lie more in the tradition of the Franckens and Sebastiaen Vranx, and their influence remains dominant until about 1640–5, when he became familiar with the style of Rubens's and van Dyck's late works.

In Antwerp itself certain stylistic traits were never fully explored because of the dominance of Rubens and van Dyck. Caravaggism, for example, found its belated adherents elsewhere, in Brussels, Ghent, and Bruges. As we have seen, Rubens and Jordaens freed themselves from these influences before 1620. When Theodoor van Loon of Brussels (1581/2–1667) decorated the pilgrimage church of Scherpenheuvel

(Montaigu) with six great scenes from the life of the Virgin (1623–8; Plate 122, A and B; the seventh, *The Assumption of the Virgin*, is of later date), memories of the Italian works which he had studied in Rome fifteen years earlier were still fresh in his mind.[5] The remarkable thing is that this cycle reflects Italian Caravaggism much more purely and majestically than his own earlier paintings. His source of inspiration was the art of Borgianni. The robust Italian forms, the heavy masses of light and shadow, and the emphatic plasticity of the bodies create a monumentality which has nothing academic about it. There is occasionally something of Rubens about the draperies, but the almost sombre veracity and passionate realism express a vision and an attitude to life which we do not find in the earlier painter. In the work of so Italianate an artist it is easy to detect other Italian influences – particularly in his later period there are reminiscences of Annibale Carracci and Bassano – but in spite of this van Loon is not an ordinary eclectic painter. In the Montaigu paintings he shows himself unquestionably an artist of daring and vision.

Two Antwerp painters, Gerhard Seghers (1591–1651) and Theodoor Rombouts (1597–1637), did remain faithful to Caravaggism, though in a more superficial way. Both were probably pupils of Abraham Janssens. Seghers, who was made a master in the guild in 1608, turned about 1628 from youthful Caravaggism to a rather dry style derived from Rubens. This he maintained for the rest of his life. It was at this turning-point that one or two of his paintings rose above the ordinary run, for example the *Assumption of the Virgin* (1629, Grenoble; Plate 121A) and the *Adoration of the Magi* (1630, Bruges, Onze Lieve Vrouwekerk). The well-informed Joachim von Sandrart noticed that in his youth Seghers painted in the manner of Manfredi. To this name we can add that of Honthorst. A composition which even in his day must have made a great impression, judging from the many copies of it, is the *Denial of St Peter* (print by Schelte à Bolswert). These paintings with their candle-light effects do not attract us now, nor were they up-to-date even in their own day. Seghers's highest achievement, if not his earliest, is the *St Teresa in Ecstasy* (Antwerp 509). He did much work for churches in Ghent, and in 1635 co-operated on the work for the triumphal arch for the Cardinal Infante Ferdinand. Some of his later works have a charm of their own. In them he abandoned the all-too-ready imitation of Rubens's fully-modelled style and, by means of warm colours and a Venetian sensitiveness, achieved a new painterly beauty (*Martyrdom of St Livinus*, Ghent, St Bavo; *St Ivo*, Antwerp, St Jacobskerk).

There remain a few gaps in our knowledge of Seghers's development, particularly in his youth. About Rombouts we know more – we even possess a painting from his Italian period, the *Two Musicians* (Lawrence, Kansas, University Museum; Plate 123B). We also know compositions by him in the manner of Abraham Janssens (*Cephalus and Procris*, Leningrad 2977) and we have quite a number of Caravaggesque genre scenes with half-length figures (Plate 124B), cellar lighting, and all the rest of the apparatus of Caravaggio (*The Dentist, Card-Players*, Madrid 1635–6; *The Denial of St Peter*, Vaduz, Liechtenstein Gallery, 628). He rarely used candle-light effects, preferring cold colours and whitish bodies with shadows passing over them. The *Deposition* in Ghent (St Bavo) is the major work of his first period (Plate 123A). He often used Classicist forms, from

the same love of brightly lit, erect bodies (*Emmaus*, Antwerp, Atheneum). After 1630 he too changed to the warm Venetian palette and the more painterly style; *The Marriage of St Catherine* (1634 Antwerp, St Jacobskerk) is free from all Classicist and Caravaggesque elements.

The Caravaggesque works of Rombouts and Seghers made more impression in Ghent than in Antwerp. Native painters followed their example. Jan Janssens (1590–after 1650) specialized in representations of the *Crowning with Thorns*, and there are a few martyrdoms of saints in the manner of Honthorst, whose *Lamentation* of 1633 was in St Bavo. Janssens had a coarse touch, rather like Baburen's at Utrecht. However, he did achieve one exceptional painting, an *Annunciation* in the style of Terbruggen (Ghent). This is a highlight, but there was no evolution. Antoon van den Heuvel (1600–77) also remained faithful to native Caravaggism for a long time; only in his later years did his work tend towards a somewhat weak de Crayer style. The Caravaggist Gerard Douffet (1594–1661/5) lived at Liège. It seems that he had worked in the studio of Rubens round about 1612–14. The paintings ascribed to him show that he represented an interpretation of Caravaggism otherwise unknown in Flanders, in which there were French influences as well. That these French influences were stronger at Liège than in Flanders is natural, for the principality of Liège belonged neither in culture nor in politics to the Spanish Netherlands.

After the decline of Caravaggism in Ghent and Bruges Nicolaes de Liermaker, called Roose (1600–46), in the course of his short life filled the churches of Ghent with decorative, pallid altar-pieces. His contribution to the triumphal arch of 1635 does not amount to much. The works of Jacob van Oost I (1601–71), on the other hand, deserve attention. He became master of the Bruges Guild in 1621. His paintings of the first period have an exceptionally sensitive and refined colouring such as we associate with the best works of the Caravaggists of Holland and Flanders – but twenty years later. The *Calling of St Matthew* (1640, Bruges, O. L. Vrouwekerk) is obviously Caravaggesque. The *St Sebastian* (dated on the frame 1646, Bruges, Hospice de la Potterie) is in its form and manner of painting a continuation of Terbruggen's masterpiece of 1625 at Oberlin College. The most powerful and expressive work is the *Christ at Emmaus* (Bruges, O. L. Vrouwekerk; Plate 124A). It is neither signed nor dated, but there is much in favour of an attribution to van Oost; the pink colouring of the less important figures especially is related to his portraits. Towards the end of the forties Caravaggism was replaced by a lyrical Venetian mood, with light greyish, bluish, and pink colours, as can be seen in the sensitive *Madonna and Saints* of 1648 (Bruges, O. L. Vrouwekerk; Plate 120B).

As a portrait painter van Oost was closer to the bourgeois Dutch conceptions than to fashionable Antwerp. The *Family on a Terrace* (dated 1645, Bruges 181; Plate 125B) is, by reason of its clear Classicism, its *trompe l'œil*, and its astonishing foreshortening entirely outside Flemish tradition. Other late examples are the fine portraits of Leonora Sophie Ulfeldt and Ellen Kirstine Ulfeldt of 1665 (Castle Frederiksborg), which look like Dutch portraits in the style of Jan de Bray, as does the portrait group to the right in the *Calling of St Matthew*. We do not know how these Dutch characteristics came to Bruges in the 1640s. The Classicism of Haarlem with its bright colours is also

to be found in van Oost's late altar-pieces (*St Margaret*, 1667, Bruges, O. L. Vrouwe-kerk).

Though van Dyck's work was the most important source of inspiration for many of the generation born between 1600 and 1610, those who assisted and collaborated with Rubens, such as Abraham van Diepenbeeck (1596–1675), Cornelis Schut (1597–1655), Willem Panneels (1600–after 1632), Theodoor van Thulden (1606–69), Erasmus Quellinus (1607–78), Jan van der Hoecke (1611–51), and Frans Wouters (1612–59), worked in the tradition of their master, at least during their first years. Naturally it was the Rubens style of the thirties which they adopted. Abraham van Diepenbeeck was important as a glass painter and illustrator of books. Cornelis Schut is at present known for certain only by his engravings (in the loose style of the later Rubens); his paintings are concealed among a host of uncertain attributions. Panneels in his rare paintings entirely followed the later Rubens. Jan van der Hoecke was inspired by Rubens (e.g. *Holy Family*, Stockholm, Academy), but also by van Dyck (*Christ on the Cross*, Bruges Cathedral). Theodoor van Thulden's abundant production for Antwerp, Paris, and the Spanish and Dutch Netherlands is well known to us both through research made during the last few years and because we have a number of signed and dated paintings by him. He too carried out some of the Rubens sketches for the Torre de la Parada (1637). His early works are reminiscent of the teaching in Rubens's studio about 1635, and there is also a certain connexion with the work of Simon de Vos. Till the end of the fifties van Thulden used warm colours and loose, painterly compositions of great decorative charm (Plate 126B). As a painter of mythological and allegorical scenes he was rather unconventional. Concerning what was painterly, there is little distinction between his conception and that of such a pupil of Rembrandt as Bol. About 1660 his work begins to show elements of Classicism, to be traced back partly to van Dyck (*Rinaldo and Armida*, 1664, Dessau).

In the work of other painters, and among them Rubens's collaborator Erasmus Quellinus, van Dyck elements are more pronounced from the first (*Achilles with the Daughters of Lycomedes*, 1643, Vaduz, Liechtenstein Collection; *St Roch*, 1660, Antwerp, St Jacobskerk; *Holy Family*, Antwerp 204). The same is true of Jan van Boekhorst, a pupil of Jordaens, and especially of Thomas Willeboirts Bosschaert (1613–54), who was a pupil of Gerhard Seghers. History pieces *à la* van Dyck were particularly popular in the Northern Netherlands, and Willeboirts delivered many biblical and mythological paintings for the court of Orange between 1641 and 1650, to decorate the palaces of Frederik Hendrik and Amalia van Solms (Plate 126A). Van Dyck was also Willeboirts's model in his portraits (*P. de Jode and his Family*, Duke of Bedford Collection). All other portrait painters too, with the exception of one Dutch-minded group, continued the van Dyck tradition, including Justus van Egmont, Lucas and Pieter Franchois, and Justus Sustermans (who lived his whole life abroad and therefore lies outside our survey). The later generation was more closely connected with the Franco-Italian portrait style. The paintings of J. F. Voet (1639–89) are variations on Pierre Mignard's portraits. The exceptions are provincial or bourgeois painters who painted soberly and reliably in the Dutch manner.[6] The most talented of this group was Pieter van Lint (1609–90). His dry,

careful manner of drawing has something pleasant about it; his biblical scenes often take place round a portrait group of sober Antwerp folk (*Betrothal of the Virgin*, Antwerp Cathedral).

The nervous Classicism of van Dyck, rather than the radiant Baroque of Rubens's later works, is the basis for the Flemish art of the mid century and its third quarter. The Rubens elements are for the most part used superficially and without coherence. Frans Wouters (1612–59), for instance, was inspired by the graceful style of Jan Brueghel (he was a pupil of Pieter van Avont, who was among Brueghel's immediate successors), and in consequence was inclined to translate Rubens's art into something decorative and playful. Jan Thomas van Yperen (1617–78) used the type of Rubens's late female figures, but by elongating the proportions created a mannered style quite foreign to that of Rubens. Finally, Lucas Franchois (1616–81) and Pieter Thys (1624–77) were unswerving followers of van Dyck, which is all the more surprising in Franchois's case, since according to de Bie he was a pupil of Rubens. François Goubau (1622–78) and Theodoor Boeyermans (1620–78), as representatives of the generation of 1620, also worked in this tradition. It seemed as though van Dyck would remain the model for history painters for the whole of the second half of the seventeenth century.

However, towards the end of the century there was a new, dual impetus. In the first place the van Dyck tradition cooled off into an emphatically clear-cut Classicism, which flourished particularly in the south, in the bishopric of Liège, where cultural ties with France were the strongest. Bartholomé Flémalle (1614–75), who worked for many years in Paris, offers a striking example of this style. It was continued, less strictly, in the work of his pupil J. W. Carlier (1638–75). Gerard de Lairesse (1640–1711) also originated in this sphere of influence, though he left for Holland when he was only twenty. There was less Classicism in Antwerp and Brussels. Pieter Ykens (1648–95) and V. H. Janssens (1658–1736) represent the Classicist tendency, but more by a weakening of Baroque bravura than by conscious design. The other current can be described as a renewed attempt to enrich the Classicist schemes by painterly effects. Much of the work done in this period (by Herregouts, for example) reminds one of the later Jordaens; it is pallid in colour and cluttered with detail. Jan Erasmus Quellinus (1634–1715), for instance, produced large decorative canvases which are typical of this Late Baroque style; Classicist architecture is pushed into the background to give the pulsating movement and warm colours more play. In Ghent Jan van Cleef (1646–1716), a pupil of de Crayer, exercised his limited talents in this style and in a belated Caravaggism. Godfried Maas (1649–1700) was probably the most talented of these late successors of Rubens; his work is instinct with an unrest born of an urge to painterly movement over the surface, which has an Italian accent (Plate 127B). Within the framework of Classicism nourished on Roman examples, Louis de Deyster (1656–1711), a Bruges painter, kept a loose technique with blue and pink tones, crumbly in texture, making a pattern that lies stylistically between late van Dyck and the Rococo (Plate 127A).

INTIMATE SCENES OF EVERYDAY LIFE

Side by side with the grandly-conceived works for churches and palaces, Flanders had plenty of room for bourgeois genre-painting continuing the traditions of the sixteenth century. Renewal and enrichment did not come in the first place from contact with the art of Rubens – the pathos and the noble grace of Rubens's compositions hardly affected the works of the *Kleinmeister*. Jordaens's exuberant festivities, too, found no echo among the peasant painters or the masters of a more delicate genre art, though the latter did admire van Dyck's elegant idiom. Their relations with the Northern Netherlands, on the other hand, were close, particularly with Haarlem and Rotterdam. Travel and many other kinds of exchange and interaction developed a realism that was both naïve and refined.

We have seen how Pieter Brueghel the Younger went on mass-producing his father's peasant scenes almost until 1640 (p. 56). This aftermath of Brueghel's art in the Antwerp of the seventeenth century would be even more evident, had not some of the most talented painters of this group emigrated to the north (Pieter de Bloot, David Vinckeboons, and Roeland Savery). Beside the Brueghel peasant tradition, the elegant cabinet piece with its entertaining details also remained alive for a long time. Jan Brueghel (d. 1625), Frans Francken II (d. 1641), and Hendrik van Balen (d. 1632) are already known to us as the principal painters in this field, and the tradition was continued in the second half of the century. At first sight a division into a poor man's and a rich man's genre must seem rather superficial, but closer examination will show that the iconographic and stylistic premises of the two groups are indeed very different.

The Brueghel tradition was given a new lease of life by the brief appearance of a painter of real genius, who, it can be said, re-fashioned it in the spirit of the seventeenth century. Adriaen Brouwer (*c.* 1605–38) was born at Oudenaerde, worked in 1625–6 and perhaps even earlier in Amsterdam and Haarlem, and in 1631–2 was a master in the Antwerp Guild. None of his paintings are dated, and only a few bear a doubtful monogram. We do not know if Brouwer painted before he went to Holland, but it can easily be shown that his early works, i.e. those probably produced in Holland, have a clearly Flemish character, and that the later ones, certainly painted in Antwerp, are executed with a Dutch sensitiveness for painterly qualities. No sooner had Brouwer settled in Holland than his 'Flemish' style was taken over by genre painters at Haarlem, Utrecht, and Rotterdam. The influence of his late works on the Antwerp painters was even more marked.

It has been said that Brouwer's earliest development was determined by his meeting with Frans Hals, but the few points of contact are of no importance as compared with the Flemish characteristics which appear in Brouwer's early work. They amount to a resurrection of Brueghel's naturalism, without his dependence on Mannerist schemes of composition. The handling of the brush in Brouwer's early peasant scenes is wild, and the colours are unbroken and violent. The figures crowd together. The accentuation into groups is obtained by the arrangement of the walls in the background, and by

the simple pots and pans, which in addition form marvellous still lifes (Plate 128A). Strength and directness of colour remained characteristic for the next few years, while the compositions gradually gained in clarity. Often the figures are arranged in a simple triangular composition in the foreground (Plate 129). The thick brushwork, the lively action, the sense of drama, and the radiant glory of the colours are all in the Flemish tradition, and accord with Rubens's work of 1610–12. The passion for representing emotions, whether in card-playing or music-making or in the tortures of the saints, is a typically Flemish trait. Flemish, too, is the amalgamation of contradictory emotions and movements in compositions rigidly and strictly built up according to architectonic principles. We have seen in Rubens's work of the thirties how this sense of drama weakens and the inner passion grows.

In Brouwer's work this development from colour to tone, from rigid composition in one plane to a loose, painterly treatment in space, may have been hastened by his stay in Holland, because such methods belonged to Holland or were at any rate in use there once Rembrandt had created his new style of painting light and chiaroscuro. *The Card Players* in Munich (562) makes the change clear: the intimacy of enclosed space is suggested by painting the dim light in warm greens and browns. However, the balance in colour and composition should not blind us to the fact that there is here a strength of gesture which conveys an inner tension unknown to the Haarlem peasant painters. Brouwer's genius lies in this very reconciliation of such contradictory elements: a sensitive painterly handling of the interior (as was customary in Holland) and a majestic pattern of gestures within a well-arranged composition. In the seven following years, all that was now left to Brouwer, he produced several masterpieces. Among them are pieces of pure poetry, such as *The Good Friends* (Oosterbeek, J. C. H. Heldring Collection), where the brushwork alone produces the exquisite result; but there are also richer compositions in which the painterly beauty of the surface goes with emotional strength and monumentality. A simple pattern of doctor, patient, and onlooker, or of a group of peasants in a cottage, is made into a great work of art (Plate 128B).

The landscapes painted by Brouwer in the last years of his life are probably the least traditional paintings of these years in Flanders. No one could guess from the village street-fairs which he painted in his early years what his landscape sketches of some ten years later were to be like. Splendid as these impressionist sketches are, they are exceeded in importance by a few more complete works, such as *The Shepherd piping at the Roadside* (Berlin; Plate 141). Here again it is the sensitive brushwork which immediately attracts and excites us. The quiet, peaceful landscape in bright sunlight is observed with a restraint that is almost Dutch. The poetry of the scene, however, is carried by a monumental composition, whose scale is large and whose forms are full. Brouwer cannot be called a specialist in peasant scenes or in landscape; he is a painter of wider vision. Rubens, ever a collector of the unusual, was one of the first to realize this, and to buy Brouwer's works.

When David Teniers (1610–90) became a master of the Antwerp Guild in 1632/3, Brouwer had just returned from the Northern Netherlands. Teniers had been a pupil of his father. We do not know how the elder Teniers painted, because there is no sound

basis for the numerous attributions to him.[7] The biblical stories painted by young David in the years 1633–6 (Sale, Brussels, 19 December 1927, no. 29; Antwerp, Openbare Onderstand; Berlin 866 B) are almost genre scenes, and link up with the tradition of Frans Francken II. The many representations of the Witches' Sabbath are in the tradition of Francken and Jan Brueghel.[8] In 1636, in fact, Teniers had married Anna Brueghel, a daughter of Jan Brueghel. But his peasant scenes derive from Brouwer, though they have a certain detachment and distinction belonging personally to Teniers. Violence was not in his nature, nor could he ever reach Brouwer's concentration of expression and composition. His peasant scenes gradually change into genre scenes of fashionable folk, and his soldiers and peasants behave in a much less wild and uproarious manner than the drinkers and smokers of Brouwer. But even in paintings in this mood – and there are many in which Teniers gets close to Brouwer – he tries to achieve refinement and delicacy in colour and gesture (Plate 130A).[9]

Finally, there is a third element in Teniers's art: his relationship with Holland. It is not known whether Teniers ever spent any time there, but certain characteristics of Dutch art – which he may of course have studied in Dutch paintings in Antwerp – fascinated him, particularly in his early years. It is obvious from his themes and style that he was in contact with other painters of the Brouwer circle; we repeatedly find links with Pieter Quast, Cornelis Saftleven, and Andries Both. *The Barn* at Karlsruhe (193, of 1634), for example, is a work with Dutch chiaroscuro effects and with a still life of farm implements *à la* Saftleven. What Teniers took over from Holland is the importance of still life in his paintings on the one hand, and the painterly treatment of the surface on the other. In the painting of the barn at Karlsruhe there is also a still life with books, conceived on the model of the Vanitases of the school of Leiden. This motif is repeated in other works of Teniers (e.g. Brussels 751). It is of the kind which Jan Davidsz de Heem had painted a few years before. That Teniers must have been in contact with de Heem later in Antwerp is shown by another of his pictures (Wiederhofer sale, Vienna, 18 February 1902, no. 111), in which a composition of a wine-glass and grapes is interpreted entirely in de Heem's Antwerp manner. Perhaps the most striking example of the Dutch influence on Teniers is the still life in the Wachtmeister Collection (Vanås 59); it looks as though he had copied a Dutch work here.[10]

In 1645 Teniers became Dean of the Antwerp Guild. Shortly afterwards he moved to Brussels, where he became court painter to the Archduke Leopold Wilhelm (and after Leopold Wilhelm's departure in 1656 court painter to his successors). One of Teniers's special interests was the archduke's picture gallery (Plate 135B), built up in accordance with a type familiar in Antwerp from the beginning of the century (see p. 155). Teniers made many small copies of Leopold Wilhelm's foreign (and particularly his Venetian) paintings. Moreover, he compiled the catalogue, a fine piece of work with many engravings. Teniers also supplied works of art; in other words he was an art dealer, which is shown by the fact that Leopold Wilhelm still owed the painter 2,400 guilders when he left for Vienna. These activities as '*ayuta de camera*' did not influence Teniers's artistic development. His acquaintance with Titian, for instance, did not enrich his later style. His best works date from the years before he went to Brussels. In 1662 he bought a

country house called De drie Torens (The Three Towers) near Perck in the neighbour-hood of Vilvorde. We can see the towers of his little château in the background of many of his landscapes, which are certainly among the best works of his later period; even his landscapes of the forties are stronger and richer than what had gone before.

In the years 1640 to 1650 Teniers painted some monumental processions, such as the *Civil Guards' Procession in Antwerp* (1643, Leningrad 572) and the great landscapes with villagers celebrating a feast (London, National Gallery, 952, of 1643; another version Duke of Bedford, of 1646; *The Dance in Front of the Castle*, Buckingham Palace, of 1645). The motley processions are unified in tone by the marvellous, broad, warmly painted passages of landscape. This love of tone and atmosphere is completely Dutch, and could not have been derived from the landscapes of Rubens and his circle. The portraits of the Civil Guards are painted with a Dutch thoroughness that we know, for example, from the early works of ter Borch (who indeed must have lived for some years in Antwerp). Another typical Dutch genre subject, the *Guard Room*, was given new life by Teniers. His variant is more colourful and has more depth than his Dutch models by such painters as Palamedesz. Teniers uses the subject to show all sorts of amusements, such as card-playing, dice-throwing, music-making, and eating and drinking. Where he paints soldiers in such scenes, their weapons arranged in still-life fashion provide particularly colourful accents (Plate 130B). Cheerful colouring against a light background, for pre-ference with a view through into another room in which a window or door opens out-doors – these are the characteristics of Teniers's interiors in his best period. Execution is careful to the smallest detail. His Kitchens and Stables show this too (e.g. The Hague 260 of 1644; Plate 131A; Leningrad 586 of 1646; Madrid 1798): the still lifes of fruit and vegetables, placed apart from the rest, are painted with a delight in colour and modelling which was only to be achieved again in the nineteenth century, in France.

Towards the end of the forties the quality of Teniers's art began to decline. Figures are now doll-like, and the compositions often lack clarity and emphasis. Sometimes a specially elegant subject compensates for the lack of original and direct vision, for example *The Marriage of the Artist* (Edmund de Rothschild Collection; Plate 131B). Representations of such official functions as the *Bird Shoot* at Brussels, in the presence of Leopold Wilhelm (1652, Vienna inv. 756), are crowded with entertaining details, but the vision is scrappy, and the colour much more restless than in the Antwerp pro-cession painted nine years before. In the last twenty years Teniers appears to have painted less than in the two decades before. There is no dated work from the years 1680 to 1690. His work as an art-dealer, troubles concerning the 'peintre de la Chambre' of Don Juan of Austria, and family quarrels impaired his creative powers. He went on using the old themes: village feasts, elegant parties, kitchen interiors, and landscapes. The colours be-came greyer. There is the familiar animation, but the flourish has gone.

Teniers's landscapes are remarkable not only because of their personal charm but also because of their place in the development of Flemish landscape art. In this genre Teniers links up with Paul Brill and Jodocus de Momper (1634, Dulwich College), but seldom with Brouwer (Berlin 859A) and apparently never with Rubens. In 1640 the connexion with de Momper is still evident in the preference for yellowish-brown, sandy colours

and fantastic landscape *coulisses* (Leningrad 580). Soon, however, Teniers began to use a greater variety of colours here too, and his paintings fill up with tiny figures. Often the landscapes are only backgrounds to outdoor genre scenes, but even then they are carefully brushed in and arranged. There are some charming scenes among them – shepherds with their flocks, fishermen drawing in their nets watched by a fashionable company (Plate 143A). Landscape in this conjunction with delicate genre is rarely to be found in Flanders, but in Holland Teniers had a counterpart in Adriaen van de Velde. He excelled the Dutch, however, in that he could as readily place his scenes on a large canvas as on a small, without the execution becoming superficial or the composition losing its decorative coherence.

Pieter Brueghel II, the matter-of-fact copyist of the old Pieter Brueghel's genre, and Adriaen Brouwer, the artist who re-created it, died almost in the same year. Brouwer's influence can be found all over the Netherlands between 1630 and 1640, chiefly, of course, in Antwerp, but also in Rotterdam. Many Dutch artists must, like him, have travelled to Flanders, and many Flemings to Holland, so that it is sometimes difficult to distinguish national characteristics. The 'Pseudo van de Venne' is in my opinion a Flemish artist. He may also have worked in France. If, however, as some suggest, he was born in the Northern Netherlands, he must have lived for some considerable time in Antwerp. He must also be a contemporary of the young David Ryckaert III; like him, he modelled himself upon Brouwer. He has something in common with Cornelis Saftleven of Rotterdam (1607–81), who perhaps painted in Antwerp in the first half of the thirties. Hendrick Martin Sorgh (1611–70), also from Rotterdam, came under the influence of Brouwer's work, probably also in Antwerp, about 1632–3.[11]

Joos van Craesbeeck (1605–54/61), 'baker and painter' at the castle of Antwerp, where Brouwer was once imprisoned, was one of Brouwer's most delicate imitators. He specialized in small genre scenes with a few figures, coloured with great refinement and a particular preference for thick white and yellow brushwork (Plate 132B). His fighting and drinking peasants tend, however, to be caricatures, which is never the case with Brouwer. The larger compositions are clumsy but amusing. He experimented with chiaroscuro effects of which Brouwer had no knowledge. About 1651 Craesbeeck must have gone to live in Brussels, where he became a burgess and a master. His painting underwent no real development in the last years, though the gestures became less accentuated, and the colour somewhat more pallid, rather like that in the contemporary paintings of Egidius van Tilborch. It is not impossible that Craesbeeck finished some incomplete works of his master in the course of the years. The figures in the Pannwitz *Family Group*, for example, are certainly by him, but it seems not unlikely that he might have put them into a landscape begun by Brouwer.[12]

None of Craesbeeck's paintings are dated, and his work can be grouped only by analogy with the developments of contemporaries. The career of David Ryckaert III (1612–61) establishes our chronological sequence. He, too, began by following on from Brouwer's middle and late style, though, of course, his approach was rather different from Craesbeeck's impasto and his emphatic manner. The early Ryckaert, that is the Ryckaert of 1636–9 (he was master in 1636), saw Brouwer with the eyes of the Rotterdam

painters, of the Saftlevens, Sorgh, and Diepraam. He painted bare barn interiors, in brownish colours, with a few coarse figures (Plate 133A).[13] About 1639–40, however, a few individual characteristics appear for the first time: now he often painted old men with full, long beards and old peasant women with round faces, a type which we also encounter in Jordaens's paintings. In the course of the years his composition of merry gatherings became richer and fuller. He must have studied similar festivities painted by Jordaens and Teniers. He introduced a new colour, a whitish-pink, which he used particularly for faces, giving them a pleasant though weak expression. White dresses often add another light accent to the general gaiety. Instead of the peasant scenes we now have burghers' feasts.

The change of subject is probably not of great importance. There were painters of the fashionable world in the first years of the century too (they will be discussed later), but interest in what was fashionable and refined became more general among painters after 1650, because the whole realm of painting, after a phase of sometimes brutally realistic representation of man and nature, now took on an idealized aspect. There was still occasional opposition of course: the burlesque of Jordaens, imitations of Teniers and Ryckaert by Thomas Apshoven (1622–64/5), and the broad jests of Teniers imitators at the end of the century. Among these are David Boone and Jacob Smeyers (1657–1732), whose rather unsatisfactory paintings are sometimes ascribed, understandably enough, to Egbert van Heemskerck.

One of the painters of more idealized village scenes was Egidius van Tilborch (1625–78). He lived at Brussels, and it was there that he became acquainted with the art of Craesbeeck, which determined his early style (e.g. Hamburg and Metropolitan Museum, New York, both of 1657). Later he specialized in indoor and outdoor portraits of families and of his friends, grouped in an unforced, genre-like manner (e.g. The Hague 202; Copenhagen 179; St Catherine's College, Cambridge; Tichbourne House of 1670). Out of this combination of group portrait and genre scene he developed such amusing and crowded pictures as the *Open-Air Banquet* (Boston, Vose Galleries; Plate 134A). Such scenes are worthy of Jan Steen, whose technique must have excited Tilborch's admiration (compare his *Adoration of the Child*, Antwerp 890, with Steen's treatment of the same subject). The market scenes by Mattheus van Helmont (1623–after 1679) are also Dutch in their subject matter, their informality, and their naïvety (Budapest 414). But Helmont was an eclectic working mostly on the lines of Teniers.[14]

In the whole of Flemish genre as a speciality of certain painters it is remarkable how little use was made of the principles of great decorative painting. With two exceptions, there was no contact between the genre specialists and Rubens and his school, or the Caravaggists like Rombouts and Gerhard Seghers. The first exception is Willem van Herp (1614–77), who had the power to make a style of his own out of the different tendencies followed both by large-scale painting and by the *Kleinmeister* (Plate 132A). This style, despite obvious derivation from Rubens, has a peculiar charm and sometimes a dignity which make one think of French influence (Bourdon, Le Nain). The other is Simon de Vos (1603–76), a painter of biblical subjects in the Rubens–van Dyck tradition. In his small genre-pieces he starts in the manner of Frans Francken, but always aims at a

grander, more agitated style, using Baroque forms (Plate 133B). He produced many amusing compositions, occasionally making copies after Johann Liss, who had passed through Antwerp around 1617.

Although the Brouwer tradition is the only one of real importance and interest in Flemish genre-painting, the school of Frans Francken II is not entirely without significance. The little scenes of people dancing, playing, and eating by Christian Jansz van der Laemen (1606?–52?) originate in Francken. There is also a certain connexion with Dutch versions of these themes via Dirk Hals, Palamedesz, and Duck. Only van der Laemen's early pieces (1638, A. Schloss Collection) are influenced by Brouwer's painterly technique.[15] Hieronymus Janssens, called 'The Dancer' (1624–93), a pupil of van der Laemen, often painted fashionable society dancing and making music. Hence his nickname. His manner of painting is softer and more pallid than that of his master; he belongs to the generation of Tilborch, but is a narrower specialist.

However, the most brilliant professional of fashionable genre and portrait painting is Gonzales Coques (1614–84). All later painters interested in fashionable portraiture, whether they followed the tradition of the Franckens, like Janssens the Dancer, or that of idealized village painting, like Tilborch, use Coques's type of conversation piece as their model. As Coques became a Master in the Guild only in 1640/1, he probably went to live abroad after his apprenticeship with David Ryckaert II and Pieter Brueghel III. It is not impossible that he stayed in Holland, and he may have come into contact with the work of van Dyck in England.[16] Coques's earliest interiors (Kassel 150, of 1610, and 151) reveal a meticulous treatment of detail which reminds one of ter Borch. We can recognize the fellow citizen of Brouwer in the crumbly brushwork of the faces and in the warm, gay colouring. In later years he used compositions or gestures derived from van Dyck, or a landscape background dependent on Rubens, but these haphazard borrowings hardly altered his style (Plate 134B). He remained a *Kleinmeister*, like most of the professional genre painters, and, if only in this respect, has a certain affinity with the Dutch group of genre painters; Jan Mytens (also born in 1614), with his reminiscences of van Dyck, is his exact counterpart. Among his most faithful and by no means feeble imitators are François Duchatel (1625?–94?), Lancelot Volders, and K. E. Biset (1633–c. 1710).[17]

Because it developed outside Flanders, the painting of everyday life by the Flemings in Italy – among whom Cornelis and Lucas de Wael, Jan Roos, Vincent Malo, and Jan Miel (Plate 137) never returned to Flanders – can be mentioned only in passing. These painters and the Italian and Dutch–Italian *bamboccianti* formed a single group, which must be considered in another context. But Antoine Goubau (1616–98) did return to Antwerp in 1650 (perhaps even earlier). His genre scenes with Italian landscapes (Plate 136B) resemble the Dutch – those by Karel Dujardin for example – and so do his landscapes, which will be discussed elsewhere (p. 154). His art had little influence in Flanders.

Michael Sweerts of Brussels (1624–64) is a similarly isolated figure, and it is only comparatively recently that we have come to know of his Flemish origins. He was from 1642 to 1652, and perhaps till 1654, in Rome, where he belonged to the *Virtuosi del Panteon*. He is a belated *bamboccianti* painter, combining the Neopolitan–Caravaggesque

treatment of light with academic–classical figure compositions. His works are in no sense eclectic, although we can detect the influence of many other models, for instance the Le Nains. His Italian scenes with beggars, people bathing (Plate 136A), or artists sketching have an exceptional charm. They are painted in dark brown and light grey and have an elegiac quality seldom to be met with in the Baroque realism of the north. His portraits, too, are more nostalgic and sensitive than the usual run of bourgeois portraits in the Low Countries. His art has something in common with van Oost and Dujardin. After his return from Italy he lived for some years in Brussels, where he was busy in 1656 with the founding of an Academy. In 1658, however, we find him in Amsterdam. Three years later he went to India with a group of missionaries. He died in Goa.

LANDSCAPE PAINTERS

Before Rubens and Brouwer added a new element of personal experience, three principal tendencies determined the character of Flemish landscape painting: the pathetic–romantic landscape of de Momper (d. 1635) and Kerstiaen de Keuninck (d. 1632); the graceful, Mannerist cabinet pieces of Jan Brueghel (d. 1625) and his followers; and the topographically accurate village scenes developed out of the school of Pieter Brueghel the Elder. Pieter Brueghel the Younger, the Grimmers, Denis van Alsloot, and many lesser-known artists worked in this genre, which pleased both rich and poor; indeed, it seemed for a while as though the realistic trend would gain the ascendancy. De Momper and Jan Brueghel both painted many views of villages and of woodland and hillside paths which give the impression of being carefully observed from landscape that really exists. As a result, the imaginative and also the poetic and pathetic vision of nature as a majestic whole was weakened by a plethora of entertaining detail. The influence of Rubens and Brouwer was limited, though we shall see that the decorative aspects of Rubens's landscapes played an important part in Flemish landscape art about the middle of the century.

Besides the demand for big, decorative landscapes there was also a market throughout the century for the *fijnschilders*, the painters of meticulous detail, who continued to work in the style of Jan Brueghel. One of his most careful imitators was his son, Jan Brueghel II (1601–78). He worked for the dealers, providing copies of his father's paintings which were sometimes sold as genuine Jan Brueghels. In addition, his stepmother possessed landscapes and other paintings on which both father and son had worked, which were put on the market as the father's work.[18] In consequence of all this, the painting of the younger Jan Brueghel is difficult to distinguish from the works of his father, though a few dated paintings at Dresden of 1641–2 indicate that the son's colours are somewhat lighter and his drawing rather less precise. We also know a few copies after Jan Brueghel by Isaak van Oosten (1613–61) which date from the middle of the century (Orléans, of 1650; Vaduz, Liechtenstein Collection, 754); others of his followers were Pieter Gysels (1621–90), Mattys Schoevaerts (master in Antwerp 1690), and Theobald Michaud (1676–1765), men of modest talents. Gysels was capable of very delicate brushwork in

stiff, graceful little lines (e.g. Augsburg 2501 of 1680; Frankfurt 1127). Schoevaerts of Brussels differs from the others in bringing to the fore the same decorative elements that we find in contemporary Dutch–Flemish landscapes and views of the Rhine with little figures by Herman Saftleven and Boudewijns. The rapid, broken, sometimes undisciplined brushwork of Michaud can be called progressive in that it points forward to the eighteenth century; it betrays its real period only by the compositions, which are so old-fashioned as to resemble those of 1610 or 1620 (Plate 155B).[19]

The Brueghel tradition in the seventeenth and eighteenth centuries is no more than a curiosity, however.[20] To find out what genuine landscape painting looked like we must examine the other tendencies. The romantic mountain landscapes of Jodocus de Momper had a late exponent in Jan (or Hans) Tielens (1586–1630), while about 1620 Jacques Fouquier (1590–1659) turned more and more to Paul Brill and the Classicists, especially before he went to France. Earlier paintings (Cambridge 732 of 1617; Nantes 404 of 1620) are still closer to van Alsloot and de Momper. A signed drawing (Rotterdam, Museum Boymans), not dated but belonging to the first years of his career, is even Dutch in character and could have been produced in the circle of Esajas van de Velde (we do not know where Fouquier was born). He worked for the rest of his life in France; drawings and etchings are the only works that we can certainly ascribe to this period.

A younger member of the de Momper family, Frans (1603–60), became master in Antwerp in 1629. In the years around 1645–50 he worked in Holland, and this is the period with which we are most familiar. His work corresponds entirely with the technique and ideas of Jan van Goyen, though his preference for a broad brush-stroke is perhaps a survival from his training in Antwerp. Indeed, Frans de Momper was conservative by nature, remaining faithful in his early work to the technique of Jodocus de Momper – a remarkable course for an artist of his generation. His early winter scenes and village views are taken directly from compositions by the elder de Momper and by Jan Brueghel. The deer hunt in Amsterdam (Douwes Brothers) is also a composition of Jan Brueghel's, remodelled with some energy. His charming *Fishing by Night* (Leipzig, recent acquisition), on the other hand, returns to a composition of Patinir, using the technique of Jodocus de Momper. It is easy to distinguish this early group of landscapes from a few small paintings of 1650–60 (e.g. Brussels 1097), in which the elegant style of Teniers has been assimilated.[21]

Meanwhile the appearance of Rubens somewhat altered the style of the generation born in 1585–95. A feeling for unity of composition and decorative beauty overcame the concern with detail which absorbed the painters of the school of Pieter Brueghel. The work of Jan Wildens (1586–1653) is an outstanding example of the change in taste and style. We know something of his early manner from a series of *The Twelve Months* engraved and published by Hendrik Hondius in 1614, ordinary simple *vedute* in the style of the Grimmers, Jan Brueghel, and van Alsloot. Shortly afterwards Wildens must have gone to Italy, whence he returned in 1618, and for a long time the influence of Paul Brill can be traced in the way in which he unites into a single mass the groups of trees, the roads and hills. He became a collaborator of Rubens, who, while demanding treatment in accordance with his own decorative principles, showed him at the same time

how the full and rounded modelling of bush, tree, and figure could be used to give monumentality to a painting. In the *Winter Landscape with Hunter* of 1624 (Dresden 1133; Plate 146B), Wildens even tended to over-emphasize the plasticity of everything in the foreground. His best works were produced in the years 1625 to 1635, when he painted landscapes of great decorative beauty (Antwerp 987 of 1631; Budapest 54.102 of 16(2)9).[22] At this time he always introduced big trees and broad hills, never the open, distant views with vast skies which are so typical of the Dutch experience of space. His later works, which do imitate this Dutch approach to landscape, remain old-fashioned in their topographical accuracy (Amsterdam 2679 of 1636) or are tiresomely detailed, somewhat like those of the followers of de Momper (Vienna 880a).

Lucas van Uden (1595–1672), who was made a master in 1627, nearly twenty-five years later than Wildens, was less tied to these Flemish landscape traditions. At the same time he was more susceptible to the loose brushwork of Rubens and the painterly qualities of his impressionistic landscapes. In his early period, indeed, his landscapes were often more or less freely copied from Rubens (e.g. Munich 938 and W.A.F. 1092; Munster Exhibition 1939, no. 74, of 1629; Frankfurt 544), but he also translated Rubens's landscapes into an idiom of his own (e.g. Cambridge 92). He returned again to Rubens for inspiration in two landscapes of 1635 (Munich 4981 and Barnard Castle 16). The multitude of colours is replaced by a universal green, which fits in with the intimacy and tenderness of a close woodland view or a pleasant range of hills. Often Teniers painted little figures into these landscapes (Plate 142B). Van Uden's best works were painted in the years 1630 to 1650. They are graceful and without pedantry, and sometimes even have a touch of Brouwer's vitality. Van Uden was also a pleasing etcher and a good draughtsman who – and this is significant for his painterly principles – could also work after Titian and other Venetians (Wurzbach, II, 51–5).

The *paysage intime* is rarely to be found in Flanders, though many of Rubens's sketches were of this type, and nearly the whole of Brouwer's and Teniers's landscape paintings. Where *paysage intime* exists there is often contact with Dutch ideas. Gillis Peeters (1612–53) and Gillis Neyts (1623?–87?) both have a typically Dutch feeling for detail and the values of light and shadow in a modest subject. Neyts also did delicate little landscape drawings with body colours which continue the tradition of Jan Brueghel. Robert van der Hoecke (1622–68) also belongs to this group. His small landscapes, painted in one tone, often with a crowd of soldiers, mounted or on foot, much resemble the brownish landscape *vedute* of Herman Saftleven and other Dutchmen. It is another sign of Dutch influence that the masters of the small landscape tended to specialize. Daniel van Heil (1604–62) of Brussels, for example, concentrated on scenes on the ice and on conflagrations, van der Hoecke on scenes of war. Both have in common with all the others that their pictures were not country but town and village scenes. Under this influence from Dutch specialist work, the old interest in the burlesque life of the village street (Pieter Brueghel the Younger, early Brouwer) is revived on a higher plane, with greater refinement and subtler methods of expression.[23]

While in Antwerp landscape painting threatened to lose itself in town and village scenes, there grew up in Brussels a school of decorative landscape painting. Denis van

Alsloot the Elder (see p. 68) had already tried to link topography with decorative woodland scenes. The younger generation, represented by Lodewijk de Vadder (1605–55), Lucas Achtschellinks (1626–99), and Jacques d'Arthois (1613–86), went much farther. D'Arthois is certainly the most important in this group, not least because he trained many pupils. He understood the art of decorative arrangement and of satisfying distribution of groups of trees and of openings into distance. Routine painting could not, of course, be avoided, and one must also allow for a certain haste in finishing. There are, however, many very successful and carefully executed compositions (Aschaffenburg, many in Madrid, and Plate 143B). We can understand how it was that his style was accepted as the most suitable for big landscapes, with or without a biblical framework. Where biblical subjects were introduced, the pictures were often intended for the choirs of Gothic churches; there is such a series in Ste Gudule in Brussels today, painted by d'Arthois and some less talented artists.[24] Lodewijk de Vadder, whose paintings are rarely signed, had a much more personal technique, often showing a vitality, almost a frenzy, which we have hitherto found only in Brouwer's sketches. According to de Bie, Lucas Achtschellinks was his pupil. It is difficult to reconstruct the *œuvre* of Achtschellinks, because no signed painting of his survives and the traditional attributions do not inspire confidence. One must consider these decorative artists as one group, in which individual interpretations are of lesser importance. Indeed, even as regards the relatively best-documented member of the group, Jacques d'Arthois, the development of his painting cannot easily be traced owing to a lack of established dates. Those of his paintings which link up with the work of van Alsloot and van Uden are very probably early.

In Brussels too there were some painters who transferred the principles of large-scale decoration to small pictures. Lodewijk de Vadder had preceded them in this, for his gift for swift improvisation found its happiest expression in cabinet pieces. In the work of Pieter Bout (1658–1719) men and beasts are more important than the landscape, whether decorative or not. His paintings have an intimate Dutch character precisely because of the lively story they tell of shepherds, fishermen, and comedians. He never visited Italy, and there is only a tradition that he was in Paris about 1675–7, so that he must have taken the material for such animated country scenes from Dutchmen specializing in Italian subjects, such as Asselijn, Esselens, and Pieter van Laer, to mention but a few whose relationship to his work is specially close. He often collaborated with Adam Frans Boudewijns (1644–1711), who played the same role in Brussels as the late imitators of Jan Brueghel in Antwerp: that is, he filled the sitting-rooms of the bourgeoisie with friendly, conventional little landscapes.

Meanwhile Antwerp too had its decorative landscapes. Gaspard de Witte (1624–81) and his pupil Cornelis Huysmans (1648–1727) are the foremost representatives of this genre. De Witte went to Italy and France in his early years, and his work has a pronounced Classicist bent. He was decisively influenced by the work of Gaspard Dughet. Cornelis Huysmans, on the other hand, was emphatically a colourist. His woodland views, painted with a broad brush, glow in their warm, dark tones like the canvases of the Venetians a century before. In this period of rising Classicism such an open acknowledgement to Titian and the beauty of colour is a rarity. His seeming affinity to Rubens

is due to their common admiration for the Venetian painter. His younger brother Jan
Baptist Huysmans (1654–1716) adopted his preference for the Venetians without pro-
ducing such pleasing results. There were, of course, Flemish artists in Rome itself who
practised the classical landscape in the manner of the 'Little Poussin', Gaspard Dughet.
Jan Frans van Bloemen (1662–1748), nicknamed Orizonte, is an outstanding representa-
tive of this genre. His views of Rome dating from the first years of his sojourn in Italy
are of great charm (Rome, Palazzo Corsini; Madrid 1607).

At all times the Netherlanders in Italy, both from the north and the south, produced
very remarkable small paintings. In a previous chapter we have had a look at the Flemish
share in the movement of the *bamboccianti*, and the echoes their work produced in
Flemish painting (p. 149). In this type of picture it is sometimes difficult to draw a
dividing line between Italianist genre, landscape, and *vedute*. Antoine Goubau (1616–98),
for example, who has appeared in a previous chapter as a genre painter, could just as
well be mentioned here for his amusing paintings of the Roman scene (Plate 136B).
There is a stateliness in his compositions which those of the much more numerous
Dutch landscape painters as a rule lack. Van Bloemen, whom we have just mentioned,
was his pupil, but the painter who really carried his Italian scenes to their logical con-
clusion was Pieter van Bloemen (1657–1720), the brother of Jan Frans. His genre scenes
have a certain monumentality and pathos (Plate 154A). He sometimes borrowed com-
positions from Wouwerman, as did his contemporary Jacob van Huchtenburg in
Holland. His views of the Forum and the Campagna are dignified and deep in colour.
In contrast to the free, somewhat playful approach of the Dutch, the Flemish Italianate
painters have a real feeling for the structure of classical landscape and the proper place of
human beings in it. They are really closer to Poussin and Le Nain than to the Dutch
realists.[25]

More important than Goubau and his Italianate followers is Jan Siberechts (1627–
1700/3), who, after an early stay in Italy – for the actual dates there is no documentary
evidence – returned to Antwerp, where he became master in 1648/9. His earliest paint-
ings (of 1653) are so close to the Dutch Italianists Jan Both and Dujardin that he must
have been in contact with their work at its source. At this period Siberechts was more
Dutch than anyone else in Antwerp, that is to say Dutch in the style of Both, Dujardin,
and Pijnacker. Examples of this phase are the painted chest of 1653 in the Lanskoronski
Collection, *Spring* of the same year in Berlin (2028), and *The Castle on the Hill* at
Providence.[26] Siberechts could have met these Dutch artists during his conjectural stay
in Rome, and also his fellow-countryman Goubau, who was there from 1644 to 1650.
If we look at Siberechts's later work, it seems that he must above all have admired
Pijnacker's style, in particular his marvellous bluish tints. In the course of the sixties
Siberechts's personal vision developed and he produced certain typical motifs which he
then repeated and varied over and over again with strange logicality: herdsmen with
cart and cattle struggling through shallow water, or a coach or a farm cart on a flooded
road. On both sides of the road or the water he often placed a long row of pollarded
willows or poplars, which provide an odd perspective. The water is deep blue, the
splashes made by the horse, cart, and wading peasants startlingly white. The sunlight

creates wonderful reflections, which somewhat soften the contrasts of deep colours. On the whole, the figures move heavily and clumsily, particularly if one contrasts them with the graceful little dolls of Berchem, but, on the other hand, restraint sometimes grows into true monumentality. Such preoccupation with the majesty and integrity of the composition is seldom to be found among the Dutch, though it is common in French painting. It is not only the colour and the carefully measured gestures of the figures which bring about this sensation of heavy grandeur; the modelling of the landscape too is very round and solid (the big trees provide a specially good opportunity for this). It seems as though everything in these landscapes is tangible as well as visible. A landscape of Siberechts is never simply decorative, like most of the Antwerp or Brussels landscapes of this period. Three-dimensional vision safeguards against mere surface effects, the strong blues are most unusual between the yellowy-brown and yellowy-red tones of the customary wood and hill scenes, and the surprising play of converging lines had been found before Siberechts only in the monotonous work of the painters of church interiors. Occasionally Siberechts chose a motif outside his usual repertoire, and these paintings are always particularly amusing and striking (*The Sleeping Peasant Girls*, Munich 2165; Plate 144; *The Cradle*, Copenhagen; *The Girl Searching for Fleas*, S. del Monte sale, London, 24 June 1959, no. 56). In 1672 or shortly afterwards Siberechts went to live in England. The English nobility employed him to paint views of their estates and houses, and he produced bird's-eye views, movingly simple, of Longleat, Nannau Hall, Wollaton Hall, and many other places. His normal landscapes, without topographical detail, are richer. He took pleasure in painting gnarled tree-trunks and hills with winding paths, motifs with which the Antwerp countryside could not supply him. The colours fade into a light brown and grey with tender hues of blue and pink. As a water-colourist he continued in the tradition of van Dyck – no mean achievement among all his other qualities.[27]

More Specialists

Apart from landscape and town view, and the representation of the lives of ordinary people and of the court, we find, particularly in Antwerp and Brussels, some other specialities which were developed partly by artists already known to us, partly by some we have not hitherto met. A typical Flemish theme is the painting of the collector's gallery. Here too Jan Brueghel stands at the beginning, with his Allegories of the Senses.[28] The starting-point is not representation of a particular collection, but the Late Mannerist love of graceful decoration, of complicated perspective, and the abolition of the boundary between actual and painted space: the game of the painting inside the painting. Pieter Neefs, the painter of perspectives, took up this theme, as did other artists from the school of Jan Brueghel such as Jan van Kessel, Adriaen van Stalbemt, and Hans Staben. With the work of Frans Francken the new genre acquired a more realistic aspect. Paintings, particularly by Rubens and his school, fill the high walls in rows one above the other. The gallery of the well-known collector Cornelis van der Geest was painted by Willem van Haecht (1593–1623) at the moment when the Archduke Albert

and his retinue were visiting it (1628, New York, Mrs Mary van Berg; Plate 135A), an event which had taken place thirteen years before the picture was painted.[29] Other canvases show Apelles among a collection of paintings in his studio, or Joseph escaping from the embraces of Potiphar's wife, 'being a little picture gallery'.[30] Fantasy and reality, decorative finery and the homely everyday, go hand in hand. In painting the art gallery of the court of Brussels, David Teniers presents the treasures of his master Leopold Wilhelm without any allegorical or mythological dressing up (Plate 135B). On the contrary, everyday formalities are introduced, for the archduke with his retinue is greeting the painter as he fulfils his joint duties as custodian of art treasures and as artist. On a middle-class level the followers of Teniers, such as Thomas Apshoven, embroidered on this theme until far into the eighteenth century (Balthasar van den Bossche). Meanwhile, many of the Antwerp painters who specialized in genre scenes, including Hieronymus Janssens the Dancer, Gonzales Cocques, and Egidius Tilborch, translated the theme of the collector's gallery into less exalted terms. Sometimes they reduced the grand galleries to pleasant living-rooms hung with pictures and made them the background for their conversation pieces; sometimes, on the other hand, they painted magnificent galleries in probably imaginary palaces, filling them with countless works of art.[31]

There were also painters who specialized entirely in elaborate architectural fantasies. Wilhelm Schubert van Ehrenberg (1630–c. 76) and Antoon Ghering (master in 1662, paintings dating from 1641) are among them. Ghering's early works still stem from the tradition of Neefs and probably from that of the Dutch architectural painters, such as Hendrik van Steenwijck and van Bassen. In contrast to the Dutch approach, the Flemish specialists were interested in architecture as such, in classical forms and Baroque decoration, not in what effect light and shadow has on interior space. The church of the Jesuits, with its ceiling decoration by Rubens (destroyed by the fire in 1718), apparently greatly impressed them, for Ehrenberg as well as Ghering painted it a number of times. Whether it is fantasy or nature that is to the fore in the iconography of the collector's gallery and the church interior, the feeling for display and Baroque pathos in line and decoration permeates all Flemish art.

Delight in action and a talent for display produced another speciality in Flanders, which became separated from the landscape with figures: this was equestrian painting. Again it had its origin in pictures by Jan Brueghel, this time in those representing military life, surprise attacks, sacking, and plundering. Brueghel often put such scenes into his woodland views and open hilly landscapes, and sometimes Sebastiaen Vranx added figures of this kind to the landscapes of Brueghel and Momper.[32] Just as architectural painting in its first phase belongs to the Netherlands in general, not specifically the south, so does the theme of mounted soldiery; in the Northern Netherlands it was Hendrik Pax and Gerrit van Santen who inherited the manner of Brueghel and Vranx. A pupil of Vranx was Pieter Snayers (1592–after 1666), in whose work one can observe a remarkable development from the early colourful skirmishes of a few horsemen to wide panoramas, accurately portrayed and showing siege, fighting, and conquest. The field stretches out like a map, with a few genre motifs of marching or camping horsemen in

the foreground. This bird's-eye view of war was much liked by the princes who commissioned pictures, and Snayers was Isabella's court painter in Brussels from 1628.[33] Of the same period as Vranx, though younger, were Pieter Meulenaer (1602–54) and Simon Douw (master in Antwerp 1654). Their wild, romantic fights, painted in unified tones, correspond stylistically to the Dutch equestrian scenes of Palamedes Palamedesz, Jan Jansz van de Stoffe, Jan Martsen de Jonge, and others. Careful analysis of the landscape elements, however, also reveals a relationship with de Momper and Teniers. A famous pupil of Pieter Snayers was Adam Frans van der Meulen (1632–90), who was brought to Paris by Colbert about 1665. He painted careful yet fluent studies of the campaigns of the army of Louis XIV, leaving out no topographical or military detail of importance, but abandoning the bird's-eye views of his master. Van der Meulen had a talent for the elegant painting of colourful military scenes. The true brutality of the events is hidden behind a pall of gunpowder smoke in the distance, and attention is drawn away from it by the handsomely dressed cavalry officers in the foreground. He began with somewhat clumsy equestrian battles and pillaging expeditions (1657, Madrid 1653; 1660, Augsburg 503) but later developed great facility and taste in portraying Brussels society. These portraits, which begin about 1660 (1662, London 1447; Plate 145B), could not have been done better by Coques. Unhappily for Flemish art, van der Meulen's style found no succession. Compared with the Dutch development, Flemish architectural painting and landscape painting with figures lacked homogeneity. To complete the iconographical survey of cavalry scenes we must go to such minor masters as Karel Breydel, Frans Rubens, the Bredaels, and Jan Broers. Painters such as Pieter van Bloemen, on the other hand, belong in a different context (see p. 154).

The painters of seascapes and river and harbour scenes, too, form no more than an appendix to landscape painting in general. A style special to this type of subject did not exist as it did in Holland. Andries van Eertvelt (1590–1652) represents the early phase, characterized by a preference for wild seas painted in a fantastic way. The stylistic feeling is not unlike that shown in the infernos of Jan Brueghel; in both cases the spirit is one of Mannerist playfulness combined with endless repetition of frightening motifs. But it must not be forgotten that Jan Brueghel was at home in this style at the time when van Eertvelt was born. The best among the painters of sea and ships of the following generation was Bonaventura Peeters (1614–52). His interest in topography safeguarded him against too fantastic a treatment of his harbour views. Much of what we find admirable in the landscapes of van Uden and Teniers excites us in his work too: the spontaneous sense of nature, the sensitive painting in one tone with a few colour accents, and a Baroque love of movement. His seascapes of the thirties are closely allied to the simple Dutch marine paintings of Jan van Goyen, Pieter Mulier, and Simon de Vlieger. In his last years Peeters was more interested in decorative elaboration. Mediterranean motifs provide a welcome excuse for playing with fantastic mountain valleys and extraordinary adornments of strange warships. Hendrik van Minderhout (1632–96), born at Rotterdam, was another painter of large decorative seascapes (Plate 145A). The late Baroque love of fine colour and stately form produces weird compositions, again drawn for preference from Italian motifs. Occasionally he painted an Antwerp fish market with the same

M

colourful movement, or other motifs from the harbour of Antwerp and from the city itself. The combination of Italian decorative seascape with simple local topography is typical of this generation. Lingelbach, Storck, Nooms, and many other Dutch specialists in seascapes and town views worked with the same playful elegance in the same two directions.

STILL LIFE

This section deals with a last group of specialists, again subdivided according to iconographic types and artistic trends. 'Still life' is a relatively new title for pictures which were described in old inventories as 'Vanitas', 'Kitchen', 'Flowers', 'Fruit', or 'Breakfasts'. The seventeenth century produced in addition a type of still life which on the face of it is anything but still: the animal and hunting piece. In other countries, for example in England, one could hardly put such a painting (the sporting picture, for example) into this category; in Flanders, however, the function of hunting scenes was primarily decorative, and the men who painted them also produced the great kitchen pieces with their displays of game and fish, and the garlands of fruit and flowers.

To get the simplest idea of the situation about 1600, we should direct our attention principally to two types: the monumental kitchen piece and the painting of a vase of flowers. The former derives from the tradition of Pieter Aertsen and Joachim Beuckelaer, and the hunting still life and the breakfast displays are derivatives of it. The vases of flowers had been painted conscientiously and with masterly skill by Jan Brueghel (p. 60). Observation coupled with a Late-Mannerist playfulness, fascinated by intertwined lines and a multitude of colours, make such pictures highly attractive. It can perhaps also be suggested that Jan Brueghel's art continues that of scientific illustration, which had arrived at its climax in the Flemish miniatures of the late sixteenth century. The fact that this art was linked (for example in the work of Joris Hoefnagel) with Mannerist schemes of decoration à la Floris is an additional pointer to the origin of Brueghel's Mannerist reminiscences. However, before examining the evolution of the flower piece in the Southern Netherlands, it might be useful to cast a glance at the other type, the monumental, decorative animal painting and animal still life, which developed gloriously in the immediate circle of Rubens and through his example during the early years of the seventeenth century.

Frans Snyders (1579–1657), contemporary and sometime collaborator of Rubens, is the first specialist of this kind. We know practically nothing about his early work. In 1602 he became a master, and in 1609 returned from Italy. He had been a pupil of Pieter Brueghel II and was a protégé of Jan Brueghel, who particularly pressed his introduction to Federigo Borromeo as 'un delli primi pittore d'Anverso'.[34] He had apparently made his name as a painter of still lifes earlier. What look like his first essays in the genre, *Fruit and Game* (1603, Brussels, Gallery Willems) and *Vegetable and Game Dealer* (1610, Brussels, private collection),[35] do not support his high reputation in any way,[36] for they are rather tame, clumsy compositions in the manner of Aertsen and Beuckelaer, whose airy Mannerism has foundered in a disjointed piling-up of fruit, game, and vegetables.

Stylistically speaking these early paintings are on the same level of decorative Classicism as the works of Otto van Veen in the same period. Only the brushwork, at the same time loving and powerful, which Snyders uses for a single grape or a basket of fruit betrays a new feeling for a warm, living plasticity. About 1615 Snyders's work reached maturity. The pictures of 1614–15 (Cologne 2894, dated 1614; sale R. Chasles, Brussels, 16 December 1929, no. 90, dated 1616) are solidly and vigorously painted, balanced in composition, and as freely modelled as the Classicist pictures of Abraham Janssens, with whom Snyders did in fact work. The series of the four markets painted about 1615–20 for Alexander Triest (Leningrad 596, 598, 602, 604) are of true greatness and delight us not only by the craftsmanship with which nature is portrayed, but also by their purposeful and simple construction, with marked division into rectangular compartments (Plate 147B). The typically Baroque scheme of diagonal composition was apparently used by Snyders only later.

We know that Snyders was called in by Rubens to help on his great pictures; collaboration on the *Prometheus* (Philadelphia), for example, is proved by Rubens's correspondence with Sir Dudley Carleton.[37] Another example is the *Hunt with Samson* in Rennes (139; Plate 146A). It was in 1612–15 that Rubens began to adapt his solidly modelled and highly coloured style to the Classicism of Antwerp, and from the Leningrad series we can easily see how Snyders's many unbroken colours could merge with a Rubens-like firmness of touch. In his handling of light reflected on certain objects (in the fish still lifes, for example) Snyders improved on Rubens and other contemporaries. His hand has rightly been detected (again in the treatment of fish) in Rubens's *Miracle of the Fishes* at Malines (partly executed by van Dyck) and in van Dyck's (?) *Fish Market* (better called the *Calling of St Matthew*) at Vienna (inv. 383).[38] Rubens also provided Snyders with oil sketches of subjects which were suited to his interest. The *Philopomen* (Paris 2124) is an example of such a dependence (Madrid 1851). In my opinion even the figures in the large painting were done by Snyders; indeed, in quite a number of large paintings by him the figures and the still life are clearly done by the same hand. The painting of 1610 already shows him as quite a good painter of life-size figures. Indeed, Jan Brueghel in 1609 spoke of a *St Sebastian* as 'cominciato del Maestro Francesco Snyders'.[39] It is not impossible that Snyders began as a figure painter and only gradually became interested in still life.[40] In any case he greedily plundered elements of colour and form from Rubens's sketch; the dead swan in it becomes an indispensable motif in innumerable later pictures by Snyders. Another motif which appears frequently is a deer hung up; this again recurs in several variants. Snyders also painted a wreath of flowers for Rubens round one of the latter's compositions. The *Ceres* in Leningrad (Rooses 582) is in fact an outstanding example of the collaboration of the two artists. If we compare Snyders with Jan Brueghel (who must have preceded him in this form of collaboration with Rubens), we see the basic differences between the delicate painter of detail and the robust Baroque artist. Snyders's garlands of fruit are carried by putti so as to stress their solidity, and they have the same strength and weight as the architecture which they adorn. A comparable Brueghel garland (on the *Nature Adorned by the Graces*, Glasgow) looks like a band of twinkling stars without weight, depth, or volume.

We cannot say with certainty when Snyders painted his first hunting piece, but his stag hunts resemble Rubens's late hunting pictures, not his earlier ones. Other subjects must have preceded the hunting scenes, such as the Bird Concerts, Cockfights, and also the Lioness from the Normanton Collection, which is related to a Lion Hunt in Bordeaux (266).[41] The later works are more expansively planned; the piling up of motifs and objects is abandoned in favour of views into broad landscapes of great decorative beauty, like those of Jan Wildens, with whom Snyders may have worked (Plate 147A).

Snyders's brother-in-law, Paul de Vos (1596–1678), specialized in hunting scenes, and it is not easy to distinguish one painter from the other. The early works of de Vos particularly (e.g. *Fighting Cats*, Madrid 1866) are entirely under the influence of Snyders.[42] It is striking and significant that, as time went on, de Vos's hunting scenes became much more Baroque, and dogs (generally lean animals) jump in the air or tumble over one another. He has perhaps more feeling for movement in his compositions than Snyders, and does not aim at Snyders's stateliness. In keeping with this, de Vos uses lighter and greyer colours. His work has recently been rediscovered and given the recognition it deserves.[43]

Yet another artist of the generation of 1590–1600 who began his career under Snyders's aegis is Adriaen van Utrecht (1599–1652/3). His *Kitchen* of 1629 in Kassel (156) is entirely in the best Snyders tradition. There are also paintings of the thirties (Brussels 476; Stockholm 2349; Madrid 1853) for which Snyders was obviously the example. In the course of time Adriaen's compositions became more spectacular and more decorative. He tried to equal the elaborate still lifes of Jan Davidsz de Heem, which had made a great impression in Flanders and especially in Antwerp, and the original connexion with hunting scenes became looser. The excited movements of hunting dogs and wild animals now interested him less than the glitter of gold and silver, the scales of fish, oyster shells, and the sheen on fruit.

Snyders's most important pupil, Jan Fyt (1611–61), speedily extricated himself from the influence of his master. To hunting scenes he preferred the trophies of the hunt, to impassioned movement quiet contemplation. This development does indeed reflect the more general change of Baroque into Classicism, and also of an indigenous Flemish extroversion into an imported Dutch introvert art. Dutch influence became especially strong with the years among those specialists who were least dependent on Rubens. The mixture of influences could produce very striking works, and this is particularly so in the case of Fyt. As early as the forties Fyt was painting large elaborate still lifes with dead hares, fruit, vegetables, and metal vessels, and he was painting them in a much freer, looser style than that of the usual game pictures. Often they include a spotted dog as a picturesque motif. The zenith of his development was reached by Fyt about 1650–5 with a number of still lifes which can be grouped round one at Stockholm dated 1651 (Plate 148A). Fyt had a great feeling for decorative beauty and for arrangement on a large scale, but he also had an eye for surface, rough or smooth, whether it be the fur of a rabbit or the skin of a fruit, and for light playing on them (Plate 150B). A careful finishing of all details is a specifically Dutch quality which Fyt may have learned to appreciate when he travelled in Holland. He probably also admired the paintings which

Jan Davidsz de Heem made in Antwerp. The frequent repetition of the motifs that attracted him is sometimes boring, but the *peinture* is more refined and the bravura of the brushwork richer than had been seen up to then in Flanders. Fyt often achieved the greatest success when he painted subjects not usually his. Thus, for instance, his few flower pieces are decidedly more impulsive, more modern, as it were, than the works of the specialist flower painters. Dutch examples played only an indirect role here in so far as they helped to do away with Snyders's iconographic clichés and open the way for direct observation.

The Snyders–Fyt tradition continued through the seventeenth and into the eighteenth century. Among those who belonged to it in the second half of the seventeenth century, the most gifted was Pieter Boel (1622–74). His freedom in interpreting it is sometimes astonishing. The *Dead Birds in the Snow* (Basel, Lindemeyer–Christ Collection) or the *Game* at Kassel (162) are fresh and personal. The *Vanitas* of 1663 (Lille 61; Plate 148B) has a high finish and possesses all the best qualities of Flemish decorative art. Boel's pupil David de Koninck (*c.* 1646–after 1699) is much more conventional.[44] Adriaen de Gryeff (*c.* 1666–1715) sets his small hunting still lifes in Classicist landscapes, and they have little decorative appeal. On the other hand, the crumbly technique with accents of colour is attractive and strikes a personal note.[45]

The tradition of Aertsen, Beuckelaer, and their imitators determined the iconography of the breakfast pieces as well. It is strange, however, that the earliest Flemish group, namely Osias Beert (*c.* 1580–1624), Jacob van Hulsdonck (1582–1647), Alexander Adriaensen (1587–1661), and Clara Peeters (1594–after 1657?), should also have had their counterparts in Holland (Floris van Dyck, Floris van Schooten, and others). Both groups were closely connected with the flower painters, in Flanders with Jan Brueghel, in Holland with Ambrosius Bosschaert, an artist of Middelburg, who was born in Antwerp. The stylistic relationship extends even to the German painters of flowers and still life (Jan Soreau, Georg Flegel). We cannot here go into the origins of this parallel movement at a time when national styles were on their way to a full maturity. Beert and van Hulsdonck cling to very archaic compositions with objects placed side by side on the neutral ground of a brown table. Each had his special preference among the objects painted: Beert loved the grey tones of oysters, van Hulsdonck the varied colours of fruits in a china dish. Both paint with subtlety, but neither is in the least interested in giving an illusion of space. Nor was either affected by Baroque dynamics. Such painters of immobility, once they have outgrown Mannerist patterns, remain in a stylistic vacuum, which, however, gives their work a special, again one ought to say a Mannerist, charm.[46]

Clara Peeters's early paintings are closely linked with this ornamental Mannerism. She had an exceptional gift for fine drawing, which she displays in her handling of the twisted forms of metal objects. Her later works are more harmonious and warmer in colour, and more finished as compositions. Her breakfast pieces with the great lumps of cheese (Plate 149A) are almost impossible to distinguish from those of Floris van Schooten, a painter of Haarlem. Clara Peeters was indeed in Holland in 1612 and 1617. There she may well have been induced by what she saw to soften her former hard

ornamental style of drawing and allow access to a Dutch feeling for tonality, warm hues, and effects of light. Adriaensen outgrew the style of his first breakfast pieces after he had become interested in other types of still life. In addition, he modelled his style on that of Jan Fyt's dead birds, and on de Heem for the decorative co-ordination of large-scale still lifes. He always enjoyed painting fish because of the play of light on their damp, shining, brownish-grey scales. The Dutch specialists of this period did it too, and did it in the same way.

The breakfast piece disappeared quickly in Flanders, however, and what took its place was the much-loved 'Trophies of the Hunt' and the spectacular decorative fruit piece with bronze vases, flowers, and silk draperies. The only exceptions are certain artists who followed definite prototypes. Jacob van Es (1596?–1666) and Frans Ykens (1661– 93?) were among those who for a long time remained faithful to the first primitive phase of the Flemish breakfast piece and only much later adopted the decorative style of Fyt and de Heem. During a short interim period, however, they did paint a few break- fast pieces with a Dutch feeling, after the example of Pieter Claesz and Willem Claesz Heda.[47] The Heda style may have been introduced into Antwerp by Jan Davidsz de Heem (1606–83/4). De Heem, who came from Utrecht, became master in Antwerp in 1635–6, and burgess in 1637. His few dated pieces from the thirties [48] are entirely in the monochrome style of Claesz and Heda, which he must have acquired at Leiden and Haarlem after his early years at Utrecht. Soon after 1638 de Heem must have adapted his style to the preferences of Antwerp, for his still life of 1640 in Paris (2392) has a character entirely different from that of his preceding works. But to judge this change properly it is necessary first to examine a third type of Flemish still life, the flower piece.

The most important flower painter at the beginning of the seventeenth century was Jan Brueghel (see p. 60). He was the first to make the 'Vase of Flowers' and the 'Wreath of Flowers' into an independent work of art. Snyders, in addition to wreaths of flowers, introduced wreaths of fruit. A somewhat younger artist, Ambrosius Bos- schaert (1573–1621), also born in Antwerp, started the painting of flower pieces in the Northern Netherlands at about the same time as Jan Brueghel, and independently of him. Brueghel's example was followed fairly consistently by a few Antwerp painters whom we have already met as painters of breakfast pieces: Beert, van Hulsdonck, Clara Peeters, van Es, and Adriaensen. Jan Brueghel II also copied his father's works, as might be expected, and Beert's pupil Frans Ykens painted some quite good pictures in the style of Brueghel.

It was Daniel Seghers (1590–1661) who brought about a revival of this genre, or rather a more decorative, spacious version of it. He was a pupil and collaborator of Jan Brueghel, became a master in 1611, and a few years later turned Jesuit. The painter priest excited the curiosity of princely patrons, gained international repute, and never lacked commissions. His religious house profited, for the Grand Elector of Brandenburg, for example, exchanged works of art for sacred relics! Seghers specialized in garlands of flowers and flower decoration round a seemingly sculptured *trompe l'œil* cartouche, the central part of which generally presented a religious subject, occasionally painted by someone else. There is an essential difference between Seghers's work and that of Jan

Brueghel: Brueghel's painting is naïve, Seghers's sophisticated. The flowers are arranged in complicated bouquets, and scenes from the Passion are surrounded by thistles and roses (Plate 150A). Dark colours and angular forms dictate the character of the compositions in Passion scenes; in fact, Seghers's paintings generally had a dark background, like those of the Caravaggists of Ghent (among whom was his namesake Gerhard Seghers, who was only three months younger). Often (particularly in pictures for Protestant clients) he left the centre piece free so that other painters could place there what else might be required. He also collaborated with other artists. His early work is unknown to us, and his paintings are dated only after 1635, although Jan Brueghel, who died in 1625, had owned still lifes by him. It seems probable that the earliest garlands are those more closely linked to Snyders's work than to that of Jan Brueghel, though the vases of flowers belong to the Jan Brueghel tradition. Here too the colouring is dark (with a few contrasting touches of white), and there is nothing left of the gay variety of the older generation.

Seghers had plenty of imitators. Among them Jan Philip van Thielen (1618–67) had some reputation. His compositions are quieter and more orderly, but also duller, particularly because the genre as such no longer had the charm of novelty. Another follower of Seghers was the priest Jan Anthonie van Baren (1616–86). He was the curator of the collection of Archduke Leopold Wilhelm, who owned eleven of his still lifes. Van Baren was responsible for the famous catalogue of 1659, which gives us such a great deal of information about Flemish art from the fifteenth to the seventeenth century. Hieronymus Galle (1625–after 1679) also painted in the style of Seghers, but was on the whole more interested in vases of flowers and in game and fruit.

Jan Davidsz de Heem (1606–83/4) certainly adopted much from Seghers's flower painting. He must also, however, have been influenced by the garlands of fruit by Snyders and Adriaen van Utrecht. It is remarkable how quickly and how completely he rejected the style of the monochrome bouquets in favour of more decorative and colourful arrangements with a wealth of flowers and fruit, among which lie glittering objects of metal. The elaborate still lifes of 1640–2 (Paris 2392; Stockholm, K. Bergsten Collection) have nothing more in common with the Dutch style of a few years before.[49] The composition, it is true, is uncertain and bitty; there are too many vistas, ornaments, and foreshortenings, and only in later works of his do these grow into unity.

But one cannot say that de Heem simply followed in the tradition of Seghers and Fyt; his colour sense, for example, is quite different from that of Seghers. His paintings have none of the Caravaggist swarthiness, and the colours are cheerful and light, with many shades of red, yellow, and blue. As far as Fyt is concerned, the position is reversed. It was Fyt who underwent the influence of de Heem in the first half of the forties; the simple compositions of his paintings during those years with their fruit and lobsters, and their careful and restful surface modelling (1645, Leningrad 613), would be unthinkable without de Heem's example. De Heem in those years had a preference for diagonally arranged compositions, a last echo of Dutch principles.[50] His simple subjects developed in the course of the years into complicated and elaborate paintings with illusionist tricks and with such a sophisticated and perfect handling of the surface that the dewdrops on

the fruit and leaves look almost real. But it would be wrong to assume that these still lifes were painted only for the sake of the beauty of the colour or for the decoration. They continued to serve the purpose of presenting the Vanitas theme, sometimes by the addition of a skull, a clock, or a faded flower, and sometimes by an emphatic reference to Christ's suffering and death. Under a crucifix by the side of a bouquet de Heem wrote: 'But the most beautiful of flowers men do not see' (Munich 568, painted together with Nicolaes van Verendael; Plate 151; a similar painting in Dublin, 11, of 1653).

Although de Heem was often away from Antwerp after 1658 (especially from 1669 to 1672), his art had an enormous influence in Antwerp, and, indeed, in other places, especially in Utrecht. He had many pupils and imitators. A few, such as Jan van der Hecke (1620–84), Jaspar Gerards (of Gerardi, c. 1620–before 1654), and Kerstiaen Luyckx (1623–after 1653) occasionally produced paintings clearly Dutch in the execution and choice of subject, and others, such as Jan Pauwels Gillemans (1618–75) and Alexander Coosemans (1627–89), did not produce more than decoration. Joris van Son (1623–67) and Cornelis de Heem (1631–95) are the best of this group. Van Son was actually in command of quite a variety of approaches. Towards the end of the century flower painting declined all round into decoration of a fairly unexciting kind; the colours became dull and the technical execution unimaginative (Caspar Pieter Verbrugghen I (1635–81) and II (1664–1730), Jan Baptiste Bosschaert (1667–1746)). Only occasionally could a painter such as Nicolaes van Verendael (1640–91) maintain a high level.

In conclusion, one imitator of de Heem and Seghers must be mentioned who in later years occupied himself with other specialities. This is Jan van Kessel (1626–79). In most of his still lifes painted between 1650 and 1660 he does not differ from his contemporaries. He also copied de Heem's work (Dresden 1221), and painted fruit and flowers as elaborately and carefully as his masters. But his speciality was the exact, zoologically correct painting of insects, butterflies, caterpillars, shells, and fish. Sometimes he painted his little creatures so that they wriggle to form the letters of his name (Plate 149B). His elegance and loving observation resemble those of Joris Hoefnagel and Jan Brueghel. This was a revival of the early seventeenth-century style of the *Kunstkammer*, a revival such as we have observed in other fields. Spanish amateurs were apparently particularly attracted by these pictures – the Prado in Madrid has no less than forty of van Kessel's small paintings.

THE EIGHTEENTH CENTURY

ONE feels tempted to interpret the artistic changes that began to manifest themselves in the Southern Netherlands in the course of the seventeenth century, and continued to operate into the eighteenth, as the new vision, the new style of a new century. We are used to reckoning in centuries, and the division of time after that fashion lures us into planting our milestones wherever two centuries meet. Yet we are all well aware of the fact that evolutions of style are gradual. Revolutionary events are the work of a few men of genius, and the *fin de siècle* mood does not come into operation by clockwork.

Nevertheless, there is an essential difference between the situation about 1600 and that about 1700. About 1600 different forms and styles did indeed converge, and this may be attributed partly to the spiritual currents usually labelled Mannerism, Classicism, and Baroque. The opening of the eighteenth century displays no startling stylistic innovations in Flanders; our division according to genres, for instance, would still work very satis-factorily. A shifting of accents had occurred, however, during the last decades and at the turn of the seventeenth century, and this offers a welcome opportunity for putting for-ward some reflections which may serve either as a conclusion to the previous chapters or as an introduction to the last.

A comparison between Rubens (b. 1577) and Teniers (b. 1610) illustrates the shift fairly accurately. Rubens is the Christian humanist whose creations, as much for the church as for the palace, are presented with Baroque passion and infectious conviction. Teniers is the illustrator of daily life rendered with a full appreciation of its painterly possibilities. Similarly, in more general terms, the feeling for the true pathos of the Christian faith, for suffering and martyrdom, vanished from altar-pieces during the late seventeenth century, and the world of the painters grew more matter-of-fact and bour-geois as well as more restricted. This is why specialists of every degree could thrive in it. There is a perceptible turn in the direction of grace and of a beauty of the lighter kind. In the eighteenth century this tendency continues. The painting on an altar or a church ceiling is made subordinate to the decorative demands of the frame and the character of the whole church interior. The still life is now primarily decoration for *sopraporti*. But the clearest proof of this transition towards a world at once matter-of-fact and playful is the change in the interpretation of the landscape. Landscapes are no longer painted for the sake of their own romantic or Baroque beauty, but are reduced to backgrounds for parties out on the canals to enjoy themselves or out shooting, or for horsemen and in-fantry in battle. Whatever may be the exact numerical relation between altar-pieces and genre pictures, there can be no doubt that genre painting as such became the most im-portant facet of Flemish eighteenth-century art. The leaders are the men who follow Teniers without being direct imitators. They now give Flemish art its peculiar character and charm. However, before this main theme of the eighteenth century can be examined, the less important genres must be briefly reviewed.

RELIGIOUS ART AND PORTRAITS

It is characteristic of the spirit of Flemish art in the eighteenth century that historical painting is of little importance. This forms a contrast between Flemish art and that of large areas of Europe. Why, in a land that gave birth to Rubens, did the art of decorative wall and ceiling painting not rise to such heights as it did, for instance, in south Germany, not to mention Italy? This is especially strange, as neither of these regions could boast anything like the Flemish tradition of the seventeenth century. Only in the sculpture and the architecture of eighteenth-century Flanders did the spiritedness and the fantasy of the Baroque survive. The pulpits in carved wood and the grandiose church façades are the true witnesses of the Late Baroque and Rococo. The painter-sculptor Willem Ignatius Kerricx (1682–1745) is a typical example: as a painter he is an arid imitator of his master Godfried Maas; as a sculptor he is original and full of daring and fantasy.[1] In the younger generation the situation is the same as in the older. The comparison can, for instance, be made between Mathias de Vis (1702–65), a painter of Bruges, and Guillaume Jacques Herreyns (1743–1827). Old-fashioned light effects are coarsely elaborated (de Vis, *Adoration of the Shepherds*, Bruges, St Jacob), or the tradition of van Dyck is tiresomely embroidered upon (Herreyns, *Samson*, 1775, Brussels sale, 7 March 1928, no. 195; *Adoration of the Magi*, Brussels 219). Liège at this period was a fairly productive centre in genre painting too, but specifically Flemish traits are even weaker than they had been in the seventeenth century in this territory, which does not belong politically to the Southern Netherlands. The Liège painters were trained mainly in Paris and in Rome.[2]

It is characteristic of the decadence of history painting that Flemish artists like Balthasar Beschey (1708–76), who in fact continue the Jan Brueghel–Teniers tradition, occupied themselves with altar-pieces as well. Indeed, Beschey's biblical scenes look like enlarged copies of Rubens engravings (*The Story of Joseph*, 1744, Antwerp 12–13).[3] Beschey was a highly esteemed artist, professor and director of the Academy and Dean of the Guild of St Luke at Antwerp. Moreover, he was the master of Andreas Cornelis Lens (1739–1822), who is one of the first representatives of neo-classical art in Belgium. Lens's Classicism is neither harsh nor cold. He always uses a flowing colour which gives a kind of smooth gracefulness to his compositions (Plate 153A). The *Annunciation* of 1809–10 in St Michael in Ghent, for instance, is, within the framework of provincial Flemish art, a fine work of considerable aesthetic value. There is merit too in the mere fact that Lens renounces the cheap plagiarism of many of the imitators of van Dyck and Rubens.[4] Joseph Benoît Suvée (1743–1807) of Bruges is generally rather more old-fashioned, though in his portraits he is uninhibited and modern (portrait of Rameau, 1793, Bruges). The art of portrait painting altogether preserved style and remained important, whether it tended more towards the Dutch preference for excessively delicate surface (Zeger Jacob van Helmont),[5] or towards French exemplars (François Louis Lonsing, 1739–99, and the Liège painters).[6] Lonsing, Jacob van Schuppen (1670–1751), and François Stampart (1675–1750) worked mostly abroad.

With one solitary exception, Flemish altar-painting in the eighteenth century is homogeneous and unexciting. The exception is Pieter Jozef Verhaeghen (1728–1811), another pupil of Beschey. He settled at Louvain. There he carried out extensive commissions for monasteries and churches in the neighbourhood, and the Abbey of the Parc and the church at Averbode still possess numerous canvases by him. What distinguishes his work from that of his contemporaries is his broad, robust technique and an almost savage treatment of the pigment. At a period when almost everybody aimed at refinement and an impersonally smooth finish, Verhaeghen took as his models the wild and robust painters of the Baroque. His work is original and decorative, though he did not aim very high (Plate 152). His sane middle-class taste safeguards him from the imitation of Rubens and the heroic style of van Dyck that runs right through most of the eighteenth-century altar-pieces, and he is drawn by instinct towards Jordaens's homely decorative art. His work recaptures the unkempt, jovial vitality of Jordaens, and even Jordaens's bronze colour scheme proved acceptable to this exceptional eighteenth-century character. The pedestrian but picturesque and always attractive art of Verhaghen is the most convincing answer to the problem of large altar-pieces in an age when men preferred conviviality to religious emotion and classical erudition. A journey to Italy (1771–3) did nothing to modify Verhaeghen's conceptions, and the growing Classicism obtained no hold upon him. On the whole he looked to those examples of the Dutch seventeenth-century genre that tended to be exuberant, for example the biblical scenes of Benjamin Gerritsz Cuyp. But in spite of all this, Verhaeghen did not live in the past. On the contrary, his art is a healthy and natural expression of the style of his period, and the verve of his biblical scenes is more convincing than the anaemic variations upon themes of Rubens and van Dyck produced by his contemporaries.

DECORATIVE ART AND STILL LIFE

Apart from decorative altar-paintings with a serious purpose, there was also scope for a more playful decoration of church and monastery. An example is the grisailles imitating sculpture which found their place in ecclesiastical surroundings as well as in the *sopraporti* of the drawing-rooms of the well-to-do. Maarten Josef Geeraerts (1707–91) produced a large number of such works.[7] The most ambitious of such sculptural *trompe-l'œils* are the *Seven Sacraments* in the cathedral of Tournai by Pieter Joseph Sauvage (1744–1818; Plate 153B), inspired by the late series of Poussin. Most still lifes were intended to be decorative, and found their place above doors and windows. Just as the sculptural grisailles may well have been inspired by the Dutchman Jacob de Wit, who from 1708 spent many years in Antwerp, so the painters of still life in the eighteenth century took a lively interest in Dutch prototypes. Antoine Clevenbergh's *Trophies of the Hunt* is an eighteenth-century translation of Jan Weenix rather than of Fyt. Pieter Andreas van Rysbraeck (1690–1748), on the other hand, does continue Fyt's style.

In flower paintings one must distinguish between two currents. One has as its prototype Jean George Christiaen Coclers (1715–51), and is French in inspiration. It continues the

tradition of Monnoyer. The other competes with the Dutchman Jan van Huysum; Jan Frans van Dael (1764–1840) is its principal exponent, but many more both preceded and worked concurrently with him. Some of them settled in Paris as soon as they had finished their apprenticeship in Antwerp. They cannot, therefore, be numbered among the representatives of Flemish painting.[8] However, this genre is in any case international, and there were rich collectors throughout Europe who felt the greatest admiration for perfect finish given to a decorative arrangement of flowers. The fact that in all fields there was such a strong tendency to look to Paris for inspiration explains why the influence of the Antwerp tradition was so slight among these flower painters. The van Spaendoncks from Tilburg, Gerard (1746–1822) and Cornelis (1756–1840), who received their training in Antwerp, also spent the rest of their lives in Paris. Taking it all in all, this style of flower painting was typical neither of France nor of Antwerp. The model for all those who practised it was Jan van Huysum (d. 1749), a Dutchman. His works indeed enjoyed an incredible reputation right into the late eighteenth century. Finally, towards the end of the century, the refined, over-polished style changes into something more matter-of-fact and more dryly executed, which fits better into the bourgeois Classicism of the time.

LANDSCAPE

There was not much landscape painting in the eighteenth-century Netherlands. Painters amused themselves by imitating the small landscapes of Jan Brueghel; a past master at this kind of work was Theobald Michaud (1676–1765; Plate 155B).[9] Artist and collector were both fascinated by convivial scenes of life in the country. Paramount among such subjects are hunts, battle scenes with soldiers on horseback, fighting or plundering, and scenes of military life with camp-followers, or with townsfolk or peasants. Remarkably enough, here also the native tradition that ran from Vranx to van der Meulen was given up, and the Dutch Wouwerman, whose paintings fetched enormous prices at Paris sales in the eighteenth century, provided the inspiration. Wouwerman and van Huysum were among the painters of whom the small art collector was specially proud. Only Teniers and a few Dutch genre painters equalled them in reputation. The Fleming Karel van Falens (1683–1733), whose work we can follow from 1703 onwards, is one of the many imitators of Wouwerman, and perhaps one of the best. There is no trace in him of Flemish schooling. Jan Pieter Verdussen (c. 1700–63) worked in the same manner at Marseilles and Avignon; his father Pieter Verdussen (1662–after 1710), who remained in Antwerp, had already a pronounced Dutch landscape-style. Jan Frans van Bredael (1686–1750) and Jan Peter van Bredael (1683–1735) also followed Wouwerman's example (Plate 154B). Jan Peter stayed a long while at the court of Prince Eugène, while Jan Frans worked in England. However, as far as connexions with England are concerned, Pieter Tillemans (1684–1734) is of much greater interest. After a training in Antwerp, in 1708 he settled for good in England, where Arthur Devis became his pupil.[10] He did not bring with him any specifically Flemish manner, as he had been brought up at home in the sphere of Dutch influence. On the other hand, neither was he

the first to introduce Wouwerman's style to England, for this had been established there by earlier Dutch painters such as Dirk Maes.

The Italianizing landscapes and Italian vistas which were painted by artists such as Pieter and Jan Frans van Bloemen (d. 1718 and 1748; p. 154) were hardly appreciated at home during the eighteenth century. A pupil of Pieter van Bredael I, Henri Frans van Lint (1684–1763), settled early in Rome, and his small vistas have the charm of carefully drawn topographical records, with every *palazzo* and every garden precisely in the right position. It is not improbable that van Lint got to know the Roman works of Gaspar van Wittel (Vanvitelli; d. 1736); for it is indeed only his Italian *vedute* of about 1730–5 that possess something like Vanvitelli's naïve matter-of-factness (e.g. *View of Naples*, 1734, sale, London, Christie, 15 July 1949, no. 79). Van Lint's older work is much more decorative and resembles that of Michaud and Huysman.

The change of style during the second half of the century can easily be recognized by simply comparing what artists of the past painters now chose to imitate. Wouwerman is superseded by Wynants, Cuyp, and Potter; in other words, realistic middle-class landscape replaces the courtly, elegant, agile ornamental art to which, after all, the *cavalleresche à la Wouwerman* belong. Nicolaes Henri Joseph de Fassin (1728–1811), a painter of Liège, is in this respect in a transitional position. This 'mousquetaire du roi de France' still painted scenes with horses in the light-hearted and elegant genre of Wouwerman, but his landscapes with cows and goats are already more solid in structure and the brushwork is heavier. One might compare them with Karel Dujardin's Italian landscapes.

Henricus Josephus Antonissen (1737–94) and his pupil Balthasar Paul Ommeganck (1755–1826) are the best representatives of the new phase in landscape-painting (Plate 155A). It is not by accident that Antonissen copied Wynants's paintings and Ommeganck Berchem's etchings. Antonissen is more naïve and more ornamental, Ommeganck tends to be romantically serious and is occasionally even a little bombastic. After 1800 his landscapes become rather dry and lack articulation, and the little grey sheep which he then liked to paint do not improve the structure. However, one now and then finds an extraordinarily successful portrait by him which is representative of the naïve middle-class Classicism of the early century (portrait of J. B. Berré, Antwerp 809). The Brussels painter Johan Baptist de Roy (1759–1839), who was self-taught, also worked in the old-fashioned Dutch manner. On the other hand, especially in the smaller towns, one occasionally comes across artists working for rich collectors whose country seats, estates, and town houses they portray, or for the small man who wants copies of the expensive landscapes of Teniers, or else for the church which may order the sort of decorative canvases and hangings which also went into living-rooms and which were sold by the square yard. Hendrik Frans de Cort (1742–1810) is one of the topographers (particularly of views in the neighbourhood of Averbode), who painted with a meticulous soberness derived from van der Heyden. Hendrik Aarnout Myn (1760–1826), a pupil of Ommeganck, is known among other things for his copy of Teniers's *Brickworks*,[11] and P. N. van Reyschoot (1738–95) decorated churches and houses in Ghent.

SCENES FROM EVERYDAY LIFE

While Rubens's impassioned art transfused the whole of Flemish painting, there was but a modest place for the scenes from everyday life painted by devoted specialists, often after Dutch models. During the eighteenth century, however, it was these specialists who painted whatever had value in the eyes of their contemporaries: still life, landscape, and decorative and genre pieces. The purest taste of the period is in the genre scenes. It has been shown earlier that the landscape painters gradually degenerated into genre painters. For those who understand the conditions of Flemish painting there is nothing surprising in the fact that it is Teniers and not Brouwer who was the most esteemed and therefore the most copied among old masters. This cult was carried on into the nineteenth century. Indeed, if we look at Paris, which at that time held the monopoly of taste, we see that there Teniers was worshipped by the conservative collectors as one of the greatest of all artists, and that his works were priced correspondingly. Various Teniers types had a long life in Flanders: the alchemist, the scholar, the artist in his studio, the doctor. A painter like Jan Josef Verhaegen (1726–95), who simply continued to embroider upon Teniers's usual village scenes and his small kitchen pieces, is an exception. He painted without much elegance, but with the coarse brushwork and the healthy simplicity of his brother Pieter, who, although younger, was the leading member of the family (see p. 167).

Balthasar van den Bossche (1681?–1715) and Jan Josef Horemans I (1682–1759) are closely linked as painters of artists' studios in the Teniers tradition. When van den Bossche makes up his mind to leave alone the standard subjects and the hackneyed compositions of Teniers, he is capable of the most amusing little scenes (Plate 156A). An example is the group portrait of the militia during their reception by burgomaster Jan Baptist Del Campo (1711, Antwerp 379, now in the Vleeshuis).[12] The repertory of Horemans is more extensive. By him the artisans, the shoemakers and tailors, are brought upon the scene. He also painted charming group portraits and family scenes on terraces or indoors – a worthy successor to Gonzales Coques (Plate 157A) – and copied in his own manner paintings by Jan Steen, Brakenburg, Cornelis Bega, and Janssens the Dancer. He was the first artist whose paintings are occasionally light in colour, whereas what had up to then distinguished all the Teniers worshippers from their model was their predilection for sombre brown colours in interiors. Parts that lay in shadow frequently disappeared altogether into an opaque blackness. Horemans's son, Jan Josef Horemans II (1714–after 1790), collaborated with his father for a long time. It has been asserted that the lightening-up was due to him; in any case what is certain is that paintings of the years after the death of the elder Horemans (such as *The Four Seasons*, New York, of 1761–2) are entirely different in colour from those of 1710–30.[13] It remains difficult, however, to distinguish the father's work from that of the son. J. B. Lambrechts (1680–after 1731) also belonged to the older generation, which often persisted in its devotion to the seventeenth century, including its Dutch representatives. His greyish-green colour and a few recurring models make it fairly easy to identify him; yet his paintings

have often been catalogued under Horemans's name. His crumbly brushwork probably derives from the Dutchman Egbert van Heemskerck, and is thus ultimately inherited from Brouwer, a Fleming, not a Dutchman.

The group just reviewed remains, notwithstanding its aspirations towards elegance, a community of picture-makers who illustrated the life of ordinary people for middle-class collectors. For them the models of Teniers and Egbert van Heemskerck are on the same level. Although subject matter does not really determine their style, by subject and interpretation these painters seem to belong to another group than their contemporaries Pieter Snyers, Pieter Angillis, Frans Xaver Henri Verbeeck, and Jacques Ignatius van Roore. Pieter Snyers (1681–1752) was also a still-life painter, and, like Pieter Angillis (1683/5–1734), often displayed fruit and vegetables in the foreground of his market scenes. This still-life material is painted with a thin brush, in streaks of light paint. Occasionally they introduce pilgrims and tramps and paint them so sensitively that one must look for analogies, if not for examples, to France (Le Nain) and Italy (Ceruti) (Plate 156, B and C). Snyers and Angillis also worked in England, although there are no English subjects in their paintings. The early work of Angillis shows him still entirely under the influence of the dark paintings of van den Bossche (Stockholm 1480, of 1716), but his charming little pictures of the 1720s are light and the colours sparkle in the sun, as they do in the paintings of Lancret. Naturally, among the figures with which Angillis furnished his paintings there are types from Teniers.[14] Verbeeck (1686–1755) and van Roore (1686–1747) are the representatives in Flanders of the meticulous painting of Leiden. Van Roore painted in Amsterdam and Rotterdam (with one interruption) from 1720.[15] After the death of Frans van Mieris the Leiden type of genre piece had become not only a manner but a mania, with partisans and admirers in every European court. Antwerp was no exception. Melchior Brassauw from Malines (1709–after 1759), with Verbeeck and van Roore, belongs to this group. They painted with such attention to detail that their impersonally artificial technique obliterates their national characteristics and makes it impossible to catalogue them as belonging either to the Northern or the Southern Netherlands.

The second half of the eighteenth century produced only two genre painters whose work has attractions for us: Jan Anton Garemijn from Bruges and Léonard Defrance from Liège. Garemijn (1712–99) is genuinely Flemish in practising the village genre in the tradition of Teniers. It is natural that his early works are most closely dependent on his model. *The Digging of the Ghent Canal* (1753, Bruges, Museum Groeninge) is the best work of his first period. Its brushwork is vigorous, with a lovely execution of detail. The dark colour belongs to the style of the period – we have found it in Horemans and his contemporaries. Garemijn's style went on to acquire a more international flavour, however (Plate 157B). Venetian and French conceptions, it appears, were becoming known in Bruges. His paintings grew light and rosy, until the restlessness of the highly ornamental Rococo was overtaken by a final neo-classical phase about 1790. Except during this last phase, he also regularly painted altar-pieces for churches in Bruges, and these, by their tender pink and blue and their loose composition, breathe more of the spirit of French Rococo than his peasant and middle-class genre scenes (series of eight scenes 1760–1, Hl. Annakerk; St Francis de Mulder, 1793, St Gilliskerk).[16]

Léonard Defrance (1735–1805), being younger than Garemijn and enjoying a different upbringing, developed very differently. He was born at Liège, which had long been a centre with a culture of its own (see p. 142) where the Flemish Baroque had little influence. Everywhere in Liège painting showed traces of French Neo-Classicism. Defrance underwent this influence for seven years (1745–52), while he studied under Jan Baptiste Coclers. During his years in Rome, Naples, and southern France (1753–64) he can hardly have been influenced differently. The portraits and figures of saints which he painted at that time prove this. In Liège too, after his return, he painted biblical scenes which followed the rustic Classicism of the pupils of Bertholet Flémalle – rustic in the wildly gesticulating figures, classical in the orderly architecture and the elegant system of perspective (*Flagellation*, Liège 92). A radical change occurred in 1773, when he undertook a journey to Holland in the company of Henri de Fassin. Here he discovered Dutch genre painting. He copied industriously and found in Paris a rapid sale for his copies. Soon he began to paint domestic and street scenes of his own invention – the quack, the juggler, the blacksmith, the tobacco factory, guard rooms with soldiers, prisons during the Revolution. A prominent part of his work is occupied by scenes with workers in foundries and forges; the light effects produced by burning fires formed the main attraction for the painter and his public (Plate 159). These genre scenes, painted gracefully and with care, like those of his Leiden models, cannot yet be called direct imitation. In the whole of his *œuvre* there are only a few works in which he paints 'in the old style'.[17] His art is a genuine personal revival of Dutch bourgeois painting, and it fits in precisely with the little pictures painted in Paris by Boilly and others at about the same time. It is not surprising that Defrance's works found a ready sale in Paris: during his periodical visits he was able to assimilate French manners and taste more than superficially. Although it was not the first time that a new trend towards realism and naïvety had looked for support to seventeenth-century Holland – examples are by no means exceptional in Flemish and Walloon art, especially among the landscape painters of the following generation – the remarkable thing is that Defrance manages, within this trend, to preserve an original and personal vision. The Classicist self-portrait from his later years, placed against a wall of soft red-brown and grey, reveals him as an artist of great sensitiveness (Plate 160). It is ultimate proof of how completely successful 'le petit maître wallon' had been in welding together the grace of the French and the direct perception of the Dutch.

There may be some doubt whether one should consider Louis Joseph Watteau (called Watteau de Lille; 1731–98) a Flemish painter. He was, however, born at Valenciennes and lived for the whole of his life in this town and in neighbouring Lille, and both Valenciennes and Lille had belonged up to 1668/78 to the Southern Netherlands and were culturally still part of Flanders. Watteau studied at the Paris Academy, but returned in 1755 to Lille. There is nothing academic in his art, not even in the large altar-pieces which he painted towards the end of his life for churches in and around Lille. More revealing for the sources of his art is a painting of 1781. This, *The Temptation of St Anthony*, transfers Teniers into the art of the eighteenth century.[18] The elegant crowd of onlookers wear modern and fashionable clothes, but the composition and the scenery is that of Teniers and de Momper. Teniers was at the back of Watteau de Lille's mind too

in the many rural scenes which he painted for his Valenciennes and Lille clientele (Plate 158). Teniers's heritage (like that of Wouwerman, to which Watteau also paid tribute) spread far into France. But what in French art must be considered as an undercurrent was here, in Flanders and around the Flemish border, the main stream of genre painting. Watteau de Lille embroiders on the old Flemish tradition with much taste and refinement. His son François Louis Joseph Watteau (1758–1823) for a long time followed his father's manner, but in his later years the stories turned more matter-of-fact, and his *sopraporti* and other decorative pieces reflected the style of Hubert Robert. However, notwithstanding his admiration for the elegance of French Rococo art, François Louis Joseph Watteau preserved to the end of the Napoleonic Age the Flemish touch of the brush and the Flemish feeling for realism.

LIST OF THE PRINCIPAL ABBREVIATIONS USED IN THE NOTES AND BIBLIOGRAPHY

A.Q. *The Art Quarterly*

A.Q.	*The Art Quarterly*
B.M.	*Burlington Magazine*
Bull. I.B.R.	*Bulletin de l'Institut historique belge de Rome*
Bull. M.R.	*Bulletin des Musées Royaux*
Correspondance	C. Ruelens and M. Rooses, *Correspondance de Rubens*. 6 vols. Antwerp, 1887–1909
Evers, *Neue Forschungen*	H. G. Evers, *Rubens und sein Werk, Neue Forschungen*. Brussels, 1943
G.B.	*Gentsche Bijdragen tot de Kunstgeschiedenis*
G.B.A.	*Gazette des Beaux-Arts*
Glück, *Brueghel*	G. Glück, *Brueghels Gemälde*. 5th ed., Vienna, 1951
Glück, *Rubens*	G. Glück, *Rubens, Van Dyck und ihr Kreis*. Vienna, 1933
Glück-Haberditzl	G. Glück and F. M. Haberditzl, *Die Handzeichnungen von Peter Paul Rubens*. Berlin, 1928
Jahrb. K.S.	*Jahrbuch der kunsthistorischen Sammlungen*
Jahrb. P.K.	*Jahrbuch der preussischen Kunstsammlungen*
Magurn	R. S. Magurn, *The Letters of P. P. Rubens*. Cambridge, Mass., 1955
Münch. Jahrb.	*Münchener Jahrbuch der bildenden Kunst*
Puyvelde, *Sketches*	L. van Puyvelde, *The Sketches of Rubens*. London, 1947
Revue belge	*Revue belge d'archéologie et d'histoire de l'art*
Rooses	M. Rooses, *L'œuvre de P. P. Rubens*. 5 vols. Antwerp, 1886–92
Rotterdam exhibition (1953)	Catalogue by E. Haverkamp Begemann of the exhibition *Olieverfschetsen van Rubens*. Rotterdam, 1953
Seilern, *Paintings and Drawings*	[Count Antoine Seilern] *Flemish Paintings and Drawings at 56, Princes Gate, London, S.W.7*. London, 1955
Travaux (Hermitage)	*Travaux du département de l'art européen, Hermitage, Leningrad*
Wildenstein exhibition (1950)	Catalogue by L. Burchard of the exhibition *Peter Paul Rubens*. London (Wildenstein), 1950
Z.B.K.	*Zeitschrift für bildende Kunst*
Z.K.	*Zeitschrift für Kunstgeschichte*

NOTES TO THE INTRODUCTION

p. 2 1. The unity of the history of the Netherlands has been particularly stressed in the writings of P. Geyl, see bibliography and *Eenheid en tweeheid in der Nederlanden* (Lochem, 1946); *Holland and Belgium, their common History and their Relations* (Leiden, 1920).

2. Karel van Mander, *Schilderboek* (Haarlem, 1604 and 1618), ed. C. van de Wall (New York, 1936), 189.

p. 3 3. The population of Antwerp decreased in twenty years from 105,000 in 1568 to 42,000 in 1589. The crimes of the mutinous Spanish soldiers – known as the 'Spanish Fury' – cost Antwerp enormous losses in men and goods in November 1576.

p. 4 4. Cardinal Guido Bentivoglio, *Les relations de Flandre* (Paris, 1642), 189. H. Pirenne, *op. cit.*, 393-4.

5. Illuminating accounts from travellers who p. 5 visited Antwerp during the seventeenth and eighteenth centuries, describing the decline of the city, are collected and commented upon by J. A. Goris, *Lof van Antwerpen* (Brussels, 1940), 63-4, 85, 87, 108, and 140. What the situation was like in 1627-8 is heart-breakingly described by Rubens in his letter to Pierre Dupuy (see p. 97).

6. The States of Brabant wrote to Charles II in 1691: 'Nous nous trouvons réduits à la dernière des extrémités où puissent venir ceux que de longues et frayeuses guerres ont épuisés jusques à la dernière substance et qui ne peuvent plus présenter à Vostre Majesté que des infirmités et des playes, que des gémissements et de la douleur' (F. van Kalken, *Histoire de Belgique* (Brussels, 1946), 300).

NOTES TO PART ONE

CHAPTER 2

p. 9 1. I. von Roeder-Baumbach, *Versieringen bij Blijde Inkomsten* (Antwerp, 1943), 10.

2. E. Dhanens, 'Jan van Roome', *G.B.*, XI (1945–8), 102.

p. 10 3. For various reasons it seems best to deal with this castle in the framework of Belgian monuments of the sixteenth century, though it is in the Dutch province of North Brabant.

4. P. Clemen, 'Lancelot Blondeel und die Anfänge der Renaissance in Brügge', *Belgische Kunstdenkmäler*, II (Munich, 1923), 1.

5. D. Roggen, 'Jehan Mone, artiste de l'Empereur', *G.B.*, XIV (1953), 207. Roggen accepts that the designer of the Greffe, Jan Wallot, is the same as Jean Mone from Metz, who was working in 1516 and the following years in Barcelona and was living in Antwerp in 1521.

p. 12 6. In the entirely out-of-date book *Histoire de l'influence italienne sur l'architecture dans les Pays-Bas* (Brussels, 1879).

7. A. Schoy, *op. cit.*, 119. I have never come across a copy of this first edition, which Schoy describes as 'd'une rareté insigne'.

p. 13 8. D. Roggen and J. Withof, 'Cornelis Floris', *G.B.*, VIII (1942), 79.

9. See A. Corbet in *Revue belge*, VI (1936), 223, and D. Roggen and J. Withof, *loc. cit.*, 129.

p. 14 10. Roggen and Withof believe that the Hansa House was designed by Peeter Frans or Hendrick van Paesschen (*loc. cit.*, 138–9). They also cast doubt upon the idea that Cornelis Floris was responsible for designing the house of the painter Frans Floris (p. 140).

p. 15 11. 'Pas plus qu'il n'y a de baroque français il n'y a de baroque belge.' Thus O. van de Castijne, 'La question Rubens dans l'histoire de l'architecture', *Revue belge*, I (1931), 119.

p. 16 12. C. de Maeyer, 'Le Père François Aguillon', *Bulletin de la Société royale d'archéologie de Bruxelles* (1933), 113.

p. 17 13. I regard the suggestion of E. H. Thibaut de Maisières that the façade of the former Antwerp Jesuit church is a variant of that of the Gesù in Rome (*Annales de la Fédération archéologique et historique de Belgique*, Congress, Antwerp, 1947 (Antwerp, 1950), I, 9) as entirely untenable.

14. P. Plantenga, *L'architecture religieuse dans l'ancien duché de Brabant, 1598–1713* (The Hague, 1926), figure 119.

p. 20 15. The façade of the church at Bruges probably received its Baroque forms when the designs were reconsidered after the death of Huyssens. The church was first dedicated in 1642.

p. 20 16. C. Leurs, *Geschiedenis van de Vlaamsche Kunst* (Antwerp, n.d.), II, 861; *idem*, *Geschiedenis der bouwkunst in Vlaanderen* (Antwerp, 1946), 102.

p. 2 17. J. Gilissen, 'Le père Guillaume Hesius', *Annales de la Société royale d'archéologie de Bruxelles*, XLII (1938), 216.

18. M. Libertus, *Lucas Faydherbe, beeldhouwer en bouwmeester* (Antwerp, 1938).

p. 2 19. There is probably no more than a chance likeness to the triangular spaces in the corners of the cross of the older Noorderkerk in Amsterdam.

p. 3 20. A. Jansen and C. van Herck, 'J.P. van Baurscheit I and II', *Jaarboek van Antwerpsche Oudheidkundige kring*, XVIII (1943); also F. Baudouin, *Antwerpen in de 18de eeuw* (Antwerp, 1952), 187.

p. 3 21. S. Ansiaux, 'Jean Faulte', *Bulletin de la Société royale d'Archéologie de Bruxelles* (1935), 135.

22. L. Dewez, 'Laurent-Bénoît Dewez', *Annales de la Société royale d'Archéologie de Bruxelles*, XXXIV (1930), 65.

p. 3 23. G. Desmarez, 'La Place Royale à Bruxelles', *Mémoires de l'Académie royale de Belgique*, classe des Beaux-Arts, collection in 4°, II série, tome I (1923); Paul Saintenoy, 'Les arts et les artistes à la Cour de Bruxelles, le palais du Coudemberg', *ibid.*, collection in 4°, II série, tome VI (1935).

CHAPTER 3

p. 3 1. A. Jansen and C. van Herck, 'De Antwerpse beeldhouwers Colijns de Nole', *Jaarboek van de Oudheidkundige kring van Antwerpen*, XIX (1941).

2. I. Leyssens, 'Hans van Mildert', *G.B.*, VII (1941), 73.

p. 36 3. The present statue is a copy; the original was destroyed in 1817.

p. 40 4. There is no satisfactory monograph on Artus II Quellin. Juliane Gabriels (*Geschiedenis van de Vlaamsche Kunst* (Antwerp, n.d.), II, 775) attributes a good deal more to him than does the critical Hugo

Kehrer (*Belgische Kunstdenkmäler*, II (Munich, 1923), 259).

5. G. Gepts-Buysaert, 'Guillielmus Kerricx', p. 43 *G.B.*, XIII (1951), 61.

6. O. Roelandts, 'Beeldhouwer Pieter Antoon Verschaffelt', *Mémoires de l'Académie royale de Belgique, classe des Beaux-Arts*, collection in 8°, tome IV (1935).

CHAPTER 4

p. 47 1. The stylistic problems of Flemish art in the late sixteenth century have not attracted so much attention from art historians as contemporary phenomena in Dutch art. The history of Mannerism in Flanders is not exciting. The most important observations on the subject are to be found in F. Antal's essay, 'Zum Problem des niederländischen Manierismus', *Kritische Berichte*, II (1928/9), 207. See also W. Stechow, *Kritische Berichte*, I (1927/8), 54; G. J. Hoogewerff, *Nederlandsche schilders in Italie in de 16e eeuw* (Utrecht, 1912) and *Vlaamsche kunst en Italiaanse Renaissance* (Malines-Amsterdam, 1935); F. Baumgart, 'Zusammenhänge der niederländischen mit der italienischen Malerei in der zweiten Hälfte des 16. Jahrhunderts', *Marburger Jahrbuch für Kunstwissenschaft*, XIII (1944), 187.

2. The difficult question of the correct terminology for this 'period of transition' has here not been taken up. Dutch textbooks give the name 'Romanist' to all artists who visited Italy. Antal uses 'Romanism' to refer to 'the most Italianate painters in Dutch art', and particularly for the Classicist style of Barend van Orley and Lambert Lombard. The general definition of sixteenth-century art is regarded by him as being 'Mannerism, with specially pronounced manneristic phases at the beginning and at the end of the century'. Stechow prefers to use Mannerism to mean the last stylistic peak, which was very pronounced in Holland, that is the work of the young Abraham Bloemaert, Hendrick Goltzius, Cornelis Cornelisz van Haarlem, etc.

p. 48 3. F. Antal, *loc. cit.*, 254-5, observes truly that by reducing and stiffening Venetian examples Maerten de Vos gets closer to the Florentine interpretation of Mannerism. C. Lorenzetti (*Bolletino d'Arte*, XXVI (1932), 454) also points out the connexion with Florentine art (Vasari, Zucchi). S. Sulzberger, however (*Revue belge*, VI (1936), 121), emphasizes the strong influence of Tintoretto.

4. He had this devotion to Mannerist 'Kleinkunst' in common with another survivor from his generation, the Utrecht painter Joachim Wtewael (1566–1638), as T. von Frimmel (*Kleine Galeriestudien*, I (1892), 126) has already observed.

5. The date on these side panels is illegible. p. 49

6. Coebergher (1561–1634) was also a pupil of Maerten de Vos. His earlier work was much looser in technique and warmer in tone, which now does not surprise us. See, for his paintings done in Italy, T. H. Fokker, *Kunst der Nederlanden*, I (1930), 170. The *Entombment* of 1605 in Brussels (106), mentioned in the text, is not signed. One might doubt the attribution because the *Constantine and Helena* (Antwerp, St Jacobskerk) of the same year is much more restful, and the colours subdued.

7. E. Valentiner, *Karel van Mander als Maler* (Strasbourg, 1930), 6.

8. The attribution of this *Crowning with Thorns* depends solely upon identification with a work very summarily described by Karel van Mander (ed. van. de Wall, 287). See O. Granberg, *Trésor d'art en Suède*, II (Stockholm, 1912), no. 135, and O. Benesch in *B.M.*, XCIII (1951), 353.

9. See also p. 67. p. 50

10. The painting *Burden of Time* (New York, D. Spark, another version in Leningrad), tentatively ascribed to Otto van Veen by J. S. Held (*Bull. M.R.*, I (1952), 11), is probably an early work by van Noort. Compare the signed drawing of the same subject in the R. Davies Collection, London. p. 52

11. J. Denucé, *Brieven en documenten betreffend Jan Brueghel I en II* (Antwerp, 1934), 60, 64, and 80.

12. After the discovery of an *Adoration of the Kings* (Susteren, C. Mostaert Collection) signed AB 1605, *The Raising of Lazarus* (Munich 153) and *Jupiter and Antiope* (Copenhagen 349), both signed AB 1607, can no longer be attributed to the early Janssens. All three pictures are obviously by the same hand, and it is not Janssens's. See for the old literature on this question the Catalogue of the Ältere Pinakothek (Munich, 1936), no. 153. p. 53

13. On portraits in the style of Frans Pourbus and Rubens see L. Burchard in G. Glück, *Rubens*, 383; *idem* in Thieme-Becker, *Künstlerlexikon*, XXVII (1933), 314; M. S. Soria in *A.Q.*, XV (1952), 37. Compare also the courtly portraits of Sante Peranda in Mantua (Catalogue *La Galleria di Mantova* (Mantua, 1953), 3–4; L. Ozzola in *Emporium*, p. 54

LII (1946), 193) or those attributed to Tullio India (Vicenza 81–2).

14. The few biblical scenes of his later years (*Annunciation*, 1619, Nancy 272) are hardly touched by the new pictorial realism. They are impressive compositions of classical strength, and Philippe de Champaigne may well have admired them.

15. Glück, *Brueghel*, no. 87; L. van Puyvelde, *Schilderkunst en toneelvertooningen* (Ghent, 1912), 87.

16. Glück, *Brueghel*, no. 84; catalogue *De Helsche en de Fluweelen Brueghel* (Amsterdam, 1934), no. 24; *Münch. Jahrb.*, v (1910), 114; catalogue *Peintures méconnus des églises de Paris* (Paris, 1946), no. 4.

17. Lassus Sale, Berlin, 17 April 1928, no. 90; T. v. Frimmel, *Blätter für Gemäldekunde*, II (1906), 18.

18. Glück, *Brueghel*, no. 35. The original by Pieter Brueghel the Elder is in Budapest.

19. Glück, *Brueghel*, no. 57.

20. Another 'copy' after Dürer (*Golgotha*) with landscape added, in the Uffizi (signed and dated 1604). For other examples of the connexion between Jan's work and that of his father Pieter Brueghel I, see C. Tolnay, *Pierre Brueghel l'ancien* (Brussels, 1935), 96, no. 54, and 98, no. 63; K. Boström in *Konsthistorisk Tidskrift*, XXIII (1954), 55; G. Glück, *Brueghel*, no. 11.

21. G. Galbiati, *Itinerario dell'Ambrosiana* (Milan, 1951), with literature; G. Crivelli, *Giovanni Brueghel* (Milan, 1898).

22. G. Crivelli, *op. cit.*, 7, 22.

23. Catalogue *Die jüngeren Brueghel* (Vienna, 1935), no. 25.

24. Of this composition there are a large number of versions, among them Madrid 1884; Berlin, F. A. Gutmann Collection; Munich 1895.

25. J. Q. van Regteren Altena, *Oudheidkundig Jaarboek*, IV/1 (1932), 107.

26. A. Dorner, *Jahrbuch des Provinzialmuseums Hannover*, N.F. II (1927), 68, publishes a repetition of this composition (Hanover 37) which bears the date 1591. In my opinion signature and date were added later to this rather weak repetition, and thus Dorner's view that this is the earliest composition of Jan Brueghel cannot be accepted. Other versions of the same composition are at Vienna (inv. 6329); Vaduz, Liechtenstein Collection (492; a late work of the second half of the seventeenth century with

a faked date of 1597); Stockholm, E. Perman Collection. Dates and signature on so-called Brueghels are frequently faked (e.g. Kassel 49–50 are pictures of about 1700 with a 'signature' and dates 1597–8).

27. G. Crivelli, *op. cit.*, 272. L. M. Hairs, *Les peintres flamands de fleurs au 17e siècle* (Brussels, 1955), 153–4, has adduced powerful arguments which make it improbable that the flower piece in Madrid (1418) is the same as the painting mentioned in the correspondence, as suggested by A. Ratti (*Rassegna d'arte*, X (1910), 1) among others. In my view the flower piece in Paris (2079) is an even less likely candidate, chiefly because of its inferior quality. This is merely studio work. According to M. de Maeyer (*Albrecht en Isabella in de schilderkunst* (Brussels, 1955), 156), the Paris picture is a replica after a picture made for the Archdukes. Another picture that must be deleted from the list of paintings done in collaboration between Rubens and Jan Brueghel is the *Pausias and Glycera* (Sarasota). The flowers are by Osias Beert (J. Bergström, *B.M.*, XIX (1957), 120).

28. G. Crivelli, *op. cit.*, 241, 283.

29. G. Crivelli, *op. cit.*, 63, 75, 107, 167–8, 184.

30. Dr L. Burchard draws my attention to the fact that he considers the *Flowers and Fruit* (Plate 44B) to be a work by Frans Snyders.

31. Federigo Borromeo, *Musaeum* (Milan, 1625); F. Clerici, *Allegorie dei sensi di Jan Brueghel* (Florence, 1946), 15; M. de Maeyer, *op. cit.*, 148; J. A. Goris, *Lof van Antwerpen* (Brussels, 1940), 64–5; *Correspondance*, II, 119–20.

32. J. Denucé, *op. cit.*, 79. There must have been a third Frans Francken. His work, for example the small figures in the church interiors of the Neefs family, is not easily distinguished from the work of Frans Francken II. Other members of the Francken family were also painters. S. Gudlaugsson (notes in the Netherlands Art Institute, The Hague) has been able to identify a few paintings by Isabella Francken (Budapest 546 as J. Fouquier; Paris, Dr C. Benedict).

33. J. Denucé, *op. cit.*, 49.

34. Reproduction in E. Bassermann Jordan, *Unveröffentlichte Gemälde alter Meister im Besitze des Bayerischen Staates*, I (1906), no. 21.

35. The landscape at Würzburg (309) is dated 1599, but cannot be judged as a composition because it is only a fragment. The signature of the winter landscape at Kassel (51), 'Brueghel 1599',

. 57

. 58

p. 59

p. 60

p. 61

p. 63

p. 65

does not look original to me. The painting is certainly a joint effort by Jodocus de Momper and Jan Brueghel, but its date is not certain. Unacceptable is the attribution to Momper of the signed landscape dated 1627 which is illustrated in Y. Thierry, *Le paysage flamand au 17e siècle* (Brussels, 1953), 186.

p. 65 36. Inventory of Herrman de Neyt, Antwerp (J. Denucé, *De Antwerpsche 'Konstkamers' in de 16e en 17e eeuw* (Antwerp, 1932), 95). Toeput's *Fall of Phaeton* at Hanover (390) of 1599, and the landscape in a private collection at Paris (*Revue belge*, IX (1939), 9) of 1601 are indeed an introduction to the art of de Momper.

37. A copy of Pieter Brueghel's *Conversion of St Paul* unknown to me is supposed to be in Sweden (Glück, *Brueghel*, no. 37). K. Boström, *Konsthistorisk Tidskrift*, XX (1951), 1, and XXIII (1954), 45, attributes even the *Storm* in Vienna (Glück, *Brueghel*, no. 48) to de Momper. F. Grossmann, *Bulletin Museum Boymans*, V (1954), 81, suggests that the big mountain landscape, Vienna 985, has its origin in a lost composition of Pieter Brueghel representing the St Gothard Pass in Switzerland.

p. 66 38. D. C. Rich, *Bulletin of the Art Institute of Chicago*, XXX (1936), 38; F. McPherson Burkham in *Bulletin Allen Memorial Art Museum, Oberlin*, VIII (1950/1), 5.

39. J. Denucé, *op. cit.*, 63, 89.

40. Inventory Wijntges, 1614 (F. M. Haberditzl, *Jahrb. K.S.*, XXVII (1908), 163). Another example is *The Sermon on the Sea*, landscape by Tobias Verhaeght and Jodocus de Momper, a few figures by Ambrosius Francken (van den Branden, *Geschiedenis der Antwerpsche schilderschool* (Antwerp, 1883), 312).

41. O. Benesch, *Beschreibender Katalog der Handzeichnungen in der Albertina, Die Zeichnungen der niederländischen Schulen*, XV, 35.

p. 67 42. A landscape in Brussels (Belgian Recuperation Service) also in this style (see G. Camp in *Bull. M.R.*, I (1952), 139). Other examples in the manner of Hendrik van Balen: Dresden 940 (of 1622); *Vertumnus and Pomona*, Galerie Abels, Cologne (of 1629).

43. See also p. 150. The following worked more in the tradition of de Momper and Verhaeght: Joos Goeimare from Courtrai (1575–1610; in Amsterdam from 1586); Martin Rijckaert (1587–1631/2); and the so-called Master of the Winter Landscapes, who was not altogether convincingly identified

with Gijsbrecht Leytens by J. F. J. J. Reelick (*Oud-Holland*, LIX (1942), 74). Jaspar van der Lanen belongs rather to the followers of Gillis van Coninxloo (L. Burchard, *B.M.*, XC (1948), 237; F. J. Dubiez, *Oud-Holland*, LXV (1950), 120).

44. F. C. Legrand in *Revue belge*, XXVI (1957), p. 6· 163.

CHAPTER 5

1. Questions concerning Rubens's birth, and par- p. 7· ticularly the place – Cologne, Antwerp, Siegen? – exercised the minds of students for years. The question is now settled. See R. C. Bakhuizen van den Brink, *Het huwelijk van Willem van Oranje en Anna van Saxen* (Amsterdam, 1853); L. Ennen, *Uber den Geburtsort des P. P. Rubens* (Cologne, 1861); R. C. Bakhuizen van den Brink, *Les Rubens à Siegen* (The Hague, 1861); H. Riegel, *Abhandlungen und Forschungen* (Berlin, 1882), 167; H. Kruse, *Nassauische Annalen*, LIV (1934), 1, and *Siegerland*, XXII (1940), 2.

2. *Correspondance*, VI, 177; Magurn, 406 (letter of 25 July 1637 to Georg Geldorp).

3. On Rubens as letter-writer see *Correspondance*, I, 1, and VI, 1; Magurn, 1.

4. *Correspondance*, IV, 290 (letter of 1 August 1627).

5. *Correspondance*, II, 336. p. 7·

6. G. Scioppius, *Hyperbolimaeus* (Mainz, 1607), 110 (*Rubens-Bulletijn*, IV (1895/6), 115; *Correspondance*, II, 3). The Marquis of Spinola said 'that Rubens had so many talents that his knowledge of painting should be considered the least of them' (*Vita Petri Pauli Rubenii*; L. R. Lind in *A.Q.*, IX (1946), 39).

7. S. Birket Smith, *Otto Sperling Selvbiografi* (Copenhagen, 1885); W. v. Seidlitz, *Repertorium für Kunstwissenschaft*, X (1887), 111.

8. *Vita*, ed. L. R. Lind, 37; Roger de Piles, *Conversations* (Paris, 1677; ed. 1681, 30).

9. *Correspondance*, II, 149, 165; Magurn, 62.

10. Domenici Baudii, *Epistolarum Centuriae III* (Leiden, 1620), 644; *Correspondance*, II, 44. The portrait engraving by W. Panneels of 1630 (C. G. Voorhelm Schneevoogt, *Catalogue des estampes* (Haarlem, 1873), p. 100, no. 46) has the inscription '... Petrus Paulus Rubenius, pictorum Appelles ...'; 'l'Appeles de notre Temps' he is called in a letter by

Justus Rycquius of 13 December 1614 (*Correspond-ance*, I, 16). In Cornelis de Bie's *Gulden Cabinet* (Lier, 1661) he is 'unierso fere terrarum orbe cele-berrimus Pictoriumque huius saeculi omnium facile Princeps'.

11. [Jean Puget] de la Serre, *Histoire curieuse* (Antwerp, 1632), 68–9.

12. Letter of P. Chifflet, 6 June 1640; *Correspond-ance*, VI, 303.

p. 72 13. Letter of Roger de Piles of 23 August 1677 (*Rubens Bulletijn*, II (1883/5), 175).

14. The best survey on the problems connected with the interpretation of the old sources about Rubens's teachers is J. Muller Hofstede in *Bull. M.R.*, VI (1957), 165.

15. F. J. van den Branden, *Geschiedenis der Ant-werpsche schildersschool* (Antwerp, 1883), 409.

16. Even if a few of the paintings published by Held, van Puyvelde, Valentiner, and Konnerth (see bibliography) really were by Rubens they could give no decisive information concerning his early style. We know, however, that Rubens was already painting in this first Antwerp period. This is evident from the following clause in the will of his mother, who died on 19 October 1608: 'all the other paintings which are good belong to Peter who made them' (P. Génard, *Rubens* (Antwerp, 1877), 373).

p. 73 17. Drawing in the F. Lugt Collection (Glück-Haberditzl, no. 22); cf. H. G. Evers, *Neue For-schungen*, 32.

18. There are also drawings after classical statues, jewels, and Renaissance reliefs, which were done in Antwerp in later years; for example, the series of Roman Emperors of about 1620 (London, Hind, 54; Paris, Louvre, cat. F. Lugt 1085–1102; Cam-bridge, Mass; cat. F. Sachs, no. 485), which were engraved only in 1638. Cf. L. Burchard in Wilden-stein exhibition (1950), nos 9–10; catalogue *Anvers, ville de Rubens et Plantin* (Paris, 1954), nos 413–14.

19. *Correspondance*, I, 388. On this see also M. de Maeyer in *G.B.*, XI (1945/8), 147.

20. *Correspondance*, I, 225; Magurn, 37. A good character sketch of Duke Vincenzo by C. Ruelens in *Rubens Bulletijn*, II (1883), 244.

21. *Correspondance*, I, 96–225; Magurn, 24–37.

22. A. Luzio, *La Galleria dei Gonzaga, venduta all'Inghilterra nel 1627-28* (Milan, 1913). Later

in 1607 Rubens bought Caravaggio's *Death of the Virgin* and a work of Roncalli for the Duke and Duchess; *Correspondance*, I, 359–63, 412.

23. On the occasion of the marriage of Marie de' Medici (drawing in London, Glück-Haber-ditzl, no. 153). Glück also ascribes to Rubens a painting of Marie de' Medici (*Jahrb. K.S.*, XXII, N.F. VI (1932), 162).

24. *Veröffentl. der Prestelgesellschaft* (1925), no. 72, p. 74 as van Dyck; L. Burchard in G. Glück, *Rubens*, 374; *Sitzungsberichte der Berliner Kunstgesch. Gesell-schaft* (15 January 1932), 10.

25. M. de Maeyer, *G.B.*, XIV (1953), 75, assumes that the *Elevation of the Cross* (on canvas; the two others are on panels) is only a copy of the damaged original made during the restoration of about 1614. There is something odd about this painting. Ac-cording to Smith (*A Catalogue Raisonné*, II (London, 1830), no. 535), the picture had been sold to a certain Count Woronzoff and was spoiled in transport. The *Vita* speaks only of two paintings without mention-ing the subjects.

26. C. Norris (*B.M.*, XCV (1953), 107, and cata-logue *Vlaamse Kunst uit Brits bezit* (Bruges, 1956), nos. 82/3) believes that this series of apostles, of which there is a repetition in the Galleria Pallavicini at Rome, was first made in Antwerp, about 1610.

27. M. Boschini, *Carta del Navegar* (Venice, p. 75 1660), 59 (cf. C. Ruelens in *Rubens Bulletijn*, III (1886), 82). See also R. Longhi in *Annuaire des Musées Royaux*, II (1939), 123, with reference to the oldest biography of Rubens by Mancini, *c.* 1620 (*Cod. vat. Barb. Lat.* 4315, f. 126v.).

28. Typical for Rubens's method of working is that he used this and other drawings made in Italy to some extent in Antwerp. An interesting case is cited by Ursula Hoff in *Old Master Drawings*, XIII (1938), 14.

29. Rubens must have worked for or in Genoa p. 76 on various occasions. The *Adonis* and the *Hercules* mentioned on p. 74, which according to Bellori were painted for Giovanni Vincenzo Imperiale, must have been produced at the beginning of his stay in Italy. The portrait of a Genoese lady (formerly in the possession of the Gallery Matthiesen) is earlier than the other Genoese portraits, which are prob-ably contemporary with the *Circumcision* at S. Ambrogio (*c.* 1606). Rubens in a letter of 1628 said himself that he had been 'più volte a Genova' (*Correspondance*, IV, 423; Magurn, 265). Roger de

Piles and Bellori confirm this, Bellori most emphatically: 'è quivi (in Genoa) fermossi più che in altro luoga d'Italia'.

p. 76 30. The sketch is in Leningrad (L. van Puyvelde, *Sketches*, no. 1). W. R. Valentiner, in *A.Q.*, IX (1946), 153, publishes another *modello* in the Bergmann sale, New York, 12 May 1949, no. 33.

31. *Correspondance*, I, 354; Magurn, 39.

p. 77 32. The connexion of the various drawings and sketches with the final version of the painting at Grenoble is a rather complicated problem; see H. G. Evers, *Neue Forschungen*, 107; Seilern, *Flemish Paintings*, no. 14. The painting in Potsdam is not a *modello* but a separate painting; E. Haverkamp Begemann in *Bulletin Museum Boymans*, V (1954), 16.

33. This book by Philips Rubens (1574–1611), published in 1608 by Balthasar Moretus, contains five engravings after drawings by Rubens. The brothers met repeatedly in Italy, particularly in Rome. Philips wrote several letters for his brother from Rome to the court of Mantua (*Correspondance*, I, 5–20, 62). He left Rome in 1607. The drawing of a standing saint (L. Burchard Collection, Wildenstein exhibition (1950), no. 43), 'closely related' to the first altarpiece of S. Maria in Vallicella, gives the impression of having been inspired by a piece of classical statuary.

p. 78 34. *Correspondance*, I, 427; Magurn, 45.

35. M. de Maeyer, *G.B.*, XI (1945/8), 147; on 11 December 1608 Rubens was mentioned for the first time in the correspondence of an Antwerp resident (*Rubens Bulletijn*, III (1886/8), 165).

36. Letter of 10 April 1609 (*Correspondance*, VI, 324; Magurn, 20).

37. Rubens writes in 1629 from London: 'Non sono però fuori di speranza di compyr il mio voto del viaggio Italico ansi mi cresce la voglia d'hora in hora. E protesto che se la fortuna non me lo permette non vivero ne moriro giami contento ...' (*Correspondance*, V, 153; Magurn, 323).

38. Identical with Vienna, inv. 6344/5? See Glück, *Rubens*, 46; notes by L. Burchard, 379; L. Burchard, Wildenstein exhibition (1950), no. 31.

39. See p. 85.

p. 79 40. *Correspondance*, II, 61.

41. Copies after the picture before the repaint in 1628–9 are in the Duke of Wellington's Collection, London (by A. van IJzendijke?) and in the Christopher Norris Collection, Polesden Lacy.

42. For the drawings for the figures see Glück-Haberditzl, nos 45, 60–4, and 92. Some drawings were re-used for other compositions in 1615–16. The drawing at Oxford (catalogue K. T. Parker (1938), no. 200) could have served already for the 1603 *Elevation of the Cross* at Grasse. According to L. Burchard, this and the Rotterdam drawing (Rotterdam exhibition (1952), no. 63) are connected with the *Descent from the Cross* at Lille (Rooses, 311).

43. L. van Puyvelde, *Sketches*, no. 6. Other important sketches of this period: *Capture of Samson*, Chicago; the same subject, R. von Hirsch Collection, Basel; *Philopomene*, Paris 2124.

44. Studies of heads from the same period are the *Hercules* (London, L. Burchard Collection), and two heads in the Metropolitan Museum, New York (on loan from the Milton de Groot Collection); one of the latter was used for the *Disputà*.

45. The sketches for the outer panels in Dulwich; a drawing in the Count Seilern Collection, London (*Paintings and Drawings*, no. 54).

46. J. Held in *Miscellanea Roggen* (Antwerp, 1957), 129, puts this composition into Rubens's pre-Italian period.

47. Since the original versions on panel of the *Drunken Hercules* (Dresden 987) and the *Hero Crowned* (Munich 997) have been discovered, two compositions which until then had only been known in studio replicas on canvas, there can be no further doubt that this pair (like *Temperentia* and *Volupta*) belongs to the same phase of Rubens's work; E. Hensler in *Festschrift Paul Clemen* (Düsseldorf, 1926) and in *Kunstchronik* (1926), 662; L. Burchard, *ibid.*, 763.

48. In my opinion only a studio work. The prin- p. 80 cipal champion of its genuineness is L. van Puyvelde (e.g. in *Jaarboek van het Kon. Mus. voor Schone Kunsten*, Antwerp (1942/7), 83).

49. Rooses, 334/9. Paid 27 April 1612.

50. A particularly sensitive appreciation by H. Kauffmann in *Wallraf-Richartz Jahrbuch*, XVII (1955), 188. The sketches for the outside (St Christopher; Munich 72) seem to have been made earlier than 1614. The sketches for the inside of the side panels in the Count Seilern Collection, London (*Paintings and Drawings*, nos 16–17). The so-called sketch of the *Descent from the Cross* in the Lee of Fareham collection at the Courtauld Gallery, London, is only a repetition (E. Haverkamp Begemann in *Bulletin Museum Boymans*, V (1954), 16).

51. Teresa was beatified in 1610, and canonized in 1622 (É. Mâle, *L'art religieux après le concile de Trent* (Paris, 1932), 161); a date about 1615 is hence very possible. See also L. Burchard in Wildenstein exhibition (1950), no. 4.

52. Rooses, 136, 178, 325, 633, 698; III, p. 69.

p. 81 53. J. G. van Gelder, *Nederlands Kunsthistorisch Jaarboek*, III (1950–1), 102. In these years Rubens acquired Sir Dudley Carleton's collection of antique statues. On 1 June 1618 the transaction was completed, Rubens giving a series of his own paintings in payment. Some seven years later Rubens sold the antiques again to the Duke of Buckingham (*Correspondance*, II, 130 ff.); see pp. 71, 96.

p. 82 54. L. Burchard (Wildenstein exhibition (1950), no. 29) has pointed out correctly that the *Lion Hunt* at Munich (602) and the sketches belonging to it (L. van Puyvelde, *Sketches*, no. 17) are from a later period (*c.* 1622). See also C. C. Cunningham in *Wadsworth Atheneum Bulletin*, XXXIII (1952).

p. 83 55. The *St Catherine* (Voorhelm Schneevoogt, *op. cit.* (Note 10), p. 114, no. 35) is regarded by some as the only print etched by Rubens himself; see H. M. Hind in *Print Collectors Quarterly*, X (1923), 61.

56. *Correspondance*, II, 199; Magurn, 69.

57. F. v. d. Wijngaert, *Inventaris der Rubeniaansche prentkunst* (Antwerp, 1940), no. 193.

58. H. G. Evers, *Graphische Künste*, VI (1941), 21; idem, *Neue Forschungen*, 117; F. Lugt, Louvre catalogue, drawings, no. 1018.

59. M. Rooses in *Rubens-Bulletijn*, I (1882), 203; II (1883), 48, 126, and 176; *Correspondance*, II, 78; H. F. de Bouchery, 'P. P. Rubens and Balthasar Moretus', *Rubens en het Plantijnsche Huis* (Antwerp, 1941), 5; F. v.d. Wijngaert, 'Rubens als boekverluchter voor de Plantijnsche drukkerij', *ibid.*, 53; catalogue *Anvers, ville de Plantin et de Rubens* (Paris, 1954), 219.

p. 84 60. *Correspondance*, VI, 308.

61. *Correspondance*, V, 336.

62. H. G. Evers, *Neue Forschungen*, 167; see further Glück-Haberditzl, 72, 80, 102, 155, 166/7, 183, 214–17; M. Jaffé in *A.Q.*, XVI (1953), 131; E. G. Lisenkof in *Travaux* (Hermitage), III (1949), 49; W. M. Dobroklonsky, *Drawings by Rubens* (Catalogue of the Hermitage) (Leningrad, 1940), no. 20; K. T. Parker, catalogue drawings Ashmolean Museum (Oxford, 1938), I, no. 202; L. van Puyvelde,

Flemish drawings, Windsor Castle (London, 1942), no. 282.

63. F. v. d. Wijngaert, *Rubens en het Plantijnsche Huis* (Antwerp, 1941), 59.

64. M. Rooses in *Rubens-Bulletijn*, I (1882), 297; *Correspondance*, VI, 174.

65. Designs in grisaille for the title pages of Math. Sarbievius, *Lyricorum Libri*, IV (Antwerp, 1632); printer's trade-mark of Jan van Meurs (*c.* 1629): both in the Museum Plantin-Moretus, Antwerp; Aedo y Gallaert, *Viaje* (Antwerp, 1635): Victoria and Albert Museum, London; Balthasar Corderius, *Catena* (Antwerp, 1628): Count Antoine Seilern Collection, London (catalogue no. 33); Caspar Gevartius, *Pompa Introitus Fernandi* (Antwerp, 1642): Fitzwilliam Museum, Cambridge, no. 240.

66. See Rotterdam exhibition (1953), no. 81.

67. The drawing (in the Metropolitan Museum, p. 85 New York) is ascribed to Rubens himself by L. Burchard (Wildenstein exhibition (1951), nos 46–7), and by C. Norris (*B.M.*, XCIII (1951), 89) to Jeghers with corrections by Rubens. See also p. 106.

68. The study for the *Baptism of Christ* is in the Louvre (cat. F. Lugt, no. 1009). The sketch for *All Saints* in the Boymans Museum (259) repeats the composition of the same subject in the *Breviarium Romanum* (see p. 80) but is not a preparatory study for it; the big painting which would correspond to it has not been preserved or was never painted. The figure of St Sebastian appears clearly on the early painting of *c.* 1608 (in the Palazzo Corsini, Rome; see G. Glück, *Rubens*, 18; Zoege von Manteuffel in *Kunstchronik* (1930), 129).

69. *Correspondance*, II, 199; Magurn, 69. See also *Correspondance*, II, 202–12.

70. *Correspondance*, VI, 108; Magurn, 398.

71. *Repertorium für Kunstwissenschaft*, X (1887), p. 86 111.

72. *Correspondance*, II, 35; Magurn, 55. When on 1 November 1610 Rubens bought the house on the Wapper, he undertook to bring up and teach the son of the seller, Hans Thijsz (*Oud-Holland*, XXX (1912), 215).

73. *Correspondance*, II, 135 and 170; Magurn, 59.

74. *Correspondance*, II, 277 and 286; Magurn, 77.

75. See a letter to a M. Felix, unknown to us, of 16 January 1618 (Magurn, 57). See also *Correspondance*, II, 228, 237, 261, 272, and 286, and Rooses'

interpretation of Rubens's exchange of letters with Lord Danvers in *Correspondance*, II, 329. Rooses, I, 10; *idem* in *Rubens-Bulletijn*, v (1897/1910), 279. Concerning the assistants and the decoration of the Jesuit church see p. 89; L. van Puyvelde, *Rubens* (Paris–Brussels, 1952), 174 and 190, warns us against the assumption that most of Rubens's great commissions were carried out with the help of pupils; in my opinion van Puyvelde minimizes the importance of sources which oppose his view.

p. 86 76. *Correspondance*, VI, 257 ff.; Magurn, 412–14.

77. For example *Correspondance*, II, 69; Magurn, 56. Peiresc, in connexion with the designs for the Medici cycle, speaks of 'schizzi' and 'dissegni' (*Correspondance*, III, 40). Rubens, in a letter of 27 January 1628, speaks of 'dissegni' for the Gallery of Henri IV (*Correspondance*, IV, 357; Magurn, 234).

78. Rooses, I, 44.

p. 87 79. The patron who gave the commission for the Jesuit church demanded the sketches for the ceiling paintings in case Rubens failed to provide an altar-piece for the side chapel. Peiresc also warned Rubens that the Abbé de Maugis was trying to get hold of the sketches for the Medici cycle under false pretences (*Correspondance*, III, 40).

80. *Dissertation sur les ouvrages des plus fameux peintres* (Paris, 1681); *Œuvres diverses de M. de Piles*, IV (Paris, 1767), 386.

81. The 'second' series of the Medici cycle (Munich) shows certain changes in comparison with the first (Leningrad); they must be regarded not only as stylistic changes made by the artist but also as iconographic changes demanded by the patron.

82. The drawing of the man squatting in the *Elevation of the Cross* was also used in the *Abraham and Melchisedek* (Caen); Glück-Haberditzl, 60 and 92; F. Lugt, Louvre catalogue, no. 1030. See also Note 42 to this chapter.

83. For example, the standing figure after Correggio (F. Lugt, Louvre catalogue, no. 1106) was used in *Esther* for Ahasuerus (Jesuit church) and also in the *Union of Scotland and England* (Whitehall).

84. Mariette, *Abecedario*, ed. P. de Chennevières, v (Paris, 1858–9), 68–9.

p. 88 85. K. F. Suter, *B.M.*, LV (1929), 181; LVI (1930), 257; F. Lugt, Louvre catalogue, no. 1084.

86. Further evidence against this is provided by the only known preparatory drawing (in the Vic-

toria and Albert Museum), which is entirely in the style of Rubens (K. T. Parker in *Old Master Drawings*, IV (1929), 19). The paintings in Vaduz are really neither sketches nor cartoons according to the usual method of Rubens. Is it possible that the bulk of the original sketches by Rubens and the cartoons themselves have disappeared? (See Rooses 707 I, 708 I, 709 I, 711 I, 712 I, 713 I; a sketch for Rooses 713 is in Antwerp, no. 5036.) In this case the series in Vaduz would be a sort of in-between stage, which was not unheard of in Rubens's studio. That there were originally more series appears from the old attributions: painted by van Dyck after the sketches of Rubens (account G. Coques, 1661); 'composed by the Heer Rubbens and painted by Heer van Dyck' (inventory J. B. v. Eyck, 1692); 'Fece [A. van Dyck] li cartoni e quadri dipinti par le tapezzerie' (Bellori).

87. L. Burchard has pointed out (in conversation) that the two big altar-pieces and the sketches for them (Rooses 432 and 432 bis, 454 and 454 bis) are considerably earlier (1614–16) than the ceiling paintings.

88. Mantua, S. Trinità; Rome, Gesù (L. Burchard in *Actes du XIIIe congrès* (Brussels, 1930), I, 127); Genoa, S. Ambrogio; Neuburg (Pfalz) Jesuit church.

89. The monogram of Christ carried by the p. 89 angels repeats the composition of Rubens's altar-piece in S. Maria in Vallicella. We have drawings by Rubens of the details of the façade, ceilings, altars, etc. See also p. 24.

90. P. P. Rubens, *Palazzi di Genova* (Antwerp, 1622) (Rooses 1230); O. van de Castijne in *Revue belge*, I (1931), 102.

91. Rooses, I, p. 44; *idem* in *Rubens-Bulletijn*, III (1886/8), 265.

92. The *Return from Egypt* is probably identical p. 90 with the painting in Hartford (Goris-Held 51); the subject was entirely in line with Jesuit thought: the new trinity on earth reflects the trinity in heaven according to St Francis de Sales (É. Mâle, *L'art religieux après le concile de Trente* (Paris, 1932), 312).

93. The original of the letter has been lost; we have only a French translation. *Correspondance*, II, 286; Magurn, 77.

94. J. B. Greuze and J. G. Wille climbed a ladder p. 91 in the Palais Luxembourg 'pour voir de près les tableaux faits par le grand homme' (*Mémoires et journal de J. G. Wille* (published by G. Duplessis

(1857), I, 139). Delacroix complains of the ill-judged nineteenth-century restoration (*Rubens-Bulletijn*, IV (1890/6), 204).

95. *Correspondance*, III, 319 (the correspondence is preserved in a French translation only); Magurn, 101.

96. *Correspondance*, IV, 357; Magurn, 234.

97. *Correspondance*, V, 340–1; Magurn, no. 217.

p. 92 98. Apart from the two pictures in Florence, three other big paintings of the cycle are known which were finished by pupils (Munich 952; Hamburg, Neuerburg Collection; Göteborg; see A. W[estholm] in *Göteborg's Museum Arstryck*, 1951/2, 223).

99. *Correspondance*, V, 404–48; Magurn, no. 221.

100. *Correspondance*, III, 85.

p. 93 101. The *bozzetti* in Cambridge (Fitzwilliam Museum, 228–31, 241–3) and Bayonne (950–1) are not accepted as such by L. Burchard and L. van Puyvelde.

p. 94 102. Rooses, 162. The predella is in Marseilles (915–16). The sketch in New York reproduced by L. van Puyvelde (*Sketches*, no. 19) is only a later repetition, according to L. Burchard by B. Beschey. See also Goris-Held, no. A.52. Concerning portrait studies for the Magi see M. Jaffé in *B.M.*, XCVI (1954), 302. The comparison of this *Adoration of the Magi* at Malines with the triptych of the *Miraculous Draught of Fishes* from the same period (Malines, Onze Lieve Vrouwe over de Dijle; Rooses 245–9) shows that van Dyck must have assisted in painting the latter work.

103. Rooses, 174. The sketch is in the Wallace Collection, London (L. van Puyvelde, *Sketches*, no. 51). The portrait of Nicolaes de Raspaigne (Kassel 92) was used as the model for a king.

104. The commission was given about 1612 by Bishop Maes, but after the bishop's death Rubens's design was not accepted by his successors. See Rubens's complaint of 19 March 1614 (*Correspondance*, II, 69; Magurn, 56). The colour sketch ('il dissegno colorito') is in London (no. 57). G. Glück and F. Winkler's criticism of the sketch is incorrect (G. Glück, *Rubens*, 198; *Repertorium für Kunstwissenschaft*, XLIV (1923), 133; H. G. Evers, *Neue Forschungen*, 145).

105. Rooses, no. 359; *idem, Rubens-Bulletijn*, I (1882), 59. Sketches The Hague (926) (L. Burchard in Wildenstein exhibition (1950), no. 2), Langton Castle, and Mrs Weiss. The Cathedral Chapter was very kindly disposed towards Rubens: to let him work undisturbed for the last months in the church they ordered the Mass to be said not at the high altar but in another chapel.

106. A still earlier composition is in Brussels p. 95 (Rooses 407), of about 1615–16, with the opening of the grave as an important link and the charming motif of the two women picking roses from the grave. The later Flemings (Jordaens, Schut, and van Loon) took over this theme. A *modello* in Buckingham Palace (Rooses, 356; exhibition catalogue *The King's Pictures*, London 1946/7, no. 279) of about 1611 is the preparation for the bottom part of the Brussels *Assumption*, while the top part is used in the Viennese *Assumption* (Rooses 357).

107. Rooses, 214. This important work was prepared by two drawings, both in Stockholm, and a series of sketches (partly known only through copies). For the chronological order of these, see L. Burchard in Kaiser Friedrich Museum Catalogue (Berlin, 1931), no. 780; F. Grossmann in *B.M.*, XCVII (1955), 337.

108. 'Historical' portraits, that is to say portraits of historic personages from earlier portraits, were often painted by Rubens; sometimes they were true copies (after Titian, Massys, and others), sometimes they appear to be free variants upon old types, for example the portraits of the Emperor Maximilian I and Charles the Bold at Vienna (inv. 700 and 704; for the dating see L. Burchard in G. Glück, *Rubens*, 393). For his friend Balthasar Moretus, Rubens made two series of Moretus's ancestors, well-known scholars and artists, some after Italian portraits. The payment was so modest that we are not surprised to find that Rubens's pupils did all the work (Antwerp, Museum Plantin Moretus). See Rooses, *Rubens-Bulletijn*, I (1882), 281; *Correspondance*, V, 302; catalogue Antwerp Exhibition (1955), nos 468–9; H. F. Bouchery in *P. P. Rubens en het Plantijnsche Huis* (Antwerp, 1941), 33.

109. *Correspondance*, III, 134, 320. p. 96

110. Rooses, 907. The genuineness of the sketch in Zanesville, Michigan, is called in question by Goris-Held (no. A.3). Another portrait of Buckingham (head and shoulders) is in the Uffizi (copy?). The study of the head in the Albertina in Vienna (Glück-Haberditzl, no. 156) is particularly beautiful.

111. The sketch is in the National Gallery, London (Rooses, 820; Puyvelde, *Sketches*, no. 52). L. Burchard has pointed out that the composition

is inspired by Primaticcio, whose work Rubens copied at Fontainebleau during his second visit to France (see J. Q. van Regteren Altena in *Bulletin of the Rijksmuseum*, I (1953), 8; Wildenstein exhibition (1950), no. 50; F. Lugt, Louvre catalogue, no. 1078).

p. 97 112. For Rubens's various journeys to Holland see W. Stechow in *Oud-Holland*, XLIV (1927), 138; P. T. H. Swillens in *Jaarboek Oud-Utrecht* (1945/6) (1947), 105.

113. *Correspondance*, VI, 34.

114. *Correspondance*, VI, 82; Magurn, 391–2. According to Rubens this must have happened three years before. Apparently the Infanta nevertheless burdened him again with political missions.

115. *Correspondance*, V, 177; Magurn, 329.

116. *Correspondance*, IV, 264; Magurn, 184 (letter of 28 May 1627). In another letter, at least a year later, Rubens writes in the same vein again to Pierre Dupuy (*Correspondance*, IV, 452; Magurn, 279).

p. 98 117. *Correspondance*, V, 260.

118. C. Justi, *Velasquez und sein Jahrhundert* (Bonn, 1933), 242; Rooses, nos 925, 987, and 1024–8. It is difficult to decide whether the portraits of Charles V and Philip II after Titian were made now or had already been made in 1603. See A. Scharf in *B.M.*, LXVI (1935), 259; L. Burchard in Wildenstein exhibition (1950), nos 26–8; C. Norris in *B.M.*, XCIII (1951), 7; Seilern, *Paintings and Drawings*, no. 13. Of the many versions of Philip IV (and Elizabeth of Bourbon) see Goris-Held, no. 13 (Pittsburgh, H. A. Noble Collection); A. L. Mayer in *B.M.*, XLVIII (1926), 31 (Duveen); L. Burchard in G. Glück, *Rubens*, 394; L. van Puyvelde, *Rubens* (Paris–Brussels, 1952), 152 (Genoa, Galleria Durazzo Giustiniani); catalogue of the Ruzicka Collection exhibition (Zurich, 1949/50), no. 28.

119. F. Pacheco, *Arte de la pintura* (Seville, 1649), Madrid ed. (1956), 153.

120. *Correspondance*, V, 10; Magurn, 292. Another pleasant characterization of the king is to be found in a letter of 29 December 1628 (*Correspondance*, V, 16; Magurn, 295).

121. *Correspondance*, V, 43.

p. 99 122. *Correspondance*, V, 147; Magurn, 320.

123. Rooses, 956; L. Burchard in exhibition catalogue *The King's Pictures* (London, 1946/7), no. 103.

124. Rooses, 435; H. Walpole, *Anecdotes of Painting*, ed. R. N. Wornum (London, 1876), I, 309; E. Croft Murray in *B.M.*, LXXXIX (1947), 89.

125. Letter of 18 December 1634 from which we have already quoted (see p. 97 and Note 114) (*Correspondance*, VI, 81; Magurn, 184) – 'La lettre la plus importante' (Rooses–Ruelens).

126. *Correspondance*, IV, 299; Magurn, 199.

127. *Correspondance*, III, 445; Magurn, 135. p. 10

128. Rubens cannot have copied these paintings in Madrid, for they cannot have been there before 1639. In my opinion the style of the copies excludes the possibility that they were done during Rubens's Italian period. Probably Rubens worked solely from copies after Titian which came into dealer's hands in Antwerp (a small Flemish copy after Stockholm 600 appeared in a Brussels sale, 24 November 1941, no. 100, as H. van Balen). See G. Nordenfalk, *Jahrb. P.K.*, LIX (1938), 46; G. Glück, *Rubens*, 303, 319; F. Grossmann, *B.M.*, XCIII (1951), 25; J. Walker, *Bellini and Titian at Ferrara* (London, 1956), 83 and 113.

129. Rooses, 705; K. M. Swoboda in *Neue Aufgaben der Kunstgeschichte* (Vienna, 1935), 109.

130. *Beheading of St Paul*, Aix-en-Provence, p. 1 Madeleine (Rooses 478; M. Rooses in *Rubens-Bulletijn*, V (1897), 84: copy). Coloured drawing in the British Museum (on loan from the National Gallery, no. 853E); another version, formerly in Rookloster, destroyed (F. van Molle in *Revue belge*, XXI (1952), 127). *Crucifixion of St Andrew*, Toulouse (Rooses, 295; P. Mesplé in *La Revue des arts*, IV (1954), 244). *Crucifixion*, Brussels 374 (Rooses, 274; on the different sketches see Rotterdam exhibition (1953), nos 92–3, and J. Bruijn, *Bulletin van het Rijksmuseum*, VII (1959), 3). *St Livinus*, Brussels 375, sketch in Rotterdam (Rooses, 469; see Rotterdam exhibition (1953), no. 99). *Death of Dido*, Paris, Louvre, Beistegui Bequest; another version Thomas Agnew & Sons, London, 1950 (catalogue of the Rubens Exhibition (New York, Wildenstein, 1951), no. 33). *Andromeda*, Berlin 776C (Rooses, 667).

131. *Correspondance*, VI, 220 and 228. p. 1

132. L. Burchard, *Pinacoteca*, I (1928), 14.

133. Rooses, 663. The painting in London probably originally had the same scheme as that in Dresden (977; Rooses 664). The fact is that the many copies all reflect the Dresden version.

134. Rooses, 827; *Correspondance*, VI, 207, p. 1 Magurn, 408 (letter of 12 March 1638). A colour sketch in London (279).

135. Rooses, 360. Painted about 1635–8 for the Carthusian church in Brussels. Sketch in the collection of Count Antoine Seilern, London (*Paintings and Drawings*, no. 38).

136. Rooses, 176. Sold London, Sotheby's, 24 June 1959, no. 14. The painting was done for the convent of the Dames Blanches in Malines in 1634 (E. van Even in *Rubens-Bulletijn*, 1 (1882), 99). The sketch is in the Wallace Collection, London (251). See L. van Puyvelde, *Sketches*, no. 51.

137. Rooses, 456–9; the sketch is in Leningrad. H. G. Evers, *Peter Paul Rubens* (Munich, 1942), 348.

p. 105 138. P. Gérard, *Antwerps Archievenblad*, II (1865), 168.

139. Rooses, 1049.

140. Rooses, 930, sketch in Detroit (see E. P. Richardson in *Bulletin of the Detroit Institute of Arts*, XXVII (1947/8), 1, and in *Miscellanea Leo van Puyvelde* (Brussels, 1949), 135, and Catalogue Rubens Exhibition, New York, Wildenstein, 1951, no. 30). Other portraits of the Cardinal Infante Ferdinand: as cardinal in Munich (Rooses, 928; L. Burchard in Glück, *Rubens*, 394), replica in Earl Spencer Collection (L. Burchard in Wildenstein Exhibition (1950), no. 33); three-quarter portrait in Sarasota (Rubens Exhibition, New York, Wildenstein, no. 31).

141. For equestrian portraits see G. Glück, *Rubens*, 32.

. 106 142. Rooses, 940. Two drawings, one of which is now in the Boymans Museum Rotterdam (Glück-Haberditzl, 192–3).

143. Rooses, 948. The drawing in the Louvre (F. Lugt, no. 1026; Glück-Haberditzl, no. 227) of Rubens's daughter Isabella Helena must have been a preparatory study for an enlargement of the painting on the right-hand side.

144. Rooses, 949; H. G. Evers, *Neue Forschungen*, 275.

145. Rooses, 471; see Catalogue of the Exhibition at the Royal Academy, London (1950/1), no. 225.

146. Rooses, 835; Glück, *Rubens*, 82.

147. Preparatory studies for the horses and the cart in Oxford and at Chatsworth (Glück-Haberditzl, 93–4).

107 148. Rooses, 1182, 1189, 1201; G. Glück, *Die Landschaften von Peter Paul Rubens* (Vienna, 1945), nos 1, 2 and 6.

149. Rooses, 1200 and 1169; G. Glück, *Landschaften*, nos 18 and 16 (with literature), L. Herrmann, *Untersuchungen über die Landschaftsgemälde des Peter Paul Rubens* (Diss., Berlin, 1936), 30/1.

150. *Correspondance*, VI, 255–8, etc.; Magurn, 412–14. I consider it probable that Rubens's original 'dessein' was already a colour sketch, of which the copy in the Fitzwilliam Museum, Cambridge (no. 92), gives us a good idea. Another Spanish Landscape (van Uden after Rubens?) in Philadelphia (J. G. Johnson Collection); Glück, *Landschaften*, no. 16.

151. Rooses, 1203, 1204; Glück, *Landschaften*, p. 108 nos 29–30; N. MacLaren, *Peter Paul Rubens, The Château de Steen* (London, 1946).

152. Glück, nos 31, 35, 38; Seilern, *Paintings and Drawings*, no. 41.

153. *Correspondance*, VI, 281; Magurn, 250.

154. Jacob Burckhardt's *Erinnerungen an Rubens* (English ed. London, 1950, 156–7) concludes with homage to Rubens the landscape painter and Rubens 'der grosse Erzähler', the equal of Homer.

155. From an unpublished manuscript of a course of lectures on Rubens by Professor Georg Graf Vitzthum, dating from 1940, and preserved in the Kunsthistorische Institut at the University of Bonn.

156. *Correspondance*, VI, 302–8; P. Lacroix in *Revue universelle*, 1 (1855), 218; P. Génard in *Antwerpsch Archievenblad*, II (1865), 126; Catalogue Del-Marmol, 1794, 3; Dawson-Turner, *Catalogue of the Works of Art* (Yarmouth, 1832 and 1839); W. N. Noël Sainsbury, *Original Unpublished Papers* (London, 1859), 236; J. Denucé, 'De Antwerpsche Konstkamers' (Antwerp, 1932), 71.

CHAPTER 6

1. P. Rombouts and T. van Lerius, *De Liggeren* p. 109 (Antwerp, 1872), 457–8, 545, 547.

2. L. Galesloot, *Annales de l'Académie d'archéologie* p. 110 *de Bruxelles*, 24/2, IV (1860), 561.

3. Rooses, I, pp. 43–5. See also above, p. 89.

4. *Correspondance*, II, 137; Magurn, 61.

5. G. B. Bellori, *Le vite de' pittori* (Rome, 1672), 253. Perhaps Bellori was referring to grisailles, but compare also the drawings in the Louvre (H. Vey, *Bull. M.R.*, VI (1957), 177). The so-called Rubens sketch of a *Descent from the Cross* at Lille (1101) could in my opinion be by van Dyck.

p. 111 6. Rooses, 707–14. See also above, p. 88.

7. *Correspondance*, II, 250, 262; W. H. Carpenter, *Pictorial Notices* (London, 1844), 7–9.

8. W. H. Carpenter, *op. cit.*, 10.

p. 112 9. W. J. Warschawskaja in *Travaux* (Hermitage), III (1940), 87. Other versions: Marquess of Ailesbury (London exhibition (1938), no. 116, as J. Jordaens); Oberländer sale, New York, 25 May 1939, no. 242 (*Klassiker der Kunst* (1931), 32).

10. O. Millar (*B.M.*, XCVII (1955), 313) dates the Brussels picture somewhat later.

11. There are three versions of the *Betrayal of Christ*: Madrid; on loan to Cook collection (Cambridge, Fitzwilliam); and Corsham, to which P. Bautier (*Revue belge*, X (1940), 41) has added a fourth. L. van Puyvelde (*Van. Dyck* (Brussels, 1950), 127) believes that the Madrid version is the one which was painted for Rubens H. Vey. (*Bulletin Museum Boymans*, VII (1956), 46, and *Bull. M.R.*, V (1956), 168) has made a critical survey of all the drawings and *modelli* which were done before and after the completion of the Corsham picture.

12. M. Rooses, *Jordaens* (Antwerp, 1906), 10–11.

p. 113 13. L. Burchard (in lectures given in Antwerp in 1955) also stressed the connexion between Rubens's sketches and the early paintings by van Dyck. H. Vey, *loc. cit.*, 45, maintains that many of the early van Dyck compositions start iconographically and stylistically from Rubens's inventions.

14. A. J. J. Delen, *Revue belge*, I (1931), 193.

15. O. Millar (*B.M.*, XCIII (1951), 125) has put forward the likely hypothesis that this painting was done during van Dyck's first visit to England. O. Benesch published another version (*Graphische Künste*, III (1938), 25–6).

16. See also p. 82.

p. 114 17. L. van Puyvelde in *B.M.*, LXXVII (1940), 37, and in *Z.B.K.*, XXI (1958), 183; H. Vey in *Bulletin Museum Boymans*, VII (1956), 48 (on drawings connected with these pictures).

18. See M. Jaffé and L. Burchard in *B.M.*, XCV (1953), 387. The studies of a Negro head (Brussels 389) are also ascribed to Rubens – to my mind erroneously. See also below, Notes 20 and 21.

19. The portrait, dated 1613, in the S. del Monte sale, London, 24 June 1959, no. 37 (*Klassiker der Künst*, 75) is not by van Dyck. It is not accepted

either by H. Rosenbaum, *Der junge van Dyck* (Munich, 1928), 5.

20. Attributed to Rubens in the Brussels cata- p. 115
logue and by Leo van Puyvelde (again in *Emporium*, CXXII (1955), 104).

21. In the Brussels catalogue still attributed to Rubens.

22. The dated portraits not yet mentioned are: 1618: portrait of a man and his wife, Dresden (1022–3); 1620: *Jaspar de Charles*, private collection (*Klassiker der Kunst*, 93). See also Note 23.

23. Painted in 1621. See L. Burchard in the Berlin sale catalogue of 12–13 May 1931, no. 77. The pictures were not sold and are back in the Hermitage.

24. National Gallery, Washington (Gulbenkian Loan). L. van Puyvelde in *Art in America*, XXVIII (1940), 3.

25. Manuscript in the Louvre, Paris. Regarding p. 11C
van Dyck's visit to Venice, Dumont writes: 'Il retrouva dans le coloris de ces grands maîtres [Tintoretto and Veronese] les principes de Rubens.' Since Dumont is an eighteenth-century writer, his statements have less weight than those of G. P. Bellori (*Le vite de' pittori*, Rome, 1672) or Raffaelo Soprani (*Le vite de' pittori*, Genoa, 1674), but he seems to have had access to letters of the brothers de Wael, which are now lost. See also Note 30 and M. Vaes in *Bull. I.B.R.*, IV (1924), 225, and VII (1927), 5; G. Glück in *Zeitschrift für bildende Kunst*, Beilage, LXI (1927/8), 72.

26. The financial settlement for the *Virgin of the Rosary* (p. 118) took place with a representative of the artist at Genoa on 8 April 1628. Van Dyck himself was no longer there. The picture is referred to as 'nuovamente fatto nella citta di Genova'. Van Dyck must have returned during the preceding year, as the portrait of the Antwerp collector Peter Stevens (The Hague 239) is dated 1627. Anyhow he was at Antwerp on 8 March 1628, when his will was drawn up before a notary. The older supposition that he had interrupted his Italian stay about 1622 to pay a vist to Antwerp has no reliable foundation.

27. J. Wilde in *Jahrb. K.S.*, IV (1930), 262. p. 11

28. O. Kurz in *Miscellanea D. Roggen* (Antwerp, 1957), 179.

29. C. Sterling in *B.M.*, LXXIV (1939), 53.

30. A. Salinas in *L'Arte*, II (1899), 499. See also Note 26, above.

p. 118 31. Bellori, 255. Strangely enough, these portraits are not mentioned by Dumont. Their most exhaustive interpretation in [D. Mahon and D. Sutton] catalogue of the exhibition, *Artists in 17th Century Rome* (London, 1955), nos 38–9.

32. According to L. Burchard (in Glück, *Rubens*, 412) perhaps the Flemish art-dealer Daniel Nijs is represented here, but L. van Puyvelde (*Connoisseur*, CXIV (1944), 3) identifies the sitter with van Dyck himself and Bernini!

p. 119 33. *Klassiker der Kunst*, 159.

34. Another portrait from the same period is the *Markyzus* at Leningrad (*Klassiker der Kunst*, 281); O. Panfilowa in *Bulletin of the Hermitage*, VII (1955), 36.

35. L. van Puyvelde in *Emporium*, CII (1955), 110.

36. *Klassiker der Kunst*, 206–7.

37. *Correspondance*, IV, 218.

p. 120 38. [Jean Puget] de la Serre, *Histoire de l'entrée de la Reyne mère* (Antwerp, 1632), 69.

39. J. Müller-Rostock, *Z.b.K.*, LVII (1922), 22; B. A. Mattison, *Tidskrift for Konstvetenskab*, XVIII (1934), 48. A certain J. B. Bruno in 1630 received a letter of recommendation signed by Rubens, van Dyck, and Gerhard Seghers. From this it can be seen that Bruno, on the instructions of van Dyck, had cleaned and restored several pictures by Titian (A. Michiels, *Van Dijck* (Paris, 1882), 304–5, note 3). The tenth Earl of Northumberland bought several Titians from van Dyck's estate (O. Millar in *B.M.*, XCVII (1955), 255).

40. See p. 190, Note 26.

41. Paid for by Père Marinus Jansenius. On the sketches and the alteration of the original composition see catalogue van Dyck exhibition (Antwerp, 1949), no. 14.

42. Painted in order to thank the sisters for the care and good services bestowed by them on van Dyck's father, who had died in Antwerp in 1622.

p. 122 43. Exhibited London, Royal Academy, 1950, no. 37; 1953, no. 144; Bruges, 1956, no. 89. J. Smith, *A Catalogue Raisonné*, III (London, 1831), 764: 'one of the most beautiful and moving portraits'.

44. Of the portraits of princes usually several more or less equal versions exist, of which the following may be quoted: *Isabella* at Turin, Pinacoteca; *Frederik Hendrik and Amalia van Solms* formerly at Wörlitz near Dessau; *Marie de' Medici*, private collection, Germany (*Klassiker der Kunst* (1931), 316). F. J. van den Branden (*Geschiedenis van de Antwerpsche schildersschool* (Antwerp, 1883), 713) maintains that van Dyck paid a visit to the Northern Netherlands in 1628, where he painted portraits of the family of the Stadholder and of 'several official persons and artists'. See also J. G. van Gelder, *Bull. M.R.*, VIII (1959), 43.

45. [Jean Puget] de la Serre, *op. cit.*, 69.

46. E. Göpel, *Ein Bildnisauftrag für Van Dyck* (Frankfurt, 1940).

47. W. H. Carpenter, *op. cit.*, 24; *Correspondance*, IV, 218; L. Cust, *Anthony van Dyck* (London, 1900), 85. An earlier version of the *Rinaldo and Armida* in Los Angeles (W. R. Valentiner in *Los Angeles County Museum Quarterly*, VIII (1950), 8).

48. W. H. Carpenter, *op. cit.*, 58–62; *Correspondance*, VI, 3–7. Sir Balthasar Gerbier was now in the p. 123 service of the Lord Treasurer Richard Weston. The Earl of Arundel, who after the death of Buckingham again became more influential, may have recommended the artist, whom he had already protected in 1620, to the court. Marie de' Medici could also have written to her daughter Maria Henrietta, the Queen of Charles I, in his favour.

49. On van Dyck's journeys to Holland see *Oud-Holland*, III (1885), 20; L. Burchard (and E. Göpel) in *Jahrb. P.K.*, LIX (1938), 48; J. G. van Gelder in *Bull. M.R.*, VIII (1959), 43. On 12 February 1631 van Dyck authorizes somebody in the Hague to receive money on his account (L. Cust, *op. cit.*, 82). There is perhaps also a nucleus of truth in Houbraken's anecdote of the meeting of Frans Hals and van Dyck (*De Groote Schouburgh*, I (Amsterdam, 1718), 91).

50. For the different versions see *Klassiker der Kunst* (1931), 260–1, and the accompanying notes.

51. C. Nordenfalk in *Jahrb. P.K.*, LIX (1938), 56. The version at Göteborg is certainly not the painting commissioned by Frederik Hendrik. It was done with the help of assistants.

52. A. P. Oppé in *B.M.*, LXXXIX (1941), 186.

53. E. K. Waterhouse, *Painting in Britain 1530–1790* (*Pelican History of Art*) (London, 1953), 48.

54. H. Walpole, *Anecdotes of Painting*, ed. R. H. Wornum (London, 1876), 330.

55. R. de Piles, *Cours de peinture* (Paris, 1708), 219 (quoting Eberhard Jabach).

p. 124 56. A. Koecher, *Mémoires de la Duchesse Sophia* (Leipzig, 1879), 38; Fr. P. Verney, *Memoirs of the Verney Family* (London, 1892), I, 257. See also *Walpole Society*, XIV (1936), 159.

57. For the American collections see W. R. Valentiner in the catalogue of the Detroit exhibition (1929). Most of the Hermitage van Dycks were bought by Catherine II in 1779 from the collection of Sir Robert Walpole at Houghton Hall.

58. F. Grossmann, *B.M.*, XCIII (1951), 16–17, dates the picture 1636/7. H. Vey, *Bulletin Museum Boymans*, VII (1956), 88, says that no conclusive dating is possible.

59. For reproductions and comments see *Klassiker der Kunst*, 414–33. For the equestrian portraits see G. Glück in *B.M.*, LXX (1937), 211. The so-called 'Bolingbroke Family' (Detroit), not representing that family, was also painted in Flanders around 1634 (E. P. Richardson in *A.Q.*, XVI (1953), 228; *Bulletin Detroit Art Institute*, XXXVIII (1953/4), 6).

60. The version at Antwerp (405) is inferior to that in the Camrose Collection, which I consider the original. On the sitter see D. Schlugleit in *Revue belge*, VII (1937), 142.

p. 125 61. He chose Martinus van den Enden, who handed the business over to Gerrit Hendricks in about 1645. There exists a series of beautiful portrait drawings which were made with this publication in view. The authenticity of the grisaille sketches, however, has been rightly doubted (L. van Puyvelde, *Van Dyck* (Brussels, 1950), 199, and H. Vey in *Bulletin Museum Boymans*, VII (1956), 82, and *Bull. M.R.*, V (1956), 202).

62. O. Millar in *B.M.*, XCVI (1954), 36; P. Palme, *Triumph of Peace* (Copenhagen, 1956), 282.

63. A long list of yet unpaid portraits with corrections of the prices by the king is reproduced in W. H. Carpenter, *op. cit.*, 67.

p. 126 64. *Correspondance*, VI, 310 ('he is difficult').

65. The older generation of Anglo-Dutch portrait painters such as Daniel Mytens, Cornelis Jonson, and Jan Mytens fell under his spell, not to mention the younger. The young Adriaen Hanneman is another case of clever imitation. See the early portrait of 1636 in the Wachtmeister Collection at Vanås, and L. Marcenaro in *Bull. I.B.R.*, XIX (1938), 269, who attributes a portrait group by Hanneman to van Dyck. The much discussed portrait of Mary and William II (Amsterdam 857) is also a case in question. It is from van Dyck's studio (O. Millar in *B.M.*, XCVII (1955), 314) and was formerly attributed to Sir Peter Lely or Adriaen Hanneman.

CHAPTER 7

1. This is Balthasar Gerbier's opinion; see his letter of 2 June 1640 to William Murray (*Correspondance*, VI, 299). p. 127

2. A survey of the more important studies of heads in L. van Puyvelde, *Jordaens* (Brussels, 1953), 82. Sometimes the attribution to either Jordaens or van Dyck is uncertain: the study in the former P. F. J. J. Reelick Collection (G. Glück in *Festschrift für Max J. Friedländer* (Berlin, 1927), 147) as van Dyck is attributed by Rosenbaum (*Der junge van Dyck* (Munich, 1928), 12) to Jordaens. The head of the apostle at Aix (exhibition Paris 1936, no. 20, as van Dyck) is in my opinion also by Jordaens.

3. J. Held, *Art Bulletin*, XXII (1940), 70.

4. J. A. Goris and J. Held, *Rubens in America* (New York, 1947), no. A 28; W. G. Constable, *Miscellanea Leo van Puyvelde* (Brussels, 1949), 127; J. Held in *Parnassus*, XII (1940), no. 3, p. 26.

5. L. van Puyvelde, *B.M.*, LXIX (1936), 225. p. 128

6. R. A. d'Hulst in *Bull. M.R.*, I (1952), 19.

7. Reproduced in *Pantheon*, VIII (1931), 296.

8. H. B. Wehle, *Bulletin of the Metropolitan Museum*, VI (1948), 266. p. 129

9. R. A. d'Hulst, *Bull. M.R.*, II (1953), 11. It always seems to me in looking at Rubens's *Descent from the Cross* in Antwerp Cathedral that Jordaens collaborated on the wings, which were done around 1614.

10. W. N. Eisendrath, *City Art Museum of St Louis Bulletin*, XLII (1957), no. 1, and *A.Q.*, XX (1957), 330.

11. L. Burchard, *Jahrb. P.K.*, XLIX (1928), 212. p. 130
The subject is not the same as in the painting at Copenhagen, see p. 131 (Plate 116A): the Copenhagen picture is Matthew 27: 17, but the subject here is John 21: 1–9, 'Jesus showed himself again to the disciples at the sea of Tiberias'.

12. L. Burchard has very rightly remarked that already the early 'undulating' style of Jordaens was admired and imitated in Antwerp; the German Johann Liss must have come into touch with this

phase of Jordaens's art in Antwerp around 1617 (E. Schilling in *Festschrift Karl Lohmeyer* (Saarbrücken, 1954), 31).

13. R. A. d'Hulst, *A.Q.*, XIX (1956), 237.

14. M. Rooses, *Jordaens* (Antwerp, 1906), 123.

15. M. Rooses, *op. cit.*, 140.

16. In accordance with J. Held (*Kunstmuseets Aarskrift* (1939), 20) and contrary to the opinion of L. van Puyvelde (*Jordaens*, 31, note 37) I read the date on the *Hunter* at Lille (425) as 1635. The style of the landscape, moreover, is reminiscent of those painted by Rubens in the thirties.

131 17. A study of the saint is at the museum in Stuttgart (B. Bushart in *Revue belge*, XXV (1956), 145).

132 18. M. Crick-Kuntziger, *Annuaire de la Société royale d'archéologie de Bruxelles*, XLII (1938), 135, and *Revue belge*, XXIV (1955), 25; R. A. d'Hulst, *A.Q.*, XIX (1956), 237.

19. L. van Puyvelde, *Jordaens*, 162, identifies the 'Riding Academy' with a series of 1624, which seems improbable.

20. J. Held, *Miscellanea Leo van Puyvelde* (Brussels, 1949), 153. Another painting from this series at the sale from the museums of Leningrad, Berlin, 6 November 1928, no. 387. The cartoons in the collections of the Marquess of Northampton (London exhibition (1953/4), nos 271, 274–5) and the Marquess of Bath (*idem*, nos 467 and 471).

21. See p. 126. *Correspondance*, VI, 317.

22. D. Schugleit, *Revue belge*, VII (1937), 139.

23. The decorative pictures from Jordaens's own house are of different periods. The stories of Cupid and Psyche are older than the *Offer to Apollo* of 1652 (Antwerp, J. van der Linden Collection). The quality is not high; it is therefore possible that the Cupid and Psyche pieces are studio replicas after the lost Greenwich pictures.

133 24. Rooses, *Jordaens*, 255–8; J. G. van Gelder, *Nederlands Kunsthistorisch Jaarboek*, II (1948/9), 118. The sketches now at Antwerp (799), Brussels (236), and Warsaw.

134 25. For literature see Note 18, and L. van Puyvelde, *Jordaens*, 157.

26. M. Rooses, *Jordaens*, 229.

27. J. Held's essay (*Kunstmuseets Aarskrift*, XXVI (1939), 23) on Jordaens's art and religion is very enlightening. See also M. N. Benisovitch in *Oud-Holland*, LXVIII (1953), 56; R. d'Hulst in *Bull. M.R.*, VII (1958), 93.

28. According to J. Held (*Revue belge*, III (1933), p. 135 214) painted around 1650–5, but incorporating an older composition.

CHAPTER 8

1. The late pictures by A. Sallaert are rather pale p. 136 and weak. Comte d'Arschot, *Revue belge*, XIV (1944), 148; XVI (1946), 115.

2. In this early group I would include the *Family at Karlsruhe* (117) and the so-called *Family of Jan Brueghel* in Count Seilern's collection (*Paintings and Drawings*, no. 18), both, however, unsigned and attributed by others to Rubens.

3. Reproductions of most of the paintings quoted p. 137 here can be found in E. Greindl, *Corneille de Vos* (Brussels, 1944), where the development of the artist, however, is not well demonstrated. See also *Revue belge*, XIX (1950), 61, note 63; J. Denucé, *Brieven en Documenten betreffend Jan Brueghel I en II* (Antwerp, 1934), 53, 64, 95.

4. Portraits by Hieronymus van Kessel of 1618: Schleissheim 3691/2; Épinal 55 (wrongly called A. Kessel); of 1620: sale Museum Hanover 2 July 1931, no. 201.

5. His first Italian stay was in 1602–8, his second p. 139 in 1628–9. J. Held, *A.Q.*, XVIII (1953), 150, observed a hitherto unrecorded signature and date 1616 on the *Meeting at the Golden Gate* in Montaigu, which makes the cycles even more important as one of the early monuments of Flemish Caravaggism.

6. Victor Bouquet, Pieter van Meert, Jan van p. 141 Reesbroeck, Jan de Reyn.

7. The *Hofken* (Gethsemane) in the Pauluskerk at p. 145 Antwerp, part of the *Mysteries of the Rosary* (see pp. 112 and 129), was attributed to him in the seventeenth century (see list of paintings reprinted in M. Rooses, *Jordaens* (Antwerp, 1906), 11). This picture, together with the *Transfiguration* of 1615 at Dendermonde, Onze Lieve Vrouwekerk, may be a starting-point for the reconstruction of his œuvre.

8. G. v. Terey (*Kunstchronik und Kunstmarkt*, N.F. XXXIII (1922), 781) has rightly stressed the connexion between Jan Brueghel and Teniers. The portrait in the former Gsell Collection, which Frimmel (*Lexikon der Wiener Gemälde Sammlungen*, II (1914), 166, plate 30) claims to be a dated work of 1632, must be disregarded. In any case it belongs to the second half of the fifties.

p. 145 9. Some examples of Teniers's peasants in the Brouwer style: Madrid 1391/2 (there ascribed to Brouwer); Leipzig 1066 (of 1633); Kassel 139; Munich 1838; Florence 700; London, formerly Bridgewater House, Ellesmere Collection, 222.

10. He may also have seen early still lifes by Kalf. An example of such a kitchen interior à la Kalf is in the C. T. F. Thurkow Collection at The Hague. Kalf was in Paris in the early forties and may have stopped in Antwerp on his way there.

p. 147 11. Sorgh's pupil, Abraham Diepraam (1622–70), is another astonishingly late case of the imitation of Brouwer in Holland. The picture reproduced by Schmidt Degener in *Adriaen Brouwer* (Amsterdam, 1908), opposite p. 12, is a work by Diepraam. Strangely enough, Brouwer reminiscences at Haarlem are poor, and at Utrecht Andries Both is the only artist that can be mentioned. He may have come in contact with Brouwer's art at Antwerp when travelling to France via Belgium.

12. Ascribed to Joos van Craesbeeck also by G. Böhmer, *Der Landschafter Adriaen Brouwer* (Munich 1940), 106, and F. Winkler, *Pantheon*, XVII (1936), 163, where more examples of Brouweresque Craesbeecks are reproduced and described. I add to these: *A Man drinking*, Amiens, Museum, 77; interior Schloss sale Paris, 25 May 1949, 208; *A Man Standing*, Antwerp 897; *A Man with a Coin*, New York Historical Society 274; all these catalogued as paintings by Brouwer.

p. 148 13. The date of the Valenciennes picture, here reproduced, must be read as 1638, not 1632.

14. Of the minor Flemish genre painters quite a number specialized in the 'Dutch manner' to the almost complete exclusion of any stylistic contact with the Francken–Brouwer–Teniers tradition, for example Victorijns, Cornelis Mahu, F. van Houten, Jan Hulsman, Hendrik Berckmans, Pieter Meert, and M. A. Immenraedt.

p. 149 15. Compared with this, the very superficial borrowing from Rubens's *Garden of Love* remains without significance.

16. He had several commissions in 1646–9 from the House of Orange (J. G. van Gelder, *Oud-Holland*, LXIV (1949), 48). S. J. Gudlaugsson (*Gerard ter Borch*, The Hague, 1959, I, 43) proves that the change-over to the small-size portrait and genre-piece in Flanders (as with David Teniers, Joos van Craesbeeck, and others) is due to the arrival of ter Borch at Antwerp around 1640.

17. Duchatel's most ambitious and most amusing pictures are the representations of the progresses and entries of Charles II (Prince de Ligne, Beloeil; Ghent, Byloke) in the style of Frans van der Meulen and Tilborch. For a group portrait, see P. Bautier, *Revue belge*, XI (1941/4), 241. For Lancelot Volders, see S. Gudlaugsson, *Miscellanea Roggen* (Antwerp 1957), 121.

18. Illuminating examples quoted in J. Denucé, *Brieven en Documenten betreffend Jan Brueghel I en II* (Antwerp, 1934), 63, 68, 71–2, 80–1, etc. p. 1

19. Pieter van Bredael (1629–1719) partly continues along the lines of Jan Brueghel, partly joins the group of painters of scenes with figures on horseback such as Pieter van Bloemen (p. 154). p. 1

20. See p. 168.

21. There are some borderline cases between Jodocus and Frans de Momper; I think, however, that Boston 48.505 is by Jodocus and not by Frans. The *Mountains* (Brussels 980; A. Laes, *Bull. M.R.*, 1 (1952), 57) is doubtful. Some of the landscapes of de Momper's Dutch period are based on works of Hercules Seghers.

22. I. Fenyö, *Bulletin du Musée hongrois*, no. 8 (1956), 43. p. 1

23. A pupil of Lucas van Uden, Jan Baptiste Bonnecroy, specialized in amusing panoramas of Antwerp and Brussels (Antwerp 796; Bruges, Great Seminary; Cap Ferrat, Arenberg Collection; Antwerp exhibition (1956), no. 54, and Tournai (1956), 171, no. 6, as anonymous).

24. A. Laes in *Miscellanea L. van Puyvelde* (Brussels, 1949), 173. p. 1

25. An exception is Jan Frans Soolmaker of Antwerp (1635–after 1665), who followed Berchem very closely. He lived for some time in Amsterdam before he went to Italy. He almost belongs to the Dutch school. p. 1

26. The Berlin picture (W. Bode, *Berliner Museen*, XLIX (1928), 106) is of 1653, not 1651 as T. H. Fokker (*Jan Siberechts* (Brussels, 1931), 82) believed. The Providence picture (as A. Pijnacker) is not signed, and my attribution is therefore not fully established. Sometimes the Flemish is so near the Dutch vision that mistakes in attribution occur: the landscape of the Aix-la-Chapelle sale, 26 October 1909, no. 3 (Fokker, *op. cit.*, 77) is by the Dutchman Dirk van Bergen. The charming cattle piece in Sir Alec Martin's collection (London exhibition (1927), no. 321) is probably by Hendrik

ten Oever (attribution by S. Gudlaugsson). An *Italan Landscape*, signed by Siberechts and not yet recorded, appeared at the William Wyndham sale, London, Christie, 24 April 1953, no. 144.

p. 155 27. For the English period see E. K. Waterhouse, *Painting in Britain 1530–1790 (Pelican History of Art)* (London, 1953), 80. M. Whinney and O. Millar, *English Art* (Oxford, 1957), 270–1.

28. M. de Maeyer, *Albrecht en Isabella in de schilderkunst* (Brussels, 1955), 42.

p. 156 29. L. van Puyvelde, *Revue belge*, XXIV (1955), 159; J. Held in *G.B.A.*, 6/50 (1957), 53.

30. L. van Puyvelde, *loc. cit.*, 160; the picture is probably identical with the one wrongly attributed to K. E. Biset in the Berlin sale of 11 June 1930, no. 183 (S. Speth-Holterhoff, *Les peintres flamands de cabinets d'amateurs* (Brussels [1957]), 110–11).

31. See for this genre S. Speth-Holterhoff, *op. cit.*, and M. Wimmer, *Die Quellen der Pictura-Allegorien* (Diss., Cologne, 1957), the latter stressing the allegorical implications of the subject.

32. See p. 63.

p. 157 33. J. Cuvelier in *Bull. I.B.R.*, XXIII (1944/6), 25.

p. 158 34. G. Crivelli, *Giovanni Brueghel* (Milan, 1868), 118.

35. From the Comte Cavens sale, Brussels, 23 May 1922, no. 39; reproduction in the sale catalogue and in E. Greindl, *Les peintres flamands de nature morte* (Brussels, 1956), figure 31.

36. On the other hand, if paintings like the *Vegetables* at Karlsruhe (213) are really early works of his (as I believe), his reputation as a great master in the Pieter Aertsen tradition is well deserved. For another good early work (1909) see Note 42.

p. 159 37. F. Kimball, *Philadelphia Bulletin of Art*, XLVI (1951), 43, and *B.M.*, XCIV (1952), 66.

38. Glück, *Rubens*, 185.

39. G. Crivelli, *op. cit.*, 118.

40. Snyders is more versatile than has been generally believed. The *Pots and Pans* at Stuttgart (280) is also his, although the picture is attributed to Rubens by M. de Maeyer (*op. cit.*, 142), L. van Puyvelde (*The Connoisseur Yearbook 1959*, 123), and F. Roh (*Die Kunst und das Schöne Heim*, LIII (1955), 285). See also p. 181, Note 30.

p. 160 41. See the controversy between F. Grossmann and C. Norris, *B.M.*, XCIX (1957), 6 and 126.

42. See the same subject by Snyders of 1609 at Leningrad (609). There are many good examples of

Paul de Vos's art at Madrid, but no. 1877, a copy after Snyders, must be disregarded, for the signature is false.

43. F. Manneback in *Miscellanea L. van Puyvelde* (Brussels, 1949), 147; H. Funk in *Edwin Redslob zum 70. Geburtstag* (Berlin, 1955), 316.

44. G. J. Hoogewerff in *Annuaire des Musées p. 161 royaux*, IV (1943/4), 9.

45. B. Renckens in *Kunsthistorische Mededelingen*, IV (1949), 7.

46. For these early types of Flemish still lifes, their connexions with Dutch developments and their iconographic history, see I. Bergström, *Dutch Still-life Painting* (London, 1956), 42, and *B.M.*, XCVII (1955), 303 and 342.

47. Jacob van Es, breakfasts in the Dutch manner: p. 162 ner: Amsterdam, Butôt Collection; Oxford, Ashmolean (catalogue Ward Bequest 1950, no. 26); and others. Sometimes copies after (or variations on) Jan Davidsz de Heem are attributed to van Es: fruit-piece, said to be signed and dated 1627(!), Berlin, sale, 19 January 1935, no. 319. Frans Ykens, breakfast in the Dutch manner: Ghent, S.61, dated 1636. Cornelis Mahu (1613–89), Willem Gabron (1619–78), and Isaak Wigans (1616–62) are other Flemish still-life painters in the Dutch–Pieter-Claesz–Heda manner. Heda's pictures must have been well known in Antwerp; in Rubens's inventory there were two still lifes by him.

48. 1632: *Silver and Fruit*, Birmingham, Barber Institute; 1634: Göteborg, Lindstedt Collection; 1638: *Still life*, The Hague, Del Monte Collection (cat. 1928, no. 50). See also I. Bergström, *Oud-Holland*, LXXI (1956), 173.

49. See p. 162 and Note 48; I. Bergström, *Dutch p. 163 Still-life Painting*, plates 166–7.

50. Dated examples: 1642: Vienna, Czernin Collection (97); 1643: Ghent (1902-G); Oxford, Ashmolean (cat. Ward Bequest, 35); formerly T. Christ Collection, Basel.

CHAPTER 9

1. See p. 43 (on his father) and G. Gepts-Buy- p. 166 saert, *G.B.*, XIV (1953), 253.

2. E.g. Jan Baptiste Coclers (1696–1772) went early to Italy; Théodore Aimond Plumier (1694–1733) was a pupil of Nicolas Largillière in Paris; Paul Josef Delcloche (1716–55) was a pupil of Lancret in Paris.

p. 166 3. See also p. 187, Note 102, in connexion with his copy in New York (R82–8) after Rubens's *Adoration of the Magi* in Malines.

4. On Lens's art theories, see J. Dierckx in *G.B.*, VII (1941), 173.

5. A. P. de Mirimonde, *La revue des arts*, VII (1951), 71.

6. M. de Lapouyade, *Un maître flamand à Bordeaux, Lonsing* (Paris, 1911).

p. 167 7. An important example is the large series of biblical stories in the Onze Lieve Vrouwekerk at Cambrai, based on Rubens's compositions.

p. 168 8. E.g. Jan Frans Eliaerts (1761–1848), Georges Frédérik Ziesel (1756–1809), Peter Faes (1750–1814). Another curious case of a Flemish still-life painter in the Dutch seventeenth-century manner is Jan Baptiste Dussilon (*Breakfast*, 1768, Madrid, Lázaro Collection).

9. See p. 150. The Jan Brueghel tradition flourished especially around 1700: Balthasar Beschey (see p. 166) and his brothers, Karel van Breydel (d. 1733), Pieter Casteels (d. c. 1700), Arnold Frans Rubens (1687–1719), and many others specialized in such small pictures, often with cavalry battles as their subject.

10. E. K. Waterhouse, *Painting in Britain 1530–1790 (Pelican History of Art)* (London, 1953), 143–4.

11. Dated 1781; sale, Brussels, 11 March 1929, p. 169 no. 73. The original by Teniers in Dulwich College Gallery (57). See also J. Decoen in *Clarté*, VI (1933), no. 9, p. 3.

12. P. Bautier, *Revue de l'art*, XLVI (1924), 137. p. 170 Van den Bossche was a pupil of Gerard Thomas (1663–1720), who had before that time specialized in artists' studios after the model of Matheus van Helmont. Hendrik Govaerts (1669–1720) is another minor master of this genre.

13. M. N. Benisovich in *Revue belge*, XXII (1953), 194.

14. E. K. Waterhouse, *op. cit.*, 118. p. 171

15. A. P. de Mirimonde, *La revue des arts*, VII (1957), 71.

16. P. de Keyser, *Kunst der Nederlanden*, I (1930), 11. Catalogue *Drie Vlaamse meesters van de XVIIIe eeuw* (Bruges, 1955).

17. E.g. *The Card Players* and *The Witches' Sabbath* (Liège 86–7), imitating Saftleven and Teniers. p. 172

18. F. Doisteau sale, Paris, 9 November 1909, no. 86.

BIBLIOGRAPHY

ALTHOUGH the Bibliography seems to be rather a long one, it is by no means complete. In view of the fact that no special bibliography on old or modern Flemish art exists, it was thought useful to make the references to books and articles on Flemish art somewhat more extensive than has been the case in other volumes of the Pelican History of Art.

The bibliographical material is arranged under the following headings:

I. GENERAL

A. GENERAL WORKS

BRINCKMANN, A. E. 'Die Bedeutung des vlämischen Barocks für Westeuropa', *Die Kunst der Nederlanden*, I (1930), 18.

 On sculpture and painting. Lecture.

CLEMEN, P., a.o. *Belgische Kunstdenkmäler.* 2 vols. Munich, 1923.

FIERENS, P. *L'art en Belgique.* 2nd ed. Brussels, 1946.

GABRIELS, J., and MERTENS, A. *De constanten in de Vlaamse kunst.* Antwerp, 1941.

 Some thoughts on the essence of Flemish art.

GELDER, H. E. VAN, DUVERGER, J., a.o. *Kunstgeschiedenis der Nederlanden.* 3 vols. 3rd ed. Antwerp–Utrecht, 1954–6.

 The most recent textbook.

LEURS, C., a.o. *Geschiedenis van de Vlaamsche kunst.* 2 vols. Antwerp [1939].

PIGLER, A. *Barockthemen.* 2 vols. Budapest, 1956.

 The second volume is especially important for the many Flemish examples of unusual subjects.

ROOSES, M. *Geschichte der Kunst in Flandern.* Stuttgart, 1914.

YSENDYCK, J. J. VAN, and WEISSMAN, A. W. *Documents classés de l'art dans les Pays Bas X–XVIII siècles.* 8 folios. Antwerp, 1880–1902.

B. HISTORICAL BACKGROUND

PIRENNE, H. *Histoire de Belgique*, II, 3rd ed., Brussels, 1932; III, 3rd ed., Brussels, 1950.

KALKEN, F. VAN. *Histoire de Belgique.* Brussels, 1946.

GEYL, P. *Geschiedenis van de Nederlandse Stam.* 2 vols. 2nd ed. Amsterdam, 1948–9.

PRIMS, F. *Antwerpen door de eeuwen heen.* Antwerp, 1951.

HOUTTE, J. A. VAN, a.o. *Algemene geschiedenis der Nederlanden.* Antwerp–Utrecht (in progress).

 Vols V (1952) to VIII (1955) cover our period. This is the most up-to-date general cultural history of both the Southern and Northern Netherlands. With literature.

HOUTTE, J. A. VAN. 'Onze zeventiende eeuw "ongelukseeuw"?', *Mededelingen v. d. Kon. Vlaamsche Academie van Wetenschappen, Klasse der Letteren*, XV (1953), no. 8.

> On the prosperity of Belgium in the seventeenth century.

BAIE, E. *Le siècle des gueux (Histoire de la sensibilité flamande sous la Renaissance*, VI). Brussels, 1953.

LUYKX, T. *Cultuurhistorische Atlas van België.* Brussels–Amsterdam, 1954.

C. REGIONAL ART INVENTORIES

Although in most of the cases works of sculpture and of applied art are predominant in these books, the descriptions of painted altars and other pictures given here often provide us with the only factual notes we possess.

1. Antwerp

DONNET, F., and DOORSLAER, G. VAN. *Inventaris der Kunstvoorwerpen bewaard in de openbare gestichten der Provincie Antwerpen.* 12 parts. Antwerp, 1902–40.

2. Brabant

Inventaire des objets d'art dans les communes de Brabant. Brussels, 1897.

Province de Brabant. Inventaire des objets d'art. 3 vols. Brussels, 1904–12.

BORCHGRAVE D'ALTENA, J. DE. 'Notes pour servir à l'inventaire des œuvres d'art du Brabant',
Annales de la Société royale d'archéologie, XLIII (1939/40), 121; XLVII (1944/6), 121.

3. Flanders

COUVEZ, A. *Inventaires des objets d'art qui ornent les églises et les établissements publics de la Flandre occidentale.* Bruges, 1852.

Oudheidkundig Inventaris van Oost Vlaanderen. 11 parts. Ghent, 1911–15.

DHANENS, E. 'Inventaris van het Kunstpatrimonium van Oost Vlaanderen', *Cultureel Jaarboek voor de provincie Oostvlaanderen*, 5/1 (1951 [1953]), 303–408; 7/3 (1953 [1956]), 1.

4. Ghent

Inventaire archéologique de Gand. 3rd series. Ghent, 1897–1915.

Répertoire archéologique de Gand. Ghent, 1902.

5. Hainault

Inventaire des objets d'art et d'antiquité de la province du Hainaut. 10 vols. Mons, 1923–41.

6. Liège

Inventaire des objets d'art et d'antiquité de la province de Liège. 2 vols. Liège, 1911–30.

7. Limburg

Oudheidkundig inventaris der Kunstvoorwerpen in Kerken en openbare gebouwen van de provincie Limburg. 9 parts. Hasselt, 1916–35.

II. ARCHITECTURE

A. GENERAL

PARENT, P. *L'architecture aux Pays-Bas méridionaux aux XVI–XVIII siècles.* Paris–Brussels, 1926.

LEURS, C. *De Geschiedenis der bouwkunst in Vlaanderen.* Antwerp, 1946.

LUTTERVELT, R. VAN. 'De Bouwkunst in de zuidelijke Nederlanden in de zeventiende en achttiende eeuw', in J. Duverger (ed.), *Kunstgeschiedenis der Nederlanden*, III, 3rd ed. (Utrecht, 1956), 174 ff.

B. RELIGIOUS

BRAUN, J. *Die belgischen Jesuitenkirchen.* Freiburg im Breisgau, 1907.

PLANTENGA, J. H. *L'architecture religieuse dans l'ancien duché de Brabant, 1598–1713.* The Hague, 1926.

C. SECULAR

CASTIJNE, O. VAN DE. *L'architecture privée en Belgique dans les centres urbains aux XVI–XVII siècles.* Brussels, 1934.

D. INDIVIDUAL ARCHITECTS

FAYDHERBE
Libertus, Brother. *Lucas Faydherbe.* Antwerp, 1938.

FLORIS
Hedicke, R. *Cornelis Floris und die Floris-Dekoration.* Berlin, 1913.

BIBLIOGRAPHY

III. SCULPTURE

A. GENERAL

ROUSSEAU, H. *La sculpture aux XVII et XVIII siècles*. Brussels, 1911.
> Very out-of-date.

GABRIELS, J. *De Vlaamse beeldhouwkunst*. Antwerp, 1942.
> Very brief.

LAVALLEYE, J. *Histoire de la sculpture en Belgique*. Brussels, 1942.

STEPPÉ, J. *Het koordoxaal in de Nederlanden*. Brussels, 1952.

JANSEN, A. 'De beeldhouwkunst in de zeventiende en achttiende eeuw', in J. Duverger (ed.), *Kunstgeschiedenis der Nederlanden*, III, 3rd ed. (Utrecht, 1956), 116 ff.

B. INDIVIDUAL SCULPTORS

DELCOUR
Lesuisse, R. *Jean Delcour*. Nivelles, 1953.

DELVAUX
Devigne, M. *Laurent Delvaux et ses élèves*. Brussels, 1928.

DU QUESNOY
Fransolet, M. *François du Quesnoy*. Brussels, 1941.

FAYDHERBE
Libertus, Brother. *Lucas Faydherbe*. Antwerp, 1938.

QUELLIN, ARTUS I
Gabriels, J. *Artus Quellien de oude*. Antwerp, 1930.

RYSBRACK
Webb, M. I. *Michael Rysbrack*. London, 1954.

VEKEN, VAN DER
Poupeye, C. *Nicolas van der Veken, sculpteur malinois du XVII siècle*. Malines, 1911.

VERHAEGEN
Poupeye, C. *Théodore Verhaegen*. Brussels, 1914.

VERHULST
Notten, M. van. *Rombout Verhulst*. The Hague, 1907.

VERSCHAFFELT
Roelandts, O. *Beeldhouwer Pieter Antoon Verschaffelt*. Brussels, 1939.

VERVOORT
Tralbaut, M. E. *De Antwerpse 'meester constbeldthouwer' Michiel van der Voort (Vervoort) de oude*. Brussels, 1949.

IV. PAINTING

A. DICTIONARIES AND BIBLIOGRAPHIES

Biographie Nationale (publiée par l'Académie Royale de Belgique). 28 vols. Brussels, 1866–1944.
> Most of the contents are out of date. The first Supplement, vol. 29 (Brussels, 1956, in progress), chiefly covers nineteenth-century artists.

SOMEREN, J. F. VAN. *Essai d'une bibliographie*. Amsterdam, 1882.
> Still useful for older literature.

WURZBACH, A. VON. *Niederländisches Künstler-Lexikon*. 3 vols. Vienna and Leipzig, 1906–11.
> Still useful. It must be remembered, however, that Wurzbach held very personal opinions of the great artists (e.g. Rubens).

THIEME, U., and BECKER, F. *Allgemeines Lexikon der bildenden Künste*. 37 vols. Leipzig, 1907–50.
> The articles are excellent, especially those written by L. Burchard and the late K. Zoege von Manteuffel.

Revue belge d'archéologie et d'histoire de l'art, I (1931) (in progress).
> Summaries, sometimes critical, on Flemish art appear regularly.

HALL, H. VAN. *Repertorium voor de geschiedenis der Nederlandsche schilder- en graveerkunst*. 2 vols. The Hague, 1936 and 1949.
> Although the compiler excludes Flemish art after 1550, he includes many general works and some on later Flemish artists such as Jordaens, de Keuninck, and de Momper.

Bibliography of the Rijksbureau voor Kunsthistorische Documentatie, I, 1943 (in progress; appears every second year).

> Bibliography, with summaries in English, on Dutch and Flemish art (architecture excluded).

FIERENS, P., a.o. *Dictionnaire des peintres*. Brussels, 1952.

> The most recent dictionary of painters, but the information on the seventeenth and eighteenth centuries is neither reliable nor up-to-date.

See further RUBENS, *under Section I below*.

B. SOURCES AND EIGHTEENTH-CENTURY LITERATURE

BIE, C. DE. *Het gulden cabinet*. Lier, 1661.

> Incorporated is: Jean Meyssens, *Image de divers hommes desprit*, 1649, a collection of portraits with captions on the lives and works of the artists.

FÉLIBIEN, A. *Entretiens sur les vies et les ouvrages des plus excellens peintres*. 5 vols. Paris, 1666–88.

> Vol. IV, 1685, deals especially with Rubens and van Dyck.

SANDRART, J. VON. *Deutsche Akademie*. Nuremberg, 1675–9 (Latin ed. 1684).

> The modern edition of 1925 by A. R. Peltzer is accompanied by many useful notes.

LE COMTE, F. *Cabinet des singularitez*. Paris, 1699; 2nd ed. 1702, especially vol. II, 192–288.

PILES, R. DE. *Abrégé de la vie des peintres*. Paris, 1699.

PILES, R. DE. *Recueil de divers ouvrages sur la peinture*, I, Paris, 1755, and IV, Paris, 1762.

> Important for information about Rubens.

HOUBRAKEN, A. *De Groote Schouburgh*. 3 vols. Amsterdam, 1718–20.

> German translation by A. von Wurzbach with indexes added, Vienna, 1880 (*Quellenschriften zur Kunstgeschichte*). See also C. Hofstede de Groot, *Arnold van Houbraken und seine 'Groote Schouburgh'*, The Hague, 1893.

WEYERMAN, J. C. *De levensbeschryvingen der Nederlandsche Kunstschilders*. 4 vols. The Hague, 1739–69.

> See also A. von Wolffers, *L'école néerlandaise et ses historiens*, Brussels, 1888 (defending the author's reliability); T. Levin, *Z.B.K.*, XXIII (1888), 133 and 171 (on a copy in the University Library at Bonn with MS notes by E. Quellinus); D. J. H. ter Horst, 'De geschriften van Jan Campo Weyermann', *Het Boek*, XXVIII (1944), 227.

DESCAMPS, J. D. *La vie des peintres flamands*. 4 vols. Paris, 1753–63.

> Like Weyerman, a source-book for eighteenth-century art.

MENSAERT, G. P. *Le peintre amateur et curieux*. 2 vols. Brussels, 1763.

> 'Description générale des tableaux ... des Églises, Couvents, Abbayes ... dans l'étendue des Pays-Bas Autrichiens.'

DESCAMPS, J. D. *Voyage pittoresque de la Flandre et du Brabant*. Paris, 1769.

> Contains a wealth of material on works of art in churches, monasteries, etc.

BURTIN, F. X. DE. *Catalogue de tableaux vendus à Bruxelles depuis l'année 1773 [jusqu'à 1803]*. Brussels [n.d.].

> Chiefly Flemish pictures.

C. GENERAL HISTORY OF PAINTING

BAES, E. *La peinture flamande et son enseignement sous le régime des confréries de St Luc*. Brussels, 1881.

BALKEMA, C. H. *Biographie des peintres flamands et hollandais*. Ghent, 1844.

> Of some importance for the eighteenth century.

BAUTIER, P. *La peinture en Belgique au 18e siècle*. Brussels, 1945.

> Twenty-two reproductions, with many detailed notes and literature.

BERNT, W. *Die niederländischen Maler des 17. Jahrhunderts*. 3 vols. Munich, 1948.

> Of the more than 1,000 pictures here reproduced, only a small proportion is Flemish. But among these are works by some minor artists, of whose work reproductions are otherwise difficult to trace.

BLANC, C. *Histoire des peintres. École flamande*. Paris, 1868.

> Although old-fashioned for the modern reader's taste, it contains many references of minor importance.

BODE, W. VON. *Die holländischen und vlämischen Malerschulen*. Leipzig, 1917; 8th ed. 1956, ed. E. Plietzsch.

> Although the Flemish painters fill only a sixth of the volume, the book is still relevant for Bode's personal style and outlook.

CHENNEVIÈRES, P. DE, and MONTAIGLON, A. DE. *Abecedario de P. J. Mariette*. 5 vols. Paris, 1851–9.

> Important for Rubens.

DELEN, A. J. J. 'Vlaamse Kunst vóór, tijdens en na Rubens', *Rubens en zijne eeuw*. Brussels, 1927.

DELEN, A. J. J., and BAUTIER, P. *L'art en Belgique*. Brussels, 1939.

DROST, W. *Barockmalerei in den germanischen Ländern (Handbuch der Kunstwissenschaft)*. Wildpark-Potsdam, 1926.

FRIEDLÄNDER, M. J. *Die niederländische Malerei des 17. Jahrhunderts (Propyläen Kunstgeschichte)*. Berlin, 1923.
> With a hundred reproductions of Flemish paintings.

FROMENTIN, E. *The Masters of Past Time*. London, 1948.
> The original French edition is of 1876.

GLÜCK, G. *Rubens, Van Dyck und ihr Kreis*. Vienna, 1933.
> Papers published by the former Director of the Vienna Gallery, annotated by L. Burchard and others. A most useful reprint.

GOFFIN, A. *L'art religieux en Belgique. La peinture des origines à la fin du XVIIe siècle*. Brussels [1942].
> Pp. 91–159 deal with the seventeenth and eighteenth centuries.

HEIDRICH, E. *Vlämische Malerei*. Jena, 1924.
> Serious introduction to two hundred plates.

HÜBNER, F. M. *Nederlandsche en Vlaamsche Rococoschilders*. The Hague, 1943.
> Small book.

HYMANS, H. *Œuvres*. 4 vols. Brussels, 1920–2.
> Vol. II contains his articles for Thieme-Becker and other dictionaries; vol. III his contributions to the *Gazette des Beaux-Arts*.

IMMERZEEL, J. *De levens en werken der Hollandsche en Vlaamsche Kunstschilders*. Amsterdam, 1842–3.
> Some useful notes.

KNIPPING, B. *De Iconografie der Contra-Reformatie in de Nederlanden*. 2 vols. Hilversum, 1940.

KRAMM, C. *De levens en werken der Hollandsche en Vlaamsche Kunstschilders*. Amsterdam, 1857–64.
> Important additions to Immerzeel; the copy in the Rijksbureau voor Kunsthistorische Documentatie, The Hague, has MS notes by the author.

LASSAIGNE, J., and DELEROY, R. L. *La peinture flamande*. Geneva, 1958.
> A Skira book with 112 colour reproductions. Extensive bibliography.

MICHEL, A. *Histoire de l'art*, V/2, VI/1, VI/2, VII/1. Paris, 1915–23.
> The chapters on Flemish painting are written by L. Gillet and C. de Mandach.

MICHEL, É. *La peinture flamande au 17e siècle*. Paris, 1939.
> Picture book with short introduction.

MICHIELS, A. *Histoire de la peinture flamande*. 2nd ed. Paris, 1865–74.
> Vols V (1868) to X (1876) cover our period.

MOLTKE, J. W. *Das grosse Jahrhundert flämischer Malerei*. Düsseldorf, 1944.
> Picture book.

OLDENBOURG, T. R. *Die flämische Malerei des 17. Jahrhunderts*. 2nd ed. Berlin, 1922.
> Still the most useful short textbook.

PINCHART, A. *Archives des arts, sciences et lettres*. 2 vols. Ghent, 1860–3.
> Contains some documents on Flemish painters.

PIOT, C. 'Les tableaux des collèges des Jésuites supprimés en Belgique', *Bulletin de l'Académie Royale*, 2/46 (1878).

PIOT, C. 'Tableaux enlevés à la Belgique en 1785', *Bulletin de l'Académie Royale*, 2/43 (1877).
> See also by the same *Les tableaux enlevés* ... under F. RELATIONS WITH FOREIGN COUNTRIES, 2: France.

SMITH, J. *A Catalogue Raisonné of the Works of the most Eminent Painters*. London.
> Vol. II, 1830: P. P. Rubens; vol. III, 1831: A. van Dyck, D. Teniers; vol. IV, 1833: G. Coques.

VALENTINER, W. R. *The Art of the Low Countries*. New York, 1914.
> Contains chapters on works by Rubens and van Dyck in America.

WAUTERS, A. J. *La peinture flamande*. Paris, 1883.

WILDE, G. A. DE. *Geschiedenis onzer Academieën van Beeldende Kunsten*. Louvain, 1941.

D. LOCAL SCHOOLS

1. Antwerp

As Antwerp is the centre of Flemish painting, many books devoted to the art of Antwerp are at the same time books on Flemish painting in general.

GENERAL

SANDEN, J. VAN DER. *Oud Konst-Tooneel van Antwerpen.* 3 vols. 1771.

> MS in verse, especially on eighteenth-century art, by a former secretary of the Academy of Arts. (Municipal Archives, Antwerp.)

[BERBIE, G.] *Description des principaux ouvrages de peinture et sculpture ... dans les églises d'Anvers.* 1763.

STRAELEN, J. B. VAN DER. *Jaerboek der ... gilde van Sint Lucas.* 1855.

> Meetings, lists of members, and regulations of the guild. Without index.

BRANDEN, F. J. VAN DEN. *Geschiedenis der Academie van Antwerpen.* 1867.

ROMBOUTS, P., and LERIUS, T. VAN. *De Liggeren en andere historische archieven der Antwerpsche Sint Lucasgilde.* 2 vols. 1872.

> Chronologically arranged lists of masters, pupils, etc. The chief source for any research.

ROOSES, M. *Geschiedenis der Antwerpsche schilderschool.* 1879.

> Still an important work.

LERIUS, T. VAN [d. 1880]. *Biographies d'artistes anversois,* ed. P. Génard. 2 vols.

> A collection of biographies of minor Antwerp artists.

BRANDEN, F. J. VAN DEN. *Geschiedenis der Antwerpsche schilderschool.* 1883.

> Evidently based on documents, which, however, are seldom quoted.

BOSCHERE, J. DE. *De kerken van Antwerpen beschreven door Jacobus de Wit.* 1910.

> MS notes by Jacobus de Wit, written *c.* 1748, with notes by Fr. Mols, 1774.

DELIS, E. 'La confrérie des romanistes', *Annales de l'Académie royale d'archéologie de Belgique,* LXX (1922), 456.

DONNET, F., and ROLLAND, P. 'L'influence artistique d'Anvers au 18e siècle', *Annales de l'Académie royale d'archéologie,* 7/75 (1929), 5.

DELEN, A. J. J. *Iconographie van Antwerpen.* Brussels, 1930.

> A catalogue of 1,250 pictures, drawings, and prints of Antwerp.

DENUCÉ, J. *Kunstuitvoer in de 17e eeuw te Antwerpen* (*Bronnen voor de geschiedenis van de Vlaamsche kunst,* I). 1931.

> The export of works of art by the firm of Forchoudt, Antwerp.

DENUCÉ, J. *De 'Antwerpsche Konstkamers' in de 16e en 17e eeuw* (*Bronnen voor de geschiedenis van de Vlaamsche kunst,* II). 1932.

DENUCÉ, J. *Na Peter Pauwel Rubens, documenten uit de kunsthandel te Antwerpen* (*Bronnen voor de geschiedenis van de Vlaamsche kunst,* V). 1949.

> The correspondence and dealings of the art firm Musson.

JANSEN, A., and HERK, C. VAN. *Kerkelyke Kunstschatten* (album). 1949.

Antwerpen in de 18e eeuw (published by the Genootschap voor Antwerpsche Geschiedenis), 1952; F. Boudouin, *Bouw-, Beeldhouw- en schilderkunst;* F. v.d. Wijngaert, *Teken- en prentkunst.*

CATHEDRAL

LERIUS, T. VAN. *Notre Dame d'Anvers.* 1841.

> Description of the contents before 1794.

GÉNARD, P. *Notice des œuvres d'art qui ornent l'église de Notre-Dame à Anvers.* 1877.

ST JACOBSKERK

LERIUS, T. VAN. *Notice des œuvres d'art de l'église St Jacques.* [Antwerp] 1855; also a Dutch edition.

LERIUS, T. VAN. *Tableau des œuvres d'art ... Église St Jacques.* 1871.

ST PAULUSKERK

COO, J. DE. 'Het interieur van de St Paulus-voormalige Dominicanenkerk', *Antwerpen,* IV (1958), 128.

2. *Bruges*

HAUTE, C. VANDEN. *La corporation des peintres de Bruges.* 1913.

FIERENS, G. *La peinture à Bruges.* Brussels–Paris, 1922.

DOCHY, J. *De schilderkunst te Brugge.* 1956.

> Short survey.

GYSELEN, G. 'Schilderijen uit het patrimonium van het "Bruggse Vrije" en het gerechtshof te Brugge', *Handelingen van de 'Société d'émulation' te Brugge,* XCV (1958), 25.

3. *Brussels*

PINCHART, A. 'La corporation de peintres à Bruxelles', *Messager des sciences hist.* (1877), 298; (1878), 315 and 475; (1879), 459.

SAINTENOY, P. 'Les peintres de la cour de Bruxelles au 17e siècle', *Annales de la Société royale d'archéologie de Bruxelles*, XXXIII (1927), 263.

SAINTENOY, P. 'Les arts et les artistes à la cour de Bruxelles', *Mémoires, Académie royale de Belgique, Classe des Beaux-Arts*, V/I (1934).

FRANKIGNOULLE, E., and BONENFANT, P. *Notes pour servir à l'histoire de l'art en Brabant.* 1935. (*Annales de la Société royale d'archéologie de Bruxelles*, XXXIX.)

Material from the archives of Brussels.

ANSIAUX, S., and LAVALLEYE, J. 'Notes sur les peintres de la cour de Charles de Lorraine', *Revue belge*, VI (1936), 305.

Artists working at the Brussels court in the second half of the eighteenth century.

MAEYER, M. DE. *Albrecht en Isabella in de schilderkunst.* 1955. (*Verhandelingen v. d. Kon. Vl. Acad. v. Wetenschappen, Klasse der Schoone Kunsten*, Verh. no. 9.)

Documents, carefully annotated, on the art and artists at the court of Brussels.

4. Courtrai

CAULLET, G. 'Melanges et documents relatifs aux arts à Courtrai et dans la Courtraise', *Bulletin du cercle historique de Courtrai*, V (1907/8), 235; VI (1908/9), 43, 92, 240, and 257; VII (1909/10), 187.

VLEESCHOUWER, F. DE. 'Kortrijkse kunstschilders van P. Vlerich tot J. Speybrouck', *West-Vlaanderen*, VII (1958), 308.

5. Diest

ARSCHOT, P. D', and LINDEN, G. VAN DER 'Diest, inventaire des peintures', *Commission royale des monuments et sites*, VIII (1957), 289.

6. Ghent

GOESIN-VERHAGE, P. F. *Notice et description des tableaux ... exposés au Museum du département de l'Escaut.* 1802.

BUSSCHER, E. DE. *Recherches sur les peintres et sculpteurs à Gand.* 1868.

HAEGEN, V. VAN DER. 'Les exhibitions et les ventes de tableaux et objets d'art à Gand', *Bulletin der Maatschappij van Geschiedenis en Oudheidkunde, Gent*, XIII (1905), 119.

ROGGEN, D. *Les Arcs de Triomphe.* 1925.

ROGGEN, D., PAUWELS, H., and SCHRIJVER, A. DE. 'Het Caravaggisme te Gent', *G.B.*, XII (1949/50), 255; XIV (1953), 201.

7. Liège

HELBIG, J. *La peinture au pays de Liège.* 1903.

Detailed account of the art of the seventeenth and eighteenth centuries.

FIERENS, G. 'La peinture ancienne à l'exposition de Liège, 1905', *Les arts anciens de Flandre*, II (1906).

PHILIPPE, J. *La peinture liégoise au 17e siècle.* 1945.

Thirty-two reproductions, including works by minor artists.

PHILIPPE, J. *La contribution Wallone à la peinture dite flamande.* 1948.

Short survey.

PHILIPPE, J. 'Rubens et la peinture liégoise du XVIIe siècle', *Revue belge*, XIX (1950), 51.

KOENIG, L. *Histoire de la peinture au pays de Liège.* 1951.

8. Lille

VANDALLE, M. 'L'art à Lille du XVe à la fin du XVIIIe siècle', *Bulletin du Comité flamand de France*, XIV (1951), 91; XV (1952), 31.

9. Malines

NEEFS, E. *Inventaire historique des tableaux ... dans les édifices religieux et civils ... de Malines.* Leuven, 1869.

NEEFS, E. *Histoire de la peinture et de la sculpture à Malines.* 2 vols. Ghent, 1876.

NEEFS, E., and CONINCKX, H. *Tableaux, sculptures et objets d'art conservés dans les édifices de Malines.* 2 vols. 1899.

CONINCKX, H. 'Notes et documents inédits concernant l'art et les artistes à Malines', *Bulletin du cercle arch., litt. artist. de Malines*, XIX (1909).

CONINCKX, H. 'Chronique artistique malinoise', *Bulletin du cercle arch., litt. artist. de Malines*, XXXVI (1931).

LEYSSENS, T. 'Jan Willem Fr. Herreyns en de Academie voor beeldende kunsten te Mechelen', *Handelingen van de Kon. Kring van oudheidkunde van Mechelen*, XLVIII (1943/4), 31.

AUTENBOER, E. VAN. 'Nota's over de Mechelse waterverfschilders', *Mechelse Bijdragen*, XI (1949), 33.

10. Ypres

ROGGEN, D., and DHANENS, E. 'De zeventiendeeuwse schilderijen van het Jesuitenscollege te Ieper', *G.B.*, XII (1949/50), 129.

E. SUBJECT MATTER

ROEDER-BAUMBACH, I. VAN, and EVERS, H. G. *Versieringen bij Blijde Inkomsten.* Antwerp, 1943.

ARSCHOT, COMTE D'. *Le portrait au 17e et 18e siècle.* Brussels, 1945.
> Picture book (twenty-three reproductions) with introduction.

MATTHYS, R. 'Iconographie van Bisschop Triest', *Bulletin der Maatschappij van Geschiedenis en Oudheidkunde te Gent* (1938/9).
> The portraits of Bishop Antoine of Triest.

ZOEGE VON MANTEUFFEL, K. *Das flämische Sittenbild des 17. Jahrhunderts.* Leipzig, 1921.
> Twenty reproductions of genre paintings with good introduction.

SPETH-HOLTERHOFF, S. *Les peintres flamands de cabinets d'amateurs au 17e siècle.* Brussels [1957].

WIMMER, M. *Die Quellen der Pictura-Allegorien in gemalten Bildergalerien des 17. Jahrhunderts zu Antwerpen.* Diss., Cologne, 1957.

PLIETZSCH, E. *Die Frankenthaler Maler.* Leipzig, 1910.

RACZYŃSKI, J. A. GRAF. *Die flämische Landschaft vor Rubens.* Frankfurt am Main, 1937.

LAES, A. 'Le paysage flamand', *Miscellanea Leo van Puyvelde*, 166. Brussels, 1949.

HOOGEWERFF, G. J. *Het landschap van Bosch tot Rubens.* Antwerp, 1954.

THIERRY, Y. *Le paysage flamand au 17e siècle.* Brussels, 1953.

GLÜCK, G. 'Die Malerei von Tieren, Früchten und Blumen', in *Rubens*, 353.

WARNER, R. *Dutch and Flemish Fruit- and Flower-Painters.* London, 1928.
> Useful for its illustrations only.

HAIRS, M. L. *Les peintres flamands de fleurs au 17e siècle.* Brussels, 1955.

GREINDL, E. *Les peintres flamands de nature morte au 17e siècle.* Brussels, 1956.

FUNK, H. *Das niederländische Tierstück.* MS dissertation, Berlin, 1955.

JANTZEN, H. *Das niederländische Architekturbild.* Leipzig, 1910.

F. RELATIONS WITH FOREIGN COUNTRIES

1. Italy

FÉTIS, E. *Les artistes belges à l'étranger.* 2 vols. Brussels, 1857–65.

BERTOLOTTI, A. *Artisti belgi ed olandesi a Roma.* Florence, 1880.

FOKKER, T. H. *Werke niederländischer Meister in den Kirchen Italiens.* The Hague, 1931.

SCHNEIDER, A. VON. *Caravaggio und die Niederländer.* Marburg, 1933.

PUYVELDE, L. VAN. *La peinture flamande à Rome.* Brussels, 1950.

See also p. 180, Note 1.

2. France

CLÉMENT DE RIS, L. *Les musées de Province.* 2nd ed. Paris, 1872.
> With special stress on Flemish art. Lists of paintings looted by Napoleon and sent to French provincial museums.

MICHIELS, A. *L'art flamand dans l'est et le midi de la France.* Paris, 1877.

PIOT, C. ... *Les tableaux enlevés à la Belgique en 1764 et restitués en 1818.* Brussels, 1883.
> Important for the pictures from Flemish churches, etc., both restored and not restored to the Netherlands.

CHAMPIER, V. 'L'art dans les Flandres françaises aux XVIIe et XVIIIe siècles', *Bulletin du Comité flamande de France*, I (1920).

BOYER, J. 'Peintres et sculpteurs flamands à Aix en Provence aux 16e, 17e et 18e siècles', *Revue belge*, XXVI (1957), 41.

G. MUSEUMS AND COLLECTIONS

Out of the many publications only those are mentioned below which stress especially the Flemish paintings in museums and private collections.

BIBLIOGRAPHY

1. Antwerp

BRANDEN, F. J. VAN DEN. 'Verzamelingen van schilderijen te Antwerpen', *Antwerpsch Archievenblad*, XXI (1885), 294; XXII (1886), 1.

2. Brussels

TERLINDEN, C. *Les tableaux d'histoire au Musée de Bruxelles*. Brussels [1943].

3. Cologne

GROSSMANN, F. 'Holbein, Flemish paintings and Everard Jabach', *B.M.*, XCIII (1951), 16.

4. Florence

ZOEGE VON MANTEUFFEL, K. 'Bilder flämischer Meister in der Galerie der Uffizien in Florenz', *Monatshefte für Kunstwissenschaft*, XIV (1921), 29.

5. London

GROSSMANN, F. 'Rubens et van Dyck à la Dulwich Gallery', *Les arts plastiques*, II (1948), 47.

[SEILERN, COUNT A.]. *Flemish Paintings and Drawings at 56, Princes Gate, London, S.W.7.* London, 1955.
> Critical catalogue dealing chiefly with Rubens.

6. Louvain

JANSEN, J. E. 'La peinture à l'abbaye du Parc et cat. hist. et descript.', *Annales de l'Académie royale d'archéologie de Belgique*, LXIII (1911), 115.

7. Madrid

SALTILLO, MARQUÉS DEL. 'Artistes madrileños', *Boletín de la Sociedad española de excursiones*, LVII (1953), 137.
> Inventories of Madrid collections with many Flemish pictures.

8. New York

BENISOVICH, M. N. 'Les peintres du 18e siècle en Belgique au Metropolitan Museum de New York', *Revue belge*, XXII (1953), 189.

9. Paris

DEMONTS, L. *Catalogue des peintures du Musée National du Louvre. École du Nord.* Paris, 1922.

MICHEL, E. *La peinture au Musée du Louvre. École flamande.* Paris [n.d.].
> Selection of pictures (fifty-seven from our period) with careful annotation.

BOUCHOT-SAUPIQUE, J. *La peinture flamande du XVIIe siècle au Musée du Louvre, Paris.* Brussels, 1947.
> Forty-eight reproductions with some notes and introduction.

10. Rome

REDIG DE CAMPOS, D. 'Catalogo dei dipinti olandesi e fiamminghi della Pinacoteca Vaticana', *Mededelingen van het Ned. Historisch Instituut te Rome*, 3/2 (1943), 157.

11. Tervueren

TERLINDEN, C. 'Notes et documents relatifs à la galerie de tableaux conservés au château de Tervueren', *Annales de l'Académie royale d'archéologie de Bruxelles*, 6/10 (1922), 180 and 347.

12. Vaduz

Catalogue. *Flämische Malerei im 17. Jahrhundert. Ausstellung in Vaduz 1956/7 aus den Sammlungen des Fürsten von Liechtenstein.*

13. Valenciennes

SAUVIRON, C. *Rubens et les maîtres anversois au Musée de Valenciennes.* Paris, 1958.

14. Vienna

BERGER, A. 'Inventar der Kunstsammlung des Erzherzogs Leopold Wilhelm von Österreich', *Jahrbuch der Kunstsammlungen des allerhöchsten Kaiserhauses*, I (1883), lxxxix.
> The nucleus of the Vienna collection of Flemish pictures.

ENGERTH, E. VON. *Gemälde. Beschreibendes Verzeichnis. Kunsthistorische Sammlungen*, II. Band. *Niederländische Schulen.* 2nd ed. Vienna, 1892.
> Still the basic catalogue of the Vienna Gallery.

15. Warsaw

BIALOSTOCKI, J. *Flemish Landscape in the Period of Mannerism. Catalogue Muzeum Narodowe* (in Polish). 1951.

CHUDZIKOWSKI, A. *Dutch and Flemish Still Life of the Seventeenth Century* (in Polish). 1954.

MICHALKOWA, J. *Dutch and Flemish Genre Painting of the Seventeenth Century* (in Polish). 1955.

These three books deal with paintings in the Warsaw gallery.

H. EXHIBITIONS

For exhibitions of works by one artist, see the literature on the artists.

Pictures by Masters of the Flemish and British School. London, the New Gallery, 1899/1900.

Art ancien. L'art belge au 17e siècle. Brussels, 1910.

See also *Trésor de l'art du 17e siècle. Memorial de l'exposition d'art ancien.* Brussels–Paris, 1912–13.

Oude Kunst in Vlaanderen (Scheldegouw). Ghent, 1913.

Art ancien au pays de Liège. Paris, 1924.

Paysage flamand. Brussels, 1926.

Over het Antwerpsch Geestesleven in Rubens' tijd. Antwerp, 1927.

Das flämische Landschaftsbild des 16. und 17. Jahrhunderts. Berlin (Gottschewski-Schaffer), 1927.

See *Repertorium für Kunstwissenschaft*, XLVIII (1928), 217.

Flemish and Belgian Art, 1300–1900. London, Royal Academy, 1927.

Exposition internationale coloniale. Section d'art flamand ancien. Tome I. Antwerp, 1930.

See also *Trésor de l'art flamand*, Paris, 1930.

Œuvres choisies d'artists belges du 18e siècle. Brussels, 1930.

Drei Jahrhunderte Vlämische Kunst, 1400–1700. Vienna, 1930.

Art ancien au pays de Liège. Liège, 1930.

Werken van Joost de Momper, enige voorlopers en tijdgenoten. Amsterdam (P. de Boer), 1930/1.

Cinq siècles d'art. Brussels, 1935.

Rubens et son temps. Paris, 1936.

Seventeenth Century Art in Europe. London, Royal Academy, 1938.

Forty-three Paintings by Rubens and Twenty-five by van Dyck. Los Angeles, 1946.

The King's Pictures. London, 1946/7.

Important for the entries on Rubens and van Dyck.

De Van Eyck à Rubens. Paris, 1948/9.

Tekeningen van Jan van Eyck tot Rubens. Rotterdam, 1948/9.

Fiamminghi e Italia. Bruges, 1951.

Caravaggio en de Nederlanden. Utrecht and Antwerp, 1952.

Le portrait dans l'art flamand de Memling à Van Dyck. Paris, 1952/3.

Nederlandse Architectuurschilders. Utrecht, 1953.

Flemish Art 1300–1700. London, Royal Academy, 1953/4.

Anvers, ville de Plantin et de Rubens. Paris, Bibliothèque Nationale, 1954.

Antwerpens Gouden Eeuw. Antwerp, 1955.

Chiefly sixteenth century.

Meisterwerke flämischer Malerei. Schaffhausen, 1955.

Artists in Seventeenth Century Rome. London, Wildenstein, 1955.

Small but important for its instructive catalogue.

'Scaldis'. Antwerp, 1956.

'Scaldis'. Ghent, 1956.

'Scaldis'. Mons, 1956.

Vlaamsche kunst uit Brits bezit. Bruges, 1956.

Ommegamgem en blijde Inkomsten te Antwerpen. Antwerp, 1957.

Seventeenth-century Flemish Drawings and Oil Sketches. Cambridge, Fitzwilliam Museum, 1958.

Mostly drawings from the Fitzwilliam and Sir Bruce Ingram and A. M. Jaffé collections.

I. INDIVIDUAL ARTISTS

Except for the great men, there are only a few good modern monographs on Flemish artists available. Therefore, in order to assist the reader in his own researches, articles in periodicals, etc., are also included, but it must be stressed that very often more detailed information can be gathered from studies devoted either to a certain period of Flemish art (like M. de Maeyer's *Albrecht en Isabella en de Schilderkunst*, Brussels, 1955) or to subject matter (like J. A. Raczynski, *Die flämischen Maler vor Rubens*, Frankfurt am Main, 1937; S. Speth-Holterhoff, *Les peintres flamands de cabinets d'amateurs*, [Brussels], 1957; E. Greindl, *Les peintres flamands de nature morte*, Brussels, 1956, etc.).

ALSLOOT, VAN

Wauters, A. J. *Denis van Alsloot.* Brussels, 1899.

Frimmel, T. von, in *Blätter für Gemäldekunde*, I (1905), 60.

Laver, J. *Isabella's Triumph.* London, 1947.

Larsen, E., in *G.B.A.*, 6/34 (1948), 331.

Maeyer, M. de, in *Artes textiles*, I (1953), 3.

Puyvelde, L. van, in *Verslagen en Mededelingen Kon. Vlaamse Academie van Taal en Letterkunde* (1958), 117.

BALEN, VAN

Lerius, T. van. *Biographies d'artistes anversois*, II (1881), 234.

Detailed but old-fashioned account.

BEERT
Benedict, C., in *L'amour de l'art*, XIX (1938), 307.
Hairs, M. L., in *Revue belge*, XX (1951), 237.
Hairs, M. L., in *Bull. M.R.*, II (1953), 21.
Bergström, J., in *B.M.*, XCIX (1957), 120.

BESCHEY
[*Sale-*]*Catalogue ... schilderijen ... tekeningen .. naergelaten bij wijlen d'Heer Balthasar Beschey*, Antwerp, 1 July 1776.
Luttervelt, R. van, in *Revue belge*, XX (1951), 300.

BOUQUET
Bautier, P. 'Victor Bouquet et les portraitistes flamands "pseudo-espagnols",' *Revue belge*, XI (1941), 241.

BROUWER
Schmidt Degener, F. *Adriaen Brouwer*. Amsterdam, 1908.
Bode, W. von. *Adriaen Brouwer*. Berlin, 1924.
Böhmer, G. *Der Landschafter Adriaen Brouwer*. Munich, 1940.
Knuttel, G. *Adriaen Brouwer*. The Hague, 1960.

BRUEGHEL, JAN I
Crivelli, G. *Giovanni Brueghel*. Milan, 1898.
Dorner, A., in *Jahrbuch des Provinzialmuseums Hannover*, N.F. II (1927), 68.
 The dating of the pictures mentioned is doubtful.
Regteren Altena, J. Q. van, in *Oudheidkundig Jaarboek*, 4/I (1932), 107.
Michel, E. *Catalogue raisonné des peintures ... peintures flamandes*, 43. Paris, Musée National du Louvre, 1933.
Denucé, J. *Brieven en documenten betreffend Jan Brueghel I en II*. Antwerp, 1934.
Clerici, F. *Allegorie dei sensi di Jan Brueghel*. Florence, 1946.
Klauner, F., in *Nationalmusei Årsbok*, N.S. 19/20 (1949/50), 5.
 Paintings in the E. Perman collection, the dating of which is not convincing.
Bialostocki, J., in *Biuletyn historii sztuki*, XII (1950/1), 322.
Galbiati, G. *Itinerario dell'Ambrosiana*. Milan, 1951.
 With literature.

BRUEGHEL, JAN II
Vaes, M. 'Le journal de Jan Brueghel II', *Bull. I.B.R.*, VI (1926), 163.

BRUEGHEL, PIETER II and JAN
Catalogue. *De Helsche en de Fluweelen Brueghel*. Amsterdam (P. de Boer), 1934.
 With contributions from G. Glück and others.
Puyvelde, L. van, in *B.M.*, LXV (1934), 16.

Catalogue. *Die jüngeren Brueghel*. Vienna, 1935.
Glück, G. *Brueghels Gemälde*. 5th ed. Vienna, 1951.
 Particularly numbers 11, 13, 15, 25, 35, 36, 39, 55-8, 60, 83-5, 87.

CAULERY, DE
Frimmel, T. von, in *Blätter für Gemäldekunde*, III (1907), 195.
Michel, E., in *Revue belge*, III (1933), 224.

CLERCK, DE
Frimmel, T. von, in *Kleine Galeriestudien*, I (1892), 126.
Terlinden, Vicomte, in *Revue belge*, XXI (1952), 81.
 Many biographical details, but poor in the stylistic interpretations.

COCLERS
Timmers, J. J. M. 'De Maastricht-Luiksche schildersfamilie Coclers', *Publication de la Société historique et archéologique dans le Limburg*, 3/76 (1940), 139.

COCQUES
Lerius, T. van. *Biographies d'artistes anversois*, I (1880), 132.
Gelder, J. G. van, in *Oud-Holland*, LXIV (1949), 48.
Rezniceck, E., in *Bulletin van het Rijksmuseum [Amsterdam]*, II (1954), 43.

COEBERGHER
Fokker, T. H., in *Kunst der Nederlanden*, I (1930), 170.

CONINXLOO, VAN
Laes, A., in *Annuaire des Musées Royaux*, II (1939), 109.
Willensiek, H., in *Bull. M.R.*, III (1954), 109.
 Especially on the incorrect attribution of Brussels, 1025.

COSSIERS
Mayer, A. L., in *Münch. Jahrb.* (1913), 183.
Laes, A., in *Revue belge*, XIX (1950), 43.

CRAESBEECK, VAN
Zoege von Manteuffel, K., in *Jahrb. P.K.*, XXXIX (1916), 315.
Winkler, F., in *Pantheon*, XVII (1936), 163.

CRAYER, DE
Maeterlinck, L., in *Bulletin de la Société d'histoire et d'archéologie de Gand* (1900).
Antal, F., in *Jahrb. P.K.*, XXIV (1923), 57.
Terlaan, E. van, in *G.B.A.*, 5/68 (1926), 93.
Glück, G. *Rubens*, 319.

Carton de Wiart. *Gaspard de Crayer et la corpora-tion des Poissonières de Bruxelles*. Brussels (Con-férences), 1940/1.

S[anchez] C[anton], [F. J.], in *Archivo español de arte*, LXIV (1944), 279.

Hofman, D. M., in *G.B.A.*, 6/41 (1953), 93.

DEFRANCE

Gobert, C. *Autobiographie d'un peintre liégois*. Liège, 1906.

Vallery Radot, J., in *Le Figaro artistique*, II (1924/5), 84.

Louis, M., in *Bulletin de l'Institut archéologique liégois*, LIV (1930), 92.

Louis, M., in *Revue belge*, I (1931), 201.

DOUFFET

Gevaert, S., in *Revue belge*, XVII (1947/8), 51.

Philippe, J., in *Revue belge*, XIX (1950), 56.

DYCK, VAN

1. General (pictures)

Bellori, G. P. *Le vite dei pittori, scultori ed architetti moderni*, 253. Rome, 1672.

[Dumont], MS on van Dyck (*c*. 1780), Louvre Museum Library, Paris [VE 2 R-8].

Carpenter, W. H. *Pictorial Notices*. London, 1844.

Guiffrey, J. *A. van Dyck*. Paris, 1882.

Cust, L. *Anthony van Dyck*. London, 1900.

Glück, G. *Van Dyck, Des Meisters Gemälde (Klassiker der Kunst)*. Stuttgart, 1931.

B.M., LXXIX (1941), 173–203.
> A van Dyck issue with contributions by G. Glück, L. van Puyvelde, P. Oppé, a.o.

Puyvelde, L. van. *Van Dyck*. Brussels, 1950.

Valentiner, W. R. 'Van Dyck's Character', *A.Q.*, XIII (1950), 86.

Piper, D., in *The Listener* (28 January 1954).
> On the oldest memorial notice by Baldwin Hamey.

Vey, H., in *Bull. M.R.*, V (1956), 167.

Baldass, L., in *G.B.A.*, 6/50 (1957), 251.
> On portraits.

Gelder, J. G. van. 'Anthonie van Dijck in Holland in de zeventiende eeuw', *Bull. M.R.*, VIII (1959), 43.

2. Drawings

Hind, A. M., in *B.M.*, LI (1927), 292.

Burchard, L., in *Sitzungsberichte der Kunst-geschichtlichen Gesellschaft, Berlin* (October 1931 to May 1932).

Hind, A. M., in *British Museum Quarterly*, VII (1932/3), 63.

Delacre, M. *Le dessin dans l'œuvre de Van Dyck*. Brussels, 1934.

Benesch, O., in *Graphische Künste*, III (1938), 19.

Burchard, L., in *Old Master Drawings*, XII (1938), 47.

Gelder, J. G. van. *A. van Dyck, tekeningen*. Ant-werp, 1942; reprinted 1948.

Delen, A. J. J. *A. van Dyck, Een keuze van tekeningen*. Antwerp, 1944.

Benesch, O., in *G.B.A.*, 6/30 (1946), 153.

Vey, H., in *Bulletin Museum Boymans*, VII (1956), 45 and 82.

Vey, H., in *Bull. M.R.*, VI (1957), 175.

3. Antwerp Periods

Glück, G. 'Van Dycks Apostelfolge', in *Festschrift Max J. Friedländer*, 30. Berlin, 1927.

Rosenbaum, H. *Der junge Van Dyck*. Munich, 1928.

Glück, G. *Rubens*, 275.

Burchard, L., in *B.M.*, LXXII (1938), 25.

Göpel, E. *Ein Bildnisauftrag für Van Dyck*. Frankfurt, 1940.

Glück, G., in *B.M.*, LXXX (1942), 17.

Garas, K., in *Arta Historiae Artium*, II (1955), 189.

Vey, H. *Van-Dyck-Studien*. Cologne (disserta-tion 1955), [1958].

4. Italian Period

Soprani, R. *Le vite de' pittori*. Genoa, 1674.

Menotti, M., in *Archivo storico dell'arte*, III (1897).

Vaes, M., in *Bull. I.B.R.*, IV (1924), 163; VII (1927), 5.

Glück, G., in *Z.B.K.*, Beilage, LXI (1927/8), 72.

Burchard, L., in *Jahrb. P.K.*, L (1929), 340.

Marcenaro, C., in *Bull. I.B.R.*, XVIII (1937), 209.
> On the *Crucifixion* in S. Michele da Pagana.

Glück, G., in *B.M.*, LXXIV (1939), 206.

Haars-Horenburg, R. *Anton van Dycks Aufent-halt in Rom 1622/3*. MS, Graz University Library, 1942.

Maison, E. K., in *B.M.*, LXXX (1942), 18.

Zeri, F., in *Paragone*, LXVII (1955), 46.

Vey, H., in *Bulletin Museum Boymans-van Beuningen*, X (1959), 1.
> On the *Crucifixion*.

5. Italian Sketchbook

Cust, L. *A Description of the Sketch Book*. London, 1902.

Adriani, G. *A. van Dycks italienisches Skizzenbuch*. Vienna, 1940.

Egger, H., in *Graphische Künste*, N.F. VI (1941), 30.

Tietze Conrat, E., in *Critica d'arte*, 3/8 (1950), 425.

6. Iconography

.Wibiral, F. *L'iconographie d'Antoine van Dyck*. Leipzig, 1877.

Catalogue. *The Portrait Etchings of A. van Dyck*. New York (M. Knoedler & Co.), 1934.

Weixlgärtner, A., in *Göteborgs Konstmuseums Årstryck* (1955/6), 45.

Mauquier Hendrickx, M. *L'iconographie d'Antoine van Dyck*. Brussels, 1956.

7. English Period

Walpole, H. *Anecdotes of Painting*. London, 1844; ed. R. H. Wornum, I (1876), 316.

Glück, G., in *B.M.*, LXX (1937), 212.

Nordenfalk, C., in *Jahrb. P.K.*, LIX (1938), 36.

Waterhouse, E. K. *Painting in Britain 1530–1790* (*Pelican History of Art*), 46. Harmondsworth, 1953.

Sutton, D., in *Country Life Annual 1954*, 108.

Wark, R. R., in *B.M.*, XCVIII (1956), 52.

Whinney, M., and Millar, O., in *English Art*, 67. Oxford, 1957.

Bruyn, J., in *B.M.*, XCIX (1957), 96.

Held, J. S. 'Le Roi à la ciasse', *Art Bulletin*, XL (1958), 139.

Most important article on 'key picture'.

8. Exhibitions

Loan Exhibition of Fifty Paintings by A. van Dyck. Detroit, 1929.

With excellent introduction by W. R. Valentiner.

Van Dyck Tentoonstelling, Kon. Museum voor Schone Kunsten. Antwerp, 1949.

Reviewed by Comte d'Arschot in *Les arts plastiques*, III (1949), 261.

100 opere di Van Dyck. Genoa, 1955.

Catalogue with extensive bibliography. Reviewed by O. Millar in *B.M.*, XCVII (1955), 312; L. van Puyvelde in *Revue belge*, XXIV (1955), 39, and in *Emporium*, 61/122 (1955), 98.

Both the Antwerp and Genoa exhibitions are rightly and severely criticized because of the many pictures of inferior quality.

FOUQUIER

Stechow, W., in *Kunst der Nederlanden*, I (1930), 297.

Stechow, W., in *G.B.A.*, 6/34 (1948), 419.

FRANCKEN, AMBROSIUS, FRANS I, and HIERONYMUS

Gabriels, J. *Een Kempisch schildergeslacht – de Franckens*. Hoogstraten, 1930.

Gabriels, J., in *Kunst der Nederlanden*, I (1930), 57 and 96.

FRANCHOIS

Held, J., in *A.Q.*, XIV (1951), 45.

FYT

Greindl, E., in *Miscellanea L. van Puyvelde*, 163. Brussels, 1949.

GAREMIJN

Catalogue. *Drie Vlaamse Meesters*. Bruges, 1955.

GOVAERTS

Thierry, Y., in *Bull. M.R.*, I (1952), 135.

HEEM, DE

Bergström, J., in *Oud-Holland*, LXXI (1956), 173.

HEUVEL, VAN DEN

Roggen, D., in *G.B.*, XII (1949/50), 286; XIV (1953), 205.

Held, J., in *G.B.*, XIII (1951), 7.

HOECKE, VAN DER

Mojzer, N., in *Bulletin du Musée national hongrois des Beaux-Arts*, XIII (1958), 44.

JANSSENS, A.

Oldenbourg, R., in *Belgische Kunstdenkmäler*, ed. P. Clemen, II, 243. Munich, 1923.

Pevsner, N., in *B.M.*, LXIX (1936), 120.

Roggen, D., in *G.B.*, XII (1949/50), 266.

Held, J., in *Bull. M.R.*, I (1952), 11; II (1953), 109.

JANSSENS, J.

Roggen, D., in *G.B.*, XII (1949/50), 260; XIII (1951), 7; XIV (1953), 201.

JORDAENS

1. The Main Books

Rooses, M. *Jordaens' leven en werken* (Dutch and French edition). Antwerp, 1906.

A thorough work with documents.

Puyvelde, L. van. *Jordaens*. Brussels, 1953.

The modern biography, in many respects diverging from the detailed studies by L. Burchard, J. Held (*A.Q.*, XL (1958), 81), and R. A. d'Hulst; with abridged catalogue raisonné.

Hulst, R. A. d'. *De Tekeningen van Jacob Jordaens*. Antwerp, 1957.

As the drawings are mostly preparatory studies for the paintings, the artist's development in general is carefully discussed in this book. With literature.

2. The Main Articles

Kauffmann, H. 'Die Wandlung des Jacob Jordaens', *Festschrift für Max J. Friedländer*, 191. Leipzig, 1927.

Burchard, L. 'Jugendwerke von Jacob Jordaens', *Jahrb. P.K.*, XLIX (1928), 207.

Held, J. 'Nachträglich veränderte Kompositionen bei J. Jordaens', *Revue belge*, III (1933), 214.

Held, J. 'Malerier og tegninger af Jacob Jordaens i Kunstmuseets', *Kunstmuseets Aarsskrift*, XXVI (1939), 1.

Hulst, R. A. d'. 'Jacob Jordaens, schets eener chronologie zijner werken ontstaan vóór 1618', *G.B.*, XIV (1953), 89.

Klessmann, R. 'Jacob Jordaens. Die Heimkehr der Hlg. Familie aus Ägypten', *Berliner Museen*, N.F. VIII (1958), 40.

3. Exhibitions

Tentoonstelling Jacob Jordaens. Antwerp, 1905.
Exhibition Jacob Jordaens. New York, Mortimer Brand Gallery, 1940.

KEUNINCK, DE

Laes, A., in *Melanges Hulin de Loo*, 225. Brussels, 1931.

Sulzberger, S., in *G.B.A.*, 6/33 (1948), 57.

Fechner, E., in *Yearbook of the Hermitage, Western European Art*, I (1956), 104 (in Russian).

LENS

Diercx, J., in *G.B.*, VII (1941), 173.

LIERMAKER (ROOSE)

Roggen, D. *Nicolaes de Liermaker dit Roose et les principaux peintres gantois de son époque*. MS in the Hoger Instituut voor Kunstgeschiedenis, Ghent.

LOON, VAN

Cornil, T., in *Bull. I.B.R.*, XVII (1936), 187.

Held, J., in *A.Q.*, XIX (1953), 150.

MEULEN, VAN DER

Mauricheau-Beaupré, C., in *Jardin des Arts*, XXXVII (1957), 1.

MOMPER, DE

Lilienfeld, K. Catalogue. *Joos de Momper*. Chemnitz, 1927.

See K. Zoege von Manteuffel, *Z.B.K.*, Beilage, LXI (1927/8), 90.

Catalogue. *Joost de Momper*. Amsterdam (P. de Boer), 1930/1.

Richardson, E. P., in *A.Q.*, I (1938), 185.

Boström, K., in *Konsthistorisk Tidskrift*, XX (1951), 1; XXIII (1954), 45.

Laes, A., in *Bull. M.R.*, I (1952), 57.

Also on F. de Momper.

NOORT, VAN

Haberditzl, F. H., in *Jahrb. K.S.*, XXVII (1908), 167.

Principally concerned with drawings.

Puyvelde, L. van, in *Bull. M.R.*, II (1929), 36.

Puyvelde, L. van, in *Annuaire des Musées Royaux*, I (1938), 143.

Some new attributions which are not altogether satisfying; the dating does not convince.

Hulst, R. A. d', in *Bull. M.R.*, II (1953), 16.

Held, J., in *Bull. M.R.*, II (1953), 102.

Baudouin, F., in *Antwerpen*, I (1955), no. 1, 21.

OOST, VAN

Bautier, P. *Les peintres Van Oost*. Brussels, 1945.

Hulst, R. A. d', in *G.B.*, XIII (1951), 169.

Held, J., in *A.Q.*, XVIII (1955), 146.

PANNEELS

Held, J., in *G.B.A.*, 6/23 (1943), 117.

POURBUS, FRANS II

Fokker, T. H., in *Mededelingen Nederlandsch Historisch Instituut, Rome*, V (1925), 199.

Wilde, J., in *Jahrb. K.S.*, N.F. X (1936), 211.

Soria, M. S., in *A.Q.*, XV (1952), 37.

Novoselskaya, J., in *Bulletin of the Hermitage*, XIII (1958), 52 (in Russian).

PRIMO

Puyvelde, L. van, in *Verslagen en Mededelingen Kon. Vlaamsche Academie voor Taal en letterkunde*, II/2 (1958).

PSEUDO VAN DE VENNE

Frimmel, T. von, in *Blätter für Gemäldekunde*, II (1906), 98.

Heppner, A., in *Oud-Holland*, XLVII (1930), 78.

Heppner, A., in *Aan Max Friedländer*, 51. The Hague, 1942.

QUELLINUS, E. and J. E.

Glück, G. *Rubens*, 266 and 342.

Zoege von Manteuffel, K., in *Berliner Museen*, LIV (1933), 54.

Legrand, F. C., in *Bull. M.R.*, V (1956), 61.

REYN, DE

Baron, L., in *Bulletin de la Commission historique du département du Nord*, XXXVI (1948), 209.

ROMBOUTS

Roggen, D., in *G.B.*, II (1935), 175; XII (1949/50), 225; XIII (1951), 269.

B[anti], A., in *Paragone*, no. 3 (1950), 56.

RUBENS

The writings on Rubens have become most abundant. I have tried to group this torrent of books and articles systematically and to follow those problems in literature (like that of 'early' and 'Italian' Rubens) which are foremost in the minds of modern writers, more extensively than others.

1. Bibliography

Arents, P. *Geschriften van en over Rubens.* Antwerp, 1940.

> Not clearly arranged and including much which is irrelevant.

Kieser, E. 'Die Rubensliteratur seit 1935', *Z.K.*, X (1941/2), 300.

2. Sources and Documents

Longhi, R., in *Annuaire des Musées Royaux*, II (1939), 123.

> With reference to a MS by Mancini (*c.* 1621).

Baglione, G. *Le vite dei pittori*, 362. Rome, 1642.

Pacheco, F. *Arte de la pintura.* Seville, 1649.

> Modern ed. Madrid 1956, by F. J. Sanchez Canton, 2 vols.

Boschini, M. *Carta del Navegar.* Venice, 1660.

> See C. Ruelens in *Rubens Bulletin*, III (1886/8), 82.

Bellori, G. P. *Le vite de' pittori*, 217. Rome, 1672.

> Modern facsimile ed. Rome 1931.

Soprani, R. *Vite de' pittori.* Genoa, 1674.

Piles, R. de. *Conversation sur la connaissance de la peinture.* Paris, 1677.

Piles, R. de. *Dissertation sur les œuvres des plus fameus peintres.* Paris, 1681.

> These two publications contain a 'Vie de Rubens', which may contain information given by Philips Rubens.

Baldinucci, F. *Notizie dei professori*, X, 221. Florence, ed. 1812.

[Rubens, Philips?]. *Vita P. P. Rubens.*

> Published for the first time by de Reiffenburg in *Nouvelles mémoires de l'Académie Royale des Sciences, Brussels*, X (1837), 15; republished and translated by L. R. Lind in *A.Q.*, IX (1946), 37. The original is lost. There are 3 MS copies made by F. Mols in the Royal Library, Brussels (MSS 21740; 5722; 5730). The relation between 'Vita' and 'Vie de Rubens' is uncertain. See C. Ruelens, *Rubens Bulletijn*, II (1883/5), 157.

Génard, P. *P. P. Rubens, Aantekeningen over den groten meester en zijn bloedverwanten.* Antwerp, 1877.

Riegel, H., *Beiträge zur niederländischen Kunstgeschichte*, I (1882), 235.

Müller Hofstede, J., in *Bull. M.R.*, VI (1957), 106.

3. Letters

Ruelens, C., and Rooses, M. *Correspondance de Rubens.* 6 vols. Antwerp, 1887–1909.

Magurn, R. S. *The Letters of P. P. Rubens.* Cambridge, Mass., 1955.

> Although the second publication has some newly-found letters, the old one cannot be disregarded, as all the letters are given in the original language (plus a French translation), whilst Magurn has only the English translation. Moreover, Ruelens–Rooses have incorporated all letters written to and about Rubens. See further:

Burchard, L., in *Kunstchronik und Kunstmarkt*, LIV (1919), 509.

Torelli, P., in *Miscellanea di studi storici ad Alessandro Luzio*, I, 176. Florence, 1933.

Arents, P. *Rubens Bibliografie, Geschriften van en aan Rubens.* Brussels, 1943.

4. Politics

Cruzada Villaamil, G. *Rubens diplomático español.* Madrid, 1874.

Gachard, L. P. *Histoire politique et diplomatique de P. P. Rubens.* Antwerp, 1877.

Gachard, L. P., in *Rubens Bulletijn*, III (1886/8), 108.

Ruelens–Rooses (see above), *Correspondance*, IV, 40; VI, 5 and 124.

Maeyer, M. de. *Albrecht en Isabella*, 96–8. Brussels, 1955.

Magurn, R. S. *The Letters of P. P. Rubens.* Cambridge, Mass., 1955.

5. General

Rooses, M. *L'œuvre de P. P. Rubens.* 5 vols. Antwerp, 1886–92.

> The standard work and œuvre catalogue, still today an unfailing source of information.

Burckhardt, J. *Erinnerungen aus Rubens.* Basel, 1898.

> Many later editions, among others *Grosse illustrierte Phaidon-Ausgabe*, Vienna, 1938; *Recollections of Rubens*, London, 1950.

Michel, E. *Rubens, sa vie, son œuvre et son temps.* Paris, 1900.

Rooses, M. *Rubens.* Antwerp, 1903; English ed. 1904.

Oldenbourg, R. *Rubens, Des Meisters Gemälde* (*Klassiker der Kunst*). Berlin–Leipzig, 1921.

Oldenbourg, R. *P. P. Rubens* (*Sammlung der von R. Oldenbourg veröffentlichten Abhandlungen*). Munich, 1922.

Papers and essays republished after the author's death.

Evers, H. G. *Peter Paul Rubens*. Munich, 1942.

The most modern biography, combined with much detailed research.

Evers, H. G. *Rubens und seine Werk, Neue Forschungen*. Brussels, 1943.

Valentiner, W. R. 'Rubens Paintings in America', *A.Q.*, IX (1946), 153.

Goris, J. A., and Held, J. *Rubens in America*. New York, 1947.

Coo, J. de. *Rubens-gids voor de Antwerpse Kerken*. Antwerp, 1947.

Puyvelde, L. van. *Rubens*. Paris–Brussels, 1952.

Kauffmann, H. 'P. P. Rubens im Lichte seiner Selbstbekenntnisse', *Wallraf-Richartz Jahrbuch*, XVII (1955), 181.

Excellent lecture.

6. Oil-Sketches (see also *9. Exhibitions*)

Burchard, L., in *Sitzungsberichte der Kunstgeschichtlichen Gesellschaft, Berlin* (October 1926 to May 1927), 1.

Puyvelde, L. van. *The Sketches of Rubens*. London, 1947.

Cf. *Times Literary Supplement* (24 July 1948).

Jaffé, M., in *Art News*, LII (1953/4), no. 3, 34.

Haverkamp Begemann, E., in *Bulletin Museum Boymans*, V (1954), 1.

Aust, J. 'Entwurf und Ausführung bei Rubens', *Wallraf-Richartz Jahrbuch*, XX (1958), 163.

7. Drawings (see also *9. Exhibitions*)

Parker, K. T., in *Old Master Drawings*, IV (1920), 17.

Lugt, F., in *G.B.A.*, LXVII (1925), 179.

Glück, G., and Haberditzl, F. M. *Die Handzeichnungen von Peter Paul Rubens*. Berlin, 1928.

Dobroklonsky, M. W. *Drawings by Rubens* (Catalogue of the Hermitage; in Russian). Leningrad, 1940.

Regteren Altena, J. Q. van, in *B.M.*, LXXVI (1940), 198.

Lugt, F. *Inventaire général des dessins des écoles du Nord. École flamande* II. *Musée du Louvre*. Paris, 1949.

Held, J., in *Magazine of Art*, XLV (1951), 285.

Madsen, S. T., in *B.M.*, XCV (1953), 304.

Burchard, L., in *B.M.*, XCVIII (1956), 414.

Held, J. *Rubens. Selected Drawings*. 2 vols. London, 1959.

This important book came out too late for consultation in connexion with this volume.

8. Prints

Voorhelm Schneevogt, C. G. *Catalogue des estampes gravés d'après Rubens*. Haarlem, 1873.

Hymans, H. *Histoire de la gravure dans l'école de Rubens*. Brussels, 1879.

Rosenberg, A. *Der Kupferstich in der Schule und unter den Einfluss des Rubens*. Vienna, 1888.

Wyngaert, F. van den. *Inventaris der Rubeniaansche prentkunst*. Antwerp, 1940.

Ebbinge Wubben, J. C. Catalogue. *De prentkunst rondom Rubens*. Rotterdam, 1942/3.

Lisenkof, E. G. 'The Illustrations by Rubens for the Book of Aguilonius on the Optica', *Travaux* (*Hermitage*), III (1949), 49 (in Russian).

Bouchery, H. F., and Wyngaert, F. van den. *P. P. Rubens en het Plantijnsche Huis*. Antwerp, 1951.

9. Exhibitions

Many of the most important observations on Rubens have been made in connexion with exhibitions: they are discussed (sometimes at very great length) in the catalogues or in the reviews devoted to these special exhibitions.

Rubens tentoonstelling. Amsterdam (J. Goudstikker), 1933. Catalogue by L. Burchard and J. Q. van Regteren Altena.

Sixty Paintings and some Drawings by P. P. Rubens. Detroit, 1936. Catalogue by W. R. Valentiner.

Schetsen van Rubens. Brussels, 1937. Catalogue by L. van Puyvelde.

Peter Paul Rubens. London (Wildenstein), 1950. Catalogue by L. Burchard, introduction by D. Sutton.

Reviewed by C. Norris in *B.M.*, XCIII (1951), 4.

Rubens. New York (Wildenstein), 1951. Catalogue by L. Burchard.

Rubens, Esquisses-dessins. Brussels, 1953.

Olieverfschetsen van Rubens. Rotterdam, 1953. Catalogue by E. Haverkamp Begemann.

Reviewed by M. Jaffé in *B.M.*, XCVI (1954), 53.

Tekeningen van P. P. Rubens. Antwerp, 1956. Catalogue by L. Burchard and R. A. d'Hulst.

Reviewed by M. Jaffé in *B.M.*, XCVIII (1956), 314.

Drawings and Oil-Sketches by P. P. Rubens from American Collections. New York–Cambridge, 1956. Catalogue by A. Mongan.

Herinneringen aan P. P. Rubens. Antwerp, 1958.
Small catalogue with some interesting notes concerning letters, documents, etc.

10. Special Subjects
A. Landscapes

Kieser, E. 'Tizians und Spaniens Einwirkungen auf die späteren Landschaften von Rubens', *Münch. Jahrb.*, N.F. VIII (1931), 281.

Hermann, H. *Untersuchungen über die Landschaftsgemälde des P. P. Rubens.* Dissertation, Berlin, 1936.

MacLaren, N. *Peter Paul Rubens, The Château de Steen.* London, 1946.

Glück, G. *Die Landschaften von Peter Paul Rubens.* 2nd ed. Vienna, 1945.

B. Connexions with the Art of Others
(see also C. *Before Italy;* E. *Italy and Early Spain;* and p. 188, note 128)

Haberditzl, F. M., in *Jahrb. K.S.*, XXX (1911), 287.

Kieser, E., in *Münch. Jahrb.*, X (1933), 139.

Sulzberger, S., in *Revue belge*, XI (1941), 59.
All on antique art.

Janson, C., in *G.B.A.*, 6/17 (1937), 26.
Veronese.

Janson, C., in *G.B.A.*, 6/19 (1938), 77.
Tintoretto.

Olsen, H., in *Kunstmuseets Aarsskrift*, XXXVII (1950), 58.
Cigoli.

Suida-Manning, B., in *G.B.A.*, 6/40 (1952), 163.
Cambiaso.

Dhanens, E., in *G.B.*, XVI (1955/6), 241.
Jean de Boulogne.

Jaffé, M., in *B.M.*, XCIX (1957), 374.
Carracci.

Jaffé, M., in *Art Bulletin*, XL (1958), 325.
Giulio Romano.

C. Before Italy
i. Pictures

The various attributions to Rubens's first period put forward by the different writers are contradicted by others.

Glück, G., in *Jahrb. K.S.*, N.F. VI (1932), 157.

Norris, C., in *B.M.*, LXXVI (1940), 184.
With the older literature.

Puyvelde, L. van, in *G.B.A.*, LVI (1944), 24.

Valentiner, W. R., in *A.Q.*, XVI (1953), 67.

Konnerth, H., in *Zeitschrift für Kunstwissenschaft*, IX (1955), 81.

Hevesy, A. de, in *G.B.A.*, 6/45 (1955), 21.

Held, J., in *Miscellanea Roggen*, 125. Antwerp, 1957.

Bury, A., in *Connoisseur*, CXXXIX (1957), 189.
St Andrew, private collection.

Esser, H., in *Weltkunst*, XXVII (1957), no. 9, 10.
Christ and Veronica, Mainz.

ii. Drawings

Popham, A. E., in *Old Master Drawings*, I (1927), 45.

Rosenberg, J., in *Berliner Museen*, LII (1931), 108.

Thöne, F., in *Berliner Museen*, LXI (1940), 63.

Lugt, F., in *A.Q.*, VI (1943), 99.

Schilling, E., in *Zeitschrift für Schweizer Archaeologie*, XI (1950), 251.

Jaffé, M., in *Bulletin Museum Boymans*, VII (1956), 6.

Jaffé, M., in *A.Q.*, XXI (1958), 400.

D. Italy and Early Spain
i. General

Burchard, L., in *Pinacoteca*, I (1928), 1.

Glück, G. *Rubens*, 1.

Gabriele, G., in *Bolletino d'arte*, VII (1947), 596.

Franz, H. G., in *Forschungen und Fortschritte*, XXIV (1948), 225.

Jaffé, M., in *B.M.*, C (1958), 411.

ii. Portraits

Boix, F. 'Retrato equestre del Duque de Lerma', *Arte español*, VII (1924), 41.

Burchard, L., in *Jahrb. P.K.*, L (1929), 319.
Genoese portraits.

Scharf, A., in *Old Master Drawings*, III (1929), 66.
Portrait of a Lady.

Gerstenberg, K., in *Z.K.*, I (1932), 99; II (1933), 220.
Rubens with his friends.

Longhi, R., in *Annuaire des Musées Royaux*, II (1939), 123.
Doria Portrait.

Puyvelde, L. van, in *Pantheon*, XXIII (1939), 77.
Lerma Portrait.

iii. S. Croce in Gerusalemme

Michel, E., in *Bulletin monumental*, C (1941), 294.

Evers, H. G. *Neue Forschungen*, 97.

Mahon, D., in *B.M.*, XCIII (1951), 230.

Maeyer, M. de, in *G.B.*, XIV (1953), 75.

iv. Mantua

Luzio, A., in *Archivo storico italiano*, 5/47 (1911), 406.

Wilde, J., in *Jahrb. K.S.*, N.F. x (1936), 212.

Ozzola, L., in *Bolletino d'arte*, 4/37 (1952), 77–8.

v. Fermo

Longhi, R., in *Vita artistica*, I (1927), 191.

Longhi, R., in *Pinacoteca*, I (1928), 169.

Bolletino d'arte, XXVI (1932), 387.
 On restoration.

Mazanesi, F. *La natività di P. P. Rubens*. Fermo, 1954.

vi. S. Maria in Vallicella

Evers, H. G. *Neue Forschungen*, 107.

Friedländer, W., in *G.B.A.*, 6/33 (1948), 28.

Haverkamp Begemann, E., in *Bulletin Museum Boymans*, v (1954), 16.

[Seilern, Count Antoine]. *Paintings and Drawings*, no. 14.

vii. Copies after Titian
(see also B. *Connexions with the Art of Others*)

Wilde, J., in *Jahrb. K.S.*, IV (1930), 259.

Scharf, A., in *B.M.*, LXVI (1935), 259.

Voss, H., in *Miscellanea D. Roggen*, 279. Antwerp, 1951.

viii. Other Paintings

Posse, H., in *Festschrift Koetschau*, 109. Düsseldorf, 1928.
 Hero and Leander.

Burchard, L., in *Actes du XIIe congrès*, I, 127. Brussels, 1930.
 Two altars for the Gesù.

Ozzola, L., in *Emporium*, LII (1946), 185.
 St Ursula.

Zeri, F., in *Paragone*, no. 67 (1955), 51.
 Bacchanal.

Rotondi, P. *La Circoncisione della chiesa del Gesù a Genova*. Genoa, 1955.

ix. Drawings

Suter, K. F., in *B.M.*, LV (1929), 181; LVI (1930), 257.

Regteren Altena, J. Q. van, in *B.M.*, LXXVI (1940), 200.

Tietze Conrat, E., in *Arte veneta*, VIII (1954), 209.

Jaffé, M., in *A.Q.*, XVIII (1955), 330.

Popham, A. E., in *B.M.*, XCVIII (1956), 417.

Jaffé, M., in *Oud-Holland*, LXXII (1957), 1.

 E. *Early Antwerp Period (1609–c. 1619)*
i. General

Oldenbourg, R. *P. P. Rubens*, 58. Munich, 1922.

Bauch, K., in *Jahrb. P.K.*, XLV (1924), 185.

Kauffmann, H., in *Köln und der Nordwesten*, 99. Cologne, 1941.

Gelder, J. G. van, in *Nederlandsch Kunsthistorisch Jaarboek*, III (1950/1), 102.

ii. Special Works
Adoration of the Magi, Madrid – the sketch in Groningen

Hofstede de Groot, C., in *Pantheon*, I (1928), 36.

Held, J., in *A.Q.*, III (1940), 179.

Rosen, D., and Held, J., in *Journal of the Walters Art Gallery*, 13/4 (1950/1), 77.

Erection of the Cross, Antwerp

Glück, G. *Rubens*, 56.

Grossmann, P., in *Les arts plastiques*, II (1948), 48.

Nieuwenhuizen, J. van den, in *Antwerpen*, III (1952), 63.

Grossmann, P., in *B.M.*, XCIX (1957), 6.

Descent from the Cross, Antwerp

Kauffmann, H., in *Wallraf-Richartz Jahrbuch*, XVII (1955), 188.

Schmidt, D. A., in *Travaux (Hermitage)*, III (1955), 25.

Jaffé, M., in *L'Oeil*, 43/4 (1958), 15.

Argus, Cologne

Hupp, H. W., in *Festschrift Koetschau*, 118. Düsseldorf, 1928.

Adoration of the Magi, Soissons

Benesch, O., in *Bull. M.R.*, v (1956), 35.

Samson and Delilah, Neuerburg Collection, Cologne

Evers, H. G. *Neue Forschungen*, 151.

Evers, H. G., in *Pantheon*, XXXI (1943), 65.

Massacre of the Innocents, Brussels

Glück, G., in *Annuaire des Musées Royaux*, I (1938), 151.

Prometheus, Philadelphia

Kimball, F., in *B.M.*, XCIV (1952), 67.

Tarquin and Lucretia, Potsdam

Poensgen, G., in *Kunst und Künstler*, XXVIII (1930), 207.

Holy Family with the Dove, Los Angeles

Valentiner, W. R., in *Los Angeles County Museum Bulletin*, VI (1954), no. 1, 1.

The Descent from the Cross, Lille, Seilern Collection, London, etc.

Seilern, Count Antoine, in *B.M.*, XCV (1953), 380.

Pouncy, P., in *B.M.*, XCVI (1954), 23.

Rubens and Isabella Brant, Munich

Kauffmann, H., in *Form und Inhalt, Kunst-geschichtliche Studien. Otto Schmitt zum 60. Geburtstag*, 251. Stuttgart, 1950.

Virgin with a Garland of Flowers, Munich

Kieser, E., in *Münch. Jahrb.*, 3/1 (1950), 215.

Defeat of Sennacherib, Munich; The Conversion of St Paul, Count Antoine Seilern Collection, London

Burchard, L., in *Kunstchronik* (1912), 259.

[Seilern, Count Antoine]. *Paintings and Drawings*, nos 20–1 and 57.

The Last Communion of St Francis, Antwerp

Knipping, J. P. *Rubens, De laatste Communie van St Franciscus van Assisië*. Leiden, 1949.

The Carrying of the Cross

Bruyn, J., in *Bulletin Rijksmuseum*, VII (1959), 3.

F. *Series*

Decius Mus

Rooses, M., in *Rubens Bulletijn*, V (1897/1910), 205.

Rooses, M., in *Kunstchronik*, N.F. XIX (1907/8), 143.

Crick Kuntziger, M., in *Revue belge*, XXIV (1955), 17.

Church of St Charles Borromeo (Jesuit Church)

i. *Sketches*

Rooses, M., I, p. 19.

Rooses, M., in *Rubens Bulletijn*, III (1886/8), 265.

Kletzl, O., in *Z.K.*, V (1936), 306.

Puyvelde, L. van. *Sketches*, pp. 26–7.

Rotterdam exhibition (1953), nos 26–34.

Jaffé, M., in *Gallery Notes (Buffalo)*, XVII (1953), nos 2–3, p. 2.

[Seilern, Count Antoine]. *Paintings and Drawings*, nos 25–9.

Haverkamp Begemann, E., in *Bulletin Museum Boymans*, VIII (1957), 82.

ii. *Drawings*

Glück, G., and Haberditzl, F. M. *Die Handzeich-nungen von Peter Paul Rubens*, 120–32. Berlin, 1928.

Dobroklonsky, W. M., in *Z.B.K.*, LXIV (1930/1), 35–6.

Jaffé, M., in *B.M.*, XCVIII (1956), 314.

Marie de' Medici

Rooses, M., in *Rubens Bulletijn*, V (1897/1910), 216.

Lugt, F., in *G.B.A.*, LXVII (1925), 179.

Simson, O. G. von. *Zur Genealogie der weltlichen Apotheose*. Strasbourg, 1936.

Evers, H. G. *Neue Forschungen*, 299.

Simson, O. G. von, in *The Review of Politics*, VI (1944), 427.

Puyvelde, L. van. *Sketches*, 30.

Rotterdam Exhibition (1953), nos 44–6.

Regteren Altena, J. Q. van, in *Bulletin van het Rijksmuseum*, I (1953), 8.

Concerning a visit to Fontainebleau during Rubens's Paris journeys.

Henri IV

Rooses, M., in *Rubens Bulletijn*, V (1897/1910), 216.

Puyvelde, L. van, in *Rivista d'arte* (1940), 128.

Evers, H. G. *Neue Forschungen*, 306.

Wehle, H. B., in *Bulletin of the Metropolitan Museum*, I (1943), 213.

Puyvelde, L. van. *Sketches*, 35.

W[estholm], A., in *Göteborg's Museum Årstryck* (1951/2), 223.

Constantine

Rooses, M., 718–27.

Rooses, M. *Correspondance*, III, 85.

Puyvelde, L. van. *Sketches*, 28.

Burchard, L., in *Wildenstein Exhibition* (1950), no. 19.

Rotterdam exhibition (1953), nos 37–41.

Haverkamp Begemann, E., in *Bulletin Museum Boymans*, V (1954), 9.

Also relates to the Eucharist series.

Eucharist

Rooses, M., 53–78, and V, 307.

Rooses, M., in *Rubens Bulletijn*, V (1897/1910), 282.

Tormo, E., in *Archivo español de arte*, XV (1942), 1.

Tormo, E. *En las Descalzas Reales de Madrid*. Madrid, 1945.

Rotterdam exhibition (1953), nos 73–7.

Elbern, Victor H. Catalogue. *Peter Paul Rubens, Triumph der Eucharistie*. Essen, 1954/5.

Elbern, Victor H., *Kölner Domblatt* (1955), 43.

Achilles

Rooses, M., 557 bis and 564 bis.

Crick Kuntziger, M., in *Bull. M.R.*, 3/6 (1934), 2 and 70.

Puyvelde, L. van. *Sketches*, 36; nos 67–9.

Burchard, L., in *Wildenstein exhibition* (1950), nos 12–13.

Rotterdam exhibition (1953), nos 61–9.

[Seilern, Count Antoine]. *Paintings and Drawings*, nos 31–2.

Whitehall

Rooses, M., 763–71.

Puyvelde, L. van, in *Message, Belgian Review* (1942), no. 12, 38.

Puyvelde, L. van. *Sketches*, 38; nos 70–7.

[Guide], Exhibition of Rubens painted panels. London, 1950.

Nicolson, B., in *B.M.*, XCIII (1951), 309.

Rotterdam exhibition (1953), nos 85–91.

Palme, P. *Triumph of Peace*. Lund, 1956.

Millar, O., in *B.M.*, XCVIII (1956), 258.

Millar, O. *Rubens: The Whitehall Ceiling*. London, 1958.

Pompa Introitus Fernandi

Rooses, M., 772–90.

Roeder Baumbach, J. v. *Versieringen bij blijde inkomsten*. Antwerp, 1943.

Puyvelde, L. van. *Sketches*, 39 and nos 87–90, 104.

Arents, P., in *De Gulden Passer*, XXVII (1949), 81; XXVIII (1950), 147.

Burchard, L., in Catalogue Rubens Exhibition (New York, Wildenstein, 1951), nos 28–9.

Rotterdam exhibition (1953), nos 95–7.

Puyvelde, L. van, in *Standen en Landen*, XVI (1958), 19.

Torre de la Parada

Rooses, M., nos 501–56.

Rooses, M. *Correspondance*, VI, 170.

Puyvelde, L. van. *Sketches*, 41 and nos 94–103.

Rotterdam Exhibition (1953), nos 100–14.

[Seilern, Count Antoine]. *Paintings and Drawings*, nos 39–40.

G. *Late Works*

Glück, G. *Rubens*, 82.

The Garden of Love.

Schmidt, D. A., in *Travaux (Hermitage)*, III (1949), 43.

Nessus and Dejanira.

Burchard, L., in *B.M.*, XCV (1953), 383.

Held, J., in *B.M.*, XCVI (1954), 122.

Feast of Herod.

Burchard, L., in *Bulletin of the Allen Memorial Art Museum [Oberlin]*, XI (1954), 4.

Daughters of Cecrops.

Grossmann, F., in *B.M.*, XCVII (1955), 337.

Sketch for the altarpiece in St Augustine, Antwerp.

Bjurström, P., in *A.Q.*, XVIII (1955), 27.

On drawings for the altarpiece in St Augustine, Antwerp.

RYCKAERT

Zoege von Manteuffel, K., in *Mitteilungen aus den sächsischen Kunstsammlungen*, VI (1915), 53.

SEGHERS, D.

Martin, J. R., in *Record of the Art Museum, Princeton University*, XVII (1958), 1.

SEGHERS, G.

Roblot-Delondre, L., in *G.B.A.*, 6/4 (1930), 184.

Glück, G. *Rubens*, 211.

Roggen, D., and Pauwels, H., in *G.B.*, XII (1949/50), 258; XIII (1951), 269; XVI (1955), 255 and 270.

Linnik, J., in *Yearbook of the Hermitage, West European Art*, I (1956), 167.

SIBERECHTS

Fokker, T. H. *Jan Siberechts*. Brussels, 1931.

SNAYERS

Cuvelier, J., in *Bull. I.B.R.*, XXIII (1944/6), 25.

SNYDERS

Ninane, L., in *Miscellanea L. van Puyvelde*, 143. Brussels, 1949.

SWEERTS

Stechow, W., in *A.Q.*, XIV (1951), 206.

Kultzen, R. *Michael Sweerts*. MS in the Rijksbureau voor Kunsthistorische Documentatie, The Hague. Hamburg, 1954.

Catalogue exhib. *Michael Sweerts en tijdgenoten*. Rotterdam, 1958.

Reviewed by M. R. Waddingham, *Paragone*, IX (1958), 73.

Catalogue exhib. *Michael Sweerts e i bamboccianti*. Rome, 1958.

TENIERS

There is no modern monograph on this artist.

Smith, J. *A Catalogue Raisonné*, III, 247. London, 1831.

Catalogue. Exhibition of paintings by David Teniers (from Blenheim Palace). London [1884].

120 small pictures after the Italian masters in Archduke Leopold William's Collection.

Rosenberg, A. *Teniers der jüngere*. Bielefeld, 1895.

Wauters, A. *David Teniers*. Brussels, 1897.

Valentiner, W. R., in *A.Q.*, XII (1949), 88.

THULDEN, VAN

Schneider, H., in *Oud-Holland*, XLV (1928), 1 and 200.

VEEN, VAN

Haberditzl, F. M., in *Jahrb. K.S.*, XXVII (1908), 191; XXVIII (1910), 290.
 Detailed but out of date.

Gheyn, J. van den. *Album amicorum de Otto Venius*. Brussels, 1911.

Put, A. v. D., in *B.M.*, XXXVII (1920), 189.

Winkler, F., in *Berliner Museen*, XLIV (1923), 44.

Paton, N. J., in *Oud-Holland*, XLI (1923/4), 244.

Held, J., in *Bull. M.R.*, II (1953), 100.

Müller Hofstede, J., in *Bull. M.R.*, VI (1957), 127.

Maeyer, M. de, in *Artes Textiles*, II (1955), 105.

VERHAGHEN

Munter, V. de. *Pierre-Joseph Verhagen*. Brussels, 1932.

Arschot, Comte d', in *Revue belge*, XII (1942), 267; XIII (1943), 161.

Lavalleye, J. *Pierre-Joseph Verhagen (Conférences des Musées Royaux des Beaux Arts)*. Brussels, [1945].

Cat. exhib. *P. J. Verhaghen*. Abdij van Park, te Heverle, Louvain, 1958.

Paessens, A. *P. J. Verhaghen*. [Aerschot, 1958.]
 With list of works; uncritical.

VOS, C. DE

Greindl, E. *Corneille de Vos*. Brussels, 1944.

Valentiner, W. R., in *Quarterly of the Los Angeles County Museum*, VIII (1951), nos 3/4, 12–14.

Gudlaugsson, S., in *Oud-Holland*, LXVI (1951), 64.

VOS, P. DE

Manneback, F., in *Miscellanea L. van Puyvelde*, 147. Brussels, 1949.

VOS, S. DE

Arschot, Comte d', in *Revue belge*, XII (1942), 263.

VRANX

Staring, W. M., in *Revue belge*, XVII (1947/8), 149.

Legrand, F. C., in *Bull. M.R.*, I (1952), 95.

WAEL, C. DE

Baldass, L., in *A.Q.*, XX (1957), 265.

WAEL, L. DE

Suida, W., in *Paragone*, IX (1958), 72.

WATTEAU, L. J. (DE LILLE)

Poncheville, A. M. de. *Louis et François Watteau*. Paris, 1928.

Poncheville, A. M. de, in *Mededelingen v.d. Klasse van Schoone Kunsten, Kon. Academie van België*, XL (1958), 52.

WILLEBOIRTS BOSSCHAERT

Gelder, J. G. van, in *Oud-Holland*, LXIV (1949), 40.

WOUTERS

Glück, G. *Rubens*, 222.

THE PLATES

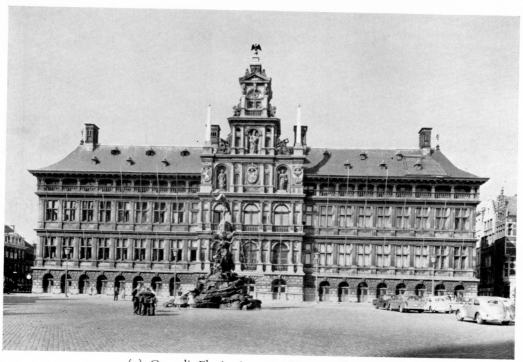

(A) Cornelis Floris: Antwerp Town Hall, 1561–6

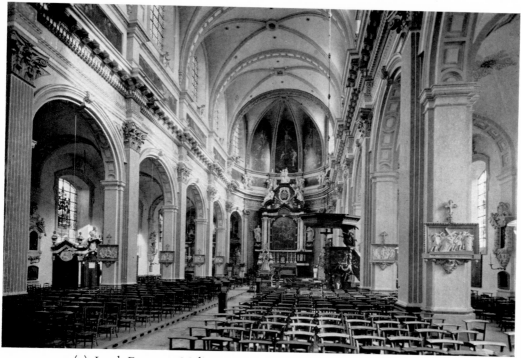

(B) Jacob Francart: Malines, Béguinage church, begun 1629. Interior

I

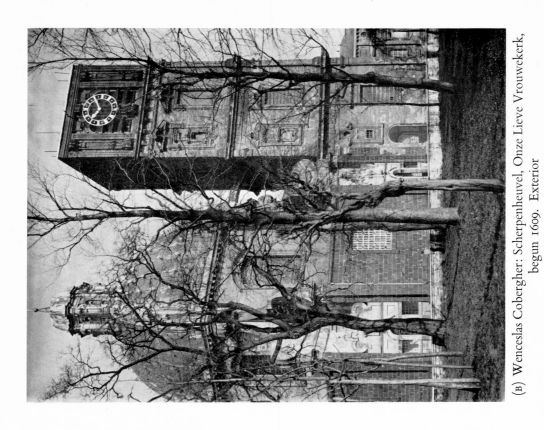

(B) Wenceslas Cobergher: Scherpenheuvel, Onze Lieve Vrouwekerk,
begun 1609. Exterior

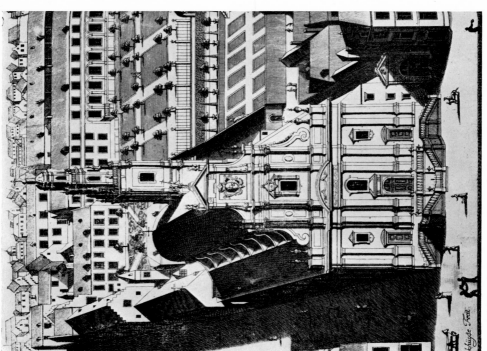

(A) Jacob Francart: Brussels, Jesuit church (destroyed).
Façade, begun 1616

2

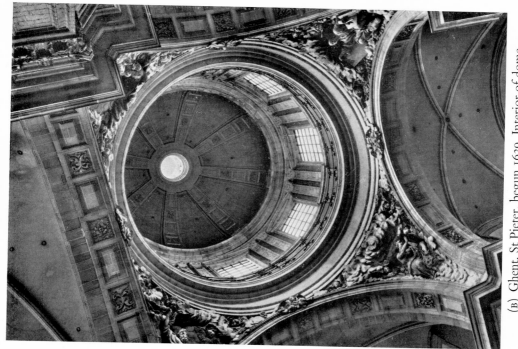

(B) Ghent, St Pieter, begun 1629. Interior of dome

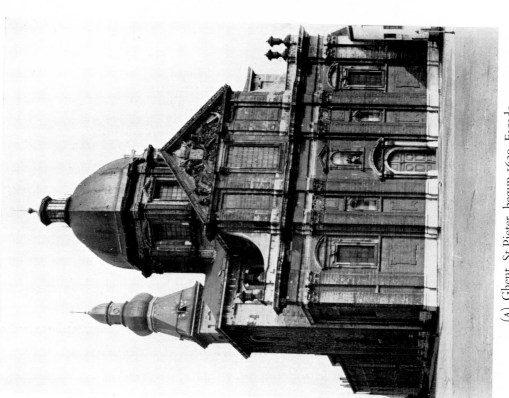

(A) Ghent, St Pieter, begun 1629. Façade

3

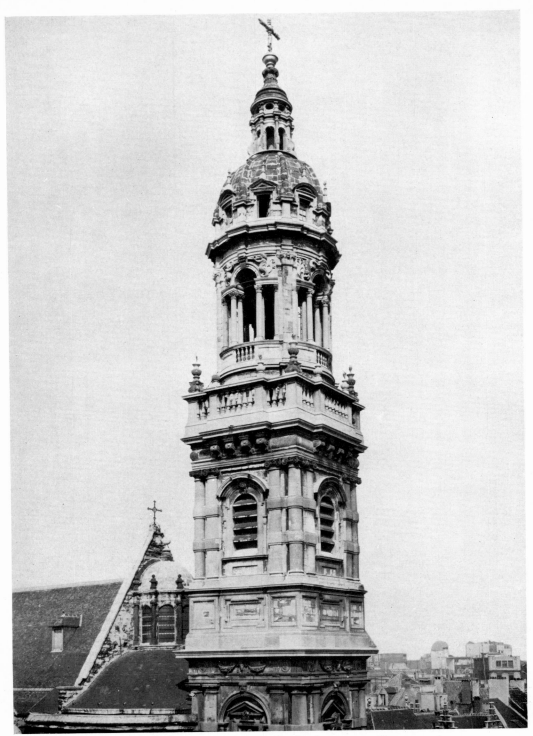

Pieter Huyssens (?): Antwerp, St Charles Borromeo. Tower, *c.*1620

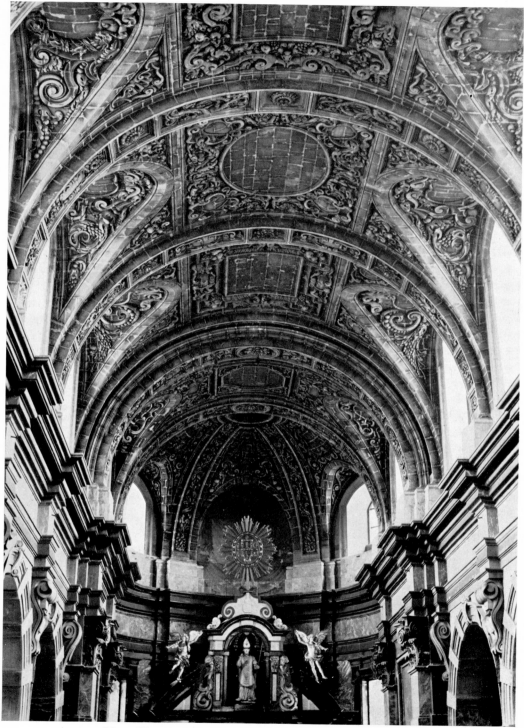

Pieter Huyssens: Namur, St Lupus, begun 1621. Vaulting

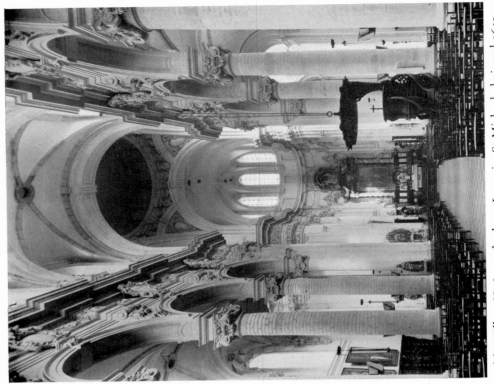

(B) Willem Hesius and others: Louvain, St Michael, designed 1650. Interior

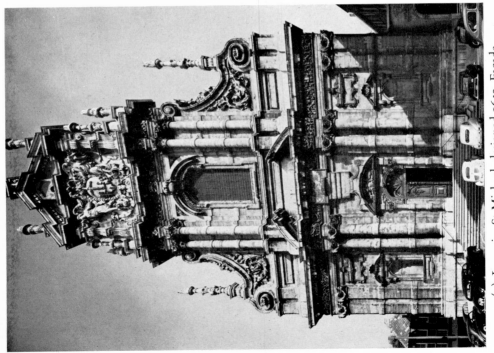

(A) Louvain, St Michael, designed 1650. Façade

6

Brussels, Grande Place, three houses on left 1697 ff, two on right mainly mid seventeenth century

(B) Laurent Benoit Dewez: Gembloux, 1762. Portico

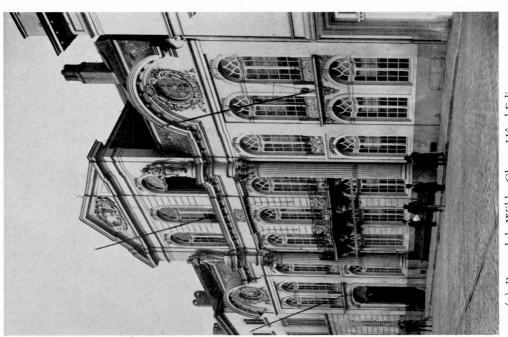

(A) Bernard de Wilde: Ghent, Hôtel Faligan, 1755

8

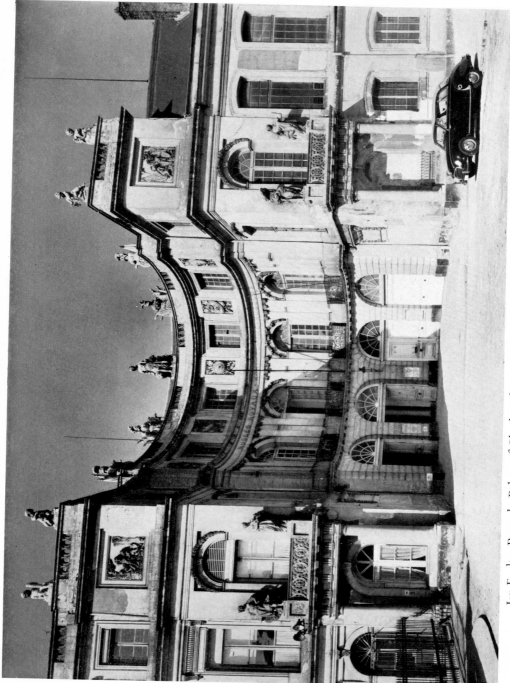

Jan Faulte: Brussels, Palace of Charles of Lorraine (now museum), begun 1757. Entrance

9

Laurent Benoit Dewez: Seneffe, château, c.1760

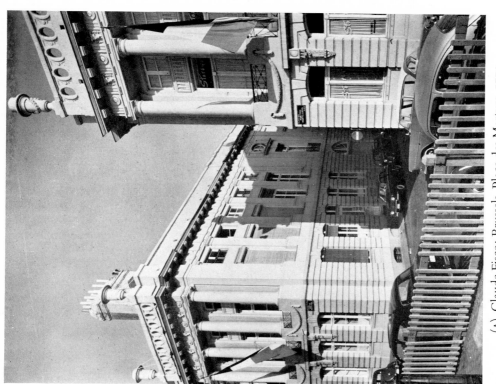

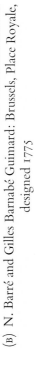

(B) N. Barré and Gilles Barnabé Guimard: Brussels, Place Royale, designed 1775

(A) Claude Fisco: Brussels, Place des Martyrs, 1775

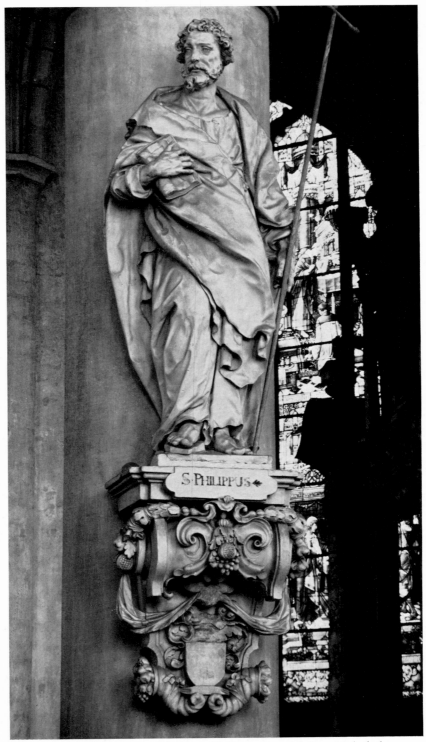

Colijns de Nole workshop: St Philip, c.1630. *Malines Cathedral*

12

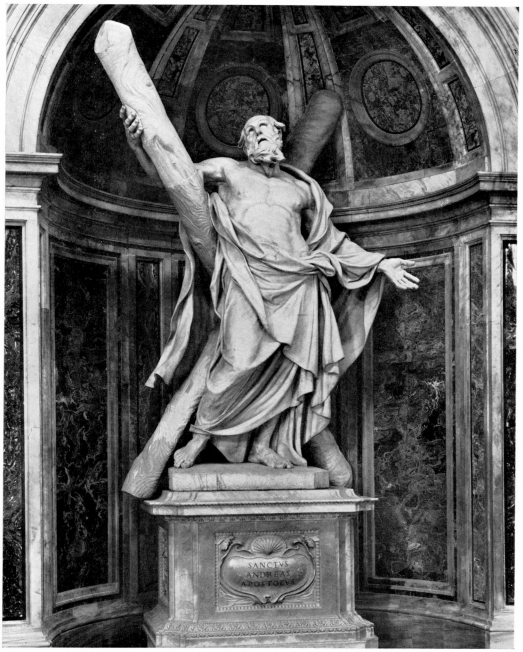

François du Quesnoy: St Andrew, 1633. *Rome, St Peter's*

(B) Artus I Quellin: Madonna Araceli, c.1645.
Brussels Cathedral

(A) François and Hieronymus II du Quesnoy: Monument of
Bishop Anton Triest, c.1640–54. *Ghent Cathedral*

14

(B) Artus I Quellin: Caryatids and relief, 1652. *Amsterdam Town Hall, Hall of Justice*

(A) Artus I Quellin: Prudence, 1652. *Amsterdam Town Hall, Hall of Justice*

15

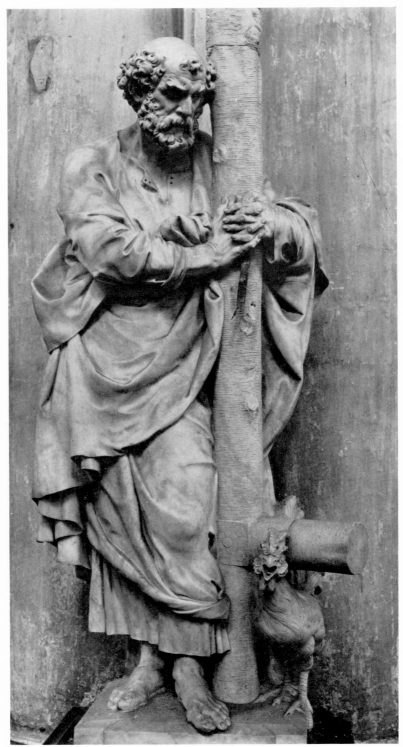

Artus I Quellin: St Peter, 1658. *Antwerp, St Andreaskerk*

16

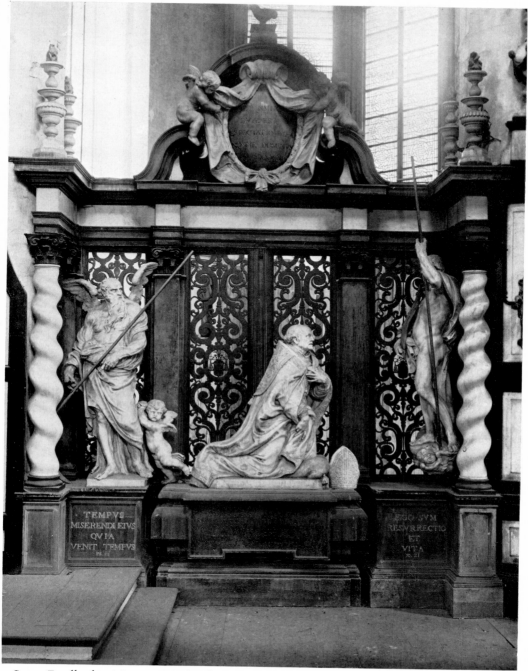

Lucas Faydherbe: Monument of Bishop Andreas Cruesen, begun *c.*1660. *Malines Cathedral*

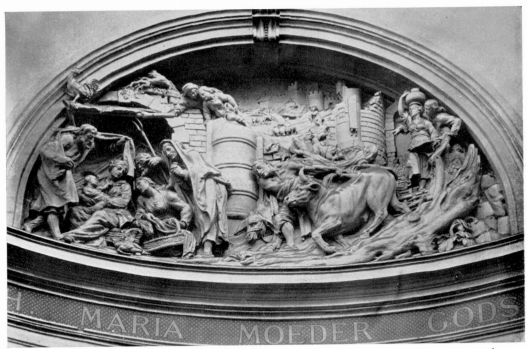

(A) Lucas Faydherbe: The Nativity, 1677. *Malines, Onze Lieve Vrouwe van Hanswijk*

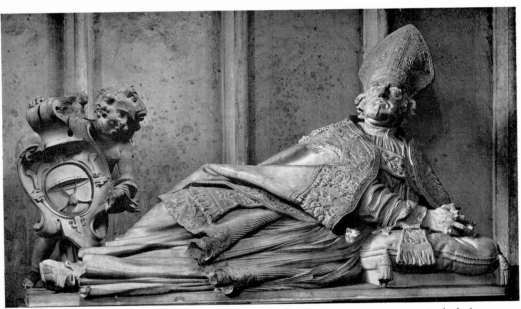

(B) Artus II Quellin: Monument of Bishop Capello, 1676. *Antwerp Cathedral*

(A) Rombout Verhulst: Monument of Admiral de Ruyter, 1681. *Amsterdam, Nieuwe Kerk*

(B) Rombout Verhulst: Monument of Willem van Lyere, 1663. *Katwijk, Reformed Church*

Artus II Quellin: God the Father, 1682. *Bruges Cathedral, rood screen*

Jean Delcour: Monument to Bishop d'Allamont, begun 1667. *Ghent Cathedral*

21

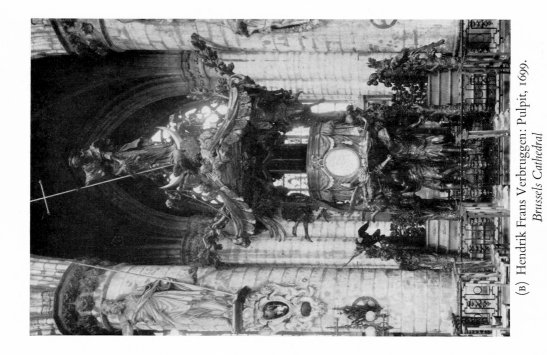

(B) Hendrik Frans Verbruggen: Pulpit, 1699.
Brussels Cathedral

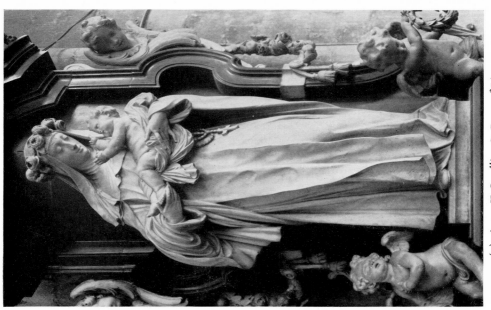

(A) Artus II Quellin: St Rose of Lima.
Antwerp, St Pauluskerk

22

(A) and (B) Hendrik Frans Verbruggen: Pulpit, 1699. Details. *Brussels Cathedral*

23

Michel Vervoort: Pulpit, 1721. *Malines Cathedral*

Theodoor Verhaegen: Pulpit, 1743. *Malines, Onze Lieve Vrouwe van Hanswijk*

Michel Vervoort: Monument of Bishop de Precipiano, 1709. *Malines Cathedral*

Michel Vervoort: Monument of Bishop de Precipiano, 1709. Detail. *Malines Cathedral*

(A) Denis Plumier: Monument of Spinola, 1715. *Brussels, Notre-Dame-de-la-Chapelle*

CHRISTO SEPVLTO WALTHERVS DE LIVERLO ET MARIA DOGIER CONIVGES POSVERE A° 1696

(B) Jean Delcour: Dead Christ, 1696. *Liège Cathedral*

Gabriel Grupello: Fountain for the House of the Fishmongers, 1675. *Brussels, Museum*

Maerten de Vos: Jonah thrown Overboard, 1589. *Formerly Berlin, Staatliche Museen*

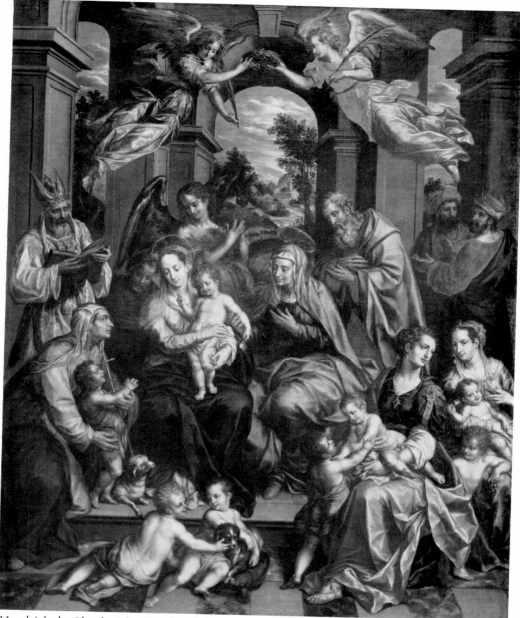

Hendrick de Clerck: The Family of the Virgin, 1590. *Brussels, Musées Royaux des Beaux-Arts*

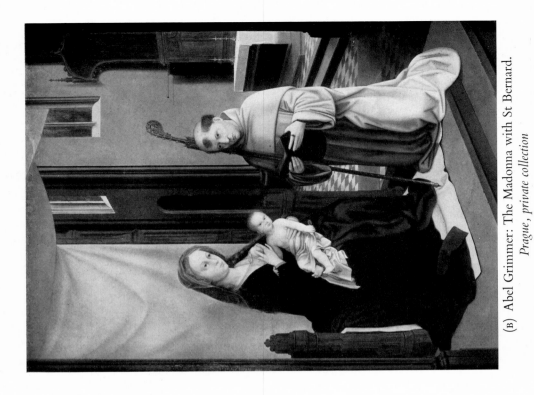

(B) Abel Grimmer: The Madonna with St Bernard.
Prague, private collection

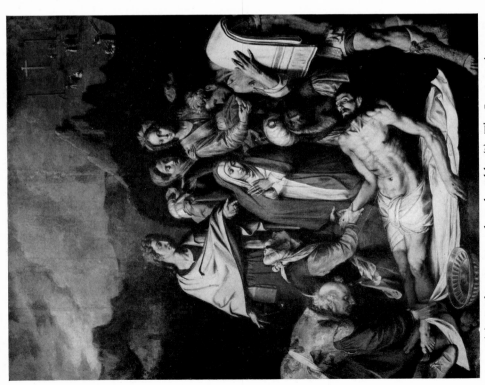

(A) Ambrosius Francken the Elder(?): The Lamentation.
Antwerp, Musée Royal des Beaux-Arts

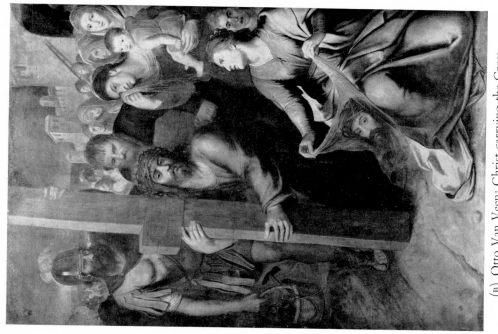

(B) Otto Van Veen: Christ carrying the Cross.
Brussels, Musées Royaux des Beaux-Arts

(A) Otto van Veen: The Mystic Marriage of St Catherine, 1589.
Brussels, Musées Royaux des Beaux-Arts

33

Otto van Veen: Triumph of the Catholic Church. *Munich, Bayerische Staatsgemäldesammlungen*

34

Abraham Janssens: Diana and Callisto, 1601. *Budapest, Museum of Fine Arts*

(A) Abraham Janssens: The Lamentation. *Malines, St Janskerk*

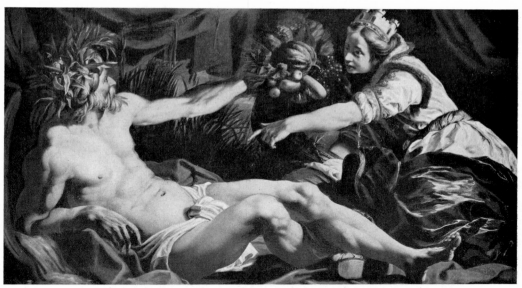

(B) Abraham Janssens: Scaldis and Antwerpia, 1609. *Antwerp, Musée Royal des Beaux-Arts*

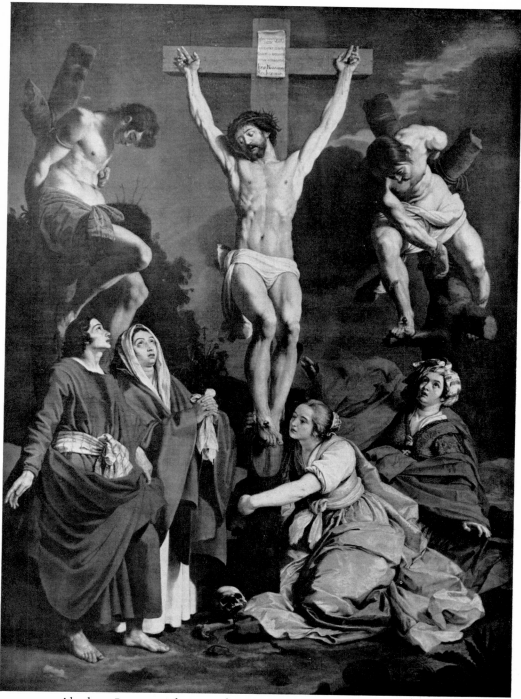

Abraham Janssens: The Crucifixion. *Valenciennes, Musée des Beaux-Arts*

(B) Adam van Noort: Pictura and Minerva, 1598. Pen and wash. *Rotterdam, Museum Boymans-van Beuningen*

(A) Adam van Noort: Adoration of the Shepherds. Pen and wash. *Antwerp, Museum Plantin Moretus*

38

MOESTA QUEROR, CIRCEN SCOPVLIS Ô BELGICA DVRIS
CONSTRINXISSE HVMEROS. AC RELIGASSE MANVS.
ET MEA REGNA NOVIS DIRARVM OCCVBERE MONSTRIS
IMMERITÒ, FER OPEM ET VINCLA RESOLVE PATER

(B) Jan Wierix, after Pieter Pourbus the Younger:
Infanta Isabella Clara Eugenia. Engraving

INACHIDES EN ALTER ERO, QVI VINDICE DEXTRA
LIBERET ANDROMEDAM, MONSTRAQVE FIGAT HVMO.
SIQVA TROPHÆA MANENT VICTOREM PERSIA, ET HYDRAM
STERNERE. BATT'AVAM GLORIA MAIOR ERIT

(A) Jan Wierix, after Pieter Pourbus the Younger:
Archduke Albert of Austria. Engraving

39

Otto van Veen: Cornelis van Veen with his Family, 1584. *Paris, Louvre*

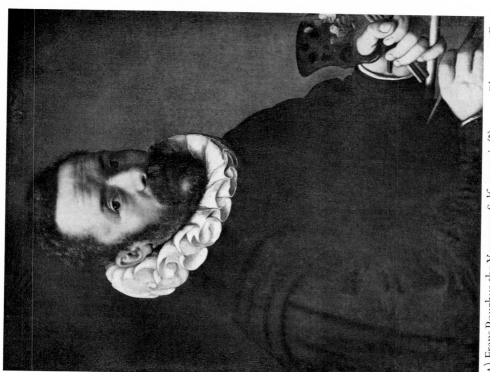

(A) Frans Pourbus the Younger: Self-portrait (?), 1591. *Florence, Uffizi*

(B) Abraham Janssens: Nero, 1618. *Berlin, Schloss Grunewald*

(A) Pieter Brueghel the Younger: The Crucifixion, 1615.
Antwerp, Comte de Buisseret

(B) Pieter Brueghel the Younger: Village Festival, 1632.
Cambridge, Fitzwilliam Museum

(A) Jan Brueghel: Allegory of the Fire. *Rome, Galleria Doria Pamphili*

(B) Jan Brueghel: The Continence of Scipio, 1609.
Munich, Bayerische Staatsgemäldesammlungen

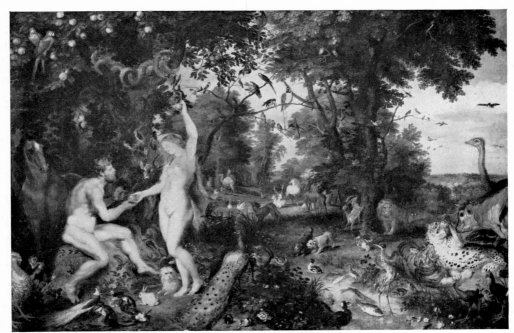

(A) Peter Paul Rubens and Jan Brueghel: Paradise. *The Hague, Mauritshuis*

(B) Jan Brueghel: Flowers and Fruit. *London, Dr Ludwig Burchard*

44

Peter Paul Rubens and Jan Brueghel: Madonna and Child in a Garland of Flowers.
Madrid, Prado

(A) Jan Brueghel: Village Street, 1605. *London, Sir Francis Glyn*

(B) Jan Brueghel: The Wood, 1607. *Warwick Castle, the Earl of Warwick*

(A) Abraham Govaerts: Landscape with Fishermen. *Budapest, Museum of Fine Arts*

(B) Sebastiaen Vranx: The Cavalry fighting near Bois-le-Duc.
Kassel, Staatliche Gemäldegalerie

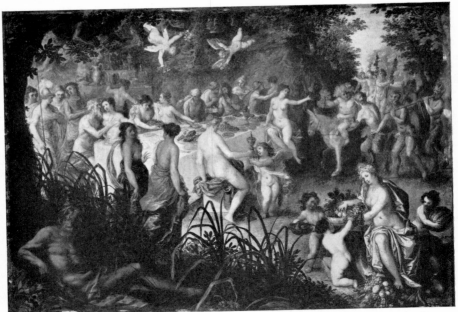

(A) Hendrik van Balen: Marriage of Peleus and Thetis, 1608.
Dresden, Gemäldegalerie

(B) Frans Francken the Younger: Witches' Sabbath, 1607.
Vienna, Kunsthistorisches Museum

(A) Frans Francken the Younger: The Jews having crossed the Red Sea, 1621.
Hamburg, Kunsthalle

(B) Frans Francken the Younger: The Taking of Christ, 1630.
Paris, Service de Récupération

(A) Jodocus de Momper: The Alps. *Kassel, Staatliche Gemäldegalerie*

(B) Jodocus de Momper: The Flight into Egypt. *Oxford, Ashmolean Museum*

(A) Kerstiaen de Keuninck: Tobias and the Angel in a Landscape.
Karlsruhe, Staatliche Kunsthalle

(B) Kerstiaen de Keuninck: Landscape. *London, Dr E. Schapiro*

(A) Antoine Mirou: The Hunters, 1611. *Prague, Národní Galerie*

(B) Adriaen van Stalbemt: The Drunkenness of Bacchus. *Château d'Anzegem, Count Philippe de Limburg Stirum*

(A) Abel Grimmer and Hendrik van Balen: View of Antwerp, 1600.
Antwerp, Musée Royal des Beaux-Arts

(B) Denis van Alsloot: Festival at the Abbey de la Cambre, 1616.
Madrid, Prado

(A) Hans Vredeman de Vries: Fantastic Architecture, 1596.
Vienna, Kunsthistorisches Museum

(B) Pieter Neefs the Elder: A Gothic Church, 1605. *Dresden, Gemäldegalerie*

(A) Hendrik van Steenwijck the Elder: Market Place at Aachen, 1598.
Brunswick, Herzog Anton Ulrich-Museum

(B) Louis de Caulery: Carnival. *Hamburg, Kunsthalle*

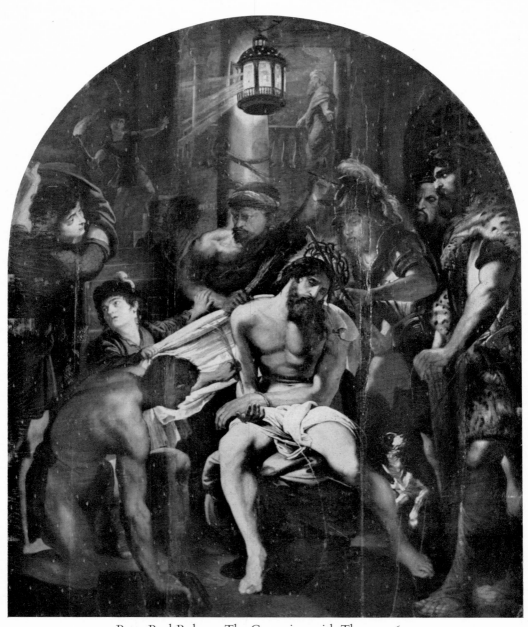

Peter Paul Rubens: The Crowning with Thorns, 1602.
Grasse, Hôpital du Petit-Paris

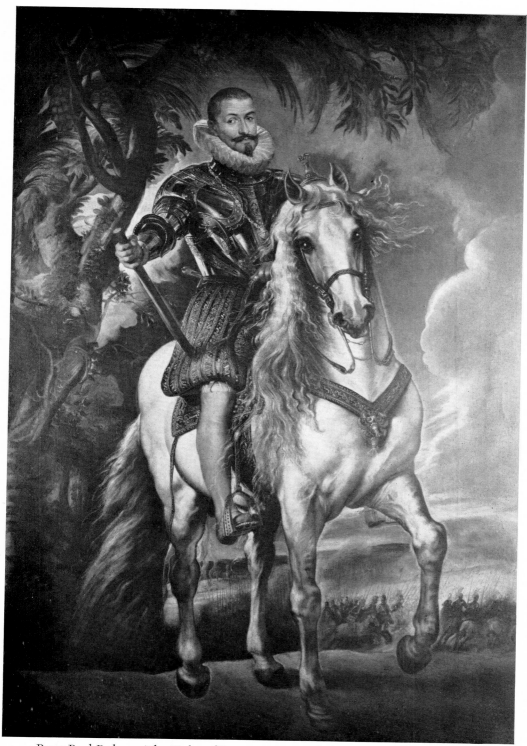

Peter Paul Rubens: The Duke of Lerma, 1603. *Madrid, PP. Capuchinos de Castilla*

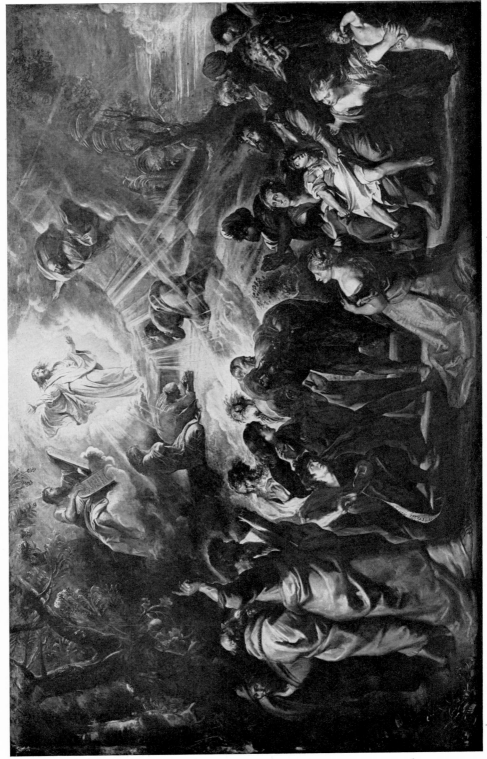

Peter Paul Rubens: The Transfiguration, 1604/6. *Nancy, Musée des Beaux-Arts*

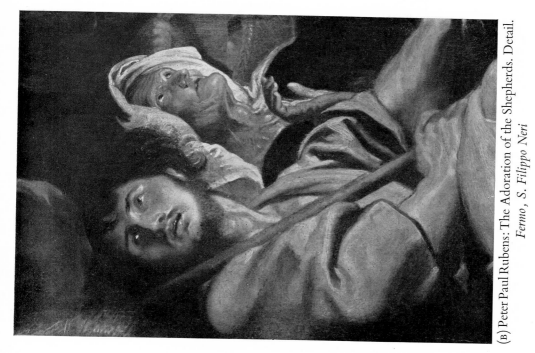

(B) Peter Paul Rubens: The Adoration of the Shepherds. Detail.
Fermo, S. Filippo Neri

(A) Peter Paul Rubens: The Adoration of the Shepherds.
Fermo, S. Filippo Neri

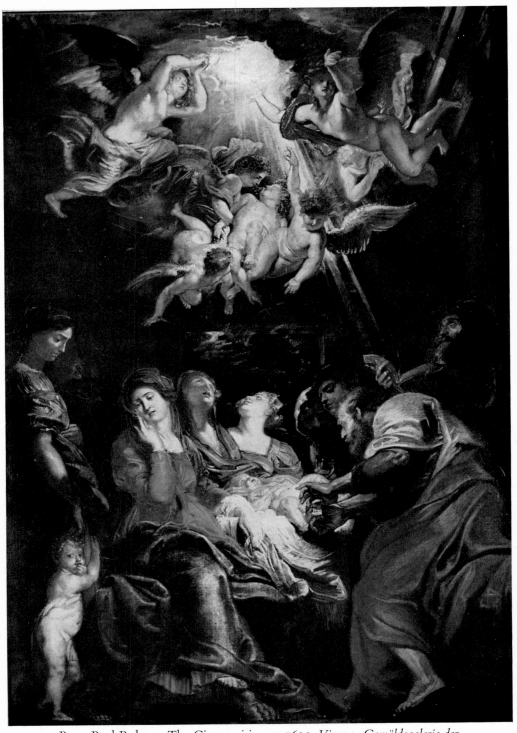

Peter Paul Rubens: The Circumcision, *c.* 1605. *Vienna, Gemäldegalerie der Akademie der bildenden Künste*

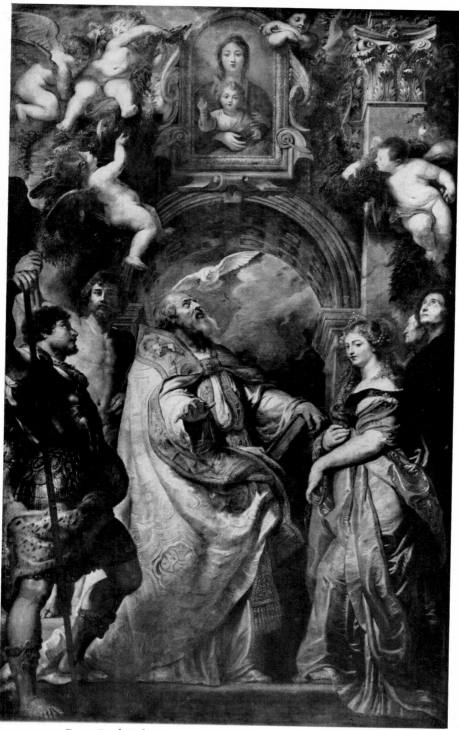

Peter Paul Rubens: St Gregory and St Domitilla, 1607/8.
Grenoble, Musée des Beaux-Arts

61

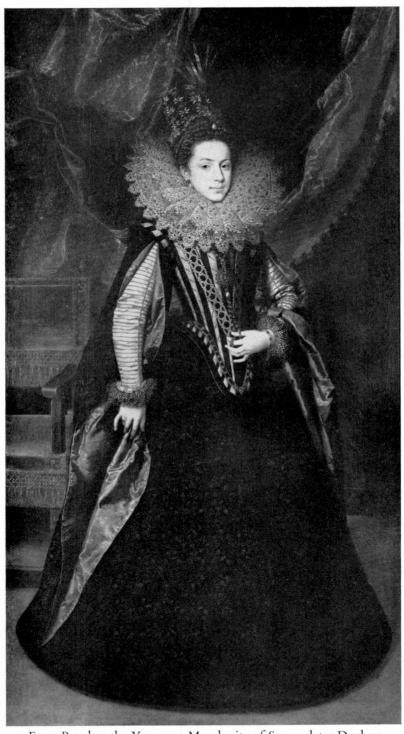

Frans Pourbus the Younger: Margherita of Savoy, later Duchess
of Mantua, *c.* 1606. *Rome, S. Carlo al Corso*

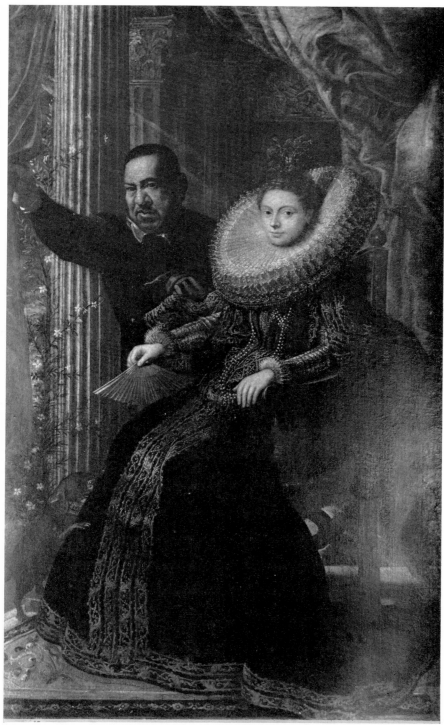

Peter Paul Rubens: Catharina Grimaldi, *c.* 1606. *Kingston Lacy, Ralph Bankes*

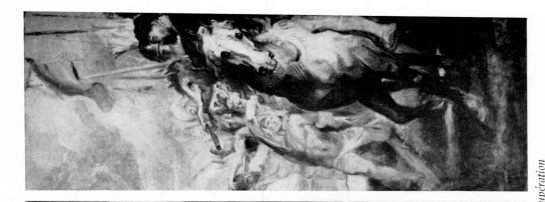

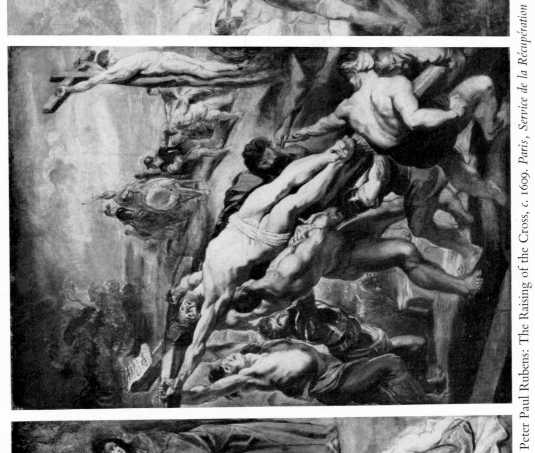

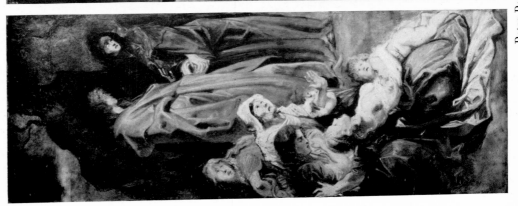

Peter Paul Rubens: The Raising of the Cross, *c. 1609. Paris, Service de la Récupération*

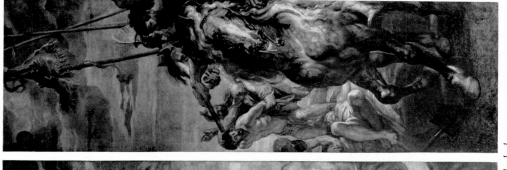

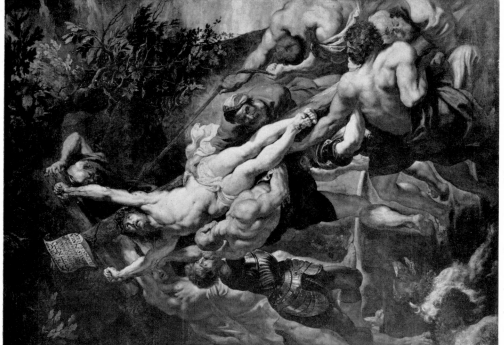

Peter Paul Rubens: The Raising of the Cross, 1609/10. *Antwerp Cathedral*

65

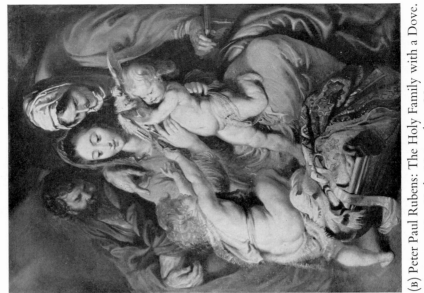

(B) Peter Paul Rubens: The Holy Family with a Dove.
New York, Metropolitan Museum

(A) Peter Paul Rubens: Samson and Delilah.
Cologne, Gottfried Neuerburg

66

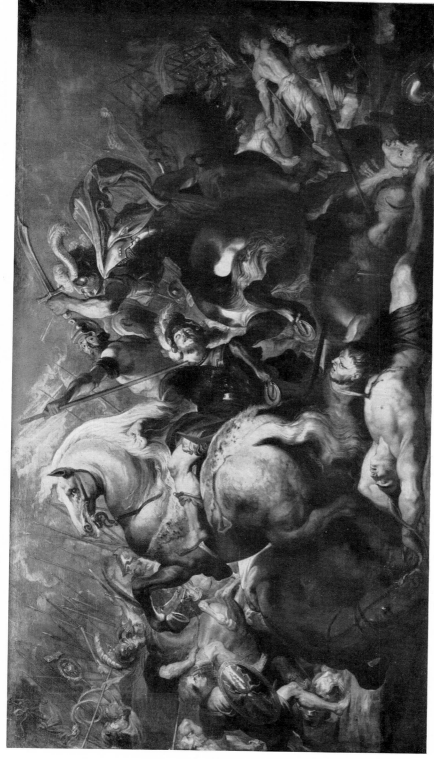

Peter Paul Rubens: The Death of Decius Mus. *Vaduz*, *H.R.H. the Prince of Liechtenstein*

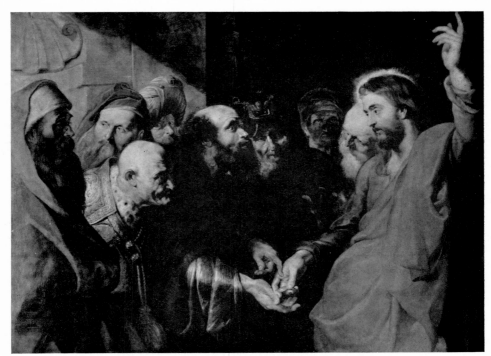

(A) Peter Paul Rubens: The Tribute Money. *San Francisco,*
M. H. de Young Memorial Museum

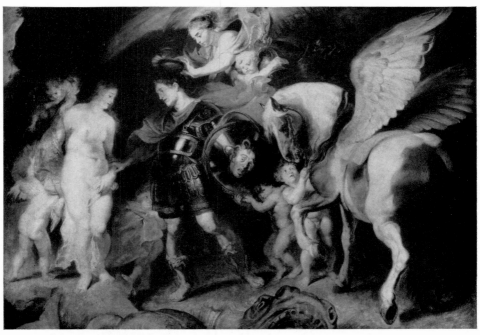

(B) Peter Paul Rubens: Perseus and Andromeda. *Leningrad, Hermitage*

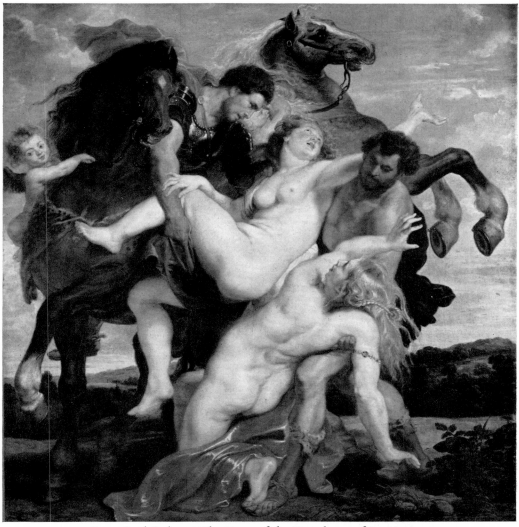

Peter Paul Rubens: The Rape of the Daughters of Leucippus.
Munich, Bayerische Staatsgemäldesammlungen

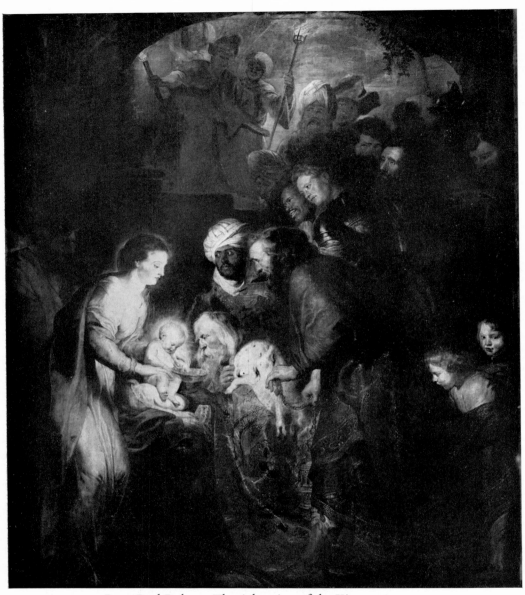

Peter Paul Rubens: The Adoration of the Kings, 1617–19.
Malines, St Janskerk

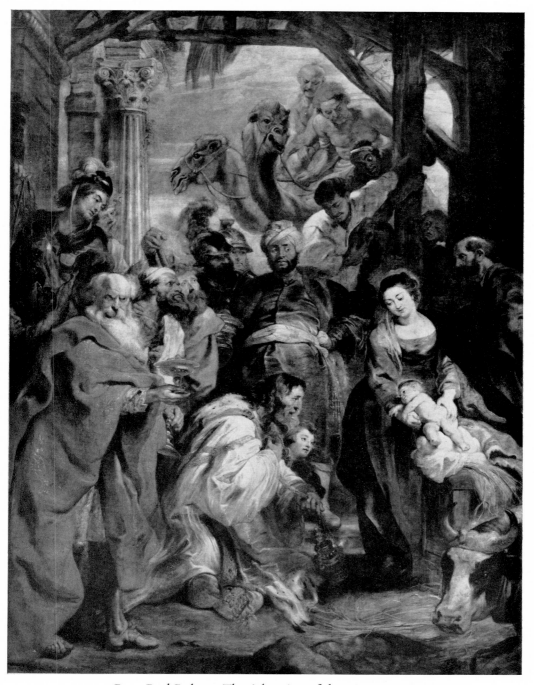

Peter Paul Rubens: The Adoration of the Kings, 1624.
Antwerp, Musée Royal des Beaux-Arts

(A) Peter Paul Rubens: Study of a naked Man lifting a heavy Object.
Black and white chalk. *Paris, Louvre*

(B) Peter Paul Rubens: Studies of Dancers. Black and red chalk.
Rotterdam, Museum Boymans-van Beuningen

Peter Paul Rubens: Study of a young Man and Woman. Black, white, and red chalk.
Amsterdam, Museum Fodor

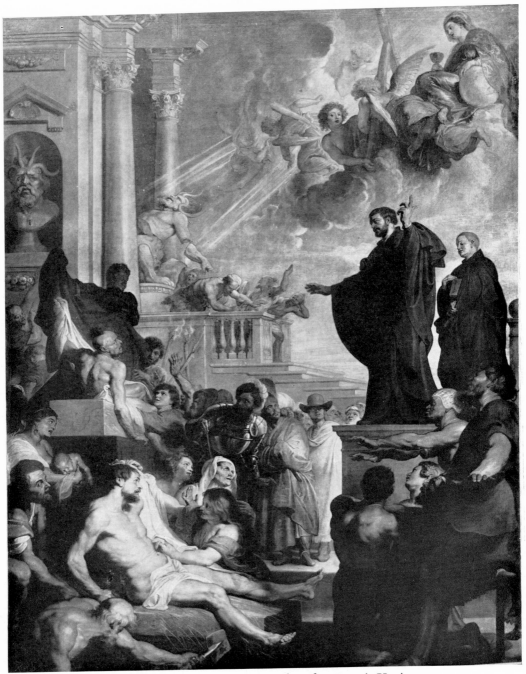

Peter Paul Rubens: The Miracles of St Francis Xavier.
Vienna, Kunsthistorisches Museum

Peter Paul Rubens: The Last Communion of St Francis, 1619.
Antwerp, Musée Royal des Beaux-Arts

75

(A) Peter Paul Rubens: The Expulsion from Paradise. *Prague, Národní Galerie*

(B) Peter Paul Rubens: Elijah carried up to Heaven, *New York, Curtis O. Baer*

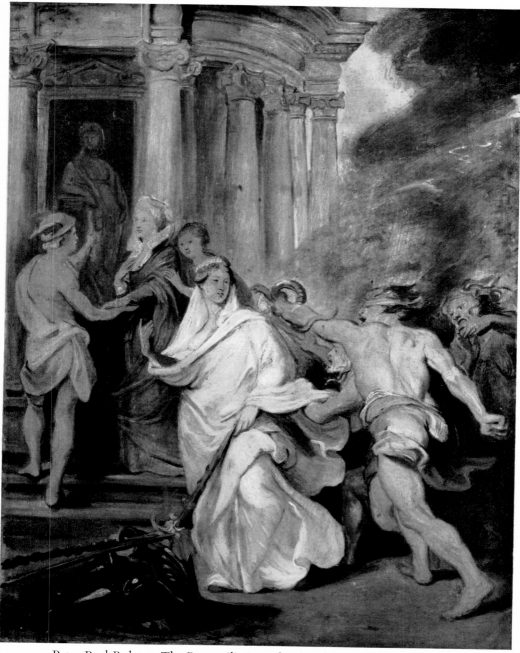

Peter Paul Rubens: The Reconciliation of Marie de' Medici with her Son.
Munich, Bayerische Staatsgemäldesammlungen

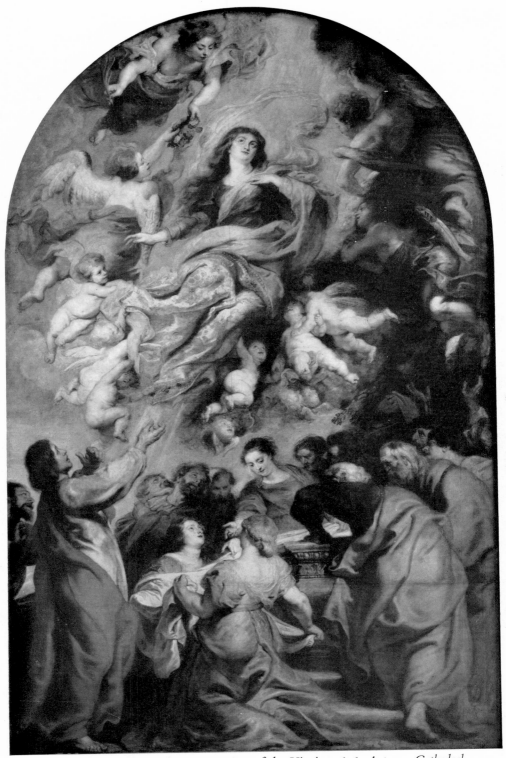

Peter Paul Rubens: The Assumption of the Virgin, 1626. *Antwerp Cathedral*

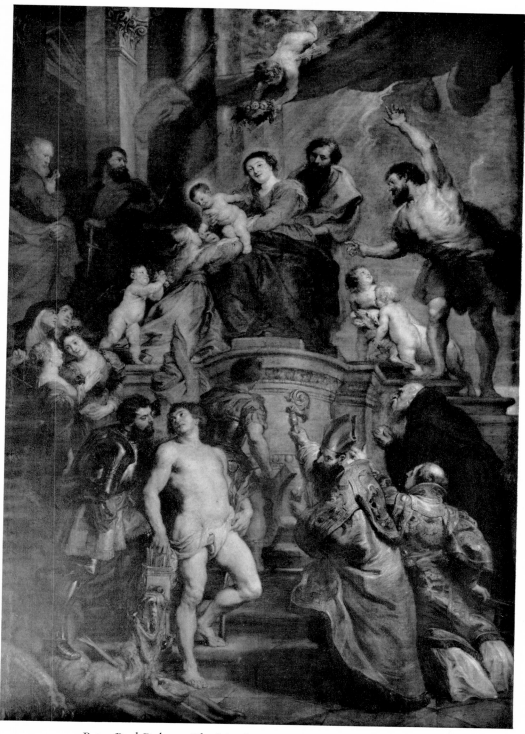

Peter Paul Rubens: The Mystic Marriage of St Catherine, 1628.
Antwerp, Augustijnenkerk

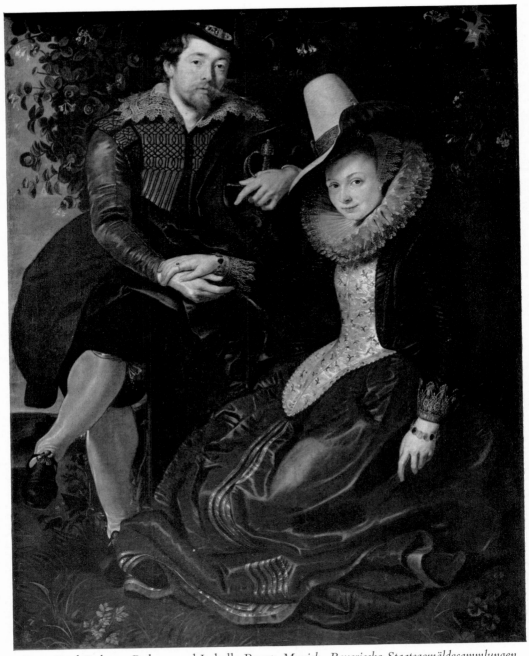

Peter Paul Rubens: Rubens and Isabella Brant. *Munich, Bayerische Staatsgemäldesammlungen*

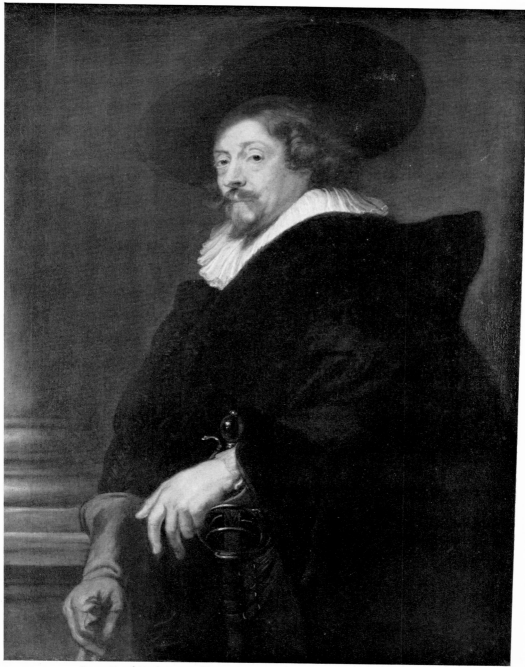

Peter Paul Rubens: Self-portrait. *Vienna, Kunsthistorisches Museum*

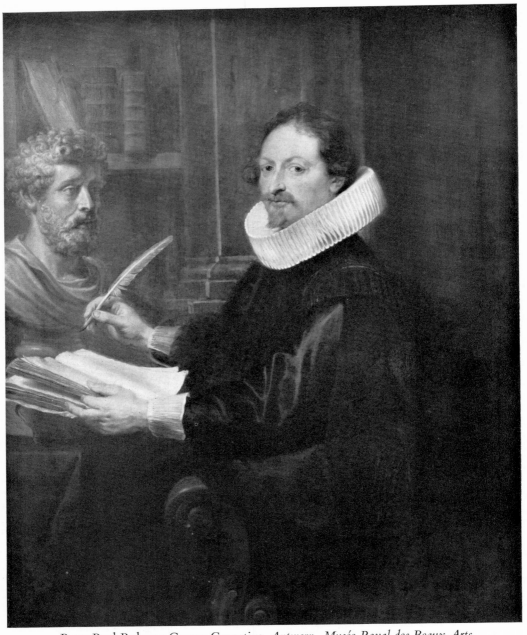

Peter Paul Rubens: Caspar Gevartius. *Antwerp, Musée Royal des Beaux-Arts*

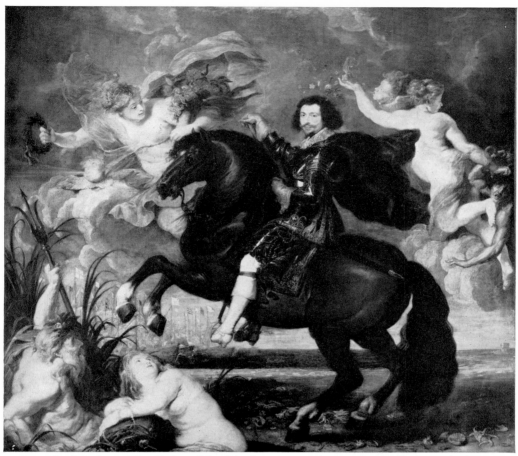

Peter Paul Rubens: The Duke of Buckingham. *Formerly Osterley Park, the Earl of Jersey (destroyed in the Second World War)*

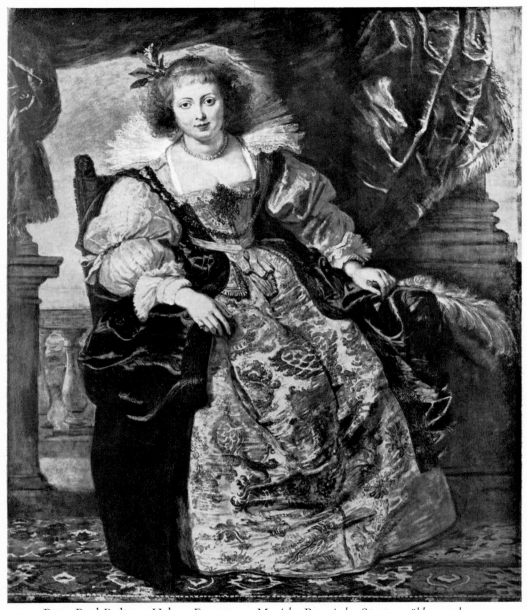

Peter Paul Rubens: Helena Fourment. *Munich, Bayerische Staatsgemäldesammlungen*

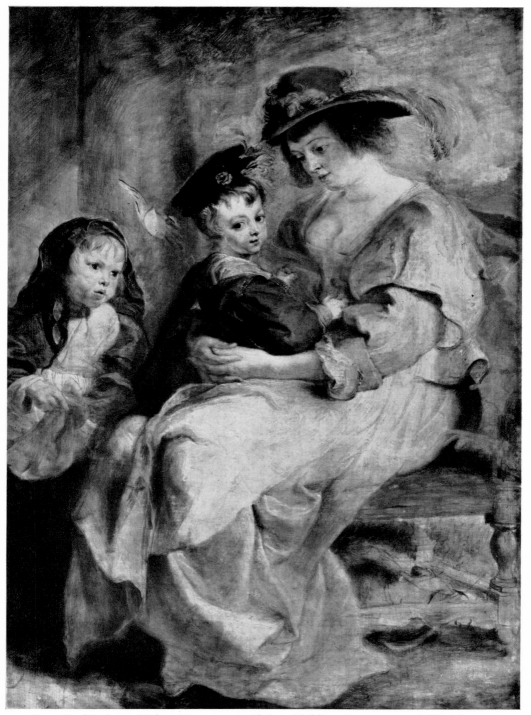

Peter Paul Rubens: Helena Fourment with her Children Franciscus and Clara-Joanna.
Paris, Louvre

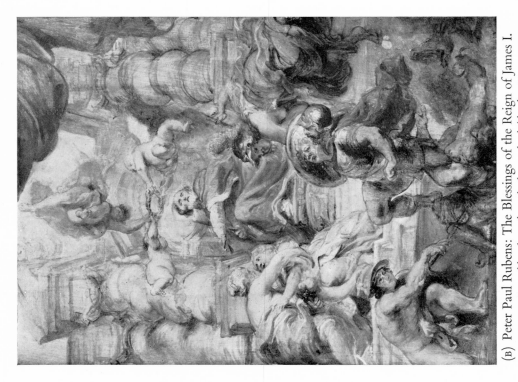

(B) Peter Paul Rubens: The Blessings of the Reign of James I. *Vienna, Gemäldegalerie der Akademie der bildenden Künste*

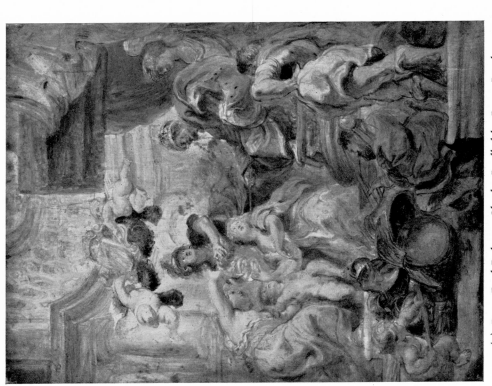

(A) Peter Paul Rubens: Charles I called by James I to be King of Scotland, *c.* 1634. *Leningrad, Hermitage*

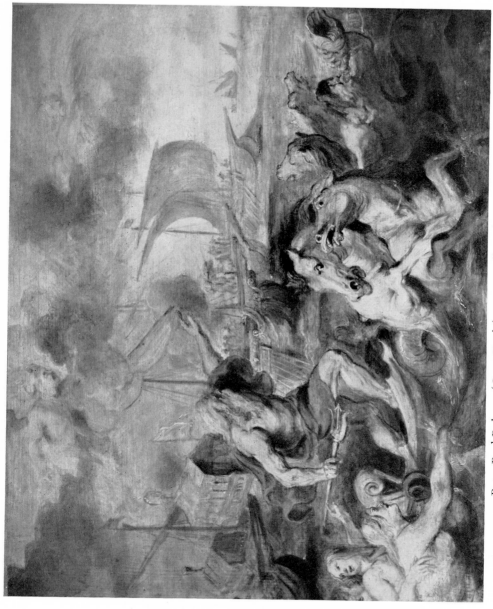

Peter Paul Rubens: 'Quos Ego' (Neptune stilling the Tempest), 1634/5. Cambridge, Massachusetts, Fogg Art Museum

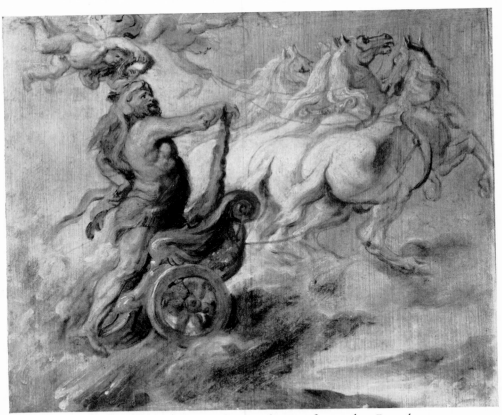

(A) Peter Paul Rubens: The Apotheosis of Hercules. *Brussels,*
Musées Royaux des Beaux-Arts

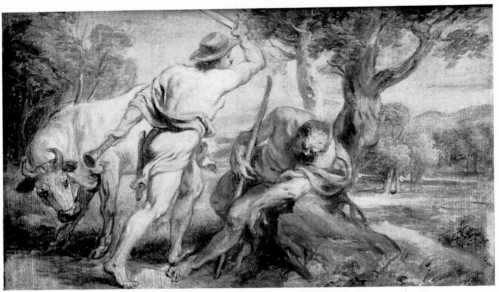

(B) Peter Paul Rubens: Mercury and Argus. *Brussels, Musées Royaux des Beaux-Arts*

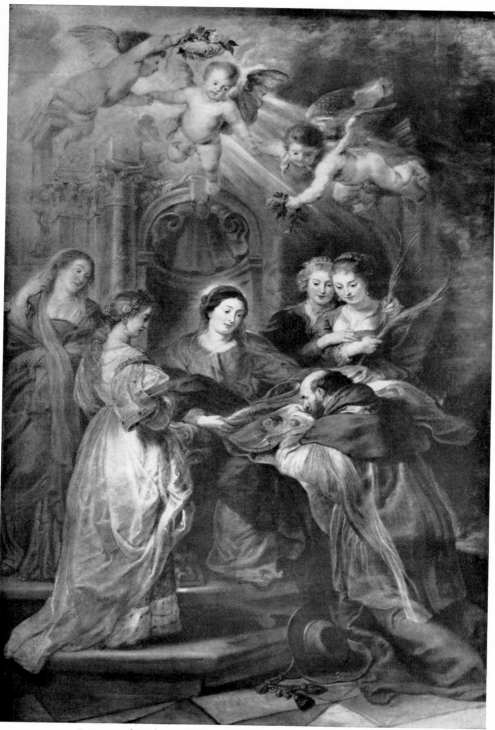

Peter Paul Rubens: Triptych of St Ildefonso (central panel).
Vienna, Kunsthistorisches Museum

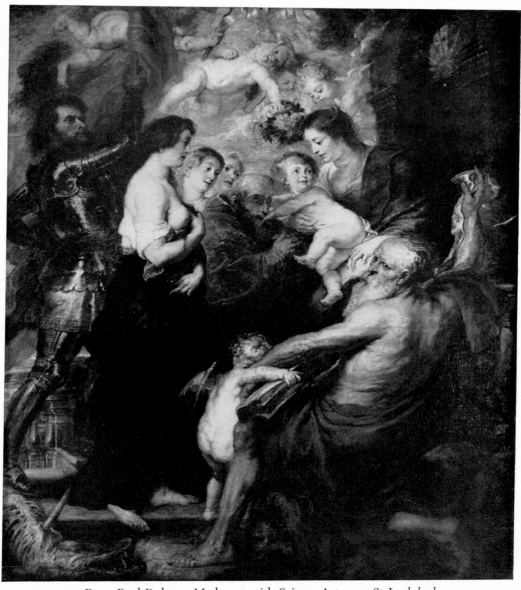

Peter Paul Rubens: Madonna with Saints. *Antwerp, St Jacobskerk*

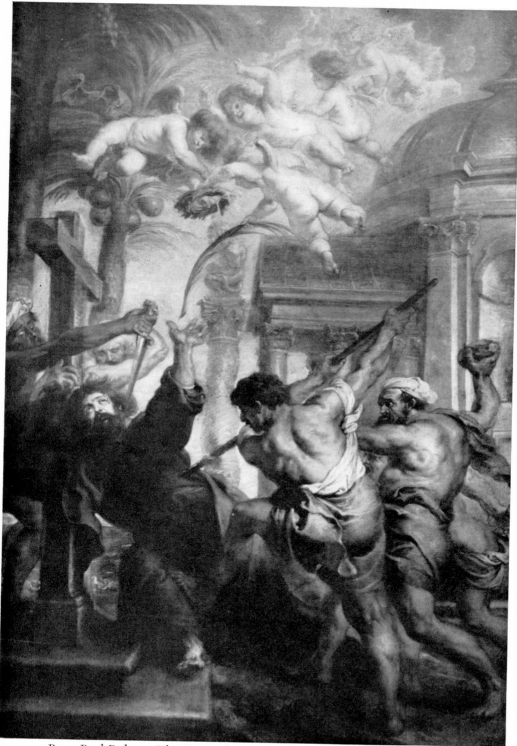

Peter Paul Rubens: The Martyrdom of St Thomas. *Prague, Národní Galerie*

91

Peter Paul Rubens: The Rape of the Sabines. *London, National Gallery*

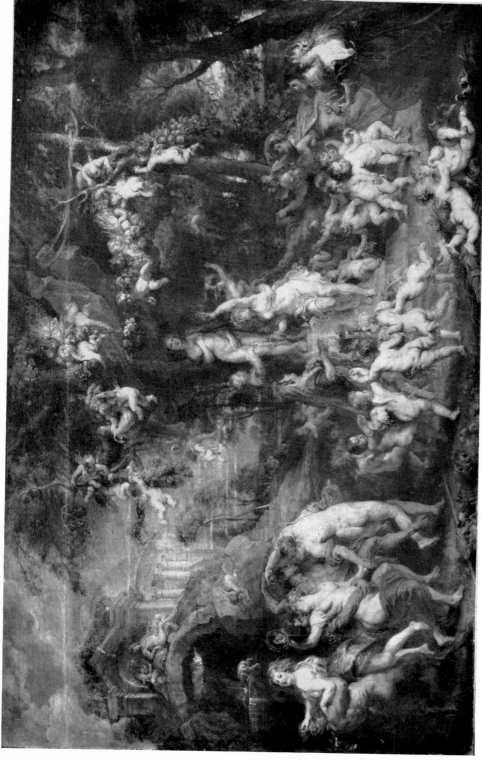

Peter Paul Rubens: The Feast of Venus. *Vienna, Kunsthistorisches Museum*

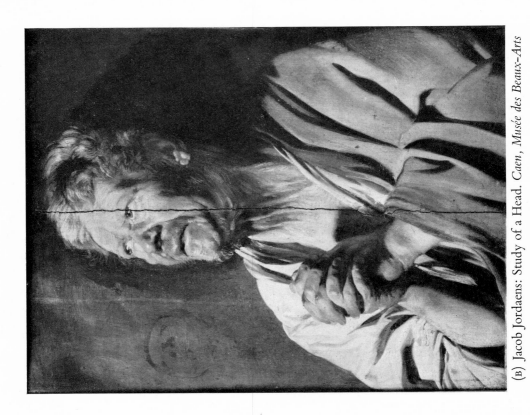

(B) Jacob Jordaens: Study of a Head. *Caen, Musée des Beaux-Arts*

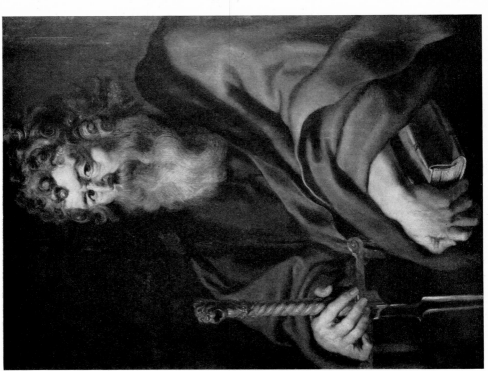

(A) Peter Paul Rubens: St Paul. *Madrid, Prado*

94

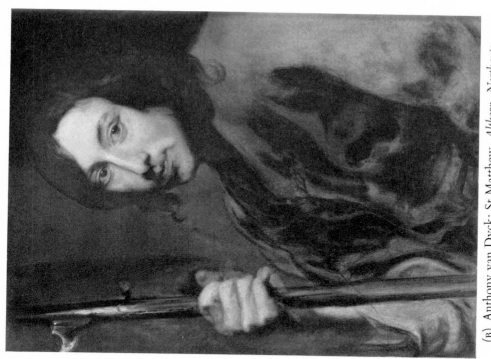

(B) Anthony van Dyck: St Matthew. *Althorp, Northants,
the Earl Spencer*

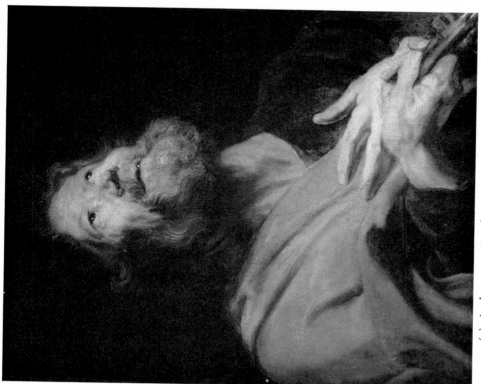

(A) Anthony van Dyck: St Peter. *Leningrad, Hermitage*

95

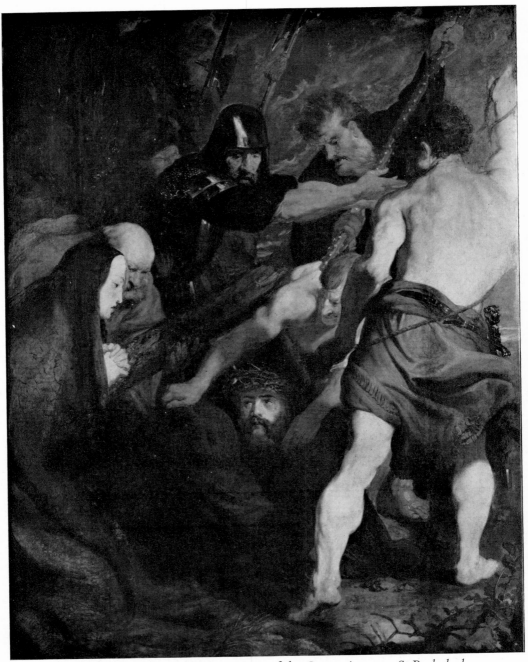

Anthony van Dyck: The Carrying of the Cross. *Antwerp, St Pauluskerk*

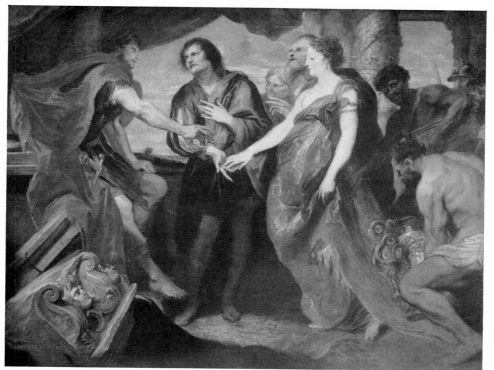

(A) Anthony van Dyck: The Continence of Scipio. *Oxford, Christ Church Library*

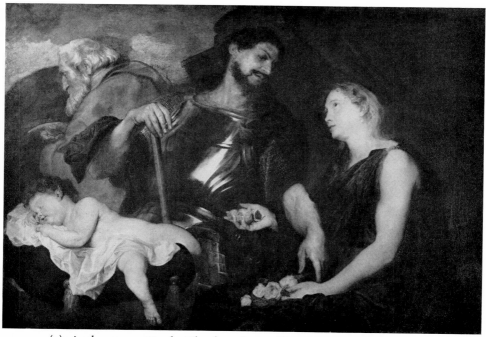

(B) Anthony van Dyck: The four Ages of Man. *Vicenza, Museo Civico*

97

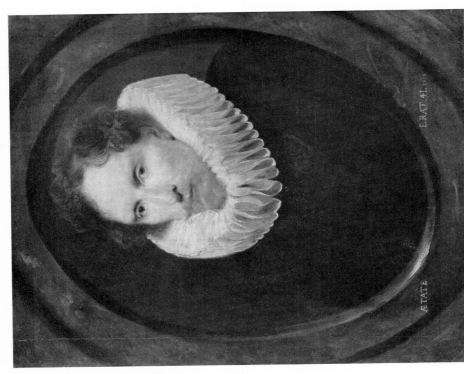

(B) Anthony van Dyck: A forty-one-year-old Man, 1619.
Brussels, Musées Royaux des Beaux-Arts

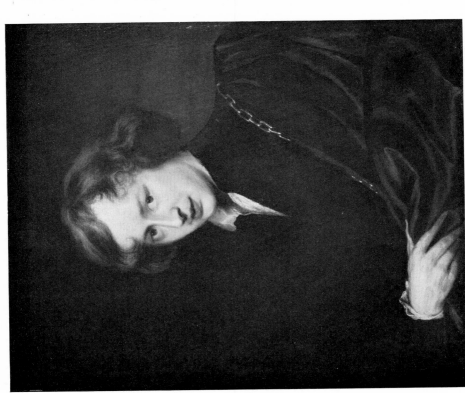

(A) Anthony van Dyck: Self-portrait. *Munich,*
Bayerische Staatsgemäldesammlungen

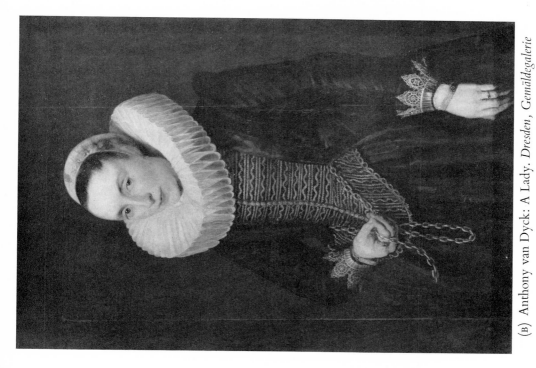

(B) Anthony van Dyck: A Lady. *Dresden, Gemäldegalerie*

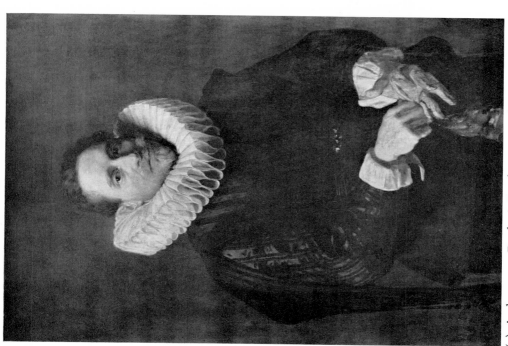

(A) Anthony van Dyck: A Gentleman. *Dresden, Gemäldegalerie*

99

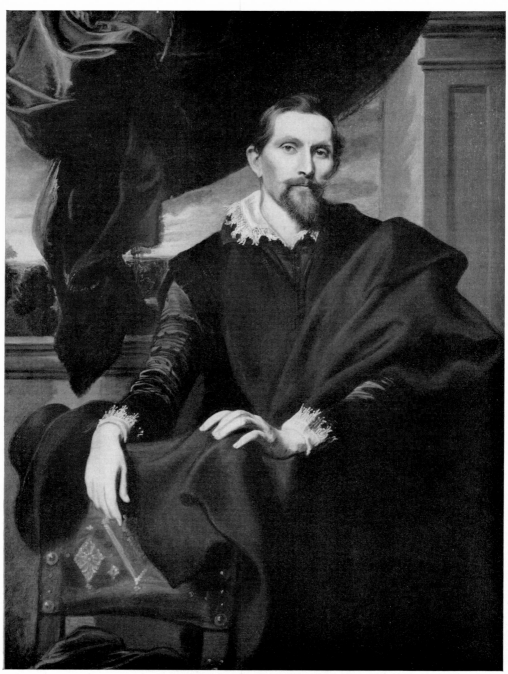

Anthony van Dyck: Frans Snyders.
New York, The Frick Collection

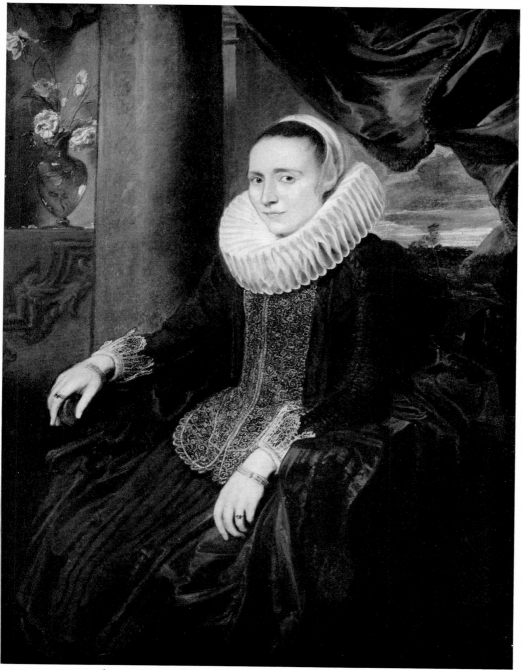

Anthony van Dyck: Margaretha de Vos, wife of Frans Snyders.
New York, The Frick Collection

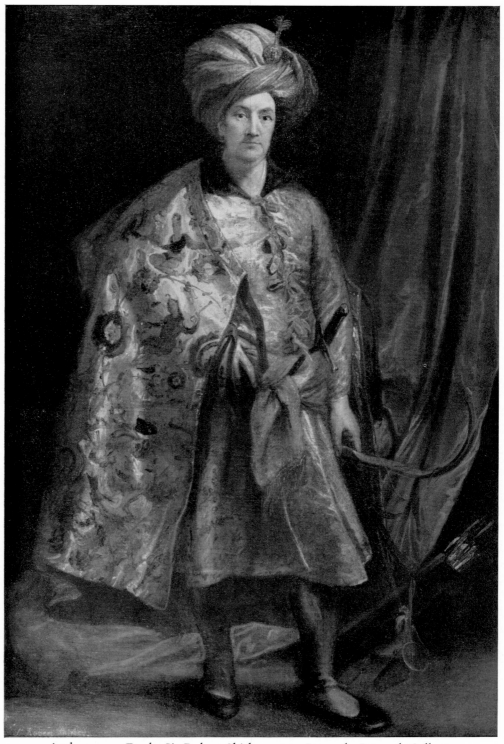

Anthony van Dyck: Sir Robert Shirley, 1622. *Petworth, Petworth Collection*

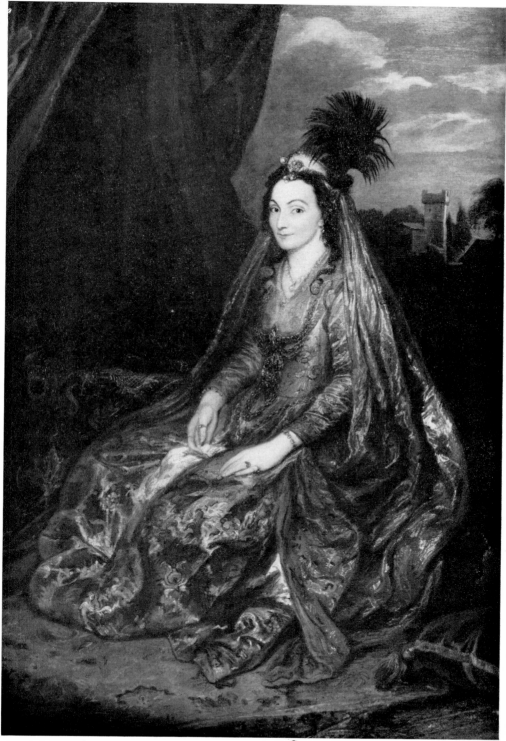

Anthony van Dyck: Lady Shirley, 1622. *Petworth, Petworth Collection*

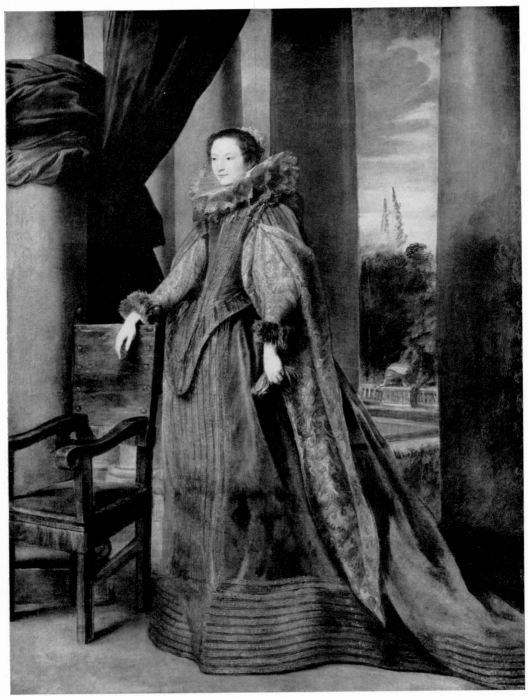

Anthony van Dyck: Marchesa Doria. *Paris, Louvre*

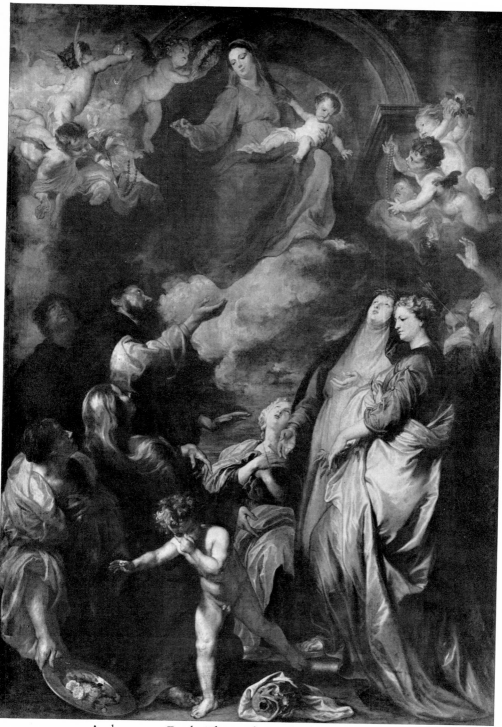

Anthony van Dyck: The Madonna del Rosario. *Palermo,*
Congregazione della Madonna del Rosario

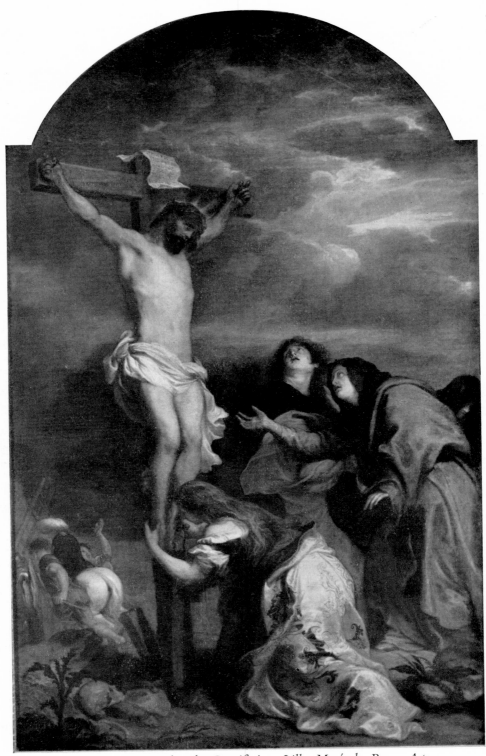

Anthony van Dyck: The Crucifixion. *Lille, Musée des Beaux-Arts*

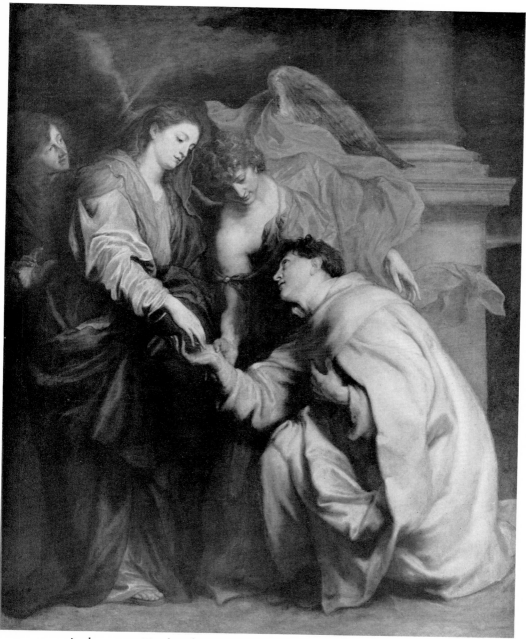

Anthony van Dyck: The Vision of the Blessed Herman Joseph, 1630.
Vienna, Kunsthistorisches Museum

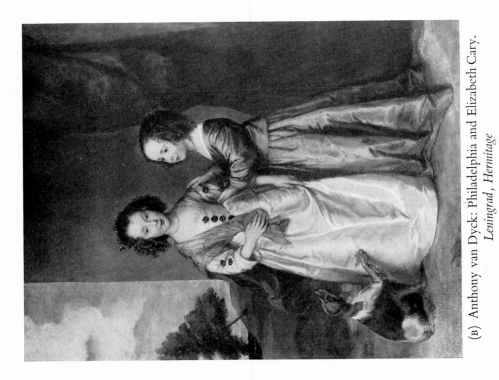

(B) Anthony van Dyck: Philadelphia and Elizabeth Cary.
Leningrad, Hermitage

(A) Anthony van Dyck: Quinten Simons.
The Hague, Mauritshuis

(B) Anthony van Dyck: Eberhard Jabach.
Leningrad, Hermitage

(A) Anthony van Dyck: Sir John Borlase.
Kingston Lacy, Ralph Bankes

(A) Anthony van Dyck: The Ypres Tower at Rye, Sussex. Pen drawing.
London, Sir Bruce Ingram

(B) Anthony van Dyck: Landscape. Water and body colour with pen.
Birmingham, Barber Institute of Fine Arts

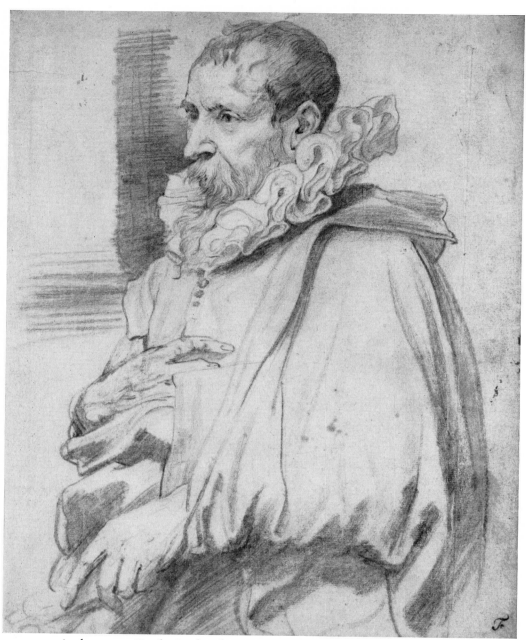

Anthony van Dyck: Study of Pieter Brueghel the Younger. Black chalk.
Chatsworth, Devonshire Collection

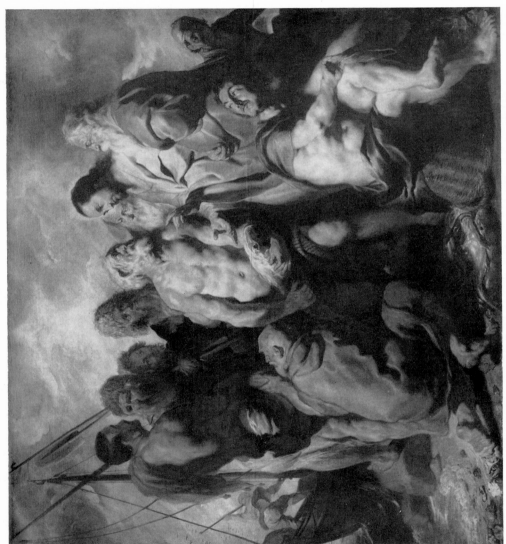

Jacob Jordaens: Christ by the Sea of Tiberias. *Antwerp, St Jacobskerk*

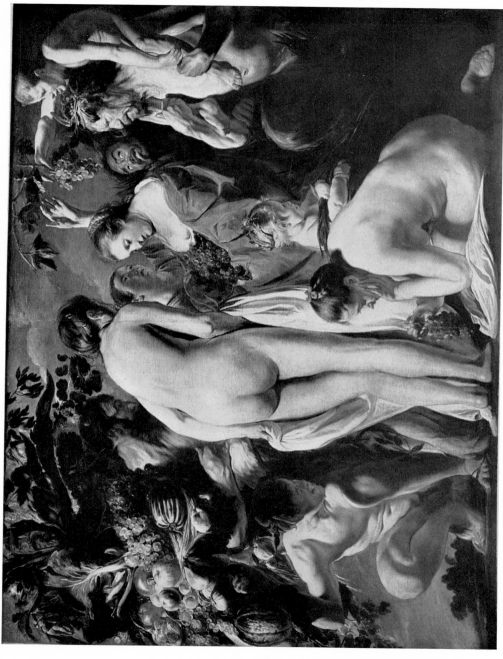

Jacob Jordaens: Allegory of Fertility. *Brussels, Musées Royaux des Beaux-Arts*

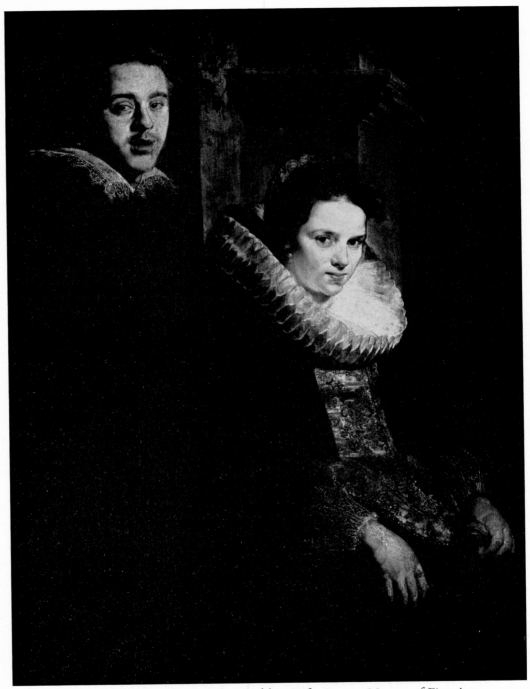

Jacob Jordaens: Unknown Man and his Wife. *Boston, Museum of Fine Arts*

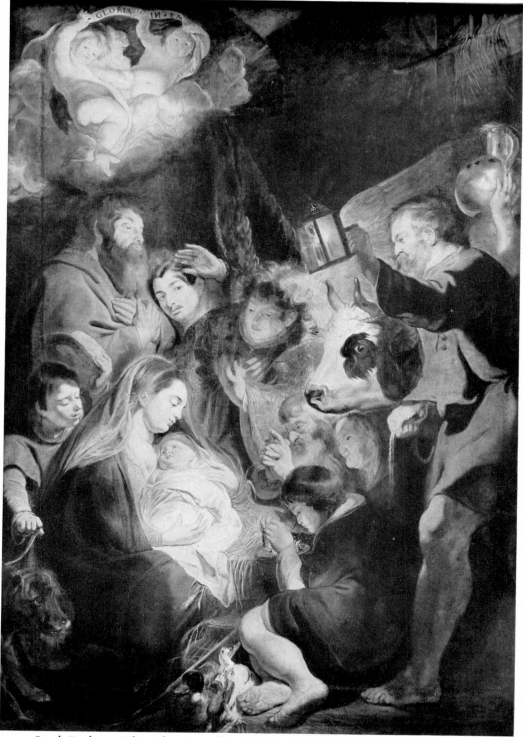

Jacob Jordaens: The Adoration of the Shepherds. *Grenoble, Musée des Beaux-Arts*

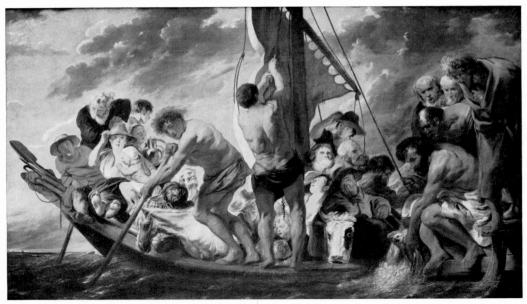

(A) Jacob Jordaens: 'Le Bac à Anvers' (St Peter finding a Stater in the Fish's Mouth).
Copenhagen, Statens Museum for Kunst

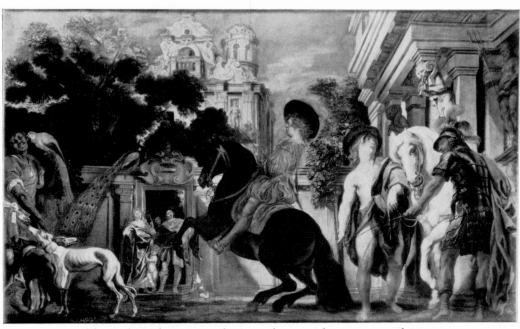

(B) Jacob Jordaens: A Riding Academy with Mercury and Mars.
Northwick Park, E. G. Spencer Churchill

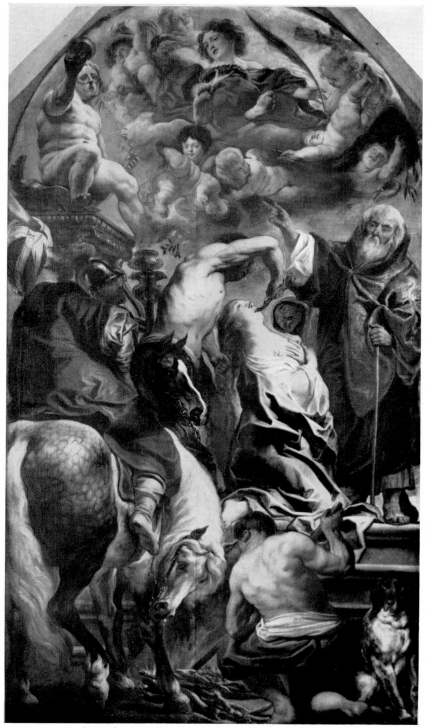

Jacob Jordaens: The Martyrdom of St Apollonia, 1628.
Antwerp, Augustijnenkerk

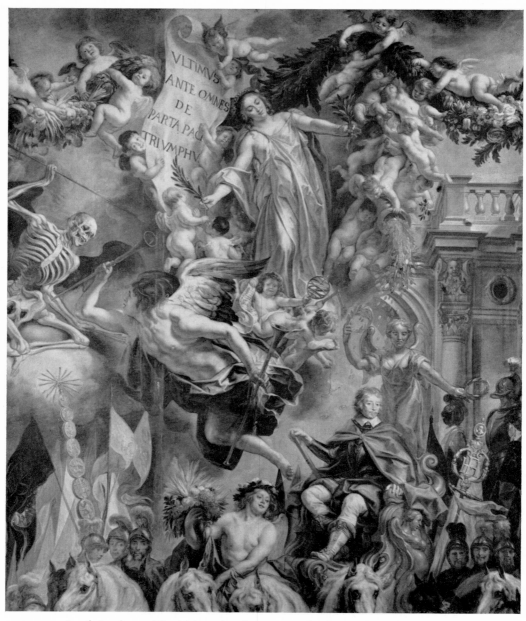

The text on the banner reads:

VLTIMVS
ANTE OMNES
DE
PARTA PAC
TRIVMPHV

Jacob Jordaens: The Triumph of Prince Frederik Hendrik, 1652. Detail.
The Hague, Huis ten Bosch

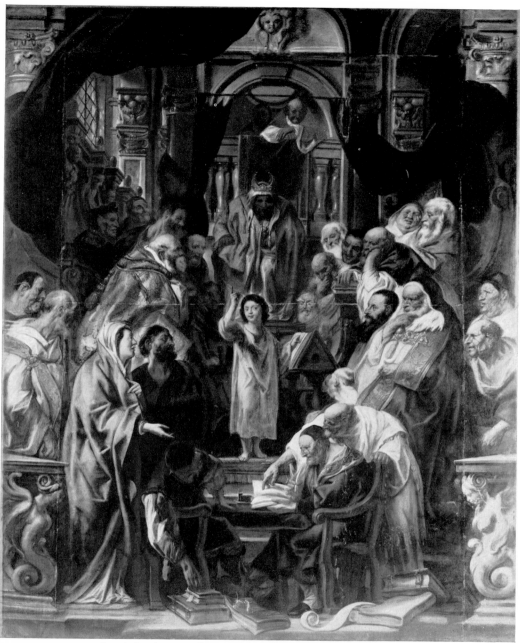

Jacob Jordaens: Christ among the Doctors, 1663. *Mainz,*
Altertumsmuseum und Gemäldegalerie

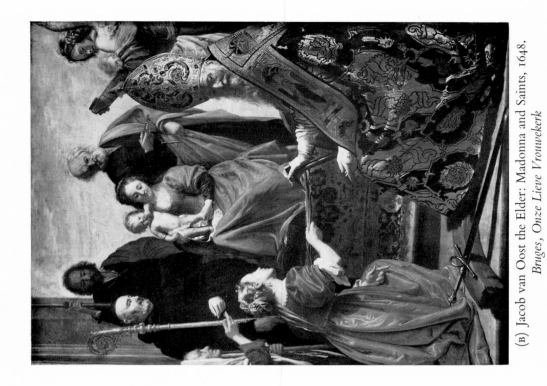

(B) Jacob van Oost the Elder: Madonna and Saints, 1648.
Bruges, Onze Lieve Vrouwekerk

(A) Cornelis de Vos: The Adoration of the Shepherds.
Antwerp, St Pauluskerk

(A) Gerhard Seghers: The Assumption of the Virgin, 1629. Grenoble, Musée des Beaux-Arts

(B) Caspar de Crayer: Madonna and Saints, 1646. Munich, Bayerische Staatsgemäldesammlungen (on loan to the Theatinerkirche)

(B) Theodoor van Loon: The Meeting of St Anne and St Joachim. Detail. *Scherpenheuvel (Montaigu), Onze Lieve Vrouwekerk*

(A) Theodoor van Loon: The Birth of the Virgin. *Scherpenheuvel (Montaigu), Onze Lieve Vrouwekerk*

122

(B) Theodoor Rombouts: The Musicians. *Lawrence, Kansas, The University of Kansas Museum of Art*

(A) Theodoor Rombouts: The Deposition. *Ghent, St Bavo*

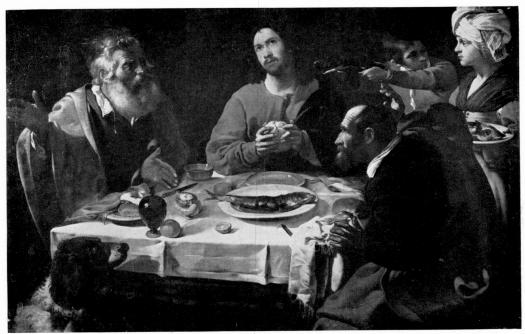

(A) Jacob van Oost the Elder(?): Christ at Emmaus. *Bruges, Onze Lieve Vrouwekerk*

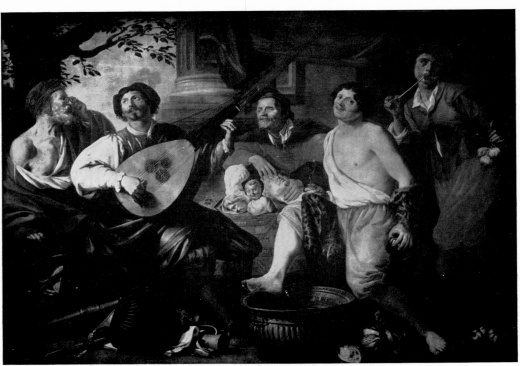

(B) Theodoor Rombouts: The five Senses. *Ghent, Musée des Beaux-Arts*

124

(A) Cornelis de Vos: The Host and the Church Vessels returned to St Norbert, 1630.
Antwerp, Musée Royal des Beaux-Arts

(B) Jacob van Oost the Elder: Family on a Terrace, 1645.
Bruges, Musée Municipal des Beaux-Arts

(B) Theodoor van Thulden: The triumphal March with the Brazilian Booty, 1651. *The Hague, Huis ten Bosch*

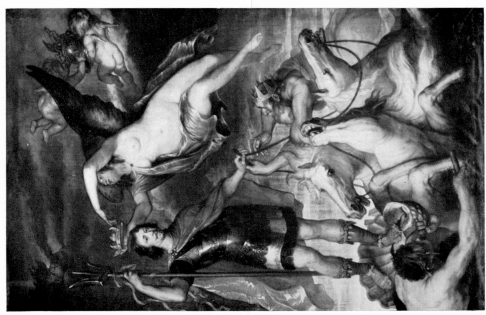

(A) Thomas Willeboirts Bosschaert: Prince Frederik Hendrik as Conqueror of the Sea. *The Hague, Huis ten Bosch*

126

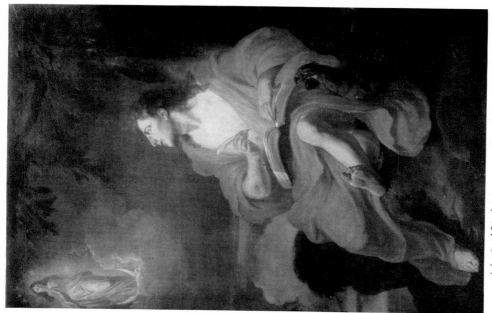

(B) Godfried Maas: St John the Evangelist.
Vilvoorde, Onze Lieve Vrouwekerk

(A) Louis de Deyster: The Martyrdom of a Bishop, 1701.
Gistel, Onze Lieve Vrouwe Hemelvaart

127

(A) Adriaen Brouwer: Peasants. *Schwerin, Staatliches Museum*

(B) Adriaen Brouwer: A Tavern. *London, National Gallery*
(on loan from Sir Edmund Bacon)

Adriaen Brouwer: The Operation. *Munich, Bayerische Staatsgemäldesammlungen*

(A) David Teniers the Younger: Music-making Peasants. *Munich,
Bayerische Staatsgemäldesammlungen*

(B) David Teniers the Younger: The Guard Room, 1642. *Leningrad, Hermitage*

(A) David Teniers the Younger: The Kitchen, 1644. *The Hague, Mauritshuis*

(B) David Teniers the Younger: The Marriage of the Artist, 1651.
London, Edmund de Rothschild

131

(A) Willem van Herp: A merry Company. *Gosford House, the Earl of Wemyss*

(B) Joos van Craesbeeck: The Artist's Studio. *Paris, F. Lugt*

(A) David Ryckaert III: The Operation, 1638. *Valenciennes, Musée des Beaux-Arts*

(B) Simon de Vos: The Fortune Teller, 1639. *Antwerp, Musée Royal des Beaux-Arts*

133

(A) Egidius van Tilborch: Open-air Banquet. *Boston, Vose Galleries*

(B) Gonzales Coques: Family on a Terrace. *Budapest, Museum of Fine Arts*

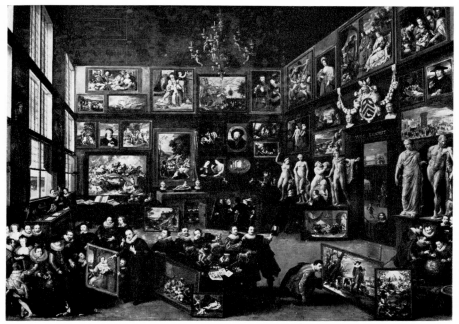

(A) Willem van Haecht: The Picture Gallery of Cornelis van der Geest, 1628. *New York, Mrs Mary van Berg*

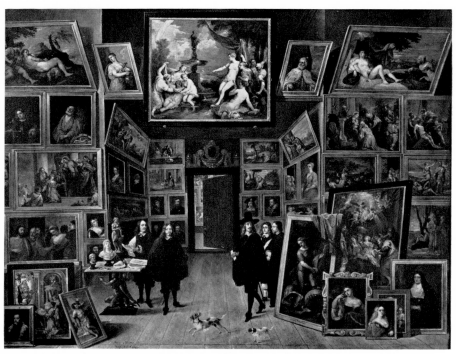

(B) David Teniers: The Picture Gallery of Archduke Leopold Wilhelm of Austria. *Madrid, Prado*

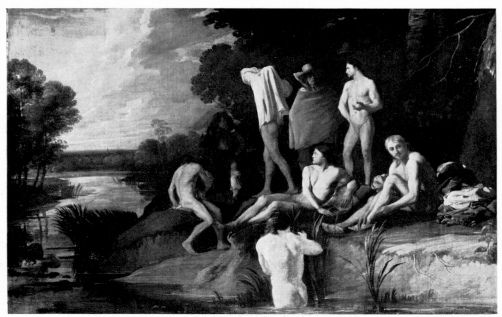

(A) Michael Sweerts: Bathers. *Strasbourg, Musée des Beaux-Arts*

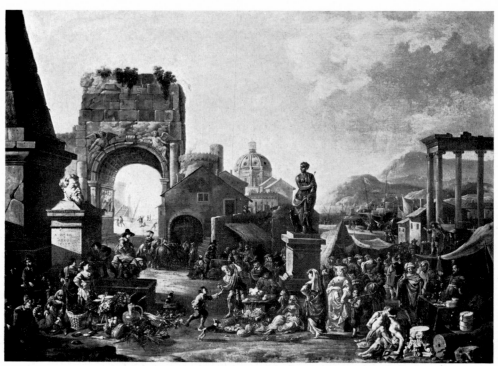

(B) Antoine Goubau: The Fair at the Forum Romanum, 1658.
Karlsruhe, Staatliche Kunsthalle

136

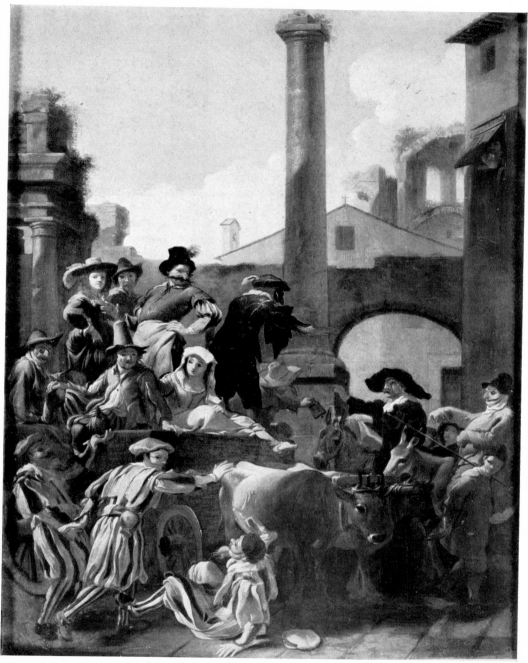

Jan Miel: Roman Carnival, 1653. *Madrid, Prado*

Peter Paul Rubens: The Farm at Laeken. *London, Buckingham Palace*

Peter Paul Rubens: The Château de Steen. *London, National Gallery*

139

Peter Paul Rubens: Landscape by Moonlight. *London, Count Antoine Seilern*

Adriaen Brouwer: The Shepherd piping at the Roadside. (*West*) *Berlin, Ehem. Staatliche Museen*

(A) Peter Paul Rubens: Landscape with Birdcatchers. *Paris, Louvre*

(B) Lucas van Uden and David Teniers: Landscape with Woodcutters.
Formerly Berlin, Staatliche Museen

142

(A) David Teniers: The Château of Teniers at Perck. *London, National Gallery*

(B) Jacques d'Arthois: Trees by the Shore. *Frankfurt, Städelsches Kunstinstitut*

143

Jan Siberechts: The sleeping Peasant Girls. *Munich, Bayerische Staatsgemäldesammlungen*

(A) Hendrik van Minderhout: Harbour on the Mediterranean. *Dunkerque, Musée*

(B) Adam Frans van der Meulen: Hunting Party, 1662. *London, National Gallery*

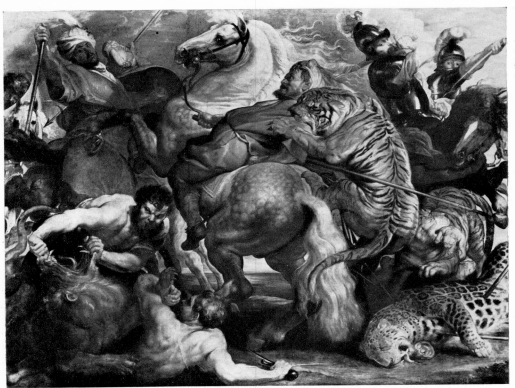

(A) Peter Paul Rubens and Frans Snyders: Hunt, with Samson. *Rennes, Musée des Beaux-Arts*

(B) Jan Wildens: Winter Landscape with Hunter, 1624. *Dresden, Gemäldegalerie*

(A) Frans Snyders: The Boar Hunt. *Poznan, Muzeum Narodowe*

(B) Frans Snyders: The Fish Stall. *Leningrad, Hermitage*

147

(A) Jan Fyt: Game, 1651. *Stockholm, Nationalmuseum*

(B) Pieter Boel: Vanitas, 1663. *Lille, Musée des Beaux-Arts*

(A) Clara Peeters: Still Life with Cheese. *Amsterdam, Dr H.Wetzlar*

(B) Jan van Kessel: Flowers, Insects, and Shells, 1670.
Nostell Priory, Lord St Oswald

149

(A) Daniel Seghers: A Pietà surrounded by Flowers.
Mosigkau, Stiftschloss

(B) Jan Fyt: Still Life with Fish and a Garland of Fruit.
(*East*) *Berlin, Staatliche Museen*

Jan Davidsz de Heem and Nicolaes van Verendael: 'The most beautiful flower . . .'
Munich, Bayerische Staatsgemäldesammlungen

Pieter Jozef Verhaeghen: Christ at Emmaus. *Aarschot, Onze Lieve Vrouwekerk*

(A) Andreas Lens: Diana and Actaeon. *Antwerp, Musée Royal des Beaux-Arts*

(B) Pieter Joseph Sauvage: Christ with Angels. *Tournai Cathedral*

153

(A) Pieter van Bloemen: Cavalrymen, 1708. *Rome, Galleria Nazionale*

(B) Jan Peter van Bredael: The Riding School, 1717. *Vienna, Gallery Sanct Lucas*

154

(A) Balthasar Paul Ommeganck: Landscape with Cattle, 1779. *The Hague, P. A. Scheen*

(B) Theobald Michaud: Landscape with River. *Budapest, Museum of Fine Arts*

(A) Balthasar van den Bossche: The Sculptor's Studio. *Warsaw, Muzeum Narodowe*

(B) Pieter Snyers: Man with a Monkey.
Zürich, Professor L. Ruzicka

(C) Pieter Snyers: The Savoyard Boy.
Aachen, Suermondt Museum

(A) Jan Josef Horemans I: Garden with Figures on a Terrace, 1735.
London, Rex A. L. Cohen

(B) Jan Anton Garemijn: The Market. *Eindhoven, private collection*

Louis Joseph Watteau: The Musicians, 1784. *Tournai, Musée des Beaux-Arts*

Léonard Defrance: The Forge. *New York, Metropolitan Museum*

Léonard Defrance: Self-portrait, 1789. *Liège, Musée de l'Art Wallon*

INDEX

Numbers in *italics* refer to plates. References to the notes are given to the page on which the note occurs, followed by the number of the note. Thus, 185[65] indicates page 185, note 65. The names of artists and places are usually indexed under the final element, particles being ignored. Where names of places or buildings are followed by the name of an artist in brackets, the entry refers to work by that artist in such buildings or places: thus Antwerp, Cathedral (M. de Vos) refers to the painting of *The Marriage Feast at Cana* by de Vos in the cathedral.

Antwerp (*contd*)
140; Buisseret Collection (P. Brueghel II), 57, *42*;
J. van der Linden Collection (Jordaens), 193[23];
Maagdenhuis (Jordaens), 131; Museum Mayer van
den Bergh (Jordaens), 129; Museum van Openbare
Onderstand (Teniers), 145, (van Veen), 51; Mus-
eum Plantin Moretus (van Noort), 52, *38*, (A.
Quellin I), 37, (Rubens), 185[65], 187[108]; Musée
Royal des Beaux-Arts (Koninklijk Museum van
Schone Kunsten) (Antonissen), 169, (de Backer),
48, (van Balen), 62, 67, *53*, (Beschey), 166, (Bon-
necroy), 194[23], (van den Broeck), 48, (Brouwer),
194[12], (Congnet), 54, (Craesbeeck), 194[12], (van
Dyck), 113, 120, 121, 124, 191[42], 192[60], (F. Floris),
48, (A. Francken I), 48, 49, *32*, (F. Francken II), 62,
(H. Francken I), 49, (A. Grimmer), 67, *53*, (A.
Janssens), 53, *36*, (Jordaens), 128–9, 193[24], (Ker-
ricx), 43, (Lens), 166, *153*, (Pepijn), 52, (A. Quellin
I), 39, (E. Quellinus), 141, (Rubens), 75, 76, 81,
82–3, 88, 94, 95, 104, 106, 186[86], 189[147], *71, 75, 82*,
(G. Seghers), 139, (van Stalbemt), 67, (van Til-
borch), 148, (O. van Veen?), *55*, (C. de Vos), 137,
125, (S. de Vos), 149, *133*, (Wildens), 152; Teir-
ninck Foundation (Jordaens), 129, 131; Vleeshuis
(van den Bossche), 170
Anzegem, Château d', Count Philippe de Limburg
Stirum (van Stalbemt), 67, *52*
Apshoven, Thomas, 148, 156
Archdukes, the, *see* Albert, Archduke, *and* Isabella,
Archduchess
Architecture, IV (Serlio), 12, 178[7]
Arenberg Collection, *see* Cap Ferrat
Arras, Union of, 2
Arthois, Jacques d', *153, 143*
Arundel, Countess of, 116
Arundel, Earl of, 111, 191[48]; portrait, 115
Aschaffenburg (d'Arthois), 153, (Vranx and J. Brue-
ghel), 63
Assche, Isabella van, portrait, 124
Asselijn, Jan, 153
Ath, Town Hall, 17
Augsburg (Gysels), 151, (van der Meulen), 157
Averbode, Abbey, 25, 28–9, 32, 178[19], (P. J. Ver-
haeghen), 167
Avont, Pieter van, 142
Aytona, Marquis d', 92

B

Backer, Jacob de, 48
Bacon, Sir Edmund, Collection (Brouwer), 144, *128*
Baer, Curtis O., Collection, *see* New York
Baglione, G., 110
Balen, Hendrik van, 60, 62, 63, 67, 112, 143, *48, 53*
Balten, Pieter, 56, 57, 64
Baltimore, Museum of Art (van Dyck), 122
Bamberg (van Dyck), 111
Bankes, Ralph, Collection, *see* Kingston Lacy

Baren, Jan Anthonie van, 163
Baren, Josse van, 50
Barnard Castle, Bowes Museum (van Uden), 152
Barré, N., 34, *11*
Basel, T. Christ Collection (ex) (de Heem), 195[50];
R. von Hirsch Collection (Rubens), 184[43]; Linde-
meyer-Christ Collection (Boel), 161
Bassano, Jacopo, 52, 74, 75, 76, 139
Bassen, Bartholomeus van, 156
Bath, Marquess of, Collection (Jordaens), 193[20]
Baudius, Dominicus, 71
Baurscheit I, J. P., 43
Baurscheit II, J. P., 31
Bayonne, Musée Bonnat (Rubens), 187[101]
Bedford, Duke of, Collection (van Dyck), 122, 191[43],
(Teniers), 146, (Willeboirts), 141
Beert, Osias, 161, 181[27]
Bega, Cornelis, 170
Beloeil, Prince de Ligne Collection (Duchatel), 194[17]
Bellori, G. B., 88, 102, 110, 116, 118, 123, 125, 183[29],
189[5]
Benavides, Louis de, bust, 39
Benedict, Dr C., Collection, *see* Paris
Bentivoglio, Cardinal, portrait, 119
'Bentveugels', 116
Berchem, Nicolaes, 155, 169
Berckmans, Hendrik, 194[14]
Berg, Mary S. van, Collection, *see* New York
Bergé, Jacques, 42, 43
Bergen (Mons), Château, tower, 23–4
Bergen-op-Zoom, Markiezenhof, 11
Bergen, Dirk van, 194[26]
Bergman sale (Rubens), 184[30]
Bergsten, K., Collection, *see* Stockholm
Berlin, F. A. Gutmann Collection (J. Brueghel),
181[24]; St Mary, Sparre monument, 38; sale (1935)
(van Es), 195[47]; Schloss Grunewald (A. Janssens),
55, *41*, (Rubens), 81; Staatliche Museen (Brouwer),
144, *141*, (van Dyck), 113, (Fyt), 160, *150*, (Ru-
bens), 101, 107, 113, 188[130], (Siberechts), 154,
194[26], (Teniers), 145, 146, 152, *142*, (van Uden),
152, *142*, (Verhaeght), 66, (M. de Vos), 47, *30*
Berne (Mirou), 67, (O. van Veen), 50
Bernini, Gianlorenzo, 36; portrait(?), 191[32]
Berré, J. B., portrait, 169
Beschey, Balthasar, 166, 187[102], 196[3, 9]
Beuckelaer, Joachim, 158, 161
Bie, Cornelis de, 86, 182[10]
Birmingham, Barber Institute of Fine Arts (van
Dyck), 117, 126, *110*, (de Heem), 195[48]
Biset, K. E., 149, 195[30]
Bles, Herri met de, 64
Bloemaert, Abraham, 50, 180[2]
Bloemen, Jan Frans van, 154
Bloemen, Pieter van, 154, *154*
Blondeel, Lancelot, 10
Bloot, Pieter de, 143
Boekhorst, Jan van, 141

M